Digital Portrait Photography and Lighting: Take Memorable Shots Every Time

Digital Portrait Photography and Lighting: Take Memorable Shots Every Time

Catherine Jamieson and Sean McCormick

Wiley Publishing, Inc.

Digital Portrait Photography and Lighting

Published by
Wiley Publishing, Inc.
111 River Street
Hoboken, N.J. 07030
www.wiley.com

Copyright © 2006 by Wiley Publishing, Inc., Indianapolis, Indiana

Published simultaneously in Canada

Library of Congress Control Number: 2006922425

ISBN-10: 0-471-78128-2
ISBN-13: 978-0-471-78128-8

Manufactured in the United States of America

10 9 8 7 6 5 4 3 2

1K/RQ/QX/QW/IN

For general information on our other products and services or to obtain technical support, please contact our Customer Care Department within the U.S. at (800) 762-2974, outside the U.S. at (317) 572-3993 or fax (317) 572-4002.

Wiley also publishes its books in a variety of electronic formats. Some content that appears in print may not be available in electronic books.

WILEY

About the Authors

Catherine Jamieson operates a small commercial and portrait photography business, keeps just ahead of two college-aged children and a pair of whacky cats, publishes one of the Internet's most popular personal photography sites (www.catherinejamieson.com), is the founder and publisher of the community photography site Utata (www.utata.org), and recently authored the book *Create Your Own Photo Blog*. Catherine's work has been published in newspapers, magazines, books, encyclopedias, and atlases, as well as upon a variety of calendars, postcards, and posters.

Sean McCormick works full-time out of his studio located just outside of Kirriemuir, Alberta, Canada, where he specializes in portraiture and landscape photography. A graduate of the New York Institute of Photography, Sean is a member of the Alberta Professional Photographers Association, the Professional Photographers of Canada, and the Canadian Association for Photographic Art. Sean's images are available for licensing exclusively through CP Images, a division of the Canadian Press. Sean's photography is viewable online at his Web site, www.digiteyesed.com. Sean and his wife also publish an eZine focused on Canadian photography called *Circle of Confusion*.

Credits

This book is dedicated to the people of Utata. May the tribe always flourish.

Preface

This book was written to help the amateur or mid-level photographer improve their portrait photography skills. With enough information to help the amateur turn their hobby into a profession, this book is aimed at people looking to attain the next level in portrait photography.

Part I of the book, "Understanding Digital Photography," answers your questions about trends and portrait photography styles; what camera equipment you will need; and not only what lighting equipment will help you achieve your goals but also how to use it in portrait scenarios. From lens crop factors to choosing between continuous and strobe lighting, the first section covers the things you will need to know to set yourself up to take excellent portrait photographs every time.

Part II, "Posing and Composing," covers composition, posing, and handling challenges. From standard poses and lighting setups to more unusual or creative posing techniques, you can learn how to put the model(s) in the right place inside the photograph and show them to best advantage. This section also covers formal (standard) poses as well as head shots and body shots and even provides information on how to compose and pose groups, children, and pets. Find out how to deal with glasses, large noses, and other photographic challenges so you can make the best portraits possible of each and every subject.

Part III, "Into Action: Creating Portraits," walks you through common portrait scenarios such as indoors with mixed light, outside in natural light, and in the studio with photographic lighting. Learn how to handle props, backgrounds, color, location shooting, and how to set up and perform a model shoot in a studio setting.

Part IV, "Post-Production and Presentation," takes you into the digital darkroom and explains the software you will be using, the methods used for basic image editing, and final touch processes that will allow you to produce high-quality, professional portrait images for your own personal use or for a professional client base.

We've also included two appendixes. Appendix A contains a list of references and resources that are helpful if you want to explore the topic of portrait photography more fully. Appendix B will help you get started in your portrait business and will help you deal with making budgets, setting up a business marketing program, and establishing pricing for your work.

As you read through this book, you will notice certain typographical conventions that are important for you to understand:

✦ An item in *italics* is a new term that has not been used before.

✦ **Bold** text is something you (the reader) must type.

✦ The odd font used for URLs is called `monofont`.

You might also notice a series of icons designed to help you find things quickly and bring your attention to specific important items:

◆ **CAUTION.** This icon tells you some piece of related cautionary information that is important for you to know.

◆ **NOTE.** This icon provides related information that may affect other information or you should keep in mind.

◆ **TIP.** This icon highlights a piece of related advice that doesn't fit in the text but is important to know.

◆ **X-REF.** This icon lets you know that the topic has been covered in another part of the book, for further exploration.

Sidebars hold related information that is more anecdotal or informative in nature than instructive and very often contain explanations for phrases, instructions or other material covered in the text.

Portrait photography is fun and rewarding. If you're reading this, chances are you're interested in it as either a hobby or a profession. We've endeavored to provide you with a well-rounded reference that will get you started on that path — whether you want to do it for the reward of the great portrait itself or to supplement or replace your income. Good luck and good shooting!

Acknowledgments

The most important people to acknowledge are the photographers at www.istoica.com, who are Chris Altorf and Jessica Pronk, and who have supplied a great number of the wonderful illustrations used in this book, including the cover images. They worked with me on tight deadlines and crazy schedules and always came through with professionalism and polish. Their genius is evident in their body of work, and it is with great thankfulness and respect that I acknowledge their contribution.

My profound thanks to the contributing Utata photographers (I will provide a list of names) who, as always, were generous and patient and brilliant.

My appreciation and thanks to the following: Greg Fallis for his most excellent and valuable assistance in gathering information and keeping the tribal drums beating; Carolyn Primeau, my assistant, for every very cool and important thing she does; and my daughter, Danielle, for putting up with me through the final weeks of work. Thank you, all.

About Istoica

Istoica is the signature for two photographers, Christopher Altorf and Jessica Hayes. Their photoblog www.istoica.com attracts more than a thousand visits a day. Noted for the clarity, wit, and illumination of their portraiture, these young artists are continually experimenting to develop their style. Posting new photos to their website every day pushes them to seek out new stories to tell in their images and playful, fresh perspectives to engage their viewers. When asked about their favorite comment, they shared that one visitor to their site wrote, "You guys bring out the true beauty in everyone." Istoica are active in the Toronto Photoblogging community, regularly to be found at meet@@hyups and group shoots.

Contents at a Glance

Contents

Part II: Posing and Composing 81

Part III: Into Action: Creating Portraits 159

Chapter 7: Outdoor Portraiture . 161

Part IV: Post-Production and Presentation 251

Chapter 10: The Digital Darkroom . 253

Chapter 11: Basic Image Editing . 275

Understanding Digital Portrait Photography

1

Exploring Portrait Photography

A portrait is a likeness. They've been etched on cave walls, minted onto the sides of coins from every age since the Bronze Age, and sketched, painted, and photographed since the beginning of recorded history. Naturally, styles and fashions have changed over time, but the portrait endures as a form of art, communication, and keepsake. We like to remember those we love, admire those we find beautiful, commemorate those we find valuable. The photographic portrait may well be one of the more important social tools we have.

But don't let this notion daunt you. The very reason photographic portraits are so important is that they are made so often by so many people. Indeed, more pictures of people are taken every year than any other subject, and more and more pictures are being taken each year. Whether you want to document your child's life, your brother's Olympic training, or the life of the man who keeps the last lighthouse lit, portrait photography is for everyone. Everyone.

If you have a basic understanding of photography — and you need only a basic understanding, and a willingness to learn a few simple but specialized techniques — not only can you take portraits, you can take *great* portraits.

Digital portrait photography is a blast! Oh, all photography is fun, of course, but digital photography offers you not one but two unique opportunities. In the first case, digital "film" is free once you own the reusable storage media, so you can practice and take as many test shots as you need; in the second case, the gratification is instant.

There's no big secret; a faerie doesn't sprinkle pixie dust on professional portrait photographers. It's much simpler: there is a collection of tools and information, that when combined together with experience and creativity, allow the photographer to make the best decisions when planning shots. The result is, as you might expect, better shots.

Whether you're sitting on the amateur/professional fence and considering starting a small portrait business, or you just want to take better photographs of the people you know, you need to understand the same basic principals. Whether you do it with an expensive professional lighting setup or a few old lamp stands and some clip-on reflector lights — or even with the sunlight and a piece of tinfoil — the ideas remain constant.

You need to know how to set up your digital camera, compose an image to best advantage, pose your model (whether it's Christie Brinkley or your granddaughter), and handle or manage the lighting. Then you need to know how to take that image from the camera to a frame or a computer monitor in a finished, professional state. That's it. Sounds easy, right? Well, it really is.

At its very root, photography is a science and therefore governed by certain immutable physical laws that actually make it easier to learn. Why? Because these laws, or rules, never change whether you are making a snapshot, a casual portrait, or a full-on glamour setup with a tiara and a feather boa. And once you have these basics rules down, you will find that photography does the most amazing thing: it becomes art.

Take a Better Snapshot

We all take snapshots, of course. And with any luck we will all continue to do so happily into our photographic old age. But a snapshot is not a portrait. Although it may well capture a moment or an event, a brilliant smile or a funny face, it has not been planned. And therein lies the difference. A snapshot is an opportunity. A portrait is an executed plan.

It's no secret that if you point your camera at enough things, you will get some good (and perhaps even great) shots. I have one or two I keep in frames on my desk that might well have been blessed by those faeries I mentioned earlier, I was so lucky to have gotten them. I wouldn't want to live in a world without snapshots, frankly, and never plan to stop taking them myself. What would the first day at the cottage or the last day of the high school be without a few carefree snapshots to stick in the family album?

Though you may not want to post-process your snapshots, they will be improved by the information in this book. From the information in the next chapter on equipment to the chapters on lighting and composition, your snapshots will improve because you will have a better understanding of the basic rules of photography — the ones that are the same no matter what style of picture you are trying to take (see Figure 1-1).

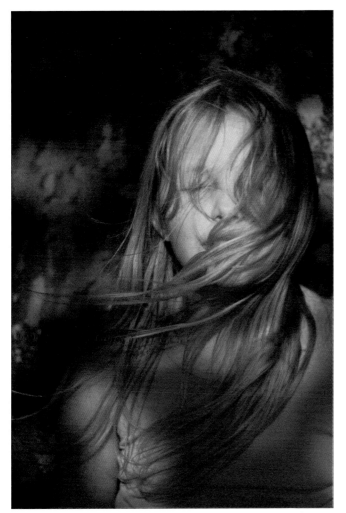

Figure 1-1: A snapshot is not, by any means, an inferior style of photograph — it is simply a distinct one. Usually taken without any specific planning or forethought, a snapshot is a moment captured. And some of them, like this one, are magical.
© Victoria Slater

A friend once said that the snapshot was the scribbled love note, the casual portrait the love letter, and the formal portrait the dedicated sonnet. "But love is love," he remarked.

Fact is, you might be buying this book because you want to take better snapshots, and you're never going near a studio as long as you live. You know something important: The shots you will want to remember later are the ones of the people you knew and loved. Those snapshots you took that summer in Nantucket and the ones of Junior when he was a chubby toddler and not a college graduate. And you want them to be as good as they can be.

This book is about making your people pictures as good as they can be, whatever you call those pictures.

If you're a snapshooter, you can improve your people snapshots by learning the basics:

✦ How to arrange your subjects in the picture to keep them clear and in focus

✦ Where to put yourself to capture the right moment

✦ How to work cooperatively with the light to get the best results

✦ How to find the right backgrounds and use the correct angles to catch features at their best and minimize problems (see Figure 1-2)

✦ How to use basic digital camera techniques to help you make decisions and get the right settings for each condition

✦ How to use common items like white plastic bags and poster boards to "do it like the pros" and improve your portraits

Figure 1-2: The particular joy of the snapshot is the ability to capture loved ones in a perspective that is uniquely yours and will always resonate with you. You can vastly improve snapshots when you have a good understanding of basic photographic composition.
© Siobhan Connally

Create a Casual Portrait

And if you're *dreaming* about a studio and your fondest wish is to hang a shingle that says "Portrait Photographer For Hire," you also came to the right book.

The primary distinction between a snapshot and a casual portrait is planning — and this distinction can be a very fine line, indeed. So, you need to know the same things, in other words. You just need to learn to control things a little more. Yes, it's true: photographers can bend the world to their will. (Well, a little . . . with the right lighting.)

If you take your camera to the beach to capture a few shots of your kids in the sand to send to your mother, you've certainly engaged in some planning. If you take your camera to the client's golf tournament and plan to capture a few casual portraits for an agreed upon fee, you've engaged in about the same level of planning.

Or have you?

Whereas a snapshot is an "as is, where is" proposition usually taken in whatever circumstances one finds oneself, a casual portrait is generally planned to a fine enough degree that you have with you a few tools to assist you; something to reflect, deflect and/or create light.

Then again, if you use your car floor mat to block the bright light, or an empty chip bag as a makeshift lens hood to catch the middle daughter diving off the floating dock, you've certainly fulfilled the requirements of using tools to assist you in getting the desired result.

As you can see, spending any real time trying to explain or quantify the difference between a snapshot and a casual portrait ends in the same unsatisfactory place. In fact, you'd be hard pressed to describe any quality distinction between Figure 1-1, Figure 1-2, and Figure 1-3, if any exists at all.

The casual portrait, a classic example of which is shown in Figure 1-3, has all of the qualities of a good snapshot and none of the drawbacks of a formal portrait. This is why casual portraiture is in growing demand, even in areas where the formal portrait was once the norm.

The reason you can't tell the qualitative difference between the first three figures is because there is none. Each is beautifully composed, each is properly exposed, each is lit appropriately, and each is cropped with good taste and an eye for design. The difference is only in intent and planning. As I said in the beginning, the rules are always the same and so they work for all styles and all intents. All that changes is the way you put things together — and how deliberately.

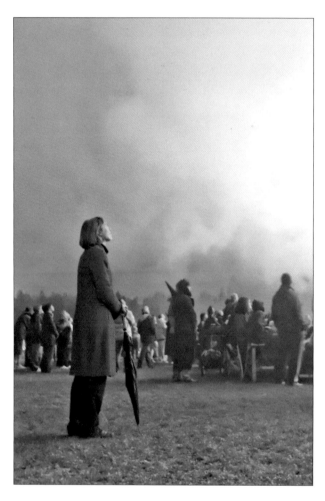

Figure 1-3: Casual portraits, like this classic example, are the most in demand these days because they provide a genuine glimpse into not only the physical aspects of a person but can often capture his or her personality as well.
© *Stephen Strathdee*

Casual portraits are characterized, primarily, by non-formal poses. Or, in many cases, no real pose at all. They are intended to provide a characterization of the models by showing them in such a way that would seem familiar to the people who know them well (see Figure 1-4). Casual portraits are the kind the wedding photographer takes at the reception hall or during the bride's preparations. They are the kind taken at company functions for the corporate newsletter.

Casual portraits are also the kind mothers take or want taken of their children, spouses of one another, and pet owners of their pets, as shown in Figure 1-5. They can be slightly posed ("Tilt your head up a little, please") or at least directed ("Can you move about a foot closer to the light while you braid her hair?") but they are never formally posed or directed to any great degree. They're not fully candid, of course—the people always know they are being photographed—but they are meant to portray the model naturally and representatively.

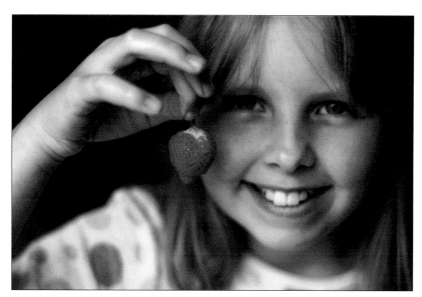

Figure 1-4: Set apart from formal portraits by informal poses that occur naturally, the casual portrait is meant to capture an expression or action that is characteristic of the person.
© Victoria Slater

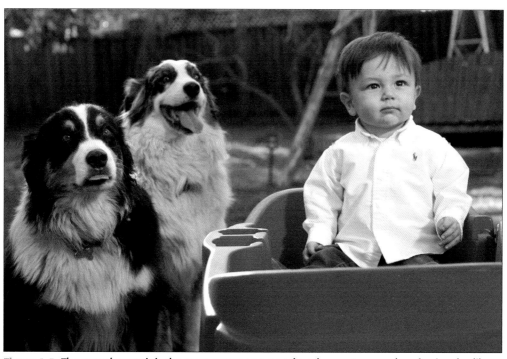

Figure 1-5: The casual portrait is the most common type taken, by amateurs and professionals alike, because it is generally the most pleasing to the client or model. "It's so me!" are wonderful words for a photographer to hear.
© Jennifer Mitchell

You can improve your casual portraits by learning more techniques:

- ✦ How to use metering to make better portraits
- ✦ How to use techniques like DOF (depth of field) and POV (point of view) changes to improve results
- ✦ How to exercise control over light and make it work for you
- ✦ How to create silhouettes, catch action, and freeze moments
- ✦ How to use basic and advanced digital camera techniques to get the right exposure every time
- ✦ How to use filters, reflectors, and basic lighting tools

Formal portraiture is slightly different, of course. But the basic rules are the same. What changes and makes them formal? More planning, more control, and a certain adherence to standard poses and lighting norms. Well, that and a few other things.

Set Up a Formal Portrait

Every CEO needs at least one serious-looking headshot, and all brides and grooms want a few perfectly lit and lushly colored portraits with sparkly highlights on their rings. There will always be yearbooks, graduations, and people who prefer a more formal style of portraiture. There will always be team pictures and Little League windups. There will be staff photos and families (with pets!) and you will surely need to know how set up formal portraits and deal with arranging groups.

Formal portraiture is not now and never will be "dead" — even though it is no longer the norm for the most common portrait scenarios (couples and kids). It will remain a steady business for photographers because part of its nature is archival; it is meant to provide documentation. And, of course, people, businesses, clubs, groups, teams, and bands will always want and need this service. I know a man who makes his living doing nothing but making headshots of real-estate agents and other salespeople who use them on their business cards and promotional materials.

Again, the basic photography rules are the same. The "formal" in the formal portrait refers to a level of control by the photographer, not the nature of the photograph. In fact, many "formals" are quite fun and can even be casual in general appearance, even though everything about them has been carefully planned by the photographer. As was the main difference between a snapshot and a casual portrait, it is planning and control that distinguishes a formal portrait from a casual one.

The portrait in Figure 1-6, for example, was made in a studio with photography lighting and a carefully considered costume and pose. Metering was done, lighting was adjusted, several poses were tried, and many shots were taken. It was a session.

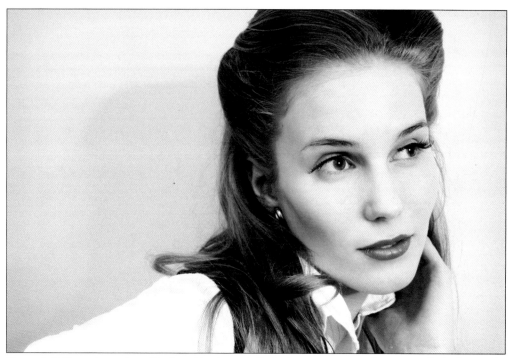

Figure 1-6: The primary benefit of working in a studio is that you can exercise a great deal of control and try many different things. Although you can create casual-style poses in the studio, they usually have a different look to them than those captured with no posing instruction from the photographer.
© Istoica.com

With this control and planning, naturally, come a whole new set of tools and techniques. When you're snap-shooting or taking casual portraits, you are at the mercy of the conditions around you and you are, basically, making the best of them. In formal work, the model is sitting in your studio, under your lights, and you can make it light, dark, or anything in between. For that matter, you can make the model light, dark, or anything in between. But why stop there? You could drape your model over an old armchair (Figure 1-7) or have your models do something related to their profession, such as the portrait of noted photographer Rannie Turnigan, who is looking at a roll of film (Figure 1-8).

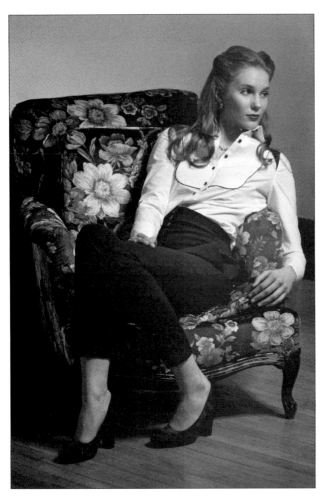

Figure 1-7: You can create your own version of classic poses and design your shots so that the lighting depicts any type of atmosphere you want. Here the lighting is all glamour, and the model's pose is exactly what you expect a glamour girl to look like: carefully casual.
© *Istoica.com*

Formal portrait photography doesn't have to be boring, staid, or even predictable. Even though you will use the same techniques and follow the same basic rules that photographers have been using for years, the end result can be as fresh and innovative as you want. The same principals that make the CEO of Big Corporation look responsible and distinguished in his standard head shot will make your dancer model look stunning in her pas de chat.

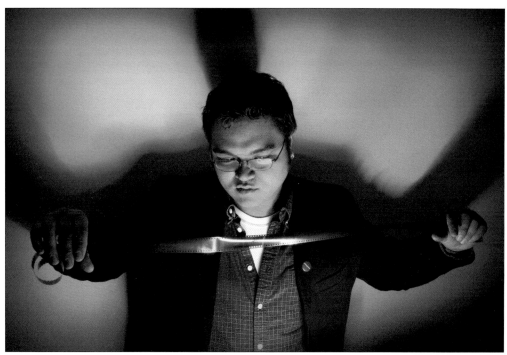

Figure 1-8: Beautifully composed and backlit, this formal studio portrait of photographer Rannie Turnigan captures not only his profession, but both the studious and fun aspects of his nature.
© Istoica.com

Improve your formal portraits by learning advanced techniques:

✦ How to pose and compose — from individuals to large groups

✦ How to use posing and lighting techniques to overcome model challenges such as large noses or eyeglasses

✦ How to set up your own studio lighting and use photography lighting techniques

✦ How to shoot in all light types and use color, props, and backgrounds to best advantage

✦ How to deal with shooting in public venues, in bad weather, and with mixed light

✦ How to deal with models and conduct a professional portrait session

Formal or studio portraits present the serious portrait photographer with the most important of all things: control. You will certainly get a few great shots when you're at the beach with the kids. You will surely come up with some amazing casual portraits while you follow the bride around on the morning of her wedding. You will use all your knowledge and skill and make good decisions in each of those cases and, doubtless, you will have some wonderful photographs. But the nature of the photographer in the studio is akin to a child in a toy store. There are just so many things to play with! Light! Color! Props!

Really, I'm always tempted to make that evil laugh sound (*mwah ha ha*) when I find myself in my studio with some time and a willing model. I believe I *have* rubbed my hands together and made a wide-eyed "what can we do today?" face.

The only totally true thing I know about art is that it pretty well universally turns out better when the artist knows how to use the tools that create it. Could Gainsborough have given us the Blue Boy if he didn't know how to mix paint or use a brush? Unlikely. Portraits such as the one shown in Figure 1-9 are not hard to create. Quite simple, in fact, if you have and know how to use the right tools.

Even though you will likely have to take the most traditional of studio portraits from time to time (that distinguished CEO, those real-estate agents), you will also have the chance to turn your studio into a fun-house and stretch your creativity as far as the walls will allow.

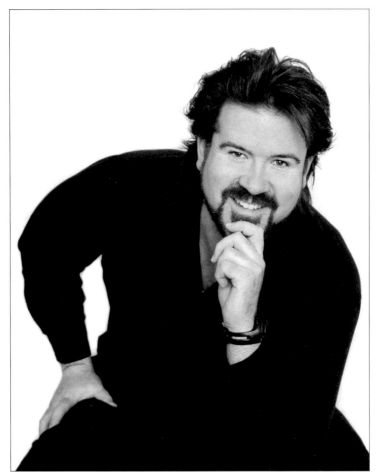

Figure 1-9: Beautifully high key and brimming with vitality, this studio portrait of Ottawa artist Gary Corcoran manages to mix the best aspects of the casual portrait (a sense of intimacy with the model) with the best aspects of studio work (even lighting).
© *Cheryl Mazak*

Self-Portraits

"Every photograph we make is part of a learning process. We turn our lens on our respective worlds, on the people who inhabit it, on the new places we discover, and on the scenes we've created. We find truth and we create fiction with our cameras. It seems a natural thing to turn the camera around and examine ourselves, or even to recreate ourselves."

This very wise passage was written by a photographer named Laura Kicey who takes, as you might have guessed, amazing and wonderful self-portraits (see Figure 1-10) — among many other subjects and themes, of course.

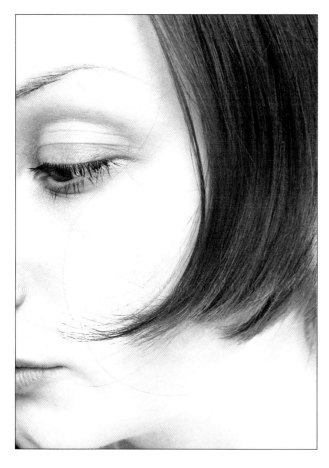

Figure 1-10: Self-portraiture is, beyond its merits as a bona fide form of art, a wonderful method of training yourself on lighting and posing, expression and nuance.
© Laura Kicey

Self-portraits are fun. But more than that, they're excellent learning tools. Van Gogh painted 35 of them in his lifetime, and Toulouse-Lautrec painted so many it is not known how many might actually exist. Reasons for doing them range from self-exploration to learning to light people, combine color, and create poses.

Dr. Joanne Ratkowski, a clinical psychologist and amateur photographer, has developed a following based on her always evocative, often provocative self-portraiture (see Figure 1-11). She, like Laura Kicey, regularly astounds a large group of people with compositions that use careful poses and calculated props. I personally believe this sort of work contains some of the best lessons in portrait composition to be had. Inside of self-portraiture there exists a rather astounding capacity for narrative photography and, as one prolific self-portraitist told me, "I can't write poetry, so I do this instead."

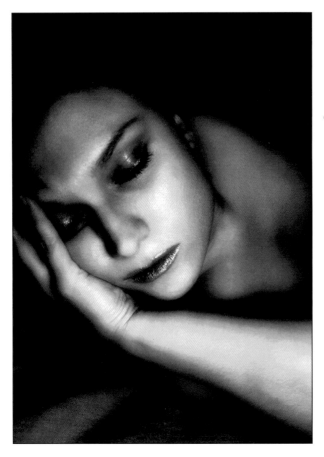

Figure 1-11: Because you will not be shy to ask yourself to perform any manner of pose, and because your patience with the photographer will exceed anyone else's, self-portraiture is often considered the most expressive of all forms of visual art.
© Joanne Ratkowski

Self-Indulgent or Self-Taught?

While there are those who consider self-portraiture to be a self indulgence, I doubt very much I could have ever learned to take photographs of other people if I had not had a cheap, patient, and convenient model (myself, of course). This is why many photographers jokingly refer to themselves as "the model of greatest convenience."

Do not discount the importance of repetition and practice. Photography posing is a very subtle and intricate process. When you consider the number of angles, simple and compound, which make up the human form when it's just standing there doing nothing, you can imagine the way that small shifts in lighting and position can reorder the whole works in unexpected ways. Many portrait photographers, therefore, use themselves extensively and exhaustively to teach themselves the ins and outs of both lighting and posing.

To work with self-portraiture, you need either a wireless remote or a cable release (or you can also use the timer on your camera) and a tripod. A mirror will prove invaluable, particularly if you are able to position it just behind the camera so you can see, more or less, what the camera will see. Aside from having the ability to create really wonderful works of art, you can teach yourself about lighting, posing, and POV (point of view) quickly and cheaply.

The fact is that portrait photography is the way we've told stories to one another since Eastman came out with the first affordable camera in 1900. Collectively, the photographs we've taken of one another are a form of social history. We've taken portraits for our own pleasure and enjoyment and to record not just the moments, but the people in them. This remains the goal of portrait photography: to record people, and not just their faces and physical features, but also their personalities.

Digital photography simply adds a new facet to the craft; a new set of tools to the arsenal. It allows such a variety of options — notably the ability to practice cost-effectively and to process you images yourself on your computer — that I feel quite safe in saying that you can do today with digital cameras what you could not have done when analogue and film were your only choices. The learning curve is radically adjusted in your favor.

Do You Have What It Takes?

I assume you own a camera. If you can point that camera at the subject and press the shutter button, then yes, chances are quite good that you have what it takes to take great portraits.

A young assistant of mine once said, "Your (camera of the same make and model) works better than mine!" Of course we laughed; it was meant as a joke, and she was fully expecting the maternal stare over the top of the reading glasses that she got. But it did get us started on a longish conversation about how the camera was much less important than the knowledge behind it. "Yeah," I replied, "mine didn't work very good when I first got it, either."

You don't need the most expensive or best camera, and you don't need the most expensive or best lighting. Even if you bought the best Hasselblad on the shelf and got the most stupendous set of lights imaginable, you'd *still* have to know how to use them.

Let's further answer the "Do I have what it takes?" question with another one: What do you need to make a great portrait?

- ✦ A camera
- ✦ Enough light to enable your camera to capture your model
- ✦ A model
- ✦ A working knowledge of how to use the camera, the light, and the environment to show the model in the best possible way

Chances are that you have the first three items already. Chances are you picked up this book because you want to tick the fourth off as well. Not coincidentally, that is exactly what this book aims to help you do.

✦ ✦ ✦

2 The Tools of the Trade

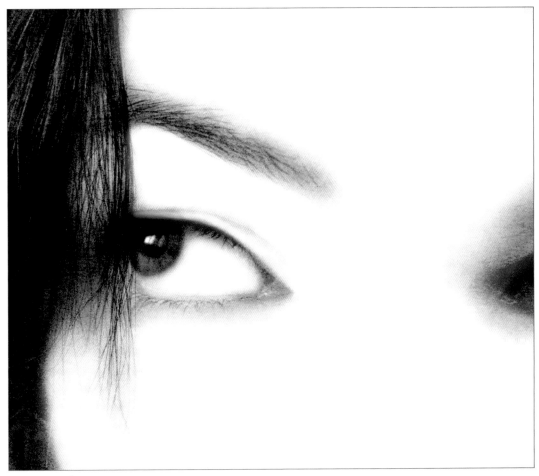

© *Cheryl Mazak*

Every job has tools. Beyond those things related to photography, mine are my computer and word-processing program, my dictionaries and reference books, my catalogues and manuals. They all need to work properly and do the job I need them to do. If not, I can't do a good job for my client (you, the reader).

Photography is exactly like that or any other job: you need some tools to do it well, and your tools need to be right for the job you're asking them to do.

All types of photography start out the same way and use the same basic tools, and if you're set up for general photography, the chances are that you will hardly need to add a thing to your collection of photography equipment. By the time people are serious enough to consider going pro, they've usually got a lot of "stuff," as I say.

Portrait photography is a specialty and thus there are some accessories and pieces of equipment specific to it. You wouldn't need a posing stool to make abstract macros of insects, for example, but you will need one to make a head shot of your client. Additionally, many lenses are particularly useful in portrait situations.

In other words, there's some "stuff" you should have when you're making portraits.

The Camera

I'm not letting any secrets out of the bag when I say that your camera is the most important aspect of being a photographer. Part of me would like to say it's your creativity and imagination—and this is true on some levels—but really, it's the camera. I don't mean to say the right camera will make you a good photographer. Let's be clear about that—it won't— but it will enable you to become one. Which leaves the logical question: What's the right camera?

There's not a simple answer for that, as you likely suspected. It depends on what you plan to do with it.

Getting the right camera for the job

The "right" camera is the one that has all the features you need to do the job you want to do. If you want to produce great family portraits, keep a Web scrapbook, illustrate your family tree, or keep your distant relatives up to date on how everyone is looking, you can do so with almost any digital camera, including those attached to your cellular phone.

If you want to do some or all of those things, plus produce small prints, keep a photo blog updated, or use your photographs in a newsletter, you need at least a 3-megapixel camera.

If you want to do any or all of those things, plus take high-quality casual portraits or print anything up to 5 x 7.5 inches, you need at least a 5-megapixel camera capable of manual focus and settings adjustment.

And if you want to do any or all of *those* things, plus produce professional formal portraits that you can print larger than 5 x 7.5 inches, you need at least an 8-megapixel camera capable of manual focus and settings adjustment.

If you want to do *everything*—to take advantage of all the tools photography has to offer, from composition to lighting to exposure control, and operate a professional service business—you need that 8-megapixel camera to be preferably of the variety that allows you to change lenses (see Figure 2-1) and manually control every aspect of its operation. For certain common portrait techniques, such as the shallow depth of field (DOF) shown in Figure 2-2, you need a camera that allows you to manually adjust settings (or override auto settings) and, in most cases, manually focus.

Using a Point-and-Shoot?

You can, strictly speaking, make any type of portrait with any type of camera—from snapshots to formal portraits. With a point-and-shoot camera, you can use lighting and props and create a digital image which will appear, on your computer, much like an image from a high-end dSLR.

If you are shooting for the Web; company, club, or community newsletters; small-circulation magazines printed on newsprint; or any other print publications where resolution does not matter greatly, the size of image your camera must be able to produce need not exceed 640 x 480 pixels. Even the smallest of digital cameras can generally create a photograph of these dimensions.

Although you can still take very good portraits with a camera that has only an auto focus mode, you cannot perform many of the more advanced shots without being able to perform selective focus and adjust aperture, shutter speed, and ISO.

Many point-and-shoot or smaller-megapixel cameras do not allow either manual focus or a great deal of control over other camera settings. You can still take great portraits, of course, and this affects none of the rules of composition, posing, or lighting. It does, however, affect how much advantage you can take of certain situations.

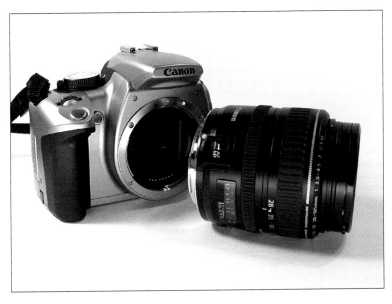

Figure 2-1: A camera which allows you to remove and change lenses, in addition to exercising full control over all settings and focus, is very important at the professional level.

© *Utata Photography*

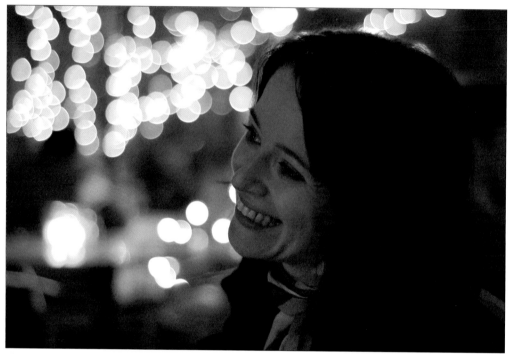

Figure 2-2: Many common portrait techniques, such as using a shallow depth of field to bring a subject's face out from the background, usually require that you have full manual control over your camera's settings and focus.
© Jeremy Sheldon

What features do you need?

The most perplexing of all questions is always "What sort of camera should I buy?" because it has so many possible answers based upon so many what-ifs. I can't tell you specifically what camera you should own, but I can help you with what features it should have.

At this level, cameras are like cars, and there are those people, to use an analogy, who wouldn't be caught dead in a Chevy (or using "X" brand camera). Camera brand preferences and loyalties can border on the fanatical. Part of this is due to the fact that once you make the initial investment in a camera body and the lens that attaches to it, you have made a significant pledge to that company and, unless you have money to spare, you usually end up staying with whatever company you started with.

Choose carefully, is what I mean to say. Table 2-1 gives you a good overview of the qualities and characteristics on which you can base your "short list" of camera options; but in the end the choice is complex and personal, and you must make it yourself. The camera must "feel right" to you.

 Caution It may sound silly to you, but it's actually quite important to handle the camera you intend to buy to make sure that it feels right to you. I am a reasonably small woman with small hands, and one of the reasons I use my Canon 350D more than my Canon 1Ds (which is a significantly superior camera) is that it fits better in my hand and feels like it's the right weight for me. Some men, on the other hand, find that the 350D feels too small and lightweight. I urge you to try before you buy and make sure you will like using the camera you select.

<div align="center">Table 2-1</div>

Feature	Personal or Web Use — No Prints	Personal or Web Use — Small Prints	Personal and Semi-Pro — Medium Prints	Professional — Large Prints
Interchangeable lenses	No	No	Preferred but not a necessity	Yes
Manual focus	No	No	Yes	Yes
Manual settings such as ISO, aperture, and shutter speed	No	No	Yes	Yes
Control over other camera functions such as metering mode and white balance	No	No	Yes	Yes
Built-In Flash	No	Yes	Yes or use of an external	Yes or use of an external
Shoot in RAW format	No	No	No	Yes

If you're sure about what you want to do in the realm of portrait photography, you will know which category you fit into and should now know which sets of features your camera should have.

If you are buying a camera for any purpose except opening a professional business, I urge you to buy the most feature-rich and largest-megapixel camera in your purpose category that you can comfortably afford. Find the megapixel category you need to be in and start checking features against prices to determine the best one for your needs.

If you are buying a camera for the purpose of opening a professional business, I urge you to buy the most megapixels you can and from a company that makes good lenses and accessories. In other words, I recommend you stay with one of the mainstream brands such as Canon, Nikon, or Olympus, or one of the higher-end brands such as Leica or Hasselblad. All cameras at this level have all of the features you need.

Megapixel and Resolution Primer

A digital camera's sensor is made up of many small image-sensing locations, or *pixels*. There are approximately one million pixels in each *megapixel*. The camera stores these megapixels in columns and rows, which become your picture width and height. For example, a Canon Digital Rebel XT (350D) is an 8-megapixel camera. Its largest size is 3456 pixels (width) x 2304 pixels (height). When you calculate the total number of pixels in this image, by multiplying the number of width pixels and the number of height pixels, it comes to 7.96 million pixels. (The camera uses some of the available sensor space to send formatting information so every digital camera produces an image slightly smaller than its sensor size allows.) There are your 8 megapixels, delivered in a standard aspect ratio of 3:2.

While megapixels are a volume measurement, *resolution* is a density measurement—or, more specifically, how wide an area those megapixels are spread over or how dense they are. For the Web it doesn't matter a lot because all images are displayed at the equivalent of 72 pixels per inch, and even a 2-megapixel camera can make perfectly acceptable Web images. If you want to print, however, the number of megapixels is very important because it affects the quality of a printed image in quite a different way.

If you printed a 3456-x-2304-pixel image at 72 pixels per inch (called *dots per inch* or DPI when printing), you could print a 48-x-32-inch picture. And it would look very ugly. In fact, you would not be able to tell what it was. In order to make a print look good, you have to increase the density of those pixels—simply, you have to stuff more of them into each inch to create a higher resolution. For a perfect print, you have to stuff 300 of them into each inch of printed space. For an acceptable print of most subjects, you have to stuff at least 200 of them into each inch of printed space.

In many cases, you can print an even larger image than the mathematics indicate. Depending upon the tonal and color range of the photograph and several other factors, such as level of *digital noise* or grain in the original, I've seen very lovely prints as large as 20 inches wide from an 8-megapixel Digital Rebel 350D. To determine whether your image can be pushed to a lower resolution and a larger size and still look good, you may have to make some test prints.

Some digital cameras allow Web-ready images to be produced in the camera and many models allow you to take your images in one of several formats such as TIFF, JPEG, or RAW. You can perform a variety of processing or "digital darkroom" techniques after the image is taken to alter it so that it creates a good print even at a lower resolution. See Chapters 10, 11, and 12 for post-processing information.

In all cases, I strongly recommend that you do the following things before you purchase a new camera:

✦ **Check for reviews, both online and in photography magazines.** A very good place to check for camera reviews is the Digital Photography Review site, which you can reach by pointing your browser to http://dpreview.com (see Figure 2-3).

✦ **Check for images taken with the camera.** The Web is a great place to find comparison photographs. Usually a quick search through Google for the camera make and model results in links you can follow to see examples.

✦ **Ask your photographer friends' opinions.** If any of them have the camera in question, ask to take a few sample pictures with it and see what you think.

✦ **Keep your eye on the news.** Camera manufacturers are often large companies (such as Canon or Nikon), but they can also part of conglomerates (such as Panasonic, Olympus, and Sony) and buyouts and mergers are not that uncommon. It's important that the camera you purchase will have available accessory parts and can be properly serviced.

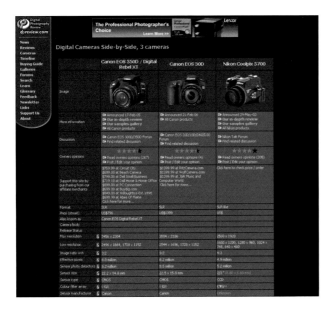

Figure 2-3: Digital Photography Review (called *dpreview* because of its Web address) is an excellent resource to research cameras and accessories. It has a very useful program where you can select two or more cameras to compare side by side.

Your camera will have come with at least one lens unless you bought only the body and not a kit (many people buy the Canon Digital Rebel as a kit); but chances are that if you have a camera, you have some form of lens. All lenses work alike, on the same principals, but they do not all work equally, of course. Even though the one you have is likely good for most situations (most standard lenses are provided to be useful under a wide range of conditions and settings), many portrait situations require a specific lens for the best results.

A word about shooting RAW

I've heard many professional photographers say that after shooting in RAW mode, they'll never go back to JPEG. The more complex reasons for this are discussed in Chapter 10, but the simple reason is that it allows more control. In the same way that the primary difference between a snapshot and a professional portrait is one of controlling the photographic elements, the difference between RAW and JPEG is that you have more control over how your finished RAW image will appear than you do with your JPEG images.

In the analogue and film world, the image was created with light and was "pressed" upon the light-sensitive material. Then in the darkroom you could adjust the exposure as needed during the developing phase. In the digital world, your camera can actually decide how it will send the image to the sensor. It makes calculations based on your camera's settings, color theory algorithms, and the conditions under which you are shooting and sends what amounts to a semi-processed image to the sensor in the form of a JPEG file. When you shoot in RAW mode, you are asking your camera to let you do all the thinking and for obvious reasons, this appeals to the professional photographer.

It is my strong recommendation that you only purchase a camera for professional use which possesses the ability to shoot in RAW mode. As an example — all you can do to an underexposed JPEG file is try to lighten it, which will usually blow out the existing light spots. In RAW processing you can actually make an adjustment that has the equivalent effect of decreasing shutter speed or increasing the aperture opening so that you can make what amount to shooting decisions from the comfort of your chair.

Know Your Camera

You have to love your camera like a sculptor loves his chisels or a painter love his brushes. You must respect it for what it can and cannot do. It will work best for you when . . . well, when you know how it works. You need to understand its limitations so you can avoid them and its strengths so you can take advantage of them. You need to learn how to control it, essentially.

This is not a book on cameras, but there are some essential functions that most digital cameras have and which will be very useful for you to understand as we go through the examples in this book. I recommend that you read your camera manual so that you can be aware of how your camera's limitations and strengths apply to you. You'll be working with:

✦ White balance

✦ Exposure lock

✦ Shooting modes (single, burst, timer)

✦ Metering modes

✦ Built-in flash

✦ ISO, aperture, and shutter speed settings

✦ Programmed modes such as sepia or black and white

✦ Manual focusing

Lenses

A *lens* is an optical device that is attached to the camera (see Figure 2-4) and which gathers in (focuses) and records the light onto the image sensor. That recorded light is, in fact, your photograph. The lens is a middleman between the raw light and the sensor of your camera. It is a very important piece of the puzzle.

Tip Take the time to do a little research on the science of optical devices such as lenses. There are so many aspects to choosing and using lenses that you could, as you might guess, fill a whole book with this information, and it cannot be covered here in any great detail. Notably there are issues such as barrel and pincushion distortion. Additionally, there is a great deal of variance between lenses of seemingly similar purpose and function based on the quality of the optical elements (the "glass") and the mechanical or electronic components. Not all lenses are created equal, in other words. One of the best Web resources I know for matters such as this is the Digital SLR Guide site which is located at www.digital-slr-guide.com/.

A lens is typically discussed and evaluated for use from two specific perspectives: aperture and focal length. And, of course, it must have the proper mount to fit your camera.

Focal range

Active focal length

Aperture range

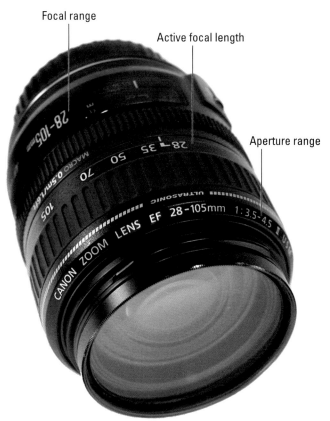

Figure 2-4: A lens is an optical device that attaches to the camera and gathers and focuses light. Having the right lens for the job is as important as having the right camera.
© *Utata Photography*

Aperture

In addition to focusing light, a lens also controls the amount of light allowed to pass through to the camera's sensor. This gatekeeper of the light lives inside the lens and is called an *aperture* (see Figure 2-5) The aperture is a variable-sized opening that is made larger or smaller when the user adjusts the aperture setting on the camera (or which the camera does automatically if you are using an automatic mode).

Most lenses use a standard f-stop scale and express their available apertures in fractions. For example, f/4 means that the aperture diameter is equal to the focal length of the lens divided by four. If the lens has a focal length of 80mm, the light that reaches the sensor arrives through an aperture opening that is 20mm (80mm/4) in diameter.

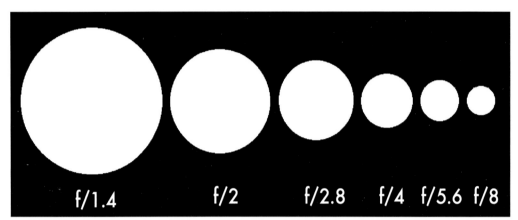

Figure 2-5: The aperture of a lens determines how much light is allowed into the camera through the lens.
© *Utata Photography*

The larger the aperture opening, the more light enters the lens. Aperture opening is measured in f/stops with the lowest f/stop number being the widest opening of the aperture. f/1.4, for example, lets in a lot more light than f/10. The more range the lens allows between its smallest and largest aperture, the more useful in more conditions it will be. The smaller the lowest f-number the lens supports, the wider open the aperture goes and the faster the lens operates.

Focal length

Simply, the *focal length* of a lens determines at what distance from the subject you are able to achieve perfect focus and how much of the scene is recorded.

Back when lenses were made for a standard 35mm format, lenses with a focal length of 50mm or 55mm were called "normal" because they worked without reduction or magnification to create images the way we see the scene with our own eyes. Generally speaking most SLR cameras came with a default lens that was capable of working at a 50mm or 55mm range.

And they still do. But (and this is an important but) with digital cameras there is a thing called "crop factor" which affects the way the same SLR lens will work on your *digital* SLR camera. Simply, it means that the lens created for the 35mm film system, which is the type that you will be using on your digital camera, does not operate the same way on your camera as it does on a film camera and will "crop" images according to the size of the sensor. Both Canon and Kodak produce high-end digital cameras made with a full-frame sensor that does not have any crop factor, but most digital cameras do not have this feature and produce an image much smaller than the 35mm equivalent. Most Canons use a crop factor of 1.6 and most Nikons use a crop factor of 1.5. Check your camera manual for the crop factor it indicates for your particular make and model. You need to know this information to make good lens choices.

Tip A very well researched and presented article on the ins and outs of lens size and crop factors can be found by pointing your browser to www.cambridgeincolour.com/tutorials/digital-camera-sensor-size.htm. It even has a focal length calculator.

The effective focal length of a lens, whether it is the same as the numbers on the side or adjusted for a crop factor, determines the effectiveness of a lens for specific circumstances and governs to what uses it should be put. It is very important to have a good understanding of how focal length works in order to ensure that you are prepared for each and every portrait scenario. A good way to remember how focal length functions is this way, with two rules:

✦ **The smaller the focal length of a lens, the more of the scene the lens will see (it takes in a wider view).** Because a very short- or wide-angle lens sees a very wide or panoramic view, it is subject to a lot of distortion when you try and use it for items close to it. It is most often used for landscapes, natural photography, and portraiture where there are large groups or "big" venues such as parades, sports events, and wedding ceremonies.

✦ **The longer the focal length of a lens, the more narrowly and close the lens will see the scene and the farther away you can be to focus crisply on detail.** Because of the magnification factor and its narrower field of vision, a long lens is excellent for picking out your model from a crowd or catching children at play without interrupting the action (see Figure 2-6).

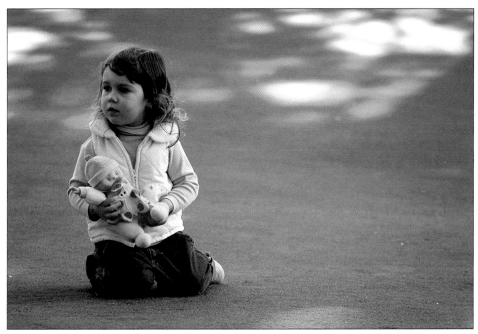

Figure 2-6: Taken from a distance with a telephoto lens, this shot was possible because the photographer's presence did not interrupt the natural behavior of the model.
© Utata Photography

Crop Factor

All focal lengths mentioned and currently manufactured are the true focal lengths of the lenses which are based upon being used in the 35mm film system. The digital SLR, however, has a smaller sensor size than the 35mm film equivalent; so while your lens is seeing the same thing, it is just being recorded by your camera differently. Think of it like displaying a movie on a screen that is slightly too small. The format is smaller so the angle of view is also smaller—your finished digital image will show less of the scene than one taken with the same lens on a 35mm SLR camera.

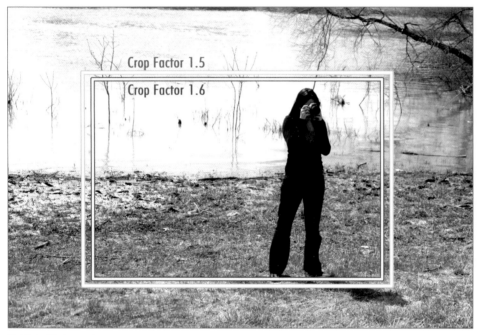

© *Utata Photography*

The same photograph would be recorded by a film camera and one with a 1.5 or a 1.6 crop factor as indicated. As you can see, the crop factor can make a significant difference in the end result.

The way that digital photographers determine the effective focal length (which is what counts) of a standard 35mm format lens is to apply a simple calculation. Depending upon the crop factor of your particular digital camera (1.6x for most Canons except the 1D series and 1.5x for most Nikons), you have to multiply the focal length of the lens with that factor to determine the effective focal length.

A 70mm–300mm zoom lens on a 350D (crop factor of 1.6x), for example, offers an effective focal length of 112mm–480mm zoom. This gives you more reach on the telephoto end but less power on the wide-angle end. In fact, the crop factor affects wide-angle lenses the most significantly. For instance, a 12mm wide-angle lens becomes ~20mm lens. A 12mm lens is a *very* wide-angle lens and serves a very specific set of purposes whereas a 20mm lens is barely a wide angle at all.

All of the lenses listed in this chapter are listed with the actual focal length as appears on the lens itself. The crop factor for your particular camera will have to be applied to determine the effective focal length of each lens. In other words, if you do not own a full-frame camera, you should be purchasing lenses based upon their effective focal length (which you will need to calculate), not actual focal length as written on the side.

Tip

Remembering what focal length means can be hard when you're first getting into buying lenses for your camera. Here's a good way to remember: If you want to take a picture of the mountain from your porch, you need a wide angle lens, which is one with a short focal length like 12mm, 18mm, or 20mm. If you want to take a picture of a rock on the side of the mountain from your porch, you need a telephoto lens, which is one with a long focal length such as 400mm, 600mm, or 800mm.

When deciding which lenses you want, the focal length is the primary consideration, and the aperture range should be an important but not decisive factor. Unless you have a lot of experience (and quite a bit of money), purchasing lenses with unusual or extreme aperture ranges is usually not necessary.

Fixed length or prime lenses

Lenses fall into two categories, prime and zoom. A *prime* lens has a fixed focal length—you cannot change it, it is what it is. The lack of the extra optical elements needed for zooming means that prime lenses tend to produce better quality images and work faster, and are generally available with a lower f/stop (an aperture that can open very wide) than zoom lenses.

Wide angle

The widest of wide-angle lenses is called a *fisheye,* and if you know what a photograph taken with one of these looks like, you probably already understand more about how lenses work than you know. A fisheye, as you may know, takes a curved or circular view—or the widest possible angle. In doing so, items on the periphery are distorted, sort of like looking through a glass ball. Clearly wide-angle lenses, and particularly the extreme wide angles, will not be very important to the portrait photographer, but should not be totally ignored as they do have a few practical applications.

✦ **Focal range: 14mm to 24mm (22mm to 38mm@1.6 or 21mm to 36mm@1.5).** This is a "super wide-angle" lens (sometimes called a *fisheye*) which displays extreme to moderate distortion at certain angles. This focal length is suitable for broad landscapes and panoramic photographs. Most landscape photographers have something from this focal length range in their arsenal.

✦ **Focal range: 28mm to 50mm (44mm to 80mm@1.6 or 42mm to 75mm@1.5).** Most kit lenses start near this zoom range. These lenses tend to produce a very high-quality image under a wide variety of conditions. They generally offer a f/3.5 aperture and the viewfinder is very bright. They are also available with lower aperture settings, but these tend to be very expensive lenses.

Standard/normal

Standard or "normal" lenses offer a perspective similar to that of the human eye. For each format it's different, but for 35mm upon which digital photography technology is based, "normal" is considered to be a lens with 50mm of effective focal length. If you have a camera with a crop factor this will mean you need a lens in the 28mm to 35mm range to achieve this "normal effect."

Prime or fixed lenses of this focal length usually have a large aperture of F/1.4 or F/1.8 and can create extremely sharp and crisp images. They can also be used for close-ups. On most digital cameras this lens works as a very fast portrait lens for a very reasonable price.

I recommend that everyone have a 50mm prime lens (or equivalent) in his or her collection. They are inexpensive, easy to find, and are generally of very high quality (see Figure 2-7).

Figure 2-7: Once the standard lens delivered with all SLR cameras (the old, analogue kind) a 50mm prime or "normal" lens was the closest you can come to a photograph which represents what the human eye actually sees. If your camera has a crop factor, "normal" might be a 28mm or a 35mm lens, dependant upon the factor in play.
© *Utata Photography*

Short telephoto

A short telephoto lens may be your best friend when you're a portrait photographer as they are useful in such a variety of field circumstances (and even a studio setting if you have a large studio). Some professionals say that the best portrait lens is, in fact, a short telephoto and if you can only have one lens, it should likely be from this category.

✦ **Focal range: 60mm–100mm.** This is an excellent range of short telephotos for portrait use, and any prime lens in it will work as a portrait lens under most conditions. Aperture ranges are generally in the f/1.8 or f/2.8 range so the viewfinder is very bright and easy to read. Because of the limited telephoto effect on these lenses, they are mostly used indoors or in studio conditions. Most often used for adult, group, and couple portraits, the telephoto effect is often not strong enough for portraits of young children. Lenses in this range are also excellent for close-up photography. If this range appeals to you and your camera has a 1.6 or a 1.5 crop factor, you should be looking for a lens in the 38mm–80mm range

✦ **Focal range: 135mm–160mm.** Relatively inexpensive and comparable to a 100mm but with a slightly better telephoto effect and often with an aperture range beginning at f/2.8. A good lens for indoor, low-light venues such as concert halls and gymnasiums. As a point of interest, the EF135/2.0L (Canon) is often considered the sharpest lens ever made. If this range appeals to you and your camera has a 1.6 or a 1.5 crop factor, you should be looking for a lens in the 80mm–100mm range

Mid telephoto

Midrange telephoto lenses are in the focal range of 180mm to 200mm (288mm–320mm@1.6 or 270mm–300mm@1.5). Generally, 180mm lenses are sold as telephoto macro lenses, but they are useful for other things. Usually available with aperture ranges starting in the f/2.8 or f/4.0, some brands have a special f/1.8 of f/2.0 version which is usually much more expensive. A disadvantage can be the size and weight of such a long lens. The 4x enlargement factor often forces you to move around, which isn't always possible, whereas with a zoom you can adjust the focal length. As a fixed length lens, nothing longer than a 180mm lens is recommended for portrait work. This is also the focal length were image stabilization as a lens feature begins to become extremely important. If this range appeals to you and your camera has a 1.6 or a 1.5 crop factor, you look for a lens in the 110mm–125mm range

Buying Prime Lenses

If you are going to use prime or fixed length lenses, I recommend that you start with the following three. The numbers in brackets represent the equivalent focal length you will need to purchase based on your camera's crop factor. Lenses will not be available in all these exact sizes, of course, so you will need to select the closest one.

✦ 24mm or 28mm wide angle (15mm@1.6 or 16mm@1.5)

✦ 50mm "normal" (31mm@1.6 or 33mm@1.5)

✦ 80mm or 100mm (50mm or 63mm@1.6 or 53mm or 67mm@1.5) short telephoto—with image stabilization, if you can afford it

When the pocketbook allows, you can add something longer such as a 200mm or even a 400mm telephoto.

Keep in mind that all recommendations are made in effective focal length (what you need) and you will need to make the conversions from the actual focal length (what will be printed on the side of the lens) based on your particular camera. If, for example, you have a Canon 350D camera, your crop factor is 1.6 and if you have a Nikon D100, your crop factor is 1.5. If you want to buy a lens with 24mm of focal length for your 350D you will need the lens closest to 15mm. If you want to buy a lens with 24mm of focal length for your D100, you will need the lens closest to 16mm.

Long telephoto

A lens is said to be a long telephoto when its focal range is between 400mm and 1200mm (640mm–1920mm@1.6 or 600mm-1800mm@1.5). Although the 400 can be an excellent portrait lens (I use one of this length quite frequently) at this length other factors start to some into play — notably image stabilization, ease of use, and simply having enough space to use it. While the 400mm is excellent for things like picking people out of a crowd at a distance and getting crisp shots of stage performances, anything much longer and you almost need two tripods to keep them stabilized and they are not suitable for most portrait scenarios. A 200mm or 300mm is more than sufficient for most portrait situations. If this range appeals to you and your camera has a 1.6 or a 1.5 crop factor, you should look for a lens in the 250mm–750mm range

Zoom lenses

A *zoom* lens has a variable focal length that can be altered by the user (see Figure 2-8 and 2-9). Zoom lenses have more internal parts and thus the optical quality of a zoom lens is slightly inferior to a prime or fixed lens. They tend to cost more than prime lenses of equivalent quality, but the good news is that you may only need to purchase one or two lenses to do everything from close up to far away.

Figure 2-8: A zoom lens is simply a lens with a range of focal lengths which can be adjusted by the user. This lens, a 75mm–300mm telephoto zoom, is reasonably manageable in its smallest or shortest state.
© *Utata Photography*

Figure 2-9: The same 75mm-300mm lens fully extended to its 300mm range becomes quite long and can be hard to manage without a solid tripod. It is unwise to even attempt to use a lens like this without a tripod or brace.
© *Utata Photography*

The list below is a summary of the most used lenses and their general application. Lens lengths are given in actual lengths (what is printed on the side of the lens) and descriptions are based upon their use with a camera with a full-frame sensor. It's a tricky topic to discuss because lenses are still sold in the 35mm film format and their focal lengths are established for the full-frame camera (the expensive ones). It makes sense, of course, to cater to the professionals when developing products and one assumes that all digital cameras will one day have full-frame sensors — in the meantime, we all have to be good with the math when making lens decisions.

While reviewing this, remember that if your camera has a crop factor to consider (and most will) you should be reading for how each effective focal length works. Decide what you want for the practical matter at hand (making good digital portraits) and then make the proper calculations to determine which actual lenses you want to purchase based upon your desired effective focal length.

✦ **Focal lengths: 16mm–35mm.** This is a very useful combination of focal lengths for general photography, suitable for landscapes and certain portrait scenarios (large groups and wedding parties, for example). If this range appeals to you and your camera has a 1.6 or a 1.5 crop factor, look for a lens that starts in the 10mm–12mm range and extends to 22mm or 25mm.

✦ **Focal lengths: 28mm–80mm.** This is a standard lens sold with many digital cameras which use removable lenses. It has taken the place of the old 50mm prime lens as the most often used. Expensive versions of this lens generally offer a large aperture of around f/2.8 while the one shipped with most cameras has a smaller aperture of f/3.5 or f/4.0. Sometimes sold in 24mm–85mm or 28mm–105mm ranges (see Figure 2-10). If this range appeals to you and your camera has a 1.6 or a 1.5 crop factor, look for a lens that starts in the 18mm–20mm range and extends to the 50mm or 55mm range.

Figure 2-10: A fairly common and very useful lens is one like this 28mm–80mm, which provides a very excellent range of focal lengths, is not too long or cumbersome; and although not the best lens for every purpose, it is a good general lens for most purposes.
© *Utata Photography*

✦ **Focal lengths: 70mm–200mm or 70mm–300mm.** This is a standard telephoto zoom lens and is suitable for bigger groups or making portraits of people at a distance. Usually available with a large aperture of f/2.8 or a more standard f/3.5 or f/4.0. If this range appeals to you and your camera has a 1.6 or a 1.5 crop factor, then you should be looking for a lens that starts in the 44mm–50mm range and extends to the 125mm or 135mm range.

✦ **Focal lengths: 100mm–400mm.** Lenses with these focal lengths generally require a tripod, and there must be a fair bit of space between you and the subject for these lenses to be useful. Except for very specific portrait scenarios, you will not likely need a lens in these ranges and will not be able to use them very effectively in most studio settings. If this range appeals to you and your camera has a 1.6 or a 1.5 crop factor, then you should be looking for a lens that starts in the 63mm–70mm range and extends to the 250mm or 300mm range.

Buying a Zoom Lens

If you are going to use a single zoom lens or series of zoom lenses, I recommend the following. The numbers in brackets represent the equivalent focal length you will need to purchase based on your camera's crop factor. Lenses will not be available in all these exact sizes, of course, so you will need to select the closest ranges.

✦ 28mm–80mm range (18mm–50mm@1.6 or 19mm–53mm@1.5) with image stabilization if you can afford it.

✦ 70mm–200mm range (44mm–125mm@1.6 or 47mm–133mm@1.5) as a second optional lens, with image stabilization if you can afford it.

All of your important ranges are covered. In the case of the 28mm–80mm lens, the range is not so great that there will be a substantial loss of aperture and speed. These two lenses will cover virtually any portrait scenario but will not be as crisp as the equivalent prime lenses.

Fast and slow

A *fast* lens does not indicate how fast a lens works but the amount of light the aperture can let in. A lens with a f-stop lower than F2.8 is considered fast, keeping in mind that the lower the f-stop number the larger the aperture and the more light gets in. A lens with an aperture of F1 is extremely fast — and usually extremely expensive.

A fast lens is very useful in low-light situations where it can give you a bit of extra shutter speed, and the wider an aperture can go, the greater control you have over the use of selective focus techniques. So, if you can afford them, fast lenses are very good to have.

Note Remember that prime lenses are generally faster than zoom lenses but that some zoom lenses can be purchased with very low f-stop numbers.

Brands and features

While you will be limited as to the range of lenses that you can use on your camera (each camera accepts only certain types and brands of lenses) most cameras will accept the lenses manufactured by the same company and from at least one other source. Sigma makes lenses, for example, for both Canon and Nikon cameras, but the same lens does not fit on both brands. And Canon and Nikon lenses cannot be used on each other's camera bodies.

Many people use and swear by Sigma lenses, and although I have never used one myself, my impression of them is that they are very good lenses offering a similar quality to those of the original equipment manufacturer. Very often they and others like them are significantly cheaper than their name-brand counterparts, and for the performance variance, if there is any, it's usually a very good trade-off.

There are also a few features available on lenses that are worth knowing about when you're making your purchasing decisions.

Silent auto-focus

Many lenses are quite loud when they are in auto-focus mode. This can be a distraction in some scenarios where you are taking candid or casual portraits and want to be as unobtrusive as possible.

Some manufacturers offer lenses with a silent auto-focus system which is commonly called Ultra-Silent Motor (USM) or Hyper-Sonic Focus (HSF). This means the lens will be silent during auto-focus (see Figure 2-11).

Quiet focus is not an essential tool for the portrait photographer, but it is an extremely good thing to have if you can find it in the lens size you want to use.

Figure 2-11: Look for a HSF or USM indicator such as this lens shows, which tells you that it is equipped with a quiet focusing motor — a very useful feature for a portrait photographer to have.
© Utata Photography

Putting Together a Lens Kit

If you are looking for the optimum start-up solution my recommendations are as follows. The numbers in brackets represent the equivalent focal length you will need to purchase based on your camera's crop factor. Lenses will not be available in all these exact sizes, of course, so you will need to select the closest sizes or ranges.

✦ 50mm prime lens (31mm@1.6 or 34mm@1.5)

✦ 28mm–105mm (18mm–66mm@1.6 or 19mm–70mm@1.5) zoom lens, with image stabilization if you can afford it

✦ 100mm–400mm (63mm–250mm@1.6 or 67mm–266mm) telephoto zoom lens, with image stabilization if you can afford it

In all cases, get the focal length lens you want with the lowest f-stop number that you can afford. The reason for this is that the wider the aperture can be made to open (the lower the f-stop number), the more light gets into the lens. And the more light there is, the faster the lens can create a focus lock and the faster it can record the image. In photography, the more light you have, the faster everything works.

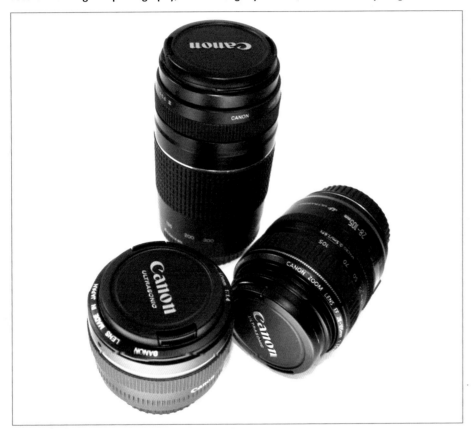

© Utata Photography

A good starter kit for portrait photography would include a 50mm prime lens, a 28mm–105mm zoom lens and a telephoto lens or zoom lens in the 100mm–400mm range.

Crop reduction

As I explained earlier, there is a digital SLR crop factor which alters the effective focal range of a lens. There are lenses designed to reduce this crop factor; the lens is designed so that the back (the part that attaches to the camera) is closer to the digital SLR sensor. This means your lenses will work on your digital SLR a lot like they did on your SLR. For most people who are starting out in photography with digital equipment, this won't be an important feature. The potential drawback to this type of lens is that it won't work with your film SLR camera.

Superior optics

There are some lenses designed with special optics that reduce flare and stray light, minimize distortion, and which were created to produce especially crisp images

Canon markets high-end lenses as the *L* series and Nikon uses *ED* to indicate their highest-quality optics. These are the lenses manufactured specifically for professional use. They tend to be prohibitively expensive unless your business is already earning a profit as they are usually more than $1,000 each and often more than $2,000. However, the images they produce tend to be more clear and sharp than others of similar focal lengths.

Image stabilization

There is a special group of lenses which include image stabilization (or vibration reduction) technology. This feature is very useful to have if you need to hand-hold your camera or shoot in low lighting. The stabilization corrects, to varying degrees of acceptability, camera shake.

Image stabilization is especially helpful, and some say essential, on lenses with long focal lengths (100mm or greater) because the effects of camera shake are magnified at longer focal lengths. Image stabilization can add a significant amount to the cost of the lens.

Accessories

Accessories are all those things not the camera or the lens. In other words, everything else. Most of us amass quite a collection of things as we go through changes in cameras and technologies, styles and fashions, and our own photographic interests. I have a great collection of close-up filters that I use to make macro shots in my garden, and I can never seem to resist magnifying filters when I find them cheaply enough. Fact is, it's the universal tale: every profession has its accessories.

Architects have rulers and drawing tables, golfers tend to collect putters and chippers, and I have yet to meet the photographer without a roomful of things related to the craft. In order to run a portrait business, you will need a few things. Not many, but a few.

Tripods, monopods, and other braces

Among other things that can harm a photograph's chance for success, one of the most prevalent is the blur caused by camera movement. In low-light situations you may often find that you simply need a long exposure, or a slow shutter speed, in order to get enough light for a good image. Very few of us can hold a camera absolutely steady long enough to get a crisp picture at any shutter speed longer than 1/30th of a second and many portraits, it won't surprise you, take longer than that to expose properly.

Tip

Camera shake is a killer you can avoid by knowing when you will need a tripod or other brace. When shooting with a telephoto (long) lens the conventional wisdom is that you can derive your optimum shutter speed from the focal length of your lens. If you are using a 100mm lens, as an example, your shutter speed should be $\frac{1}{100}$ of a second.

In this case you will need to brace or steady your camera. This is accomplished with, among other things, a device called a *tripod*. A tripod is a three-legged stand on which a camera can be fastened and held steadily. They come with a wide variety of features, in a wide variety of weights (including tabletop varieties such as shown in Figure 2-12), and are made by a wide variety of manufacturers. Subsequently, they come in a lot of price ranges and qualities, as well.

Figure 2-12: This is a tabletop tripod and clearly not meant for a wide variety of situations; however, when used with a cable release, it allows you to take excellent casual and candid portraits that you might otherwise miss because you "just can't fit in there" without ruining the scene.
© *Utata Photography*

The most important rule about tripods is that *you need one.* There are very few things beyond a camera and a lens that you need to have to produce quality portraits, but a tripod is one of them. Technically, I should be saying that what you need is a brace and support that does the same thing a tripod does: hold the camera steady. There are camera stands and studio tables and all sorts of available options for holding a camera steady, of course. So, you need to use something to brace your camera and that something is most likely a tripod.

Tip

Tripods are not always practical or allowed, unfortunately. Many public venues do not allow tripods to be used, and in many other cases a tripod simply gets in the way — of you, your model, or someone else. When you can't use your tripod, for whatever reason, you can sometimes still use a similar device called a monopod. If you can't use anything, the best advice I know to steady your camera is to steady yourself. In other words, lean on something. It's rather amazing how much being braced yourself helps the shakes. Turn yourself into a tripod.

Picking the right tripod

As a general rule, the basic things you should look for in a tripod are very simple:

◆ It should be very steady, even with your camera and your longest lens. The legs on your main tripod should not be made of a flexible material.

◆ It should be adjustable enough so that it serves a variety of purposes, but be cautious that it is not *too* extendable because this can cause it to be unstable when fully extended (see Figure 2-13).

◆ It should have adjustable feet so that you can always adjust it to be steady and level.

◆ It should allow you to firmly and safely attach your camera (and lens) with a metal screw.

Figure 2-13: Although they're very cute and tempting, beware inexpensive, compact telescopic tripods except as quick in-the-bag stand-bys. Fully extended, they are very unstable and generally do not support a serious camera and its lens.
© *Utata Photography*

If you are able to find some good deals, a few additional tripod options that would be very nice to have include:

◆ **A leveling bubble.** Akin to a small carpenter's level, built into the mounting head of the tripod, this bubble enables you to make certain that your camera is square to the scene.

◆ **Quick release function.** This allows you to screw your camera to a plate which then fits into a slot on top of the tripod. This slot has a quick release lever which enables you to easily and quickly take your camera off and put it back on the tripod. Many tripods have quick release tops that you can purchase as options. I highly recommend these.

◆ **Ball-head.** You can buy the head and body of a tripod separately from high-end manufacturers such as Bogen/Manfrotto or SLIK in order get specifically what you want. A ball head sits atop a tripod to provide support for the camera and generally provides more flexibility than a standard three-axis pan/tilt head. Aiming and leveling can be done in one motion whereas multiple positioning motions are usually required with a pan/tilt head.

Monopods

A *monopod* is like a tripod except instead of having three legs, it has only one (see Figure 2-14). A monopod is usually easier to carry as it's lighter than most tripods and folds up smaller. The benefits of a monopod are ease of use and usability in a wider number of venues. For instance, if you have a job to

take a portrait of a child who is performing in a play, you may not be able to set your tripod up in the theatre – but generally nobody objects to a monopod. They don't take as much room, they're easy to move and they're not as distracting to other people.

Tip

If you want more details on using a monopod, point your browser to www.outdooreyes.com/photo5.php3 where there is an excellent tutorial on the various foot positions which work best with a monopod.

Figure 2-14: A monopod is basically a one-legged tripod upon which you mount your camera. Although a monopod reduces camera movement and uses a much smaller footprint (takes up less space), it is quite unlike a tripod and does not stop camera shake: it merely helps reduce it.
© *Utata Photography*

In search of the perfect tripod

To look in my studio you'd think I'd spent a lifetime trying to find the perfect tripod. While it has not been a lifetime, there are certainly a lot of tripods to account for! Not to place too high an entertainment value on my strange obsessions, there is some education in this story, too.

Mini-tabletop

This is a wonderfully useful device. I paid $6.99 for it, snagged from a bin near the check-out at the photographic equipment supplier I use. Tiny, three legged, and simple in design, it has a rotating and pivoting head with a proper metal screw. You have to set it carefully and can't use much of a lens with it (it tips over, its footprint is so small) but it has been very useful over the years. I use it on tabletops (dressers, bars, mantles, and so on) where I want to capture some action unobtrusively. Great for using with a cable release, a remote, or the timer function.

Small but not tiny

A $20 find at a mega-store, it's cheap (hollow legs) and has clamps at each junction and a stiff tilt and pan lever, but it's great for those times when the big tripod is . . . well, just too much. Sometimes you can get away with one of these in a public venue where the larger-footprinted tripods get in the way and are often not allowed. Additionally, this is great as a monopod when fully extended. Even very small tripods usually open up to about four or five feet in height, which is great for a monopod (for me, anyway). Go ahead and laugh, but I often just strap the legs tightly together with a Velcro wire wrap and treat it like a monopod.

Emergency do-it-all

I paid $35 or $40 at one of those big electronics chains. It extends to about six and a half feet, but a bird sighing in the next county will make it shake at that extension. It packs back up to less than a foot in length and can fit in your hand or most of your pockets. I use this one for taking pictures of hot rods on summer nights, following children around in the park on a portrait session, or taking pictures at a concert — I just leave the camera attached to the tripod and walk around until I find something I want to shoot. It's sort of like putting a handle on your camera. It can act as a monopod at full extension and is a stable and handy little tripod at medium extension.

The pretty good tripod

This is the one that goes to most location shoots. It's solid and stable, and has a quick release system, a leveling bubble, and really "smart" feet that do a very good job of adjusting for terrain. It's heavy enough to be stable and solid but light enough to be carried a fair distance, and it has a very smooth tilt and pan lever. It doesn't get really small, even when fully folded, but it gets small enough to be carried underarm or attached to a backpack comfortably, even for a long time. Tripods like this are generally available for under $300 and if you watch the sales, you can pick them up for under $100 every now and again.

The really good tripod

Solid like a rock — you have to hurl a heavy object at it to move it. The mounting area is very tight and cork-lined and has an attaching and a bracing screw — there is a quick release attachment but I rarely use it. It has a tri-directional level, and although it's a little trickier to adjust in size than the others, no matter what size you make it, it stays solid. It's too heavy and has too large a footprint to be used for most location shoots, but if I know I will be taking a lot of pictures from one location and that tripods are permitted, this is the tripod I take with me. Additionally, if I am shooting something where I must be ready to capture motion with a long lens like a 400mm (such as a swimming event or a golf tournament) I like to have the stability of this tripod. You can expect to pay more than $300 for a tripod of this quality, and although I do not own such a beast, I have seen tripods that cost as much as $2,000. The range of available tripod qualities and prices is quite broad.

Camera Accessories

A quick search on cnet.com yielded 4,533 results for "digital camera accessories," which should give you an idea of the vast potential in this category. You can get everything from a raincoat for your camera to the wiring to enslave your flash units together into a cohesive group. There is little doubt that over time you will amass quite a collection of devices, cases, peripherals, and other items that you have upgraded because newer, better models were made available.

Other than those things that you need to operate your camera (batteries and media cards, for example) the only accessories you really, truly need are basic cleaning supplies. See Figure 2-15.

Figure 2-15: Taking care of your camera is an important part of a successful business. This is the tool you earn your income with and it pays to keep your lenses and filters clean and dust-free. Keep a good supply of basic cleaning materials on hand and always take put a basic cleaning kit in your camera bag for location shooting.
© *Utata Photography*

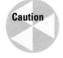

Tip Although routine maintenance such as cleaning your filters and lenses with a cleaning solution or air brush is recommended, it is also a good idea to send your cameras once every six to eight months to a professional camera cleaning service to have the sensor cleaned. Most good photographic suppliers offer a cleaning and conditioning service at a reasonable cost. Although there are many tutorials on how to clean your sensor, I do not recommend it unless you are an expert in working with both cameras and electronics.

A word of encouragement first, before the caution. Accessories range from very useful (which means they help you take a better photograph in some way, or make the job of taking photographs easier) to not very useful at all. Some accessories are just fun to have and others are fun to try out; and as long as you're not losing sight of the photography itself, accessories are hardly ever harmful. Except maybe to the pocketbook.

Caution One very important caution to remember when dealing with using your old SLR equipment with your new digital camera is that they may not be just incompatible, they may be dangerous to one another. Most lenses are fine and will work on your brand-compatible body, but extreme caution should be used when trying to utilize old flash units with new cameras. You can actually damage your digital camera's circuitry and cause it to malfunction when trying to fire its own internal flash. I recommend researching this matter fully before attempting to use your old flash on your new camera.

In-camera media/memory cards

Your camera will have been shipped with at least one of the media cards which it uses to store your photographs. Generally, this card is the smallest size available and is not at all suitable for professional work. See Figure 2-16. My friend who works in a large photography supply store tells me that the one thing that most people walk out of the store with when they have just purchased a digital camera is a memory card or two.

Figure 2-16:
Media cards, such as Compact Flash or Memory Sticks, come in a variety of sizes. Be sure that you have enough cards or a large enough card so that you will not need to cut a shoot short due to lack of memory space.
© *Utata Photography*

There are a great number of ways that photographs can be stored outside of the camera, of course, and I'll leave that to everyone's individual taste and inclination. This section is about the cards that you use inside the camera.

Generally called Compact Flash or CF cards, these come in a variety of sizes and shapes and sometimes with other names, such as Memory Stick. They are purchased generally in megabyte or gigabyte multiples and hold anywhere from 10 to 500 images, depending upon the size of image your camera produces and what settings you use.

The table below shows standard image sizes based on the megapixel size of the camera (and using the largest size and highest quality settings) and how many can be held on each card.

Table 2-2			
Size of CF Card	*4-Megapixel Camera*	*6-Megapixel Camera*	*8-Megapixel Camera*
256MB	174 JPEG	116 JPEG	87 JPEG
512MB	348 JPEG	232 JPEG	174 JPEG
1GB	696 JPEG	464 JPEG	348 JPEG
256MB	58 RAW	38 RAW	29 RAW
512MB	116 RAW	77 RAW	58 RAW
1GB	232 RAW	154 RAW	116 RAW
256MB	21 TIFF	14 TIFF	10 TIFF
512MB	43 TIFF	29 TIFF	21 TIFF
1GB	87 TIFF	58 TIFF	43 TIFF

Although people have developed an amazing array of methods to get photographs off cards (I've personally used the laptop method, a USB flash stick, and the portable flash drive options), I firmly recommend purchasing enough in-camera cards for your comfortable use. I have four half-gigabyte cards and two gigabyte cards, and I have never once encountered a problem of insufficient memory space. Watch for them to go on sale, and very often you can pick them up very cheaply when a new size is introduced. I bought my half-gigabyte cards for $20 each when they first came out with the gigabyte-sized card.

Batteries

Right after the camera itself, and having a large enough memory card, batteries are probably the most important element of your digital camera kit.

Although some digital cameras work on standard rechargeable AA batteries, most manufacturers ship their cameras with a proprietary battery type and charger which must be used (see Figure 2-17). Unless you go the route of using external battery packs, you are usually confined to the type and size of battery that are made specifically for your camera model. Many sports and wildlife photographers use external batteries because of the longer periods of time spent in the field; but for most portrait work, external batteries are not necessary.

The Battery Primer

The most important thing about batteries is having enough of the right ones. I work on a three battery system which I highly recommend. This allows for "one on the charger, one in the camera, and one on deck" at all times. I always have two fully charged batteries each time I go on a shoot, even if I expect to take only one or two shots. Better safe than sorry, I always say.

Keep extra batteries handy

The first rule is, naturally, to have at least one extra battery (I recommend two) and to keep it handy. There is nothing worse than failing to complete a shoot because your batteries died.

Bring along your charger

If you're going on a shoot, chances are there is some electricity available somewhere, and it's a good idea to take along your battery charger. Some chargers have car adaptors; adaptors can also be purchased so that you can use your car cigarette lighter slot to operate your battery charger. This is a great idea for shoots where you are far away from your studio and electricity is not readily available.

Keep playback to a minimum

If you want to preserve your battery for as long as possible, keep the playbacks (viewing the image in the LCD viewer) to a minimum because they eat a lot of battery power.

Batteries *do* lose their charge

Batteries do not stay charged perpetually, even if you have not used them. They slowly discharge their energy over time. If you have not used your camera or batteries in a long while, check before you try and use them. If you are going to leave your camera sitting for any period of time, it's best to remove the batteries altogether.

Don't let them get too cold

Using your camera in cold weather zaps batteries, sometimes three times as fast as normal use, so it's a good idea to keep your batteries and camera as warm as possible.

Water Damage

Water corrodes batteries and damages them, sometimes to the degree that you cannot use them again, and doing so could damage your camera. Keep your batteries warm and dry.

Traveling?

Keep in mind that many countries do not work with the same electrical setups that we do in North America, and you may need an adaptor for your battery charger if you are planning on traveling with your camera.

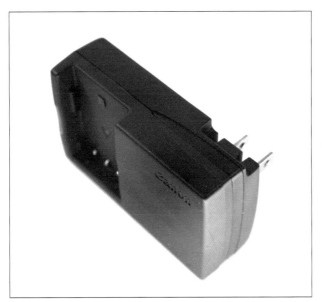

Figure 2-17: Cameras are generally shipped with a proprietary battery and charging system, but you can often purchase adaptors to use these chargers in your vehicle or with other electrical systems. If traveling, don't forget to ensure that your battery charger is compatible with the electrical system at your destination.
© *Utata Photography*

Filters

Camera filters are transparent or translucent glass disks that alter the way light enters the camera lens (see Figure 2-18). They have threaded bases that you screw into the end of the lens and come in the same sizes as the diameters of standard lenses — 55mm, 58mm, and so on.

Figure 2-18: Filters can be either protective or corrective (or both, such as the UV filter shown here leaning against the polarizing filter in its case).
© *Utata Photography*

Filters are primarily used to affect contrast, sharpness, and light quality or intensity. Simply, they filter the light coming in and change it so that the photograph itself is altered in some specific way. From the amount of light (neutral density) to the color quality of light (UV filters), filters can be used individually or in various combinations to improve upon or alter a wide variety of shooting conditions. Filters can also be used to create a very wide cross section of special effects. Filters appropriate to each type or style of photography are discussed in the chapters in Part III.

Hoods

A lens hood is usually made of soft, pliable rubber (and sometimes a stiffer polyurethane material) and is used to reduce flare and glare when shooting towards or at an odd angle to the light (see Figure 2-19). Generally under $10 at most photography supply shops, they're well worth having.

Figure 2-19: A lens hood is a must-have if you plan on shooting outdoors—which seems inevitable for the portrait photographer.
© Utata Photography

You can also purchase LCD hoods which fit over your LCD display and reduce glare so that you are able to see your image clearly, even on very bright days.

Cable release or wireless remote

I very strongly recommend that you have a remote or cable that allows you to operate the shutter release of your camera without touching it. Even a small amount of camera shake can throw off a photograph, and pressing the shutter button usually moves the camera, however minutely. Most professional photographers use a cable release for tripod shots if they are able because it eliminates camera shake absolutely (see Figure 2-20).

Figure 2-20: Cable releases, such as this one for use with a Sony F717, are wonderfully useful and nearly necessary devices for the serious photographer because they eliminate camera shake and allow for a more subjective composition.
© Utata Photography

Usually available as electronic wireless remotes or wired remotes, they are often camera specific and can be bought quite inexpensively at most camera supply stores.

Caution I do not recommend using wireless remotes if they are of the type that work only with the timer function of your camera, which is the case with the wireless remotes that Canon sells for its digital SLR line of cameras. Waiting for a timed countdown is almost always not what you want at all.

Basic Studio Accessories

You're all set with the photographic equipment you need—your camera is set and ready to go. The next chapter covers the lighting equipment you need, so what's left are the odds and ends that make a studio a studio.

A studio might well be the perfect downtown loft with skylights and miles of space, but it's just as likely to be what used to be your living room, basement, garage, or spare bedroom—at least when you're starting out.

When selecting the equipment you want to use, keep in mind the space you have to work with and don't try to overburden a small space with too many things, or you will find you and the model both feel uncomfortable when trying to work.

Posing stools

Simply, you'll need something to seat your subjects on. There are many varieties of inexpensive folding stools that you can buy at most hardware or department stores, and they work fine for most situations. Adjustable units are preferred because they allow you to work at your most comfortable level and to keep your lighting set to a standard height.

Backgrounds and backdrops

Chapter 9 covers what sorts of backdrops you can use and how to employ them in the portrait, but you will need a means of hanging them or attaching them to a wall. There are proper stands available (some take rolls of paper, which are great because the backdrop is always clean and fresh) and many photographers use some form of stand or brace, usually used in pairs, between which they hang backdrops.

As long as you have one fairly solid wall you can simply hang your backdrops with tape, tacks, or framing hangers.

Tip If you have a room which you can use as a dedicated studio, it's a good idea to paint the walls and ceiling in a matte paint of a neutral (not white, not beige) shade so that you can exercise consistent control over the lighting. Also, make sure you have some form of window covering which will allow you to completely block any outside light from entering the room if you don't want or need it. When using the space as a studio, don't forget to shut off the overhead light if there is one!

Lighting is perhaps one of the most exciting and interesting aspects of photography, and the next chapter takes you through all of the steps of setting up your studio with lighting. From what to buy to how to arrange it for a variety of poses and purposes, you'll be ready to tackle any portrait scenario when you're done.

✦ ✦ ✦

3 Lighting Primer

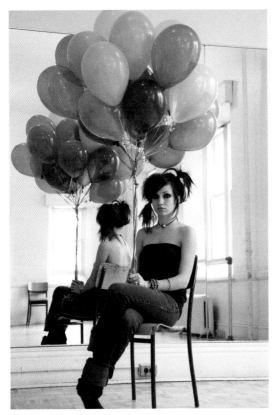

© Istoica.com

This chapter is going to examine ways to measure light, ways to control light, and ways to shape and modify light.

You can take perfectly fine portraits and remain blissfully ignorant about the intricacies of white balance or the difference between spot metering and matrix metering. But you can't do it consistently and deliberately, and those are the traits of a professional. Without controlling light you are hoping for a good result, perhaps generally aware of what that result will be, but still hoping. If you're surprised by a good result, then you're doing it wrong. You need to work yourself into a spot where you're surprised by a bad result!

Controlling light, in photographic terms, means controlling its direction, quality, and intensity. Even in 100 percent natural light the photographer does this by shifting the model, closing the curtains, or using one of the tools I talk about in this section. Using the right tools and processes helps photographers produce exactly the sort of portraits that they have planned. Though the benefits of this skill range from happier, repeat customers to a profitable business, the most important one is that you will simply be a better portrait photographer.

And when you consider the fact that sunlight has traveled 93 million miles to get here, it would be rude of us not to try to understand it.

Measuring Light

A light meter is an apparatus that measures the intensity of light in order to determine the best exposure. Note that I said the *best* exposure, not the *correct* exposure. The best exposure is the one that provides the image you want; there is no such thing as the correct exposure.

There are two primary methods for measuring light: reflective and incident. As the name suggests, *reflective metering* involves measuring the light that is reflected off the subject, as shown in Figure 3-1. This is done by pointing the light meter at the subject and reading the amount of light that bounces off the subject.

In contrast, *incident metering* measures the light that falls on the subject. Incident metering is done by holding the light meter in front of the subject and reading the amount of light falling on that location, as shown in Figure 3-2. In theory, incident metering provides the most accurate lighting information because it measures actual light rather than reflected light. In most common portrait situations, however, either metering method is acceptable.

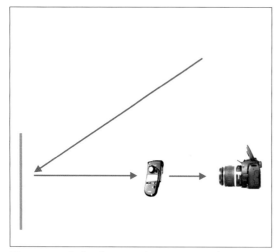

Figure 3-1: Reflective metering measures the light after it is reflected from the object being photographed.

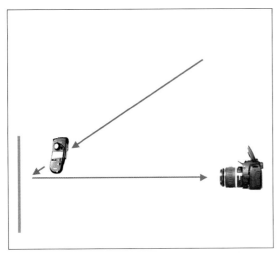

Figure 3-2: Incident metering measures the light before it hits the object being photographed.

The incident metering method is discussed in more detail in the section titled "Using a handheld light meter."

Using the in-camera light meter

Your digital camera comes with an internal reflective light meter. As noted earlier, this means it measures the light reflected off the subject. It's very simple to use; you simply point the camera at the subject. (It should be noted that spot metering, discussed later, requires a bit more thought and consideration.) The light on the subject is measured through your camera's lens.

Depending on how sophisticated your camera is, there will likely be a few different modes for metering the light. The metering mode refers to the area within the frame that the camera will meter for exposure.

Automatic metering

Most digital cameras, even the least expensive ones, have an auto setting that allows the camera's computer chip to determine every aspect of the exposure process. The camera determines the shutter speed and the aperture. The result is usually perfectly adequate. If you were satisfied with taking a perfectly adequate portrait, however, you very likely wouldn't be reading this book. Most serious photographers generally ignore the auto setting because it does not allow for deliberate manipulation of light and subject.

Center-weighted metering

This mode of metering concentrates most of the light meter's sensitivity on the center of the picture frame. This is where the subject of the photograph is most likely to be located in common portrait situations. That generally works to the photographer's benefit, and in a great number, perhaps even the majority, of situations center-weighted metering is suitable.

Not surprisingly, many traditional portrait photographers routinely use this metering mode. However, if the portrait subject is *not* in the center of the frame, then the exposure could be flawed. In addition, if there are strongly lit elements of the photograph outside the center of the frame, those elements will likely be overexposed.

Matrix metering

The matrix mode of metering reads the intensity of light in several zones within the frame (depending on the sophistication of the camera, it could be anywhere from 8 to 256 different zones) and measures them independently. Your digital camera's processor then uses a complex algorithm to determine the appropriate exposure. Depending on the values given for each zone, the algorithm may be advanced enough to assume that the top left and right quadrants will likely be the sky and the center area is probably the subject.

This form of metering is useful for standard portrait situations, but it can be especially effective for active portraits in which the subject isn't stationary. The primary drawback of matrix metering is that the algorithm isn't known to the photographer, so you can never be entirely sure what elements in the frame are being given priority.

Spot metering

As the name indicates, this mode of metering relies on measuring the intensity of the light on a very specific point within the frame. Depending on the type of camera you have, this point could range between 1% and 8% of the image area. Clearly, this is a tightly controlled metering mode.

Spot metering is very useful in portrait situations in which there are radical differences in the intensity of the light, such as between the foreground and the background as shown in Figure 3-3. It's also quite useful for close-up portraits where the natural texture of the face creates extremes of light and dark. Spot metering often provides very dramatic portraits because it allows you to "pick out" a specific subject or highlight a particular aspect of the subject.

Because of the narrowness of the metering zone and the drastic shifts in light intensity, many portrait photographers routinely bracket their exposures when using the spot metering mode. Bracketing is when you set your camera to take several images in succession, in a range of settings, to "hedge your bets," so to speak. Most good digital cameras offer an automatic bracketing option. This gives the photographer something of an insurance policy; it's hoped that at least one of the bracketed exposures will result in the desired image.

Tip Most good digital cameras come with a feature called *exposure lock*. The exposure lock does exactly what the name implies: it locks in the camera's exposure setting until you trigger the shutter. If you want to emphasize the shadow on your subject's face, spot meter to measure the light on the brightest part of the face. If you don't want the brightest part of the subject's face to be in the center of the photograph, simply measure the light you want to base the exposure on and set the exposure lock; then you can compose the shot anyway you want. Although different cameras have different methods of creating an exposure lock, pressing the shutter button half way down works as an exposure lock on most digital cameras. Check your camera's manual for instructions.

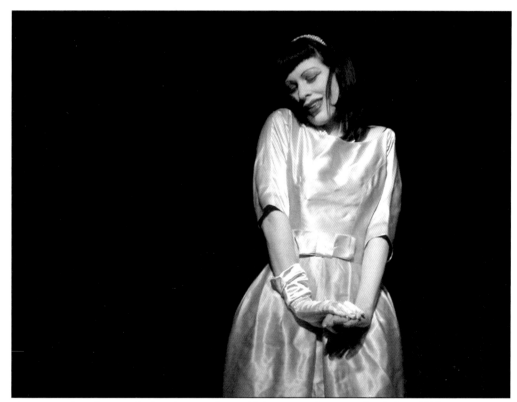

Figure 3-3: Certain portrait situations, such as a high contrast between the dark and light areas of a setup, are best suited to spot metering
© *Linus Gelber*

Using a handheld light meter

If your digital camera provides you with a perfectly good built-in light meter, why would anybody want to spend the extra money for a handheld light meter? Portrait photographers use handheld meters for the same reason doctors use a scalpel instead of a chef's knife: accuracy, control, and versatility.

Your camera's internal light meter, no matter how sophisticated it is, is limited to reflective metering. That is to say it can measure only the light that bounces off the subject. It's perfectly capable of giving you good information in the vast majority of portrait situations. However, your camera needs to perform a wide variety of functions, and light metering is not, from the camera's perspective, the most important one. The built-in tools are adequate but rudimentary. A handheld light meter, on the other hand, is dedicated to one task: giving you the most accurate measurement of light possible.

Unlike an in-camera light meter, handheld meters such as the unit shown in Figure 3-4 may be either reflective meters or incident meters. In fact, many handheld meters provide both reflective and incident options. As mentioned earlier, incident metering measures the actual light falling on the subject. In order to do that, you simply hold the meter in the area of light you want to measure. For example, if you want your portrait to feature the subject's antique necklace, you measure the light falling on the necklace. If you want the portrait to emphasize the soft light on the subject's cheek, you measure the light falling on the cheek.

Figure 3-4: Handheld light meters can make a significant difference in the way your portraits turn out, and are the best way to ensure that you are in complete control of the light and thus the result of the portrait. They help you isolate and "pick out" the features of your model that you may want to accentuate.
© *Utata Photography*

Using a handheld incident meter allows the portrait photographer to consistently obtain an accurate rendition of the subject's tonality, color, and contrasts. It does this regardless of the color or brightness of the background, the subject's reflectance, or textures.

Note One of the many advantages to using an incident meter is that as long as the meter is exposed to the same kind of light as the subject, the distance between the meter and the subject is irrelevant. For example, if you are shooting a candid portrait of an employee at the opposite end of a long, illuminated hallway, you needn't walk the length of the hallway to take the meter reading. You're both exposed to the same sort of light.

In the end, you must remember that, whether you're using a handheld light meter to measure the incidental light falling on the subject, or your in-camera spot meter, all light metering can only offer suggestions as to the exposure. The final exposure decision belongs to the photographer. The more you understand about light and how it is measured, the more capable you are of knowing when to ignore your light meter and shoot the portrait you see in your mind.

White Balance

Regardless of how well equipped your studio is, regardless of how much high-tech gear you're able to tote around, regardless of whether you're a professional or an enthusiastic amateur, at some point you're going to find yourself shooting under some sort of existing light.

By *existing light,* I'm talking about any sort of light illuminating the scene without any additional light supplied by the photographer. This includes everything from sunlight to floor lamps to the light in your aquarium. Photographers also refer to this as *mixed light.*

Shooting in mixed light was a significant problem for film photography; it is much less of a problem for digital photography. Film is chemically treated to be sensitive to color under certain outside daylight

conditions. When those conditions changed — if, for example, the sky became cloudy or the photographer moved inside where the room was lighted by incandescent bulbs — the film no longer gave an accurate rendition of color. The film photographer had three options:

✦ Use special "color-corrected" film suitable to those lighting conditions.

✦ Use filters on the lens to "correct" the light.

✦ Use artificial lighting to simulate daylight conditions. Electronic flash units, for example, are designed to simulate daylight.

The two portraits in Figure 3-5 are shown on top of one another to illustrate how important it is that your camera knows the sort of light it is working in. In my experience, even when using a high-end camera, the Auto white balance feature is not always accurate.

Film and digital cameras are both subject to the same physical laws governing light waves, of course. Digital photography, however, is much more forgiving. The powerful computer processor inside your camera makes correcting the color significantly less complex. You can, if you choose, follow the path of the film photographer and use filters on your lens to change the color temperature of the light, but it's so much easier to use the technology built into your digital camera. To do that, all you need to do is tell your camera which white is the real white.

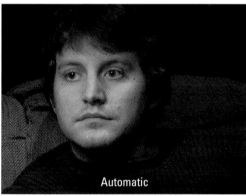

Figure 3-5: Under normal household (incandescent/tungsten) light, the portrait on the top was taken with the camera set to Automatic white balance, and the bottom portrait was taken with the setting manually adjusted to Tungsten/Indoor. The difference is immediately apparent.
© Greg Fallis

Defining White

You've undoubtedly taken photographs and later discovered that the color seemed a bit off. Perhaps the faces looked a tad orange, as shown in Figure 3-4, or maybe they took on a greenish cast. A straight-up shot taken in your kitchen has a very good chance of having an amber or yellow cast. It's happened to all of us. But why does it happen? Rest easy. It's probably not your fault. It happens because of the nature of light.

Light travels in waves of different frequencies, which are referred to as *wavelengths.* Some of these frequencies are visible to the human eye and some are not. The eye detects the different wavelengths and the brain interprets them as different colors.

Under certain conditions, however, some of the visible wavelengths of light are filtered out. The light on a sunny day is slightly different than the light on a cloudy day. The light in the shade of a tree is somewhat different from the light from an incandescent light bulb. The human eye and brain automatically compensate for those small changes in perceived color. Because of that, we're able to recognize a white object as white regardless of whether we're looking at it indoors under incandescent lighting or outside under green foliage.

For all its amazing technology, your digital camera isn't nearly as sophisticated as your eye. Your eye adjusts spontaneously to these slight shifts of color; the camera doesn't. The camera records the actual wavelengths of light. Because of that, the colors of your photographs may seem unnatural.

Fortunately, technology comes to the rescue. Almost all but the most basic digital cameras allow you to give them instructions to compensate for those slight color shifts. This is done by adjusting the white balance. In effect, you are identifying the color white for your camera under a specific lighting condition. Once the camera understands what white is under each condition, it automatically corrects all the other colors of the visible spectrum.

Most digital cameras give you at least limited control over the white balance setting. Not surprisingly, the more sophisticated the camera, the more control you'll have.

It's almost certain your camera will have an Automatic white balance setting. In essence, this permits the camera to estimate the best white balance setting for the existing conditions. For example, if your flash unit fires, the camera automatically adjusts its notion of white based on the wavelength of the flash unit.

Unfortunately, however, even the most sophisticated digital camera can make an inaccurate estimate. If that happens, your images will likely turn out with an odd color cast. It's generally best in portrait situations to give your camera the best information you have.

Some cameras have only white balance settings like Outdoors, Indoors, and Overcast in addition to an Automatic setting. More sophisticated cameras enable you to distinguish between various types of artificial light:

> ✦ **Tungsten.** Typical incandescent light bulb.
>
> ✦ **Daylight fluorescent.** The type often used in homes.
>
> ✦ **Cool white fluorescent.** The type routinely used in business offices.
>
> ✦ **Neutral white fluorescent.** Often found in desk lamps.

For more precise white balance adjustment, some digital cameras allow you to manually set the white balance. This allows for a more precise adjustment, even under very unusual conditions (a neon lit bar in

daylight, for example). It's done by aiming the camera at a white object such as a sheet of white paper or, preferably, a neutral white balance calibration card, *under the actual light conditions.* White balance cards can be purchased at most high-end camera stores.

Be aware, though, that many cameras allow you to set the white balance only in certain exposure modes (such as Aperture Priority or Shutter Priority). Check the owner's manual of your camera to determine how to set the white balance.

Shooting Portraits Under Studio Lighting

We all want to use studio lighting like the pros. It's no wonder, of course. We all want to make portraits like that shown in Figure 3-6, which was taken under carefully controlled lights in a studio setting. Light is at the heart of photography; it makes sense that the photographer wants as much control as possible over lighting. The more you can control the quality of the light, the more you can control the final product, and the more likely you are to obtain consistently good images. The hallmark of a good portrait photographer, after all, is the ability to produce quality portraits consistently and reliably.

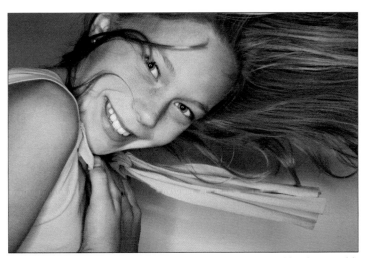

Figure 3-6: Studio lighting makes a difference. Portraits like this would be very hard to achieve without it.
© *Istoica.com*

For many years there was considerable debate among portrait photographers about which type of lighting equipment was better — continuous lighting or strobe lighting. Because of the nature of early continuous lighting (discussed next), strobe lighting was generally seen by modern photographers as superior. Recent innovations in continuous lighting, however, have reignited the debate.

There is no obvious correct answer to the debate. Each form of lighting has its own unique benefits and disadvantages. Before making any significant purchase of photographic lighting equipment, carefully consider your own unique circumstances and the style of photography you want to engage in, as well as the benefits and drawbacks of the various types of lighting. It's easier to expand on an early wise choice than to correct an enthusiastic mistake.

Continuous lighting

Continuous lighting refers to lighting equipment that stays on after it's turned on. In that sense, continuous lighting is rather like an ordinary electrical light; you flip the switch and you have light until you flip the switch off again.

Advantages of continuous lighting

One of the primary advantages of continuous lighting is that it's simple. You can very clearly see exactly how the light plays on the subject of the portrait. The shadows, the highlights, and the tonal distinctions are readily visible. You know what you're getting and that makes adjustments in the lighting much easier. This also makes continuous lighting fairly easy to learn to use as it takes less trial and error to determine the best settings for the individual situation.

In addition, unlike with strobe lighting, there is no cycling time when using continuous lighting. Nor is there any concern about triggering issues, which may occur with strobe units. Once the light goes on, it stays on until you turn it off.

Many portrait photographers feel that softbox lighting is essential for many types of portrait scenarios, and so every studio should have at least a small unit. The softness that it adds to facial features is sometimes the best way to compensate for any challenges such as wrinkles, uneven skin tones, and a very angular or sharply featured face. Additionally, as shown in Figure 3-7, softbox lighting provides a wonderfully even and moderate light for very close facial shots that have a luminescent quality. See "Softbox Lighting" for more details.

A final advantage, especially to the beginning portrait photographer, is that continuous lighting equipment is generally less expensive. This makes continuous lighting an attractive starting point in developing your studio.

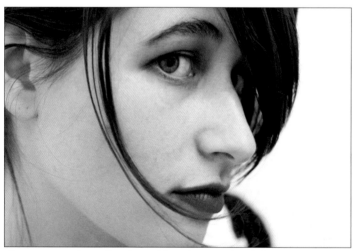

Figure 3-7: Perhaps the nicest thing about softbox lighting is the even and moderate light that it displays on a model so that even very close shots have a wonderful texture and quality.
© Istoica.com

Disadvantages of continuous lighting

The disadvantages of continuous lighting are mostly confined to the tungsten lamp. Because the lamps stay on during the session, tungsten units can produce quite a bit of ambient heat. Because for many years continuous lighting meant the use of tungsten lamps, this form of lighting is often referred to as *hot lights*. The heat was the predominant reason continuous lighting fell out of favor for so long. The amount of heat produced by tungsten lamps can make them difficult to work with. Not only are they hot to the touch (which makes them difficult to manipulate when trying different lighting patterns), the heat can also have a deleterious effect on lighting accessories (diffusers, umbrellas, and so on). In addition, the heat can be tough on models; posing for any length of time under hot lights can be very trying.

However, the development of light sources other than tungsten has rendered the term *hot* a misnomer. Several photographic equipment manufacturers now market "cool" continuous lighting.

Tungsten lamps also pose problems with white balance. That problem can be corrected through the proper use of the white balance function on your digital camera or through the use of filters (either on the camera or on the lamps). But it's generally considered best to avoid a problem rather than have to correct it. The sections that follow explain the various types of continuous lighting with which you will be working.

Tungsten

As mentioned before, tungsten lamps put out an excessive amount of heat, making their usefulness limited. The subject cannot be placed very near the lamps. Tungsten bulbs generally have an operational life of only about 30–100 hours and consume a great deal of electricity. The light emitted by tungsten bulbs is bright, but it requires an adjustment in your camera's white balance in order to reproduce colors accurately. Finally, tungsten filaments have been known to leave a slight residue on the inside of the bulb, which gradually turns the light more yellow. They are, however, the least expensive form of continuous lighting.

Fluorescent

This is one of the "cool" forms of continuous lighting. Don't confuse photographic fluorescent lighting with those annoying, flickering overhead lamps you've seen in some office spaces. Photographic fluorescent lighting offers bright flicker-free lighting with true daylight color, so you shouldn't have to adjust your digital camera's white balance. These are energy-efficient lamps, consuming less electricity and having an operational life of approximately 10,000 hours. They are significantly more expensive than tungsten lamps. Smaller fluorescent tubes, available cheaply at most hardware stores, make very good traveling lights for quick-fix situations or when you are away from the studio (see Figure 3-8).

HID

This stands for *high-intensity discharge*. These lamps are very bright. The light is generated by an electric arc being transmitted through various metallic gases, such as sodium vapor, metal halide, or mercury vapor. They create more light than fluorescent lighting but generate less overall heat.

Don't be misled by that; HID lamps produce intensely localized heat. The heat may not radiate outward, but touching a high-intensity discharge bulb is like touching the muffler on a motorcycle; it will cause an immediate burn. HID lighting requires a moderate amount of electricity (less than tungsten, more than fluorescent) and has an operational life of about 7,000 hours. HID lighting also requires a period of time (around five minutes) before the color temperature becomes stabilized. At that point, however, these lamps burn at a true daylight color.

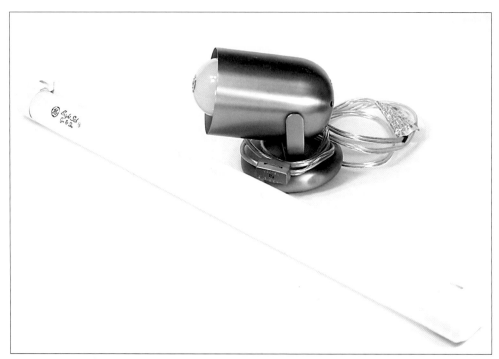

Figure 3-8: Not the flickering types that you see in office buildings, fluorescent lighting comes in a variety of shapes, sizes, and power outputs. It's a good idea to keep one or two fluorescent tubes and one or two simple flexible spotlights with wide-spectrum bulbs around the studio; they can prove invaluable when shooting on location.
© Utata Photography

Studio strobe lighting

Strobe lighting is also called *flash lighting*. Strobe flash units are similar in concept to the electronic flash on your digital camera, but that's like saying a trout is similar in concept to a shark. These are sophisticated electronic flash units, far more powerful and far more versatile than the flash on your camera.

Portraits may be taken with a single dedicated strobe light or with multiple units "slaved" to a master control either through the use of a sync cable or a wireless control. Just as with the flash unit on your camera, the camera controls when the strobe units are fired. When you press the camera's shutter release, the lights fire. It's that simple.

Advantages of strobe lighting

The most obvious advantage of strobe lighting over continuous lighting (particularly tungsten lighting) is that strobes never get hot. This generally makes for a shooting environment that's both more comfortable and safer. Strobe lights are more energy efficient as well because they provide lighting only when triggered; they don't place a constant demand on electricity. In addition, most strobe units offer some level of variable output, while continuous lights are generally limited to being either on or off.

Strobes can emit a great deal of light in a fraction of second, often more light than that provided by many forms of continuous lighting. The brighter light gives the portrait photographer a wider range of exposures to work with, and that means more control over the final product.

Another important consideration to the portrait photographer is that the immediate burst of light from a strobe unit freezes motion. This increases the odds of capturing a sharp image, which can often be difficult when photographing children, pets, or an animated pose such as the one shown in Figure 3-9.

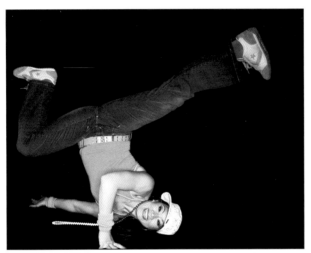

Figure 3-9: Strobe or flash lighting is a near-must for photographing children, animals, or any portrait in which motion is a factor because it emits a brighter light than most continuous lighting.

© Istoica.com

Disadvantages of strobe lighting

The foremost disadvantage to strobe lighting, especially for the amateur-enthusiast portrait photographer, is the expense. Although many photographic equipment suppliers market economy-priced strobe kits, they are more expensive than continuous lighting kits.

Whether in the studio or on location, one potential problem with strobe lighting is the linkage between the strobe units. As noted earlier, strobe lights are necessarily linked to the camera. This may be done through the use of a *sync cable,* which is simply an electrical cord that connects one or more flash units to the camera so that they are synchronized. The problem with this, of course, is the cable. The more cables you have, the greater the odds are that somebody—likely you—will trip over them.

Tip You can eliminate the problem of having a lot of cables by using some form of wireless trigger. Some units use infrared or radio-controlled triggers, which are reliable over a distance of many yards. Not surprisingly, these triggers can be quite expensive. A more modest wireless trigger involves a slave tripper that triggers the strobes to fire when they detect a flash from another source, such as your camera flash. These models have less range, however.

Whereas continuous lighting provides light on the subject continuously, strobe lights emit a bright flash and then need to recycle before they can fire again. The recycling time may be very quick; as little as a second or two. However, with continuous lighting a photographer with a good digital camera can shoot two or three frames per second. You may miss some spontaneous smiles and other facial expressions if you're using strobes.

In addition, because the lights fire so very quickly and so brightly, you can't always easily determine if one or more lamps have failed. Unless you test the units individually, you can't always be entirely sure about the intensity of the lighting. Some manufacturers resolve this problem by a clever arrangement using a modeling light.

Tip Many studio flash systems include a modeling lamp/light which is a constant-source light used to indicate where the light and shadows will fall on the subject when the actual light fires. It's like a preview light. When using a modeling light, ensure that the output of the modeling light is equal or close to the output of the flash itself, or it will give you an inaccurate preview and your final portrait will not be what you expect.

Finally, the fact that strobe lighting isn't on all the time makes it slightly more difficult to know exactly how the light plays on the subject. To determine if the lighting provides the desired effect, you have to either make some test exposures and examine them, or use a modeling light. Again, the inclusion of a modeling light increases the cost of the lighting system. The types of strobe lighting are outlined in the "Monoblock" and "Powerpack" sections.

A minor consideration, but not to be discounted, is the way that strobe lighting can affect models, particularly those who are portrait sitting and not actually professional models. Models get used to the bright flash of light and exhibit less facial and eye area stress (however subtle) with continuous lighting.

Tip While many of the higher-end digital cameras can accommodate most types of light with their internal meter, including metering their own flash emissions (or, in many cases, the emissions of external flash units made by the same manufacturer as the camera) many professionals will use a flash meter when using studio strobe lighting. A flash meter is, as the name suggests, a meter that reads the flash output. Most flash meters can meter in either spot reflective or incident modes. and the better ones can take cumulative measurements of several flash readings.

Monoblock

A *monoblock*, or monolight, is a type of self-contained studio flash unit in which the flash head and power supply are enclosed in the same box and are generally powered by AC current rather than battery packs.

Monoblocks or monolights are also sometimes referred to as compact flash heads because the electronics are actually built into the head of the lamp. In other words, these are self-contained units like the one shown in Figure 3-10. They have a plug on one end and the lamp head on the other. The head consists of the flash tube itself, all the circuitry, a fan to keep it cool, and a holder for a modeling light. Packing everything into a single unit means monolights are heavier than powerpack strobes (which are discussed in the next section). One compensation for the extra weight, though, is that in general a monoblock system puts out more light than a powerpack system with the same number of lamps.

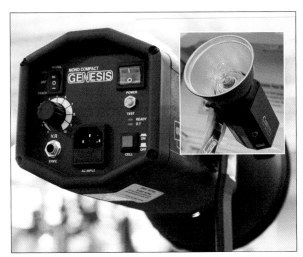

Figure 3-10: Monoblocks, or compact flash heads, are self-contained units that require their own power source but usually generate slightly more light than a powerpack unit.
© *Irina Souiki*

Because monolights are independent units, each of which must be plugged into an electrical outlet to operate, problems can arise when shooting on location. If there aren't enough electrical outlets, or if the outlets are inconveniently placed, it becomes necessary to either rely on extension cords (either plain power cord extensions or flash head extension cables) to properly arrange the lighting.

Powerpack

Powerpack lighting systems include one or more strobe lights attached to the same power supply. The primary difference between powerpack lighting and monoblock lighting is that the individual lights in a powerpack system need to be powered by the power pack whereas mono lights have their own individual power supplies and are also commonly referred to as pack-and-head systems.

All of the electronic circuitry is located in the powerpack; the strobes themselves are just the lamps. Whereas each individual monolight must be plugged into an electrical outlet, with a powerpack system only the pack itself is plugged into an outlet. This means the strobe lamps are much lighter than monolights. However, it also means that each powerpack strobe must be connected to the pack by a cable. Again, cables are always a potential problem. Although the individual strobe units are lighter in this system, the overall weight (including the powerpack) is likely to be heavier than a monolight system with the same number of lamps.

Tip

If you mostly work in your studio and your lighting stays set up in more or less the same place, there is no real need for the flexibility of a power pack and several strobes or heads. Monolights won't clutter up the floor, put the correct light where it is needed, and are quite inexpensive relative to a Powerpack system. Monolights are lightweight, easy to travel with, and good choices for location shooting.

Lighting Accessories

Simply having access to reliable, consistent light isn't always enough. There are times when we need to modify it and direct it to the places it will do the most good. Portrait photographers routinely use an astonishing array of accessories to control the light from studio lamps. The devices discussed in this section represent only a small segment of the lighting accessory universe.

Softboxes

The *softbox* has become the most popular piece of studio gear by far. Indeed, many photographers consider it absolutely essential. That may be an exaggeration, but it shows how prevalent the use of the softbox has become. As the name suggests, a softbox is a device that softens and diffuses light (see Figure 3-11). It's ingeniously simple, nothing more than a reflector-lined box covered with a panel made of a white diffusion fabric. The light from a softbox provides a very soft look with reduced shadow definition, making it an ideal accessory for portraiture. Because the softbox covers the lamp head, less light is lost than would be the case with an umbrella (umbrellas are discussed next).

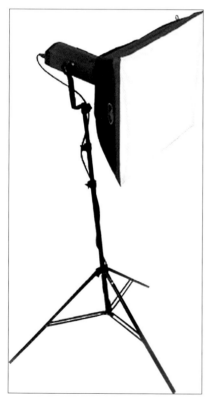

Figure 3-11: Softboxes come in a vast array of styles and shapes, and their purpose is to provide diffused, or "soft," light. There are even varieties that attach to the camera like flash units and very small portable units. They are particularly helpful for making a face appear younger and "softer."
© *Utata Photography*

Softboxes are most commonly attached to studio strobes but can also be used in conjunction with the cool types of continuous lighting. They come in a wide variety of sizes and shapes. In general, the larger softboxes provide more diffusion and softer light; smaller softboxes give comparatively more contrast. Also, the greater the distance between the lamp and the diffusion panel, the softer the effect.

Umbrellas

Umbrellas are more common than softboxes, though perhaps not quite so well loved. They're most commonly used as reflectors. The lamp is directed at the concave side of the umbrella; the light is then reflected onto the subject. This provides a soft, uniform, diffused light (see Figure 3-12).

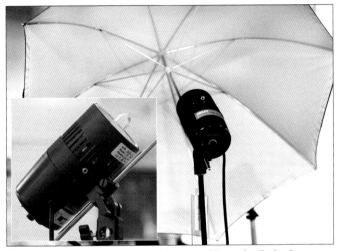

Figure 3-12: As you can see, a photographic umbrella looks a lot like a regular one but acts quite differently. By directing the light at the umbrella, it is reflected back to the model with a softer effect than a direct flash.
© Irina Souiki

Umbrellas come in several sizes (ranging up to 6 feet) and are available in white, silver, gold, and translucent. White umbrellas are the standard. They give a soft, cool light and are useful in just about every portrait situation. Silver, on the other hand, provides a somewhat more harsh and sparkly light, making it popular for glamour shots. Gold umbrellas, as might be expected, warm the light and give it a glow. The translucent units give off a very soft delicate light when used in the normal, reflective way. They also can be turned around so that the lamp shines through the umbrella, acting as a sort of makeshift softbox. Some umbrellas are reversible, with a reflective silver side for a high contrast and powerful bounce, and an opaque white side for a softer bounce.

Because more light escapes from an umbrella arrangement than from a softbox, many photographers feel umbrellas are better suited for group portraits. It takes a very large (and concomitantly expensive) softbox to give the same diffusion and coverage of a moderately large umbrella. An umbrella as a main light source is prized by some portrait photographers for the circular highlight (called *catchlights*) they create

in the subject's eyes, which is certainly a more natural appearance than the rectangular highlight created by a softbox (see Figure 3-13).

Umbrellas can be used with both continuous and strobe lighting systems.

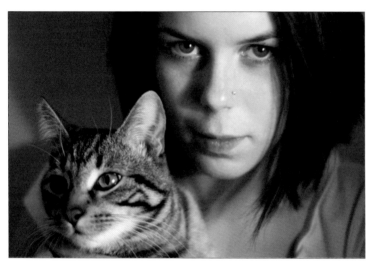

Figure 3-13: The sparkle in her eyes is not as magical as may seem. In reality, the reflection in the model's eyes is an important aspect of a portrait, and many portrait photographers use an umbrella in part because it can be used to provide a circular reflection in the eye of the model.
© Istoica.com

Collapsible reflectors

Collapsible reflectors (see Figure 3-14) are panels of pliable reflective material stretched over a collapsible frame. They're primarily used to reflect light onto (or occasionally away from) the subject, although the translucent panels can be used as diffusers.

Note These are not to be confused with the bowl-shaped metal reflectors that are commonly found on the heads of studio lamps, the apparatus that directs the light forward.

Collapsible reflectors come in white, black, gold, silver, or translucent, and provide the same sort of lighting effect as umbrellas of the same colors. Many come as 5-in-1 kits, which include a single translucent reflector and four different-colored sheaths that can be slid over it. The size of the reflectors range from 18 to 86 inches. These accessories are incredibly handy and relatively inexpensive (at least by photography standards).

As discussed in the rest of the chapters in this section, reflectors can also be made from simple pieces of poster board or emergency blankets pulled over a piece of cardboard and used in the studio. I keep a wide range of reflecting devices on hand in both my studio and my traveling kit.

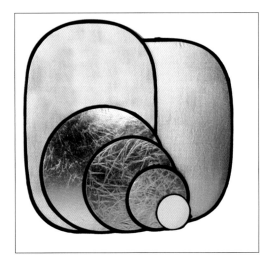

Figure 3-14: Collapsible reflectors are very useful to have, and the 5-in-1 kits available at most supply shops are excellent investments for studio and field work.
© *Utata Photography*

Snoots

A *snoot* is a cone-shaped device, the base of which attaches to the metal reflector bowl of a studio lamp. This has the effect of producing a tight, symmetrical, round beam of directed light. Snoots are often used from behind to highlight the subject's hair. More-expensive snoots are adjustable, allowing you to obtain a beam of light of the size you desire.

Barndoors

Barndoors are the height of 1920s Hollywood technology. Yet even though they've been around almost unaltered for nearly a century, they're still handy for the portrait photographer to have around. Barndoors are hinged, black metal flaps that attach to the metal reflector bowl of studio lamps. Each of the four flaps can be independently opened or closed to varying degrees. This allows you to determine how much light you want to fall on the subject.

Honeycomb grids

Like snoots and barndoors, a *honeycomb grid* is an attachment that narrows and focuses the beam from a strobe lamp. The primary difference is that a honeycomb grid provides a smoother and less dramatic gradation to the edge of the light. These grids come in four standard angles of beam width: ten, twenty, thirty, and forty degrees. The smaller the angle of beam width, the tighter the beam of light.

Gobo

One of the most useful gadgets in a photographer's studio is the *gobo*. The term gobo is short for "go between." A gobo is something you put between a light source and the subject (or the light source and the camera). It's used to block, deflect, redirect, or shift the light.

You can purchase specially designed gobos from photography supply stores, but all you really need is a piece of cardboard or some foamcore or a black collapsible reflector.

Setting Up Your Studio Lighting

After you've made the decision to buy some lighting equipment, you're faced with another difficult question: What equipment should I begin with?

As with so many aspects of photography, there is no single correct answer. It depends on so many variables: your budget, the types of portraits you want to shoot (there's no use buying a snoot if you're not shooting formal portraits), storage space (unless you have a dedicated studio, that gear has to be stored somewhere), weight (an important consideration if you're working by yourself). I can't answer the question for you, but I can give you a few ideas about where to start.

Starter kit

The reversible umbrella gives you the ability to provide a soft white bounce and a high-contrast silver bounce from the lamp. The modeling light allows you to preview the lighting. The 5-in-1 reflectors allow you to direct fill-in light and to diffuse or block existing light. At the time of publishing, a kit like this could be assembled for approximately $400:

> ✦ One monoblock strobe lamp with modeling light or one small softbox
>
> ✦ One reversible 48-inch umbrella (white and silver)
>
> ✦ One 10-foot stand
>
> ✦ Two collapsible 5-in-1 reflectors

Basic kit

This is a flexible kit that will extend your options beyond the high-contrast silver bounce and softer white bounce. The translucent umbrella can act as a softbox stand-in, giving you a very soft diffused throw. The modeling lights give you the power to preview the lighting patterns. The slave tripper allows wireless firing of both units when they detect a flash from another source. The reflectors can be used to modify or redirect light, or block unwanted light. At the time of publishing, a kit like this could be assembled for approximately $650:

> ✦ Two monoblock strobe lamps with modeling lights and built-in slave tripper or one monoblock strobe and one small softbox
>
> ✦ One 48-inch reversible umbrella (white and silver)

- ✦ One 48-inch translucent umbrella
- ✦ One 10-foot stand
- ✦ One 13-foot stand
- ✦ Two collapsible 5-in-1 reflectors

Advanced kit

This is an extremely versatile portrait kit. As with the other kits, it gives you the capacity for soft white bounce, high-contrast silver bounce, and diffused throw. The honeycomb gives you the ability to control the coverage of background or hair lights. The reflectors can modify, redirect, or block light. The modeling lights help you preview the shadows and highlights, and the slave tripper gives you control over all three lamps. At the time of publishing, a kit like this could be assembled for approximately $1,500:

- ✦ Three monoblock strobe lamps with modeling lights and built-in slave tripper or equivalent continuous lighting
- ✦ One 48-inch reversible umbrella (white and silver)
- ✦ One 48-inch translucent umbrella
- ✦ One 10-foot stand
- ✦ One 13-foot stand
- ✦ One backlight stand (extends from 17 inches to approximately 45 inches)
- ✦ One set of four honeycomb grids
- ✦ Two collapsible 5-in-1 reflectors

Portrait Lighting Basics

There is a standard lighting setup that most professionals use as a starting point. Geared toward the formal headshot portrait, it remains the best place to start when establishing the lighting for a portrait sitting. Lighting is the secret weapon that distinguishes the creative (and probably very busy) photographer from the one who sticks to a "by the book" philosophy. While all cameras work pretty much the same way and produce the same results from the same scenario, the innovative use of light is generally the line of separation between an adequate portrait and one which "wows" people.

That said, it's important to get the basics down—to be able to light the standard headshot portrait properly and effectively. It's a tired mantra, I know, but it is a true one: creating new lighting rules will require that you know the existing ones. If you use the instructions below in "Standard setup" as a starting point and learn to understand *how* the various lighting elements work together, you will be able to make the most effective lighting decisions and, subsequently, the most effective portraits.

Standard setup

The standard setup for professionally lighting a portrait sitting is as follows:

✦ The camera is always in front of the model, more or less in a direct line. If a model sat on the stool, square to the camera, he or she would be looking directly into the lens.

✦ You have a *main light* and a *fill light*. (See the sections "Main light" and "Fill light" later in the chapter.)

✦ The main light is at approximately 45 degrees to the front of the model's face (halfway between full front and full side).

✦ The fill light is opposite the main light and is much softer and usually lower to the ground.

✦ The main light is at a height so that when it is angled at 45 degrees downward (halfway between the floor and the wall) the light falls on the model's face.

Figure 3-15 shows a standard setup for a typical headshot, Figure 3-16 shows a standard setup for a glamour shot, and Figure 3-17 shows a standard setup for a group shot.

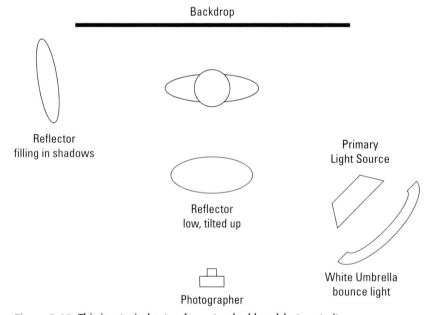

Figure 3-15: This is a typical setup for a standard headshot portrait.

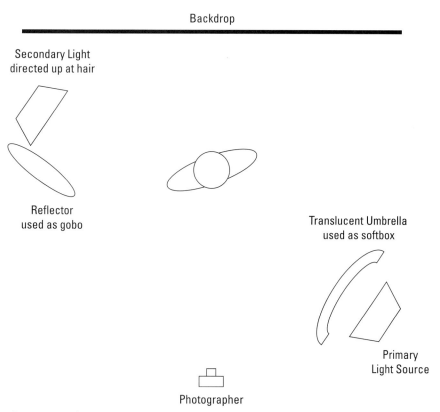

Figure 3-16: This is a typical setup for a glamour or artistic portrait.

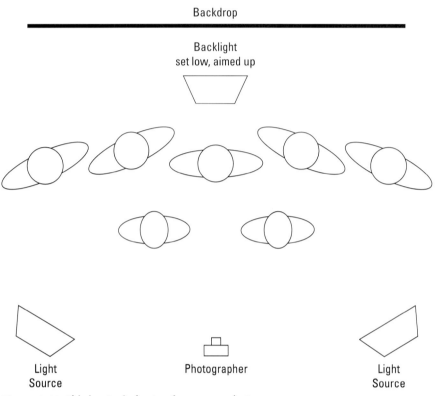

Figure 3-17: This is a typical setup for a group shot.

Main light

Sometimes called the *key light,* the main light is typically positioned about 45 degrees from the camera-model axis (the imaginary line created between the two) and should be angled toward the subject's head at about 45 degrees. Many beginner photographers pay attention to the horizontal position and direction of the light and fail to properly set it vertically, which frustrates most efforts to "get it right." To determine whether you have properly placed the main light, you can check the catchlights in the subject's eyes. The catchlights should ideally be at either the 1 or 11 o'clock position. Chapter 6 provides instructions for establishing the correct placement of lighting based on the individual portrait scenario.

Main lights exist, obviously, to light the subject, but they also exist to create contrast and character in the portrait. In photographic terms, lighting must always be viewed as a tool rather than a utility, and should be used as creatively and innovatively as possible to maintain the desired technical and artistic result. These guidelines are just that—norms and standards developed from experience—and should be treated as a starting point, not an end point.

Try these techniques for applying a main light on your subjects:

✦ As stated earlier, a strobe or softbox or other form of photographic lighting is best.

✦ Most regular light bulbs, if properly reflected and/or diffused, can be used as main light, but it is highly recommended that, if you make any investment in portrait photography at all, you make it with at least one good-quality light that you will use for the main or key light.

✦ The sun is, of course, always a good standby for a main or key light.

Tip You can create a wide array of effects simply by altering the vertical position of the main light. The higher the position of the main light, the more emphasis is placed on the texture and contours of the face. In some portraits, particularly those of the elderly, children, and babies, this is very desirable because it creates a stronger sense of personality and character in the model. Conversely, lowering the main light softens the facial textures and contours and is usually desired in glamour shots and traditional head shots. But don't forget the angles! As discussed in Chapter 6, if your subject has a broad face, for example, you can make the face appear to be slightly less broad by raising the camera position and either turning the face to a ¾ position, or adjusting the angle of the light to the face.

Fill light

The ratio between the overall light and shadow in a portrait depends upon the ratio of fill light to main or key light. A fill light that is ⅙ the brightness of the main light produces a very high-contrast image, and a fill light that's more than ½ the brightness of the main light produces a very flat image with low contrast.

The thing to remember about fill lighting, is that it is almost always at the same relative distance and position from the main light, no matter what style you are using. The fill light is typically placed on the opposite side of the camera from the main light and set slightly lower than the main light.

Fill lighting should be lower powered (not as bright by about 50%) than the main light. Fill light is there to add enough light to soften any harsh or unflattering shadows created by the main light — it should not really be considered a source as much as a modifier. If you increase the brightness of the fill light you reduce the contrast in the portrait. If you decrease the fill light you increase the contrast in the portrait (see Figure 3-18).

Fill light usually adds a second pair of catchlights, typically below the original pair. Depending upon your personal tastes, this may or may not be problematic. Some photographers find this objectionable, believing it leaves the impression that the subject has a vacant, unseeing stare. Others don't mind the second set and consider them natural.

Cross-Reference Whichever philosophy you follow, the second pair of catchlights can always be touched up or erased from the portrait in the digital darkroom, covered in Chapters 10 and 11.

When using a fill light with models who wear glasses, you have to be cautious that the fill light does not cause a reflection in the glass. Chapter 6 covers dealing with challenges such as this and provides posing and lighting solution for most common situations, such as eyeglasses.

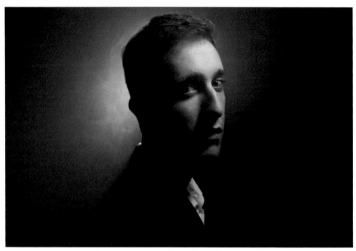

Figure 3-18: Facial contrast, and thus the "character" of the model's face, can be best preserved with careful management of the fill light. You can have contrast and character and still have a very clear and compelling portrait.
© Istoica.com

By applying the following techniques, you can provide fill light for your portraits:

✦ If you have more than one strobe, softbox, or other form of adjustable lighting, all you need to do is ensure the power is set low enough on the one you are using as fill light so that it does not exceed about half of the brightness of the main light. If you can't adjust the power or brightness of the fill lamp, simply move it back to about 50% farther away from the subject than the main or key light, or diffuse it if you are able.

✦ Most regular light bulbs, if properly reflected and/or diffused, can be used as fill light in a pinch, as can a flashlight, a clamp-on reading light, the sun, or even a handheld flash unit set on its lowest setting.

✦ By far the easiest way to quickly generate fill light is to use a reflecting device such as a collapsible reflector or for that matter a piece of tinfoil covered cardboard.

✦ Many portrait photographers try, as best they can, to use natural light as fill light because it provides a very soft appearance. To do this, shoot during the day and arrange your setup so that a window is more or less where you would place a fill light. Using a window (particularly a west window in the afternoon) can create a beautiful effect with natural light as fill light. But don't be fooled by all the ambient light; be sure to still use the main light!

Backlight

Background lights are used commonly to add depth to or separation from foreground to background. Many fun and interesting techniques can be achieved with backlight, and using colored gels (chiffon scarves work well too, if all things are fire-safe) or devices that add texture can be just the spice a portrait needs to shine (see Figure 3-19).

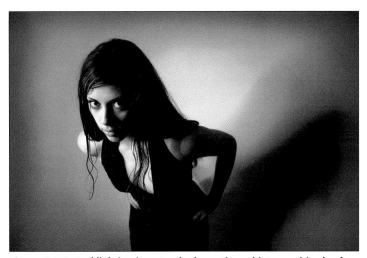

Figure 3-19: Backlighting is not only dramatic and intense, it's also fun. Used sparingly with other light it adds definition to the background, as shown in this portrait. Used exclusively it creates silhouettes.
© *Istoica.com*

By applying the following techniques, you can provide effective backlighting for your portraits:

✦ Background light is usually placed low to the ground, about equidistance between the model and background.

✦ Most lights used to provide backlight are low power (not as bright as the main light and slightly more bright than fill light) and can be directed somewhat finely.

✦ Most regular light bulbs, if properly reflected and/or diffused, can be used as backlight in a pinch, as can a flashlight or a clamp-on reading light.

✦ ✦ ✦

Posing and Composing

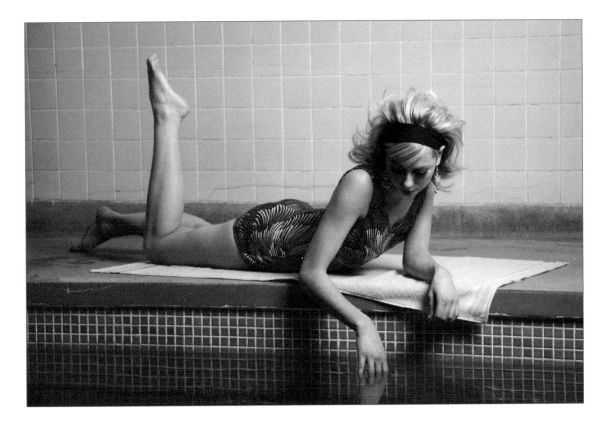

Composing a Portrait

© Kate O'Brien

A portrait is one of the few photographic scenarios in which you have control over virtually every aspect of the situation. You can't make a rock tilt its head or ask a plate of limes to bend itself more agreeably toward the camera. You can't ask a table to stand on its head or a building to round its shoulders. You can ask all of your models, expect maybe the infants and pets, to perform these tasks, and as a rule they will comply. It's a photographer's dream world; a situation where it's just you, your imagination, and a blank canvas.

A portrait is a photograph, of course, and photographs have certain compositional guidelines or rules that are almost universally applicable. *Almost* is a very critical word in that sentence. Overall composition is a

personal artistic matter, naturally, but many guidelines have been developed over the years that are generally accepted as being "more right than wrong," or, to put it more bluntly, more appealing to a broader range of people.

There is no set of specific instructions and you can't plan a portrait from a rule book, but I do believe the photograph that you imagine should be compared against the common rules. Even if you get it out of the camera and all you can think to say is, "Wow, this is perfect, I love this!" it is sometimes pretty surprising what a little shift this way or that way does for the overall quality of the portrait.

There's a caveat of course, and I'm sure you expected one. The rules, or guidelines, or whatever you care to call them are meant to guide and help you improve poor or unclear compositions; they are not there to restrict creativity or artistic choice. Many of the most famous portrait photographers in the world are famous because they have found ways to apply the rules of good composition in unique and creative ways.

In the portrait business you will certainly have the opportunity to be as creative and daring as you want to be, and you may find models who will paint their faces with any color you ask (see Figure 4-1) or let you dunk them in a tub of water. But you will also have to make standard headshots and traditional portraits (see Figure 4-2) and some people will not want you to think outside the box, not one little bit. In those cases you need to not only know the rules, but you also need to understand how to apply them in the traditional manner.

Figure 4-1: If you're very lucky you will get to work with models who let you paint their faces, dress them up, adorn them, or stand them on their heads. Don't think this frivolous — being a professional portrait photographer requires that you rise to a variety of portrait types and client needs.
© Istoica.com

As the great photographer Edward Weston once said, "To consult the rules of composition before making a picture is a little like consulting the law of gravitation before going for a walk. Such rules and laws are deduced from the accomplished fact; they are the products of reflection. . . ." I must say that I agree wholeheartedly with Edward Weston. If you understand the principles, the rules will take care of themselves, intuitively, when you are behind the camera.

Tip I believe that anyone serious in the pursuit of excellence in portraiture should consider purchasing two books that I believe to be indispensable to the craft. They are published by Phaidon Press and are called, respectively, *The Photo Book* and *The Art Book*. They're small, concise, well organized, beautifully rendered, and contain a brilliantly edited collection of art with well-chosen narrative text and biographical information. Everything you ever wanted to know about composition is in those two books.

Figure 4-2: Traditional portraits and headshots are an important part of any portrait photography business. Although you will want to experiment with out-of-the-box compositions and scenarios, you still need to know how to compose, light, and shoot a basic headshot or traditional pose.
© *Gary S. Evans*

Portrait Types

Whether they are traditional and basic or completely whacky and unique, your portrait business is likely to be primarily comprised of three basic types of portraits:

✦ **Head:** The first portrait type usually focuses the viewer's attention solely on the person's face. It is likely the most common type of portrait and the most often performed by commercial photographers. Generally there is very little visible background in a headshot. See Figure 4-3. A headshot is typically shot with a lens in the effective focal range of 50mm–135mm (80mm–90mm is considered a "normal" portrait lens). See Chapter 2 for a discussion on using lenses and calculating effective focal lengths for digital cameras. Very close headshots can be done with a lens as wide as 28mm, but there may be distortion, so the point of view is very important when using a lens wider than 50mm. Standard lighting is one main or key light at 45 degrees from the model's face, with one fill light on the opposite side. Background light is often used in face shots.

Figure 4-3: Headshots are intended to provide the viewer with a recognizable likeness of the model and generally have little or no background visible. The model's eyes are generally the center of interest.
© Istoica.com

✦ **Body:** In a partial or full-body shot there is much more visible background. The model is typically posed so that appendages are leading lines and the body proper is the secondary interest while the face or head is the center of interest (see Figure 4-4). Body shots are usually done with a lens in the 50mm–150mm range. Very wide angles are not recommended except for special effects because they tend to distort features. Standard lighting is the same as for a headshot.

✦ **Environmental:** These are an even better opportunity to select background or foreground objects that enhance the portrait. However, you need to be very careful that the added images do not distract the viewer's attention too much or in a negative way. The lens range for an environmental portrait is, quite literally, the entire range. As Figure 4-5 shows, it depends upon where the environment is (consider a shoot at an oil rig in the Arctic to create portraits of the engineers working on top of the cranes, or a young girl in her doll house).

Each of these types of portraits requires a slightly different approach, but each of them is formed using the same basic set of guidelines.

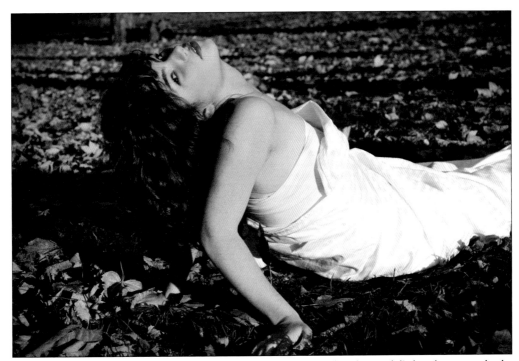

Figure 4-4: Full or partial body shots are generally composed so that the model's head or upper body is the center of interest and usually include more background than a headshot, but not as much as an environmental portrait.

© *Istoica.com*

Caution One of the reasons that a wide-angle lens is not recommended for close portraiture is that it creates a lot of distortion, which is magnified when used at too close a range. When using a wide-angle lens from a high viewpoint the forehead and nose can appear exaggerated. The hands, feet, and lower part of the body can appear much smaller in relation to the upper body. When shooting upwards, this trend is reversed: feet are huge and heads are very small. Although the wide-angle lens opens up a huge range of unusual portrait possibilities, the novelty of wide-angle portraits can wear off, so ensure that your use of wide-angle lenses does not come off as "gimmicky" and that your clients are okay with an unusual perspective.

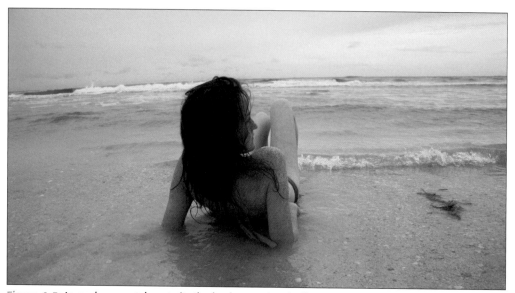

Figure 4-5: In environmental portraits the background typically occupies as much (or slightly more or less) space as the model and is meant to provide a sense of context and proportion to the model.
© Istoica.com

The Portrait Recipe

Composition is distinct from posing in that composition is the manner in which you construct the photograph. It's balance and shape, color and contrast, and, ultimately, creating a photograph appropriate to the client's needs, whatever they are.

Posing is the manner in which you display the model—or have the model display themselves. The model is, in this context, just a single element in the overall composition. You need to understand composition, in other words, before you can understand posing. They are interrelated and codependent but not the same thing.

If a portrait really could be made into a recipe, it would read like this:

Ingredients

+ Camera, lens, and tripod
+ The subject(s)
+ A background and/or prop(s)
+ Light

Method

1. **Position your portrait elements in a balanced and pleasing way to create a strong center of interest.** This would include posing the model, positioning props, placing the background, and choosing color.

2. **Position lighting so it provides the most desirable lighting according to the composition of elements and the portrait's purpose or type.** It is best to begin in the standard position and adjust as necessary.

3. **Position the camera so that its point of view provides the most pleasing or appropriate perspective of the composed elements.** It is best to begin in the standard position and adjust as necessary. The standard view for the camera is near eye level directly in front of the model.

The first section of this chapter covered the ingredients. The next section covers the method and manner in which all the tools are used together to create the portrait. This is called composition and it covers the design of the canvas — the way the ingredients are put together.

And everything about composition starts, as you might expect, with the center of interest.

Create a Strong Center of Interest

In fact, one could say that the result of good composition is a strong center of interest.

And the most important thing about all three types of portrait is that your center of interest — which is either your subject or a particular part of your subject — is noticeably dominant. The eyes must be drawn to it. Simply, you must put it in the right place.

If the portrait is a headshot, the natural center of interest is typically the model's eyes. If the portrait is a partial or full body shot, the natural center of interest is typically the upper body or face. If the portrait is an environmental one (where there is a lot of background or context used) the natural center of interest is typically the model.

You can make anything the center of interest, of course. Those are just the things that would be the center of interest based upon our common visual process. In a real life scenario, this is where we would look first. Traditional portraiture does not typically seek to alter the natural center of interest, but rather to enhance it and freeze it in a pleasing position.

Compositional uncertainty is created when the natural center of interest is not placed on a photographic center of interest. How do you ensure that the natural center of interest is placed so that it is also the photographic center of interest?

It can be very easy, in fact. First, establish the photographic center of interest. As shown in Figure 4-6, the two red dots represent where the human eye is drawn when looking at a rectangle in the aspect ratio range of 4:3 to 3:2. Generally it's the left dot for right-handed people and the right dot for left-handed people — but in either case people look at these two dots first — one and then the other. Very quickly the eye would then travel downward to the other set of yellow dots. Naturally, this visual path leads to the center of the space, but the eye does not start there. It just ends up there when there is nowhere else to go. The photographic center of interest is in one of those four spots — dependant upon the photograph.

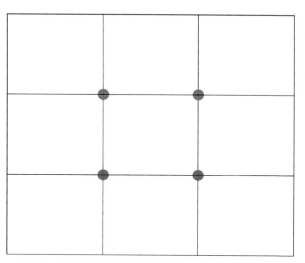

Figure 4-6: This diagram represents the places where the viewer's eye will naturally go when looking at a canvas of that size. The point placement changes according to the dimensions of the canvas but always remains in those relative positions.

Why this is the case? The upper two dots are "eye level" relative to the size of the photograph area. In a fixed space there is always an eye level, a place where our eye naturally goes first. If the model were in the middle of the frame, directly in front of the viewer as one would generally face a live person, as shown in Figure 4-7, the model's eyes would be about this relative distance apart and at about that height, right inside those red dots. We're hardwired and then trained from birth to look to eye level first, move down to the mouth, and then scout the periphery—and that's what we do. I call these four dots the "power points."

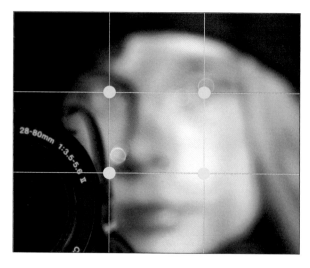

Figure 4-7: If you were to look at a photographic canvas in the same way that you do a person, you would look to the eyes first. Thus, it makes sense that whatever is at eye level will be the most prominent element in the composition.

Composition is meant to either take advantage of the natural center of interest and put it in the right place, or change the natural center of interest by putting something else in one of the four power points. You have many other devices, of course, such as leading lines, background or negative space, color and tone — but the most important aspect of composition is that all-critical center of interest. Control it, and you control the photograph.

The most prevalent way to choose where to put the center of interest is to use a compositional guideline such as the Rule of Thirds.

Using the Rule of Thirds

The rule states that an image can be divided into nine equal parts by two equally spaced horizontal lines and two equally spaced vertical lines — as shown in Figures 4-6 and 4-7. The four power points formed by the intersections of these lines can help you arrange the elements of a photograph into a pleasing composition. Specifically, they can help you choose where to put your center of interest. The vertical, horizontal, and diagonal lines that form these intersections are the guides for your leading lines and placement of any props or background elements. Every shape conceivable, including serpentines, curves, and arcs, can be accommodated inside of the Rule of Thirds (see Figure 4-8).

In each of the three major types of portrait, the natural center of interest is different, but the formula for choosing where to locate it remains the same.

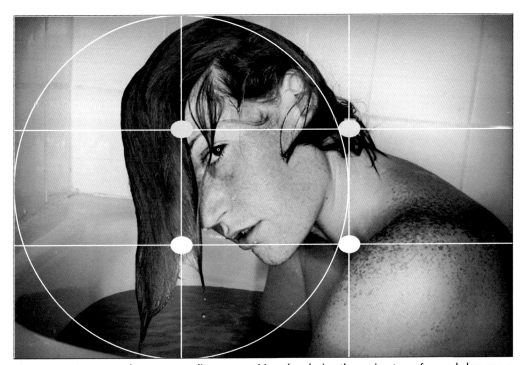

Figure 4-8: You can make very appealing compositions by placing the perimeters of curved shapes on the power points and placing circular shapes inside two of the three vertical or horizontal sections.
© Istoica.com

Theoretically Speaking

The point of composition is to ensure that the elements of an image are arranged so that their relationship to one another and to the "frame" is naturally pleasing to the eye. Subject placement is not arbitrarily made, but in fact is generally made intuitively. When someone is said to have a "good eye" this is usually meant to imply that they have a good ability to translate their intuition about "what looks best" into the finished composition.

The study of composition has always been about the analysis of "what works" after the composition has been made. This suggests it is more like a natural law; it is not a rule we have made, it is a truth we have discovered.

Intuition usually helps us ensure that placement is based on a proportion inherent in nature itself, and one that most theorists believe would be recognized by any intelligent culture. Ancient Greek scholars studied patterns, shapes, relationships, and proportions that existed in the natural world around them, and found that something they called the "Golden Proportion" was the most prevalent and pleasing relationship between all objects in a given area and, as a whole, with the area itself. Occurring naturally in the plant and animal kingdoms, the Greeks postulated that the same pleasing series of relationships and proportions found in nature would prove the most pleasing when used in all manner of art and architecture. Time-tested and true, it seems the Greeks were quite correct about this matter. From this single natural design discovery we have the Golden Triangle, the Golden Rectangle, and the Golden Spiral methods of composition.

The reason the Rule of Thirds works is that it is simply a more straightforward method of using the Golden Proportion. The four points of intersection within the Rule of Thirds grid, which I call "power points," show the most natural position for elements to be placed and which, it is theorized, produces the most appealing composition. It appeals to viewers in an instinctive way because it utilizes the Golden Proportion within the photograph's canvas. In other words, the four power points mark out where the viewer's eye will go first.

It is important to keep in mind, when evaluating your portrait against the Rule of Thirds, that the entire portrait area, including mat and frame, be used to establish compositional placement. This is why many artists choose to mat and frame photographs so that there is an equal amount of added space on all four sides when the item ready for presentation. This way the proportions are kept mostly intact and your compositional choices will not be negated by a framing or matting choice that alters the photographic center of interest.

Don't think that the Rule of Thirds is simply a grid of lines that cross through your composition and help you place elements. It also has a series of subrules, if you will, that help you apply it. It can literally be used to help solve any compositional dilemma:

1. If any line in the image is diagonal (runs from top right to bottom left, or top left to bottom right) it should be angled so that it crosses through or runs parallel to a line that would be drawn between two of the power points. Remember that lines can be actual elements (such as an arm, a leg, or a prop) or a line created with light, texture, or clothing. See Figure 4-9.

2. If the composition has a serpentine or curved shape as its main element, it should be arranged so that the middle of any circles created cross through two of the power points. See Figure 4-10.

3. If you have leading lines — lines that exist in the composition such as arms, legs, or fingers — they should direct the viewer to the center of interest along one of the vertical, horizontal, or diagonal lines that exist in the Rule of Thirds grid (see Figure 4-11).

The Rule of Thirds is an excellent tool for planning compositions and can be used very effectively for model posing as well. See Chapter 5 for detailed posing information.

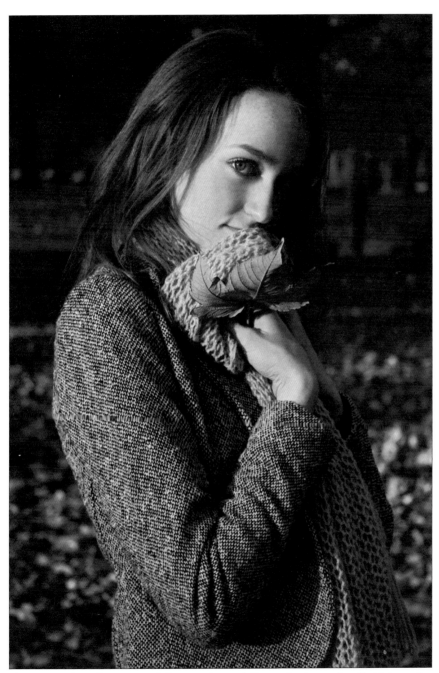

Figure 4-9: If you keep your obvious angles and diagonals along a line that intersects with two of the power points, your composition will appear more balanced.

© Istoica.com

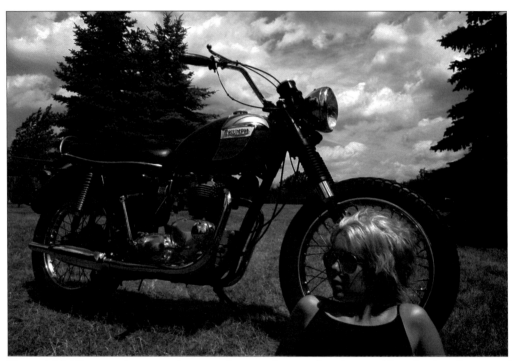

Figure 4-10: When you have wavering, curved, serpentine, or other shapes with no hard angles, try and place the alike shapes (such as the half circles created by a serpentine or the waves in long hair) so that they intersect the same horizontal or vertical line.
© Istoica.com

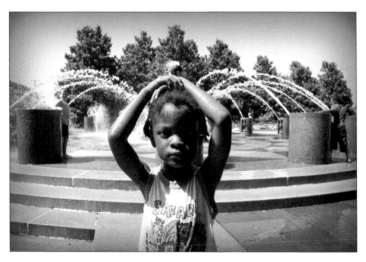

Figure 4-11: Leading lines aren't always straight, and the best way to make sure that they don't distract from your subject is to plan your composition so background, limb, or prop lines lead back into the center of interest.
© Istoica.com

Headshots

Headshots typically have only a small (or none in some cases) visible background area—the entire portrait space is generally taken with the head or face of the model. In the case of a traditional portrait the center of interest is almost universally the eyes. They should be located, as shown in Figure 4-12, close to the uppermost horizontal line, and one eye should be close to one of the upper power points.

A headshot is the most intimate (yes, even more than a nude) of all portraits in that you are forced, so to speak, to look into the subject's eyes. This requires, however subtle, a psychological engagement with the photograph, and people tend to look at them like they would a human face—always back to the eyes, in other words.

There are a variety of ways to maximize the composition of a headshot using the Rule of Thirds:

✦ If using an angled pose, try and place the cheek-to-chin line so that it is either on or parallel to one of the diagonal lines.

✦ If you have a prop or other element such as an earring or a piece of jewelry, place it so that it is close to another power point or along a direct vertical or horizontal path from the main center of interest.

✦ Generally speaking, keep the background on headshots very neutral and very small; the head should occupy as much of the frame as possible.

✦ Headshots are generally done in portrait orientation because it is easier to keep the eyes at the correct place, according to the Rule of Thirds, than using a landscape orientation.

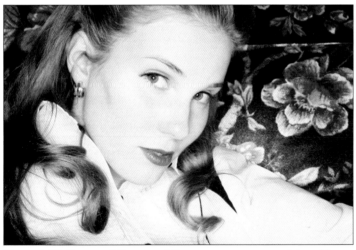

Figure 4-12: If you put the one of the eyes on a power point and keep other elements relative to that point, along vertical or diagonal lines, your composition will be more visually appealing.

© Istoica.com

Standard Headshot Using the Starter Kit

This is probably the most common of all portrait shots. In one form or another it's used for everything from high-school yearbook photographs to corporate newsletters and brochures to an actor's portfolio. It's a shot that can be done using only a single lamp. Indeed, one of the most famous portrait photographers, Francesco Scavullo, shot the vast majority of his portraits with only a single lamp. The power of a single-lamp headshot grows out of its simplicity.

The important thing to remember here is that you don't want to actually re-create sunlight; you simply want to imitate it. You want all the benefits of actual sunlight without having to deal with any of its harshness. Harsh shadows in a headshot can be dramatic and have a cinematic appeal, but unless you're photographing an acting student, it's generally best to avoid them in portraiture. What you probably want here is soft light.

The equipment listed in the starter kit (see Chapter 3) is for exactly this kind of bread-and-butter portrait work:

1. **Begin by setting up the main light source, which is the strobe lamp or the softbox.** Traditional portrait lighting suggests the lamp should be placed at an angle of approximately 45 degrees to one side of the subject, and close to or slightly above eye level. That's a good starting point rather than a firm rule. The actual placement of the lamp should depend on the model's face, the background, and the power of the lamp. Shift the lamp around as necessary until the scene suits your eye.

2. **Bounce the light off the umbrella rather than shine it directly on the subject.** This gives you a softer light that reduces harsh shadows and avoids overly bright highlights (especially important if your subject has a high hairline or is balding). Some shadow will still exist, however.

3. **To control those shadows, turn to the collapsible 5-in-1 reflectors.** Place one opposite the light source (if the lamp is on the subject's left, the reflector should be on the subject's right), as close to the subject as the camera's field of view allows. Angle this to direct light on the subject's face, bringing light into the shadows without totally removing them. Some shadow is needed to give the subject's face dimension.

4. **Because the main light source is pointing downward, you'll want to be careful of shadows caused by the subject's chin.** To avoid too sharp of a chin shadow, place your second reflector under the subject's face, just out of camera view.

Because you're bouncing the light off the umbrella, it's unlikely the modeling light will be bright enough to give you a good preview of the lighting, so you'll have to shoot some test images. One of the benefits, though, of digital photography is that test images are essentially free.

Full or partial body

Compositionally, a partial or full body shot differs from a headshot in that the body is a different shape than the face (and has arms and legs) so there will be more visible background. You can also pose a body quite differently than a face, which you can mostly just position. A body is a collection of elements but a face is a single element with a collection of features.

The face or head is the natural focal point of a body portrait and posing the model should take into account this fact. Other considerations for a full or partial body shot are:

✦ All lines created by the torso, arms, or legs (or the neck, depending upon the pose) should lead toward the center of interest or be parallel to one of the lines leading to it.

✦ The general rule of thumb is that the more of the body that is shown in the portrait, the larger the negative or background space should be around the subject, as shown in Figure 4-13. A full body portrait is generally presented with a fairly generous negative-space "buffer" or vignette around at least three sides of the form. See Chapter 9 for details on creating vignette effects in the studio.

✦ If the portrait is more form than face (the facial features are obscured or vague) the head can be treated like any other element and does not have to be the center of interest.

✦ Body portraits very often employ a secondary area of interest, which is often the hands or arms, and these secondary elements should be placed along lines in the Rule of Third grid which lead directly to the main area of interest or are parallel or perpendicular to it, as shown in Figure 4-14.

✦ Avoid putting breasts or groins on either of the top two power points because it will be very hard to move your viewer's eye anywhere else.

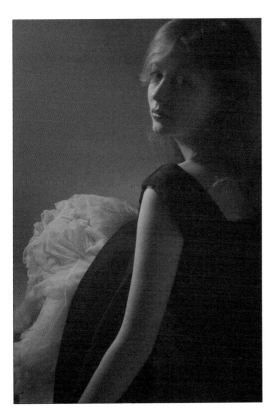

Figure 4-13: The more of the body that is shown in the portrait, generally speaking, the more background should be visible. It becomes especially important to pay attention to anything that might distract from the center of interest. Using a totally negative space for a background solves this problem and creates a very compelling portrait.
© Istoica.com

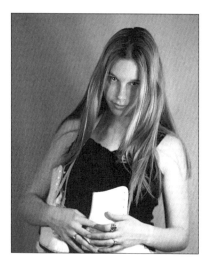

Figure 4-14: Lines, such as arms and legs, should lead back into the model and not out of the frame. Solving the problem of what to do with hands is often as easy as giving them something (or each other) to hold on to.
© *Utata Photography*

Glamour Portrait Using the Basic Kit

What makes a portrait a "glamour" shot is most often the lighting. Whereas a standard headshot is meant to provide a pleasing but accurate image of the subject, a glamour shot is intended to flatter. We're not looking for reality here; we're looking for an idealized Hollywood notion of romance, and that romance comes from the light.

For instructing on this shot I'll be using the equipment from the basic kit described in Chapter 3. Although modern professional glamour shots involve quite a bit more lighting gear, the equipment in this kit is more sophisticated than that used by the early Hollywood glamour photographers. If Cecil Beaton and George Hurrell can do it, so can you.

1. **Begin, as always, with setting up the main light source.** Using the taller stand, place it as close to being squarely in front of the subject as you can. If the model has any issues which would require corrective posing, the light can be moved slightly to the left or right. Set it slightly above the subject's head and direct the light downward using the 48-inch translucent umbrella as a makeshift softbox. This gives you the soft, diffused frontal light you want for a glamour portrait.

2. **With a four-foot diameter, the umbrella allows you to shoot a half-figure glamour shot.** Since more light spills out of an umbrella than would from a softbox, you'll need to place the lamp somewhat closer to the subject.

3. **The second strobe lamp, slaved to the first, is used to highlight the subject's hair.** Using the smaller 10-foot stand (which collapses down to about 32 inches), place it left of the camera, behind and below the subject (and, obviously, out of the camera's field of vision).

4. **Put the black sheath on one of the collapsible reflectors and use it as a gobo.** Set it along the side of the strobe nearest the camera to direct the light away from the camera and toward the subject's hair.

It's a simple but effective arrangement that consistently provides glamorous portrait lighting.

Tip

A good trick for creating negative space (all dark) backgrounds is to place the model very far away from any wall or other reflective surface and use spotlights that you can direct fairly finely. Dark or light negative spaces are very easy to alter (darken or lighten) in the digital darkroom, which is discussed in chapters 10 and 11.

Environmental

An environmental portrait is a much broader canvas and includes context, often in the form of a background that cannot be strictly controlled. As the name implies, they are generally created in the subject's environment and are meant to portray the subject inside a specific context. Traditionally used for professional clients such as architects, industrial planners, and manufacturers, environmental portraits are becoming increasingly popular with retail (families, singles, and couples) clients because they often provide a fuller "picture" of the model(s).

Many group and family portraits are environmental in nature, and a great deal of commercial work falls into this category. Being hired to take portraits at a science fair, a car show, or a singing competition would qualify in this category, as would following a family around at the beach for a day or taking a children's portrait for a Mother's Day gift. See Figure 4-15.

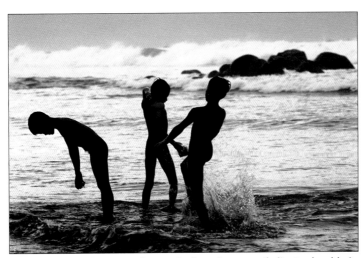

Figure 4-15: Environmental portraits for private retail clients should give a good idea of the model's character and personality that will resonate with the person for whom the portrait is intended. A corporate environmental shot would expose more of the model's features.
© Brandon Hoover

Portfolio Portraits

Aside from a retail business, where families, singles, and couples come for portraits, you can expect to be asked to produce portfolio shots for a variety of performing artists. Generally speaking, there are two types of performing-artist headshots: commercial and theatrical.

Commercial headshots

Commercial headshots are the kind used to sell toothpaste and other products. They're also precisely the same as those the real-estate agents want, or anyone else who wants a portrait for a business card. They're best characterized as being warm and friendly and having a well-groomed, polite, and pleasant look. The smile should be sincere and warm but not overly broad and very natural—either close-lipped or tooth-showing, depending upon the person's natural smile. They should be close headshots against a neutral background with a normal-to-low color saturation, in a standard pose with short lighting (see the first figure below).

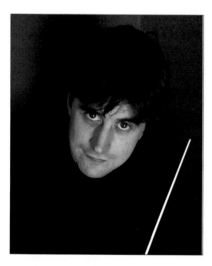

A traditional or commercial headshot portrays the person in such a way that he or she is recognizable. This is the standard shot used for yearbooks, business cards, and performing artists.

© Cheryl Mazak

Theatrical headshots

Theatrical headshots are less generic in appearance and are intended to provide some insight into the character or depth of the model. They tend to appear more serious (dramatic) except, of course, if your client is a comedian.

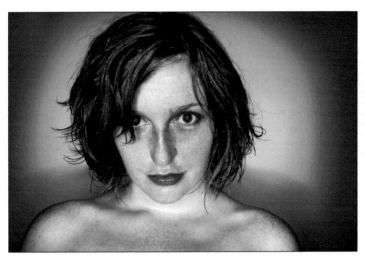

A glamour or theatrical shot is intended to portray the model accurately but in a more dramatic manner than a standard headshot. It is expected that some of the model's character will shine through the portrait.
© *Istoica.com*

Headshot tips

✦ A headshot must look like the model. Flaws shouldn't be hidden (nor exaggerated, of course).

✦ Make sure the headshot allows for easy identification. Headshots for portfolios should show the whole face clearly.

✦ Headshots should be a black-and-white 8 x 10 photograph. Commercial headshots should frame only the face from the shoulders up. The model should be smiling naturally (and showing a little teeth if this is natural).

Basic model or actor portfolio

A versatile, basic portfolio for most beginning models or actors includes:

✦ A casual headshot with minimal makeup—this should be available in both black and white and color

✦ At least one styled headshot with make up, costuming, or a prop

✦ A body shot (in a conservative swimsuit or tasteful lingerie)

✦ A motion shot

✦ A full body shot that clearly shows the model's form (a body suit or leotard is recommended for these shots)

✦ A fashion shot (more dramatic and "sexy")

Continued

Continued

Portfolio Tips

✦ Black and white is the preference at most agencies, and most models want an assortment of shots, poses, and styles in both black and white and color. Plan for this when you are considering compositions and poses.

✦ 9 x 12 inches is the standard size for a portfolio image, so be sure to shoot in the highest resolution and in RAW if possible. See Chapter 10 for tips on working with RAW files.

Included in this category, of course, are the cinematic portraits, those carefully planned compositions that include several props and where the entire canvas contains some element of the implied narrative, as shown in Figure 4-16. These portraits must be composed exactly like any other (according to the natural laws of pleasing composition) by using the lines, curves, and ratios implied in the Rule of Thirds. Place your subject(s) on one of the vertical lines and the most interesting aspect of the environment on the opposite vertical line, at or along one of the horizontal or diagonal lines that intersects it.

Although keeping the center of interest clear is important in all types of portraits, it is especially important and difficult to maintain in environmental portraits. This is simply because you are working with more elements and a larger space and there is more to keep track of.

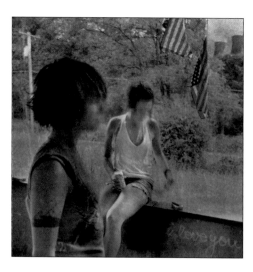

Figure 4-16: Cinematic portraits are a type of environmental portrait, and even though you are generally creating the environment, the rules of composition still need to be followed.
© *Isaac White*

There are several simple ways to utilize the Rule of Thirds when composing environmental images:

✦ Create arcs and curves where you can — or, even better, spiral shapes in your compositions. They are more pleasing than angles and straight lines.

✦ Avoid the placement of any major or distracting object in the center of the photograph.

✦ Avoid having any major element lead the viewer's eye out of the photograph. Lines should lead to the center of interest and away from the edges.

✦ Avoid clutter in the background. This is not to say it cannot be full; it can be. But if it is full, it must be carefully organized so that nothing distracts from the center of interest or hides the compositional lines.

✦ Avoid points of view that make it seem as if background items are merged with the model (such as trees that seem to grow out of heads).

Caution Choosing the center of interest by way of the Rule of Thirds is like any other photographic rule — it can and should be broken when warranted. If, for example, as shown in Figure 4-17, your model is a boxer, it is very appropriate to create an ambiguous center of interest so that the viewer's eyes are drawn from the model's eyes to the model's hands, over and over. There is an intentional confusion of dominance. Sometimes you use the rules in creative ways to end up with the same result: a strong portrait with a very compelling presence.

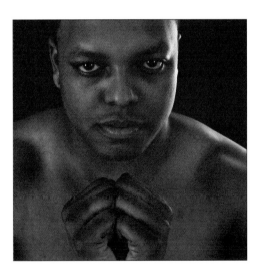

Figure 4-17: Choosing your composition is not always a simple matter of applying the Rule of Thirds. Sometimes you make choices based on circumstance and intent, such as in this case where both the hands and the eyes are near power points and intentionally compete for attention.
© *Stephen Strathdee*

Groups

Groups are a special thing unto themselves. Most photographers find groups to be among the most difficult type of portrait to create. A single model presents a very solvable problem because the compositional possibilities are both clear and varied. A second figure needs to relate to the first in some way so that, even with more than one model, they can be treated as a single compositional element, and composition is as straightforward as if there was a single model (see Figure 4-18).

Tip 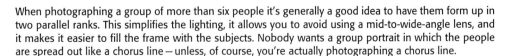 When photographing a group of more than six people it's generally a good idea to have them form up in two parallel ranks. This simplifies the lighting, it allows you to avoid using a mid-to-wide-angle lens, and it makes it easier to fill the frame with the subjects. Nobody wants a group portrait in which the people are spread out like a chorus line — unless, of course, you're actually photographing a chorus line.

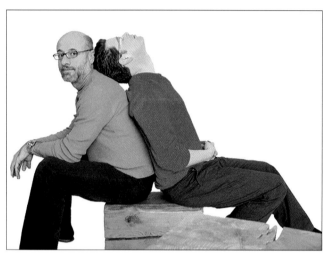

Figure 4-18: Couples and groups of two are sometimes best treated as a single compositional element and joined up in some way—usually near one of the horizontal or vertical Rule of Third lines.
© Cheryl Mazak

However, with the addition of a third, fourth, or more figures, the composition may begin to resemble a Cubist painting if you try to adhere to all the rules. Group portraits should have an atmosphere of relaxed informality and provide some indication of the relationships between the various models. Are they a family? A band? A company? A team?

Tip If the models are loosely composed (space exists between each member in the group), the background plays a major compositional role. Most often group portraits are environmental in nature, but not always (you can take them posed against a neutral background). The background could be a family home, a favorite corner of the backyard, the living room, or perhaps the front steps. In any case, the setting itself often becomes, in effect, an additional figure in the composition.

When composing a group portrait, you should usually ensure that the heads and faces do not line up horizontally. As discussed earlier, curves, triangles, and diagonals create a more pleasing composition than do straight lines or hard angles. When arranging models for group portraits, which is discussed further in Chapter 5, aim to create compositions where each model is considered an element but has a distinct individual presence.

Group Portrait Using the Advanced Kit

Whether it's a family portrait, a team picture, a wedding party, or a photograph of the local chess club, most portrait photographers are asked to take photos of a group of people at some point in their career.

Properly arranged, the advanced kit (shown in Chapter 3) should allow you to photograph groups ranging from four to twenty people. For the purpose of this example, assume you're photographing a group of seven people: five adults and two children.

Lighting a group portrait is pretty straightforward. Group portraits tend to be documentary in the sense that they're used to record a specific group of people gathered for a specific reason. You're not looking for glamour here; you're looking for well-lighted, relaxed, recognizable faces.

1. **Because this is a group portrait, there is no main light source.** Instead, use two of the strobe lamps as equal partners.

2. **Arrange the subjects in two groups, adults in back and children in front.** If possible, position them about five feet from a wall.

3. **Extend the lamp stands to about eight to ten feet in height, and set one on either side of the camera just beyond the two subjects at the ends.** Angle the lamps slightly inward to ensure even lighting of all the subjects.

4. **Place the third lamp on the small backlight stand.** This is placed behind the group and directed toward the wall. This gives the heads of the adult subjects a bit more dimension as well as illuminating the background.

5. **Simple. Effective. Quick.** If you need to shoot more than one group, they can be ushered in and out rapidly with the least amount of fuss.

Portrait Lighting Styles

I sculpt in wood sometimes, and I always think of the lighting stage of a photograph very much like the fine-sanding and oil-finishing stage of a piece of sculpture. I tend to stand back and consider the composition through critical eyes and determine where I would like to add light, create darkness, increase texture, or enhance contrast.

Backlighting always adds an element of drama and depth to a portrait, and top lighting creates very moody shadows and a somewhat glamorous sheen. Primarily when you are lighting you are looking to enhance your composition, not alter it, and so the brightest or most apparent lighting should be on the center of interest, or done in such a way that it leads the eye directly to the center of interest.

By altering vertical and diagonal alignment of the lighting you can significantly alter the dark and light balance of a photograph as well as the neutrality of the background. Experimentation is highly recommended and to help you with that, a more detailed discussion of light placement is contained in Chapter 6.

Tip

A very important thing to remember is the relationship between the light, the subject, and the background. If your model is too close to the background, or the light too close to the model, you may create unwanted and hard-to-remove shadows in the composition.

One of the most useful and inventive ways to use lighting to improve and enhance a composition is to increase the contrast or tension in an element. As an example, using a hair light on a model against an otherwise dark background creates a higher level of contrast on the top of the head, producing a halo or angelic effect. This is a traditional Hollywood method of glamour shots.

Generally speaking, portrait lighting types or styles are performed with two lights and are characterized by the relationship of the main light to the model's face. This relationship is, in turn, characterized by two primary variables: direction of light and angle of incidence.

The first factor, direction, is simply the side of the face that the main light is directed toward. There are only four variables for this aspect of the lighting equation. Light can come from the near side, the far side, the front, or the back.

Tip How big an umbrella do you need? As a general rule the umbrella size should be at least proportional to the size of the subject. For a head and shoulder shot, a 36-inch diameter umbrella will suffice. A 52-inch umbrella would be appropriate for a half-figure portrait, and for a full figure shot use a 72-inch umbrella. Using a large umbrella to light a small object works, but using a small umbrella to illuminate a large object is less effective. The 48-inch umbrella in the starter kit offers a versatile range of lighting.

Short lighting (far side)

In short lighting, the main or key light is directed toward the side of the face that is facing away from or which is farthest from the camera. This is the most commonly used lighting style and can serve to narrow a wide or full face as well as even out the contours of an angular face.

Broad lighting (near side)

Sometimes called "full lighting," broad light is when the main or key light is directed toward the side of the face that is facing or closest to the camera. This is an older style not commonly used now except in art and creative portraiture because it tends to result in a very unevenly toned portrait.

See Figure 4-19 for examples of broad and short lighting.

Short lighting, no fill Short lighting and fill Broad lighting, no fill Broad lighting and fill

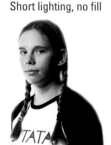 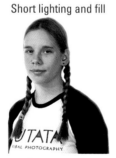 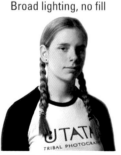 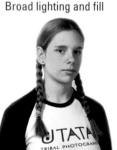

Figure 4-19: This figure shows the two main types of lighting (short and broad) with and without fill light.
© Utata Photography

Front lighting

The main light is directed at the front of the model's face. Front light is often referred to interchangeably with broad light, but this is slightly inaccurate because broad light presumes an unevenly lit face, whereas front light typically assumes the model is facing the light directly and that the light is facing the model directly—therefore the entire face is lit equally.

Used in the butterfly/glamour styles front lighting is almost never used at face level because it tends to wash out features. This style is usually not suitable for corrective posing because it takes both an evenness of feature and a good skin tone and texture to work well.

Back/rim lighting

In back or rim lighting, the main light is directed behind the model's head, usually so that the head is in the center of the lit area. When used as a backlight the main light should be placed much lower to the ground and angled upwards

Without any other light, backlight puts the entire face in a shadow and is used when making profiles and silhouettes. Rim lighting is also used in addition to a short or broad main light to set the model off from the background and add depth to the portrait composition, as shown in Figure 4-20.

Tip

A larger light source (this includes the size of the umbrella or softbox) produces softer and more diffused light. This is because the shadows it casts is larger and softer. In effect, a larger light source causes light to "wrap around" the subject. But it's important to remember that when it comes to photographic lighting, size is relative. A large light source placed a long way from the subject is smaller in relative terms than the same light source placed close to the subject. So moving the light source closer or farther from the subject directly affects the sharpness of the shadows.

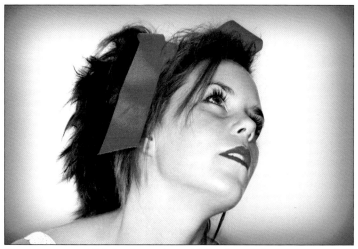

Figure 4-20: Backlighting is used to add depth and drama to portraits and sets off the model from the background.
© Istoica.com

Keep It Balanced

If you follow the Rule of Thirds, or break it judiciously, your photograph will have reasonably well-balanced elements. The trick now is to not disrupt (or disrupt judiciously) the composition of the model in the frame with the lighting or distract from it with the background. In other words, to make sure the balance stays intact or is enhanced by the lighting and the background elements, including any props.

The following sections contain tips for working with several types of composition elements and modifiers.

Color

Color is a magnificent thing, important even in black-and-white photography — perhaps more important because colors (such as red and blue) can become very confusing in a grayscale palette. Color can be used to bring even more attention to or complement the center of interest, or to provide secondary points of interest in the composition, as shown in Figure 4-21. The important thing to remember about using color is that is should never distract from the center of interest or compete with it for dominance. Primary colors should be avoided as background colors unless one has also been used on or near the center of interest. Red should be used with very special caution because it is the most commanding color in the prism, and most people look at it no matter where it is in the composition.

Chapter 9 contains detailed information about color theory while planning compositions.

Figure 4-21: The bright toy being held out to the photographer is a wonderful secondary point of interest and brings the viewer's eyes right back to the baby's face.
© Kyle Flood

Space

Space is breathing room for the eyes. It exists to provide context and allow for a neutral area. A neutral area is important because without it you cannot properly establish the center of interest. In a Where's Waldo poster, for example, there is absolutely no neutral area. This is quite intentional, of course, because it makes it more challenging to focus in on specific areas. Without a buffer to add context and define the focal area, our eyes try to see everything at once. A composition without space is unpleasant to view.

In a close headshot, for example, the space exists naturally. Our foreheads, cheeks, and chins are neutral space in our facial compositions. The power points of a full face shot, cropped in the golden proportion, are the two eyes and the two spots just under the cheeks, roughly equivalent to the edges of the upper lip as shown in Figure 4-7.

In a body shot, space is generally allowed around the subject. If arms and legs are not contained within the main body form (arms crossed in front of the body, as an example) the space between them and the main form must be used in such a way that it does not create a new center of interest or an overly dominant secondary interest. When breaking ambient or surrounding space with limbs or props, be careful that you do not split the canvas unnaturally and lead the eye away from the model's face. It is generally best to keep props close to the body or connected to it in some obvious way, as shown in Figure 4-22.

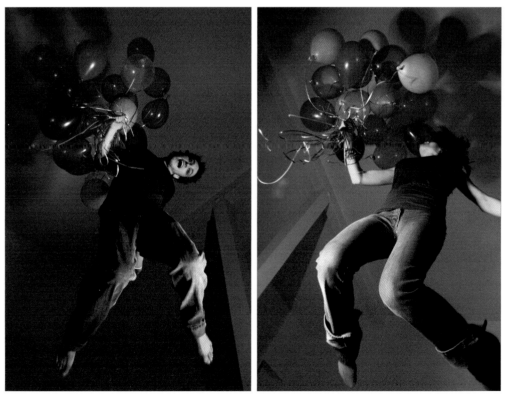

Figure 4-22: In general, keep props attached or connected to your model in some obvious way.
© Istoica.com

The Composition Roundup

Composing a good portrait can, in fact, be achieved formulaically. Until it becomes instinct, which it will when you've done it enough, it can be done "by the book." Follow the basic rules, stick to the tried and true, and soon enough you will just *know* when it's the right time to bend a rule or even outright break it. These guidelines will help you with a starting place from which you can develop your own unique style:

✦ Observe the natural laws of human perception and keep your center of interest clear and in one of the intersections or along one of the lines created by the Rule of Thirds.

✦ Don't clutter your portrait with too many elements or a busy background — do nothing that distracts from the subject.

✦ Ensure all lines, whether created with limbs, light, background elements, or props, lead to the center of interest and not out of the frame. The exception is with compositions such as Figure 4-22, where another element such as a prop forces the viewer's attention back into the frame.

✦ Where possible follow the more graceful diagonal and curved (spirals and arcs) lines created by the Rule of Thirds because they tend to be more appealing in general.

✦ Avoid any all-light (white) or all-dark (black) areas except on the periphery of the frame or as a vignette effect.

✦ Watch the angles of the face carefully on headshots because it is so easy to concentrate on getting the eyes in the right place that the line from cheek to chin becomes askew. A trick I use is to get models to lean on their fist at about desk level (naturally as if they were chatting with you over coffee and they are listening to you speak) and use that angle to position their head. Generally this creates a diagonal that works properly with the eye position based on the Rule of Thirds.

✦ Headshot and upper-body or partial-body portraits generally follow one of the vertical lines for placement, with the head being centered near one of the horizontal line intersections — avoid center placement and extreme left or right placement. If you choose to go parallel to a vertical line, go closer to the middle than to the edge.

The very best advice I can give you, honestly, is to go with your inner eye, the one those old Greeks discovered. Mother nature endowed us with certain commonalities — as a species — and it makes a great deal of sense that we should find certain patterns appealing, somewhat universally. There are always exceptions, of course, and very clever ways to apply the rules so that the outcome is both unique and appealing.

And there are times, make no mistake, when the right thing to do is to appeal to some alternate commonality and break the rules. Here's the deal: the overwhelming majority of art that lines of the walls of the museums in which we house our artistic history conforms to the rules — even the ones that do not seem to. As examples, Picasso's *Guernica* and DaVinci's *The Last Supper* are classic examples of brilliant composition. *The Last Supper* is a work of, among other things, perspective genius. Every line, every point of interest, every diverging theme, leads back, inexorably and certainly, to the center of interest, which is, in this case, the head of Jesus Christ. *Guernica* seems revolutionary, doesn't it? And it is, thematically. Each element defies our sense of proportion and perspective — but it is so gracefully balanced and perfectly composed that we are willing to suspend disbelief to behold it. It fits the pattern of beauty.

Once you have planned your composition you will need to get down to the delicate matter of posing the model or models inside of it. Quite apart from composing the overall portrait, you will need the fingers and toes to be in the right place and the nose to be on the right side of the cheek line.

Creating poses is both challenging and fun, and learning more about it will help you develop your composition instincts. You will find that poses and props come naturally to your mind when you are comfortable with general composition tactics. And you will also find that you come up with compositions instinctively from pose ideas. It's very much a chicken/egg scenario with each skill augmenting and enhancing the other. So, let's learn about posing, shall we?

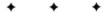

5 Posing Techniques

I f you went out and purchased a truckload of house furnishings and had them delivered to your home, there is no doubt you could put them into a good configuration (composition). The table goes here in the middle of the dining room, the curtains go over the window, the couch goes along a wall, and so forth—the gross anatomy, so to speak. What gets trickier is the angle of the coffee table to the sofa, the right way to place the three scented candles on the mantle, and where on the wall to hang those two paintings. In the analogy, this is posing.

You've planned your composition, and you know where you're going to have the guys put the piano. Now you have to decide how to place the silver frames on it, and whether it looks better angled at this window or that doorway. First you place it and then you pose it.

The first four chapters of this book prepare you for the technical end of taking portraits. You have all your equipment and a general idea of how to use it. You understand how a photograph and a portrait are generally composed. Now, really and truly, you're into the fun stuff. You have all the tools and a shiny new toolbox. Now it's time to slap the "Professional" sticker on it, because the skills in this chapter are the ones that tend to separate the amateurs from the professionals.

Working with your client and planning compositions and poses is the "fun stuff," so to speak. This is where you make or break yourself in the business. All the best glass and the fanciest camera bodies won't help you if you can't deliver portraits that make clients happy.

So, the question is: what makes clients happy?

In short, if such a thing can be shortened, what makes clients happy is getting what they want. Ergo, the most important piece of information in your bag of tricks is the chunk of knowledge that tells you want the client expects or, even better, thinks about in their wildest dreams.

So, the next set of skills you need involve

✦ Working with your client to plan a portrait composition

✦ Planning a portrait composition

✦ Deciding on how to present or pose your client(s) inside the composition

Work With the Client

Posing requires the ability to work with people and understand what result they want. This means that you have to have good listening and communication skills as well as a genuine willingness to give them what they want, not what you want them to have. It's amazing the number of people who will actually say, "Oh, whatever you think is best," when asked how they'd like a private portrait to be accomplished. But don't be fooled—they don't actually mean that.

You have to know that your idea is right for this client, that it will be both appealing and appropriate for use. Giving a corporate CEO who wants a headshot for the annual profit and loss statement a pair of goggles and a motorcycle helmet might appeal to your sense of humor, but his shareholders might not be so amused. There are ways, of course, to inject a little panache into even the most serious portraits, as shown in Figure 5-1. And setting up that wild spirited girl who plans on taking over the music business some day in front of a bookshelf and asking her to lean on her hand for a headshot will probably not earn you any points. A portrait has to work for the people who will be using it.

Tip Wide-angle lenses are fun and very important for a wide range of photography situations. However, they are meant primarily as a means of capturing a large scene—or a wide-angle view. Except for when you want to create an unusual effect, as shown in Figure 5-1, they are generally not used for close portrait work. They are great for groups or environmental portraits where you will be capturing your subject(s) as part of a larger scene, usually from a distance so that distortion is not a factor.

How best to know this? Talk to them, of course.

I usually offer private retail clients a coffee or cold drink, seat them comfortably somewhere, and ask them to tell me a little bit about what they're after. Most people are able to articulate it clearly, but it's important that you have all the right information and that they're aware of all their choices. Most corporate or commercial work is accomplished by e-mail, telephone, and contract, and it is clearly established

what you will be doing and in what style—you will already have the answers to these questions. This is for the private retail clients; the clients which come to you by way of referral or as walk-ins and call-ups.

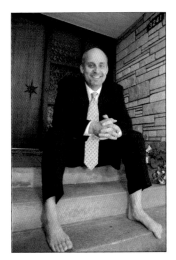

Figure 5-1: Most CEOs want traditional poses, but don't discount injecting a little fun and adventure into a portrait.
© *Tracy Marshall, Studio Zoe Photography*

Tip

It's a wise idea to talk with your clients before you show them your sample book or portfolio. By finding out what they want, or what general idea they're after, you can know which of your shots to show them to get a reaction. If they are very traditional and are left alone to leaf through a portfolio with a bunch of your best artistic work, they might become uncomfortable, thinking that you will be trying to do something "weird" with them. If they are very hip and modern and they are left to leaf through a sample book with all of your yearbook, sports team, and business card work, they might be concerned you're not "weird" enough.

Ask the right questions

By encouraging their narrative or description about what they want, I generally find a way to interject these questions or, at least, have them all answered by the time we're ready to start looking through sample books:

1. **What will you be doing with the portrait?** (Answers can range from hanging it over a fireplace to sending it in a plain brown envelope to a boyfriend.) What the portrait is used for is quite critical to planning a composition and a pose. It tells you best where to start when coming up with composition ideas.

2. **Will you want color or black and white?** Most people actually ask if they can have both to choose from. In the digital age this is not an issue, of course, so the answer is easy. When you are planning poses and compositions you should have a good idea of the colors you want to work with, and knowing you may be dealing with a black-and-white portrait means you will have to be cautious with color and tonal range.

3. **Do you want a headshot, a partial or full body shot, or an environmental shot?** Many people ask if you can do one or more of each type so they can choose. If you are agreeable to this style of work, I suggest you ensure that your business charges by the hour or exposure and does not intend to make its income on print sales. Creating several compositions and using several styles requires you to have a wider range of equipment and lighting options and takes a much longer period of time.

4. **Do you want an archival (looks exactly like you), glamour (enhances good qualities, looks more "fancy"), or abstract (we might not be able to tell it's you in it) portrait?** Although the norm would be the first and the second, my own business is comprised almost entirely of the third, so expect to get this answer at least a few times. In many cases, such as with a model or a performing artist, there will likely be several styles and types of photographs required.

Decide on a composition

Once you have a general idea of what you're doing — whether it's a model session, a performing artist portfolio, a family and their two Dalmatians, headshots of all the members of the town council, or an erotic semi-nude for someone's anniversary — you will have a good idea of which of your sample shots to show the client(s).

In many cases this is a fairly quick process. The majority of portrait work is singles, couples, and families, and the majority of them want to be displayed in somewhat traditional compositions and poses. By going through your samples and talking with them you will soon develop a good idea about what strikes them positively and what does not appeal to them.

From here the process diverges somewhat. In the case of a standard or traditional pose done in the studio, the process is simply a matter of setting a fee, terms, and an appointment. You can also do the portrait right then, if you have the time and the client is prepared, by posing them properly and taking the picture. See Figure 5-2. This is suitable for a small range of portrait work such as passports, business card headshots, yearbook make-ups, student or corporate ID work, and so on.

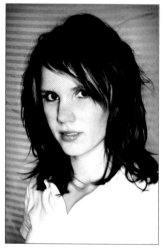

Figure 5-2: Some portraits can simply be taken "on the spot." If a portrait does not employ any special backgrounds or require any special props or equipment, and is very straightforward in pose, it takes only a few moments if the client is prepared, such as with this simple, traditional pose.

© Istoica.com

Caution If you do not have a release signed by your clients you cannot use their image in your portfolio or sample book. The client or model must specifically release any image that you expect to use for this purpose. This is the reason why many photographers have every client or model sign a release. My recommendation is that you have releases signed only for work you expect to use in your portfolio or sample book and not for each client. It will not bother most commercial or artist customers, but it often makes private, retail customers uncomfortable.

In the case of a more complicated job, such as a model's portfolio or an on-site portrait session at a large family reunion, the process is a matter of setting the fee and terms, agreeing on a general approach, and establishing an appointment date, time, and duration. A deposit should be procured in a case like this.

In the case of a complex composition — a glamour or artistic shot where props will be needed and equipment procured (a fog machine, a fan, a cage of doves, and so on) — a fee and terms should be set, a communication method and schedule agreed upon, a shoot appointment made, and a deposit procured.

Once you have planned your composition (how everything is to be arranged on the canvas), you need to turn your attention to posing — that is, the precise positioning of the model inside of the composition.

What your client needs to know

When your composition is all planned and you and your client know what you will be doing when they arrive for their appointment, you should ensure that everyone is prepared. Many portrait photographers create a small brochure or a printout to give to clients so that instructions are clear and consistent.

Hair

Clients should be told that their hair should be freshly washed and conditioned. Even if they do not usually use conditioner, it is highly recommended for a portrait session because it helps eliminate fly-away hair. Additionally, it will make the hair much shinier and more luxurious in appearance. Hair should be worn in whatever style the client prefers. It should be natural and not at all "delicate."

Many photographers keep a bottle of an organic "shine" spray on hand to use for clients with dull or damaged hair.

Makeup

Make up should be very minimal, especially around the eyes and lips, and should not attempt to conceal blemishes. Blemishes are best removed in post-processing. Bright colors should not be used. If makeup is part of your portrait plan, it is best to apply it in the studio, and the model should bring her makeup kit with her for items like mascara and lipstick.

Jewelry

Most jewelry detracts from a portrait. What rings, necklaces, and earrings that will be worn should be agreed upon prior to the appointment so that the model is not disappointed or cranky if she shows up in her grandmother's art deco earrings and you can't work them into the planned portrait.

Clothing

If the model or models are coming dressed they should be advised on good clothing choices for a portrait:

✦ Simple, long-sleeved garments in medium or dark natural tones such as brown, rust, burgundy, green, or blue are pleasing choices when using a dark background.

✦ Bold stripes, patterns, plaids, checks, and floral prints are confusing and do not photograph well.

✦ Especially bright, bold colors such as red, purple, and orange can completely overpower the face and should be worn only by darker-skinned people.

✦ Avoid light shades of color similar to flesh tones such as beige, tan, peach, pink, white, and yellow. Darker hues are both more flattering and more slimming.

✦ Light colors are very good against a white or pastel background.

✦ Couples, families, siblings, and small groups should select simple garments in the same tonal ranges. Light and dark tones together can create confusion.

✦ Clothing in medium shades complements portraits made in outdoor environments.

Casual Portrait Poses

By definition the casual portrait is less posed. This means that your model will be making most of the posing choices, but you still need to do your job and capture a good pose. And, of course, casual portraits are not the same as candid portraits; you can still direct the model and generally position them. Casual poses are intended to look like something the model would do on his or her own even if no photographer were present, and so the poses must be very close to the model's natural inclinations, which means the portrait won't be very casual or successful if you overpose the model.

Casual portraits are often best when the model is in a state of repose or relaxation, such as leaning on a piece of furniture, playing a musical instrument, reading, or cutting flowers in the garden. A great number of casual portraits are shot on-location, at the model's home or place of work.

These qualities characterize casual poses:

✦ The model's expressions and poses are completely natural — people who know the model recognize him or her instantly when viewing the portrait.

✦ The model should rarely be looking into the camera — the casual portrait is meant to be a little voyeuristic, as if you have caught the model in an unobserved moment.

✦ Any specific outstanding characteristic the person possesses, such as beautiful eyes, strong hands, smooth skin (or even very wrinkled skin), luxurious hair, or pretty lips, should be emphasized or made a point of interest in the composition.

✦ Casual poses are very often improved by a sense of action or motion — such as playing a musical instrument, turning the pages of a book, or riding a bicycle, as shown in Figure 5-3.

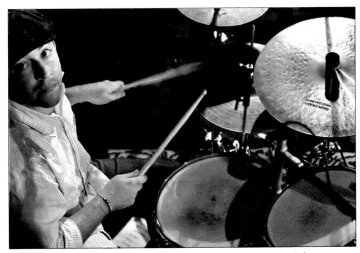

Figure 5-3: Casual portraits are intended to provide an insight into the model's personality and should not be overly posed. The photographer should be patient and prepared to capture the model at the right time.
© Stephen Strathdee

Traditional Poses

From business cards and school yearbooks to team portraits and annual corporate reports, the traditional portrait has a place in the world. Perhaps not as fun and challenging as artistic and creative shots, they're the bread and butter, so to speak, of the portrait business.

Traditional poses are characterized by, above all other things, clarity of facial feature and expression, as shown in Figure 5-4. They are archival in nature—intended to give us an accurate visual representation of the model. This is not to say that you do not employ any corrective techniques (covered in Chapter 6) with them, but you do not employ any that create an inaccurate representation. If the client has a very large nose, the client has a very large nose; and though you can minimize the potential distraction in terms of the portrait composition, you cannot correct it drastically nor do anything with it in post-processing.

A traditional portrait is intended to be realistic. With this in mind, here are several tips for posing models for traditional headshot or partial body portraits:

✦ Facial expressions should be conservative but not dull. Whatever expression appears on the model's face should be natural and appropriate to the reason for the portrait.

✦ For business portraits the expression is usually unsmiling and serious, as if the models know what they're talking about and they're serious about it.

✦ For business card portraits the expression is usually more open and smiling, as if you could easily talk to the person and trust what he or she says.

✦ For standard traditional poses such as yearbook or town council portraits, the expression should be open, natural, and have a slight but not overwhelming smile.

✦ For individual, private, traditional portraits, such as one would do for a wedding or a series of multigenerational family portraits — facial features should be closest to what they are when the model's face is in a state of natural animation, such as during normal conversation.

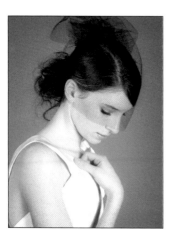

Figure 5-4: Traditional poses should present the model with no ambiguity whatsoever. Whether the portrait is a full face or a silhouette, it should be a good representative likeness and be shot with one of the standard lighting set-ups.
© Sam Javanrouh

Artistic and Creative Poses

Sometimes called "glamour" shots, I prefer to think of them as artistic endeavors. Glamour seems so frivolous, and even though many of the themes in these types of images are frivolous, the creation of them rarely is. Most simply, these shots are composed and posed with the specific intention of provoking a response in the viewer. See Figure 5-5. Used to sell products and promote fashion, often created as works of art and hung in galleries, these portraits are the lines of separation between the photographers with a booming business and those who struggle to make ends meet. They're not always glamorous, per se; sometimes they're just so creatively composed and posed that they strike everyone who looks at them. See Figure 5-6.

Cool is the word heard most often when well-executed creative portraits are shown to clients. I was lowered into a well once and took a picture of a family of four peering down at me. Hardly glamorous and hardly traditional, work like this falls into a separate category that is hard to define. "Everything in between" is probably the closest we could come.

Simply, you will earn more money and attract more referrals from very well-done portraits that are creatively composed and shot than you will from any other aspect of a portrait business.

Tip Watch the nose! The tip of the nose can get away from you in posing. If it extends past the line of the cheek, you need to make sure it extends far enough so that it does not appear to be a bump on the cheek. Better to keep it inside the facial area by having the model rotate his or her head very slightly to the left or right so that the facial line is kept intact.

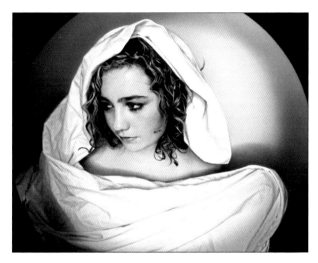

Figure 5-5: Artistic and creative poses are generally theatrical in nature and often rely upon dramatic lighting and unusual props to make an impact. Artistic portraits follow no real posing guidelines beyond ensuring that the basic compositional guidelines are followed.
© *Istoica.com*

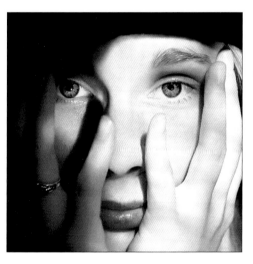

Figure 5-6: Artistic and creative poses give you a chance to zoom in, so to speak, on a particular aspect of the model's face, or to use the model's most compelling feature as the center of interest.
© *Utata Photography*

Basic Principles of Posing

Posing is theatrical in nature. Even the most simple of traditional poses would look unnatural were the person to hold it for any length of time. There are many dozens of books and many hundreds of Web sites with information on posing. All you have to do to get ideas and discover what is currently popular is to open a magazine. Virtually all magazines use photographed models in advertising as well as in article illustrations.

Once upon a time, in the sixties and seventies, all models learned the standard poses. You know, the one leg forward, bent-at-the-knee pose and the reclining-on-the-chaise-lounge pose. There were a certain number of lighting styles and a certain number of posing positions, and all portraits and even fashion photography looked . . . well, it looked the same. Today there are no standard poses—I can't give you a list of poses numbered one through ten and tell you to pick one and use it. Posing has become an art form.

Although traditional poses are still intact and often used—they are not *as* often used. Additionally, a portion of your business will be for performing-artist portfolios, and you need to be able to be creative in this area. Here are some hints that work universally when creating poses:

✦ The human body is a graceful machine—try to make poses with gentle curves and lines instead of sharp or stiff angles.

✦ If showing hands or feet, and if they are not a prominent part of the pose, they should be angled so that they do not end in a blunt line but in as close to a point as possible.

✦ Do not engage in any poses that the model has trouble holding or finds uncomfortable.

✦ Portraits in which the model and the camera face each other exactly at eye level rarely succeed. Some tilt or angle is usually required or the model will appear flat and one-dimensional. If the model is facing the camera "straight on," try having him or her look downward for a contemplative appearance. See Figure 5-7.

✦ When a model wears high heels, her posture is altered, which causes a more dramatic curve of the spine. The effect of this is that the buttocks and calves appear more rounded, the bust appears larger, and the hips have an exaggerated curvature. For this reason high heels are often used when creating modeling portfolio shots and glamour poses. You can simulate the effect of high heels by having models point their foot.

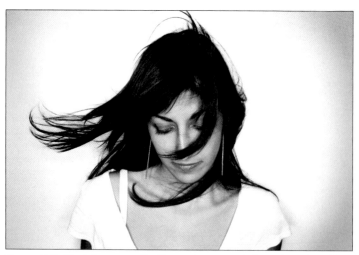

Figure 5-7: Models seem reflective and contemplative when they tilt their head downward, giving the portrait a softer feel.
© Istoica.com

Posing Individuals

Working with a single model carries with it a wide range of creative options and possibilities, and although your clients may want a "traditional" portrait, it is unlikely they want to look "cookie cutter." In other words, unless the portrait *is* a yearbook pose, don't make it look like one. You can still give people a very traditional headshot that is both interesting and creative.

Generally, once you have your client in your studio or you are at your client's location, your lighting is set and all the props and background elements you will need are arranged according to your compositional plan. What's left? Two things.

The first thing is to arrange your clients inside the basic composition. In the case of a traditional headshot or a partial body shot, this is usually a very straightforward case of sitting them on the posing stool or having them lean on a column.

The second, as you might have guessed, is to pose your model inside of the basic composition. Compose, arrange, and pose. That's the process.

Although, as shown in Figure 5-8, straight-on poses where the model is directly in front of and facing the camera can work beautifully (often used in artistic or creative portraits), it is generally best to avoid overusing this style of pose or using it with the wrong person. This pose works very well with young people (children) and "moody" young men and women, but it must be very carefully lit and exposed. In short, use this pose sparingly and carefully, but do not discount it altogether.

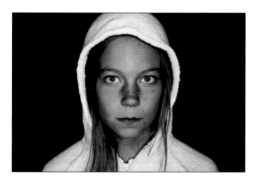

Figure 5-8: Though the straight-on pose must be used carefully and judiciously, it can be very effective with both children and "moody" young men and women.

© Istoica.com

Tip

Posing is best directed in a "look at me" way—very often the quickest way to get your clients to correct or adjust a pose is to show them what you want them to do. When you're working behind the camera, whether you're showing them how to pose or just doing your own creative thing, you should be careful to avoid negative body language of your own or expressions of frustration or impatience. Your clients need to be reassured that not knowing how to pose is common and that you know what you're doing. Your session should be upbeat and positive so that your clients' body language and facial expressions will be at their best.

The Universal Model Advice

You can best help your compositions appear natural by having the model do most of the posing work. A great deal can be accomplished if you can get every model (whether retail clients or professional clients) to follow a few basic guidelines for working in front of a camera. To this end here is some standard advice to give to each model:

✦ Don't lock joints, especially when the model is underweight. When leaning backward or forward onto the hands, don't lock elbows, wrists, or fingers. Any awkward bends should be avoided, and if something feels awkward the photographer and the model should adjust the pose.

✦ Keep fingers relaxed and separated. Avoid pressing fingers together.

✦ Relax. This is often difficult, but it is essential to have a relaxed and casual attitude in front of a camera in order to create an appealing portrait.

✦ Tilt the head to give a little life and intimacy to the image. Tilt it so that it feels natural and looks relaxed.

✦ Don't move while the photographer is adjusting equipment. Be patient; there is usually a purpose for all this trouble, and if you move from your mark the photographer (and you) may have to do it all over again.

✦ Keep your makeup fresh (don't rub) and keep your lips wet.

✦ Busts are emphasized by arching shoulders backward.

✦ Waists are narrowed by rotating the upper body slightly at the waist.

Posing the body

Essentially a classic headshot or upper body portrait is created when the model's body is facing the camera more or less squarely, with the shoulder turned and angled slightly away and the head turned back toward the camera. From here there are a great many variations that you can employ to alter the effect of the portrait.

✦ If you lean the upper body slightly forward the portrait feels more intimate and friendly and the model appears personable and gregarious, as shown in Figure 5-9.

✦ If you have the body very straight and proper with straight shoulders and a head that is more tipped than tilted, the portrait feels more serious and formal and the model seems responsible and professional.

✦ If you have the body at an angle (tilted to one side or the other) the portrait feels more casual and candid and the model seems more approachable and "down to earth."

✦ If you tilt the body backwards the portrait feels animated, as if you have caught the model in a moment of mirth or motion, and the model seems more alive and active.

✦ You can use different lighting styles (short or broad lighting, for example) to create different areas of highlight and tension.

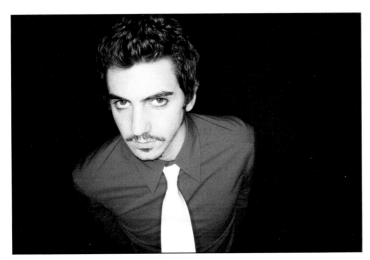

Figure 5-9: When the upper body is leaned inwards towards the viewer, the model appears very friendly and approachable.
© Istoica.com

Posing the shoulders

Generally speaking, most compositions look better if the model's shoulders are not square to the camera. Whether sitting or standing, shoulders should rarely be square to the camera because the subject will look unnaturally broad and disproportionate. The first thing to do when setting a pose is to find a good shoulder angle. Whatever the pose you want or composition you have planned, shoulders are the platform for the head (the usual center of interest) and must be positioned solidly within the compositional plan, as shown in Figure 5-10. Additionally, try to ensure that the shoulder closest to the camera is lower than the other shoulder and that the higher shoulder is not overly rounded toward the camera.

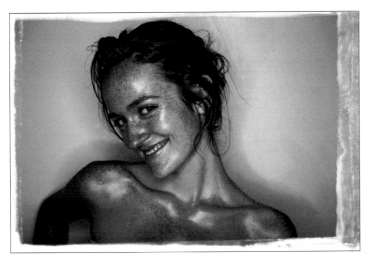

Figure 5-10: Placing shoulders in a pose must be done carefully because they can overwhelm a composition. As a rule, one shoulder should be placed lower than the other.
© Istoica.com

Language Counts

Body language is a universally recognized method of silent communication and should be considered when creating poses for photographs. Sometimes you work with standard body language expectations (such as a portrait of the CEO of a brand new and hugely successful corporation being posed with folded arms and chin raised), and sometimes you work against them for a different but equally compelling effect, such as posing a young child with his hands clasped behind his head.

Here are several common body language "phrases":

Arms crossed and chin lowered: Defensive and cautious.

Arms crossed and chin raised: Confident and a little cocky.

Resting chin on palm: Critical, cynical, and negative towards the other person.

Nose-touching: Doubtful (often reveals a negative reaction).

Swaying back: Weak ego.

Retracted shoulders: Suppressed anger.

Smiling eyes: Comfortable.

Relaxed brow: Comfortable.

Tension in brow: Confused, tense, fearful.

Shoulders hunched forward: Lacking interest or feeling inferior.

Rigid body posture: Anxious, uptight.

Leaning forward: Interested.

Fingers interlocked, placed behind the head, leaving elbows open and armpits exposed: Very open to ideas, comfortable, confident, and self-assured.

Eyes open slightly more than usual: Gives people the impression that they are welcome.

Legs wide apart or sitting straddle-legged: Feeling safe and is self-confident. Can also show leadership.

A big smile: Unreal or fake smile.

Crossed legs with highest foot in the direction of the speaker: Relaxed, self-confident, and listening very carefully.

Dangling the loose shoe from the toes: Signals physical attraction.

Pressed lips: Disagreeing and disapproving.

Pursed lips: Disapproving. The person has fixed views that cannot be changed.

Biting the lips: Lacking self-confidence.

Open hands: Trustful and interested.

Covered hands: Setting up of barriers or keeping one's distance.

Posing the head

The primary posing rule about the head is that it should almost never be square to the camera. It should be tilted or angled in some way (paying attention to the imaginary lines created by the Rule of Thirds) so that it does not lose its dimension and character.

Heads and shoulders, although connected, should appear to be separate elements in a composition. While some creative poses utilize a chin-to-shoulder melding, it is best to ensure they do join together or occupy the same space on the canvas (overlap). When positioning the head, ensure the chin is not angled in such a way that the eyes are either obscured or rendered "lifeless" through loss of light or absence of catchlight, and that brows or eyelashes are not going to cause unwanted shadows.

Generally, the eyes are the most important part of any portrait and especially a headshot. You'll have to decide whether you want your models to focus their gaze toward the camera or away from it. There's a mixed school of thought on whether it is more or less appealing to have a model look into the camera for a portrait shot. Some photographers prefer to have the model look at a point somewhere to the left or right of the camera position; others prefer to have the model looking directly into the camera.

Although the eyes are typically the center of interest, all of the other elements of the head, such as the hair, ears, and nose, must fall into an appealing position. Here are a few guidelines that will help:

✦ Hair is an important element in a portrait, because whether there is a lot or none, the area it occupies (or should occupy) is large enough to compete with the eyes for attention. If there is a lot of it, or if it is very beautiful or compelling, it can be used like a background or as a secondary area of interest in the portrait. See Figure 5-11.

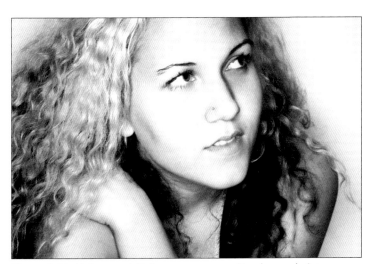

Figure 5-11: Hair, especially for women, can often be made into a focal point of the portrait, which is very effective when it completely obscures the background or *is* the background.

© Istoica.com

✦ If hair is parted on one side, the portion of the head with the widest section of the part should be closest to the camera. When the head is tilted, ensure that long hair does not create unwanted shadows on the face. Often with very long hair an upward head tilt is preferable to a downward one.

✦ The nose should be visible inside the facial area and should not extend past the cheek line unless the shot is intended as a profile portrait. Usually having the model rotate his or her head slightly to the left or right corrects the problem.

✦ If the ears are visible they should be either lit in such a way that they do not compete with the facial area for dominance, or the head positioned so that ears appear to lie flat against it.

Posing arms and hands

By paying attention to the hands and arms you can improve a good composition and complete a good pose. There are no right and wrong ways to handle hands and arms, just a series of tried-and-true practices that work in general. If you are working with a creative pose or an artistic portrait, the rules become more vague. In traditional portraiture, however, there are a variety of ways that arms and hands are usually handled inside a composition:

✦ Give the hands something to hold onto, even each other.

✦ Have the model lean his or her chin upon one hand.

✦ Have models rest their hands on the back of a chair or hold a prop such as a walking stick or something that indicates what they do for a hobby or a living.

✦ Have women models put one hand at the back or to the side of their neck.

✦ Arms and hands should be placed so that they do not interfere with the center of interest by creating their own. Specifically, do not put hands in such a way that they are over or near the groin, breast, or on one of the compositional power points.

✦ Unless you've planned them as part of your composition, ensure that the subject isn't wearing any unusual bracelets or rings that will distract the viewer's attention.

✦ When people are nervous they often tense up their muscles and limbs, especially their hands and fingers, so check to make sure that your model's hands appear relaxed.

✦ Make sure that arms and hands lead back into the portrait and towards the center of interest and do not fall out of the frame.

✦ If you are showing hands you often have to adjust lighting, particularly if the clothing or background is dark, so that the hands do not present an unnaturally bright spot on an otherwise dark portrait.

✦ Hands look better when photographed from the sides and when the hand has some tension (is holding something, making a slight fist, or even pressed against a knee, and so on).

Tip A common technique for an upper body pose is to frame the model in what is sometimes called a "triangular pose." Models fold their arms in front of their body and turn it slightly toward the camera. The lines created by the crossed arms lead to the head, which presents a pleasing triangular shape to the viewer.

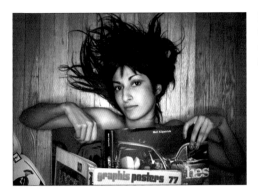

Figure 5-12: Sometimes the best thing to do with hands is to give them something to do or hold.

© *Istoica.com*

Posing feet and legs

If you're shooting full length portraits the model's feet should be positioned at normal standing distance with one foot slightly closer to the camera. The closer foot should be angled slightly away from the other foot, which "anchors" the model and gives the portrait a balanced feel.

Legs are not often in portraits and hardly ever in traditional portraits, and the feet even less so, but they are a part of most fashion and environmental portraits and a great number of casual portraits. Here are some tips for dealing with them:

✦ Bare feet can be fun! They add a bit of natural *joie de vivre* to the portrait and make the model seem friendly and approachable. If you do use bare feet, make sure the subject's toes are relaxed and not curled up or tense-looking. As with hands, you may have to adjust lighting so that bare feet do not scream for compositional attention in a dark background.

✦ Make sure your models' shoes are a good match for the rest of their clothing and are clean and polished, if appropriate. Don't be shy about polishing up the tips of a pair of shoes.

✦ When photographing women, make sure that you have planned in advance whether they want legs included in the portrait and whether or not they will be covered. If the leg is to be shown and uncovered, make sure that your lighting is set so that the leg, which will likely be lighter in color than the face and arms, does not present a compositional problem.

✦ Having each leg doing a different thing can create a good secondary center of interest in a portrait. Consider crossing them or placing one in front of the other.

Posing Couples

Many couples want a portrait for the simple reason that it makes them happy to have a picture of them together, for the times that they are apart. There are so many reasons why couples choose to hire a portrait photographer that I'd need a psychologist and a historian to explain it. Relationships are arguably the most important elements in our lives, and we like to not only remember them at their various stages but also celebrate them. See Figure 5-13.

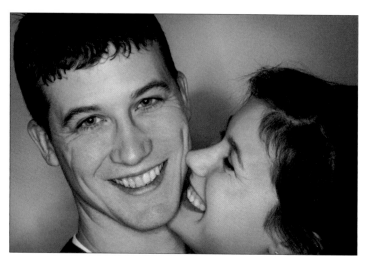

Figure 5-13: Couples like to celebrate themselves as a unit and are often much more open and self-confident when posing together. Take advantage of this to capture moments of genuine affection.
© Istoica.com

A couple portrait is, for the most part, a celebration of an important relationship, and it will be important to your clients that you capture them well. Most couples want to frame and hang or otherwise display their portrait, usually in a prominent place in their home. They've often purchased new clothing and had haircuts, and many women have their makeup and hair done professionally for their couple portrait.

Tip Couples need to be extra careful about clothing choices to ensure that your composition and posing plan is not stymied by pants that clash or shirts that melt into one another. What each person in the couple wears, in general, should be decided at the initial meeting; or, at least, you should advise the couple what will work best for their portrait. One of the most common mistakes made is that people try to dress up in a type or style of clothing that they normally do not wear or make poor choices as to what is a good portrait outfit and what is not. As a professional, you need to be able to advise them.

Posing couples presents several unique situations and is especially rewarding because the models are usually very cooperative and enthusiastic. Here are a few hints for posing couples:

✦ Both people must be comfortable in the pose and composition you've chosen. The point of a couple portrait is to illustrate a synchronicity between two people, and the pose you select must suit each of them.

✦ Generally speaking the larger of the two people should appear to be slightly behind the smaller. This is not always the case, but it is a good starting point.

✦ Poses where the couples are not facing each other can still appear intimate if you have the couple lean back against each other.

✦ Poses where the couple are engaged with each other, facing each other or making faces at each other, convey a great sense of familiarity and intimacy, as shown in Figure 5-14.

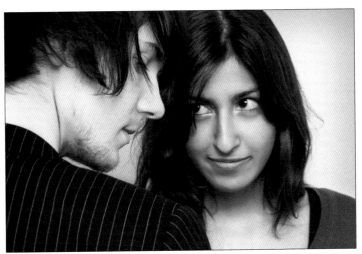

Figure 5-14: When couples face each other they appear more familiar and intimate, leading to the sense of the viewer being excluded from a private moment which, in fact, helps make the portrait more appealing.
© Istoica.com

✦ Poses where the couple is facing in the same direction, either towards the camera or off into the distance, creates a sense of equality and balance—a calm and peaceful relationship.

✦ If posed together so the majority of their bodies are touching, the couple should be treated like a single compositional element; and if they are posed so that most of their bodies are not touching or one body is posed in a different direction than the other, the Rule of Thirds should be carefully followed when placing the models.

✦ Couples often look great together against a completely negative background space (light or dark) and with props such as a single chair (one sits in it and the other leans on the back on sits on the arm) or a shared umbrella.

The Reclining Pose

Love and romance are the natural themes in couple photography. Couples often want photographs which are alluring, provocative, and even erotic—but with no trace of being pornographic. It won't surprise you then to know that many individuals, men and women, also want romantic and provocative poses.

A reclining pose is often the right one for this specific sort of request. For couples, the physical closeness of the man and woman in a reclining position conveys that they have an intimate relationship. The subject is not simply the two people, but their relationship as well.

Reclining poses are almost never shot from a "looking down" perspective, and so the camera and lighting are typically set quite low to the ground. In these portraits the pose is of particular importance; it should be as "curvy" as possible and be placed either along the bottom line created by the Rule of Thirds grid or along the diagonal, with the feet at the bottom, as shown in this photo.

Whether the model is a single or a couple, it is very important that you watch their faces closely and help them ease into natural expressions. Generally one of two things happens during a reclining pose. In the first case, the model(s) have very uncomfortable "you caught me" expressions on their faces, which is almost always inappropriate. In the second case the model(s) adopt very obvious "come hither" faces, which is equally inappropriate.

Make sure the position and pose are comfortable, that the surface your models are reclining on is comfortable, and that they are relaxed enough to be natural. Sometimes all you need to do is keep up a steady stream of conversation and get them to talk about something they are interested in, which will animate their features.

As is common in portrait work, what works best for retail work with couples and individuals is often different from what works best with commercial or creative work, such as the portrait shown here. In this case, there is a deliberate attempt at a dramatic composition and each of the expressions, props, and poses is carefully contrived to be evocative and narrative in nature. The from-the-top perspective creates a tableau view which tends to cause the viewer to examine all of the elements in the portrait, including props and background, for meaning and context. Although other reclining pose examples in the book show models in more natural states and from more traditional points of view, this example provides an excellent primer for creating narrative scenes such as those required for work in the music or publishing industries.

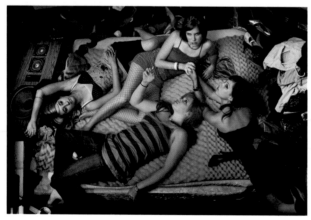

© lstoica.com

Working with Professional Models

Models who have booked a portfolio shoot should be instructed to bring the following items with them:

✦ Enough tops and bottoms for six to eight different looks. Clothes should be clean and pressed. This should include a white blouse and a black pair of pants or a simple black skirt. Clothes should be solid-colored and not too shiny or coarse in texture.

✦ One pair of jeans or casual pants, with jeans being preferred.

✦ One or two swimsuits — should be one piece with high-cut legs.

✦ One business suit or formal outfit.

✦ Proper accessories and shoes for each outfit.

Additionally, models should be advised of the following:

✦ To get plenty of sleep the night before the shoot — bags under eyes and a tired mouth detracts from the portraits.

✦ Hair should be cleaned and conditioned and simply styled — you may have to allow time in between poses for hairstyle changes.

✦ Makeup should not be applied before arriving except for a base coat and/or concealer. Makeup can be applied after the model is dressed.

✦ Poses that the models think work best for them or that best suits the sort of work to which they aspire should be practiced at home in front of a mirror. This gives you and the models a starting point.

Posing Children, Families, and Small Groups

Children and families are very fun to work with and can be quite the challenge as well.

For young children consider getting your camera down to their eye level. It puts them into a more familiar and personal perspective, and more of their personality can be seen in the portrait — the viewer is looking at them instead of down on them. Posing options for young children are quite varied but they should be appropriate for the personality of the child and expressive of his or her individual character. A little boy who talks a mile a minute and can tell you how gravity works could be photographed in front of a planetary poster or playing with a celestial mobile. The young lady who wears her mother's pearls and has a bed full of stuffed animals could bring a few to the portrait session — and maybe even the pearls!

Tip Don't ask children to say "Cheese." Instead, ask them to sing "Old Macdonald Had a Farm," "Row Row Row Your Boat," or "Itsy Bitsy Spider." Kids will know the words and usually respond well. You will get a portrait with natural, happy body language and more-appealing facial expressions.

Here are a few tips for working with children:

✦ For a dramatic look, dress all the children or a group of children in white and use the white background. For a casual look, try denim shirts or plain t-shirts in a primary color. Provide continuity by selecting a color common to all the outfits and use that color for the background.

✦ Hair clips or ribbons should be small and subtle unless you are using them as props or costumes.

✦ Young children usually don't mind having their picture taken, but they don't like to look directly at the camera. Have a parent stand behind the camera and (when you're ready to shoot) make a noise, squeeze a toy, make faces, or just mention a funny word or phrase.

✦ Teenagers can be difficult and moody to work with, and many are there because one or more parents insisted. They often rebel to this insistence by not smiling. In that case I usually make a joke about it, which usually causes, at least, a grudging smile. In any case, capturing the unique moodiness of a teenager can be accomplished with a slightly forward-leaning pose, which is "cool" and casual in appearance.

✦ Another common challenge is brothers and sisters. When posed together, they often react by arguing, teasing, pushing each other, or making faces at each other. Ask them to look at each other and try and capture a moment that is more charming and cute than argumentative and mean. If they stick their tongues out at each other, shoot it. If they're having fun, you'll get a much better picture as shown in Figure 5-15.

✦ Use what is sometimes called a "toboggan" pose where siblings straddle a bench, one behind the other, as if they were sitting on a toboggan. Keep their shoulders facing the camera, their heads turned toward you, and their hands down on their legs.

✦ Taking children's portraits while they are engaged in an activity they enjoy usually produces a more appealing and animated portrait.

✦ With children, sometimes it is simply a matter of waiting for the right moment rather than trying to force it. Children, being natural mimics, will often "pose" in appealing and interesting ways all on their own, as shown in Figure 5-16.

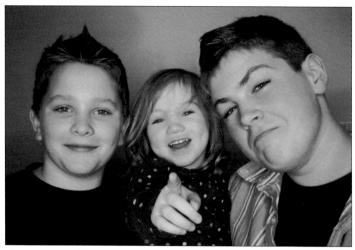

Figure 5-15: Siblings or other small groups can be arranged in a great variety of configurations, but a good rule of thumb to remember is to ensure that the heads are not all at the same level but are arranged in a pleasing, uneven line.
© Istoica.com

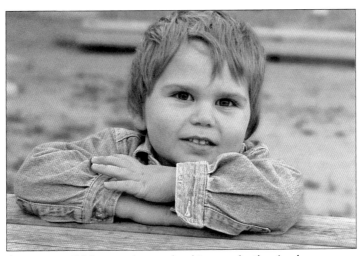

Figure 5-16: Children can be very hard to pose for the simple reason that they don't have the patience for a lot of subtle instruction. Sometimes the thing to do is to wait until they position themselves and be ready for them.
© *Brenda Anderson*

Tip
If a child just doesn't want his or her photo taken or is in a bad mood, get the parents involved. Have a parent sit in a chair and see if the child (if young enough) will sit on his or her lap while you take a sample picture. Sometimes the child will be willing to sit in the same chair without the parent.

Tip
Try using a symmetrical shape when posing small groups. An inverted triangle with one person in the front middle, two or three people in a second row, and three or four people in a third row (and so on). If the people are spaced evenly and given equal prominence, the portrait will look balanced and have an interesting graphic appeal. When posing groups in any configuration, everyone should be looking at the same place.

Posing Families for Narrative Effect

Body language is not just for individuals; groups have a collective body language all their own:

✦ Family members touching each other or overlapping shoulders tells the viewer that the family is close and connected.

✦ Placing senior members in the middle of a family grouping indicates protectiveness and respect.

✦ A couple's torsos turned to face each other shows a sense of intimacy and shared beliefs.

✦ Children placed between the adults indicates protectiveness, responsibility, and love.

✦ Hands placed on shoulders are a sign of closeness and familiarity and is appropriate for parents and grown children.

Pet Portraits

Patience is the most important element in a good pet portrait. Here are some simple yet effective suggestions that I've found can give the best results:

✦ As with children, take the photos on the animal's level, as in Figure 5-17.

✦ Don't make pets come to you or try and get them to pose. Instead, go to where they are most comfortable and wait for them to get comfortable with you. This is especially important for full body shots, which look best from the side rather than above.

✦ Have favorite treats or toys at the ready. Hold the toys up near the camera to catch the pet's interest in the right direction. Most importantly, don't be afraid to be silly. Dogs seem to like to watch human beings do silly things.

✦ Cameras can be distracting for some animals, so if you cannot get the animal to behave normally, try having someone else whom they know and trust divert their attention.

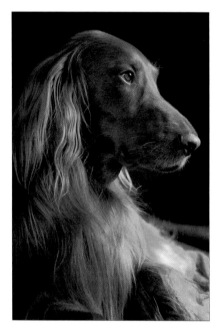

Figure 5-17: Pets almost always need the cooperation of the owner to photograph effectively. As with children, your best assets are patience and perseverance.
© *Jeff Farmer*

✦ ✦ ✦

6 The Director's Chair

© Istoica.com

Oh yes, indeed! You're a director.

Up to this point, you've got your camera and basic lighting setup, found a model, planned a composition, and have some really excellent posing ideas. That's the "Lights! Camera!" portion. Now it's time to sit in the director's chair and yell, "Action!" What's left of the portrait process is finalizing the pose by inches and degrees, adjusting the lighting for it (usually in the same way), and pressing the shutter button.

This means customizing your approach for the individual model(s) sitting in front of you. And thankfully, the world is not full of homogenous people. There are tall and short people, wide and narrow people, lumpy and smooth people—in other words, people with every physical characteristic you can imagine. Not surprisingly, there are more ordinary folks whose features and attributes are gathered together in a pleasing but not spectacular way than people who are supermodel beautiful.

I wouldn't quite go so far as to say that anyone with a decent camera and lighting can get an acceptable photograph of a beautiful person, because that's not true. However, it *is* true that the chances for an acceptable photograph increase substantially with the increased photogenic quality of the subject. But we know that the world is not full of those people and that many of the ordinary variety will want a portrait. Your skill as a portrait photographer is needed here. You need to be able to handle the issues that most of us have, such as too much weight or weight unevenly distributed; a receding hairline; large, crooked, or oddly shaped noses; ears that stick out; double chins; bad skin; or any of the other characteristics common to the human form. You can't send anyone back to the drawing table for reinvention, so it is up to you to minimize any unflattering characteristics and maximize the flattering aspects of the subject.

Challenges are not always negative in nature, of course, and come in such a variety of forms that it's safe to say there is no perfect model. Point is, everyone (everyone) has at least one *photographic* challenge for you to manage, whether it's fifteen beautiful face piercings, seven feet of glorious height, or a face full of gorgeous freckles. See Figure 6-1.

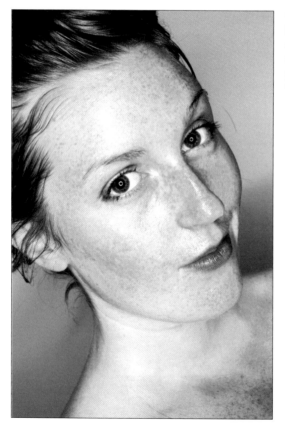

Figure 6-1: What might be a challenge photographically is not necessarily negative in any way at all. Among the difficult things to deal with are freckles, five o'clock shadow, and very short hair. These things are not problems, but they can be challenges.
© *Istoica.com*

Using Enhancing Techniques

Every portrait idea needs considered posing and/or lighting in order to best enhance your subject. Whether you have the world's largest nose to contend with or the world's most beautiful human being sitting in front of you, you still need to pose and light your subjects to best advantage. I have a friend, in fact, who thinks it is much harder to photograph the really beautiful people than anyone else.

Challenges are met with composition, of course, but most will be met with posing, lighting, and camera point of view (POV) decisions.

A portrait, from this point onward, can in fact be reduced to a simple set of three instructions:

 1. Put the model into the pose.

 2. Put the lighting into place.

 3. Make the correct adjustments to (1) and (2), check your camera and exposure settings and take the picture.

Naturally, I'm going to start at the beginning with putting the model into the pose.

The Classic Poses

Because I will be referring to these poses for the corrective techniques outlined later in the chapter, now's a good time to recap the posing techniques discussed in Chapter 5 and identify them by a common name for easy reference:

✦ **Three-quarter.** The most commonly used pose in portraiture, the three-quarter pose allows for pleasing shoulder angles and a natural incline to the head as the model turns to look at the camera (see Figure 6-2). The basic lighting setup described in Chapter 3 is designed for a three-quarter pose. Most poses where the model's body is angled away from the camera are referred to as "three-quarter" even if the angle is more like two-thirds or one-quarter.

✦ **Straight or square.** This pose places the model standing square at the camera. A great many artistic and creative portraits use this pose, and when it is lit properly (fairly evenly on both sides) it can be both pleasing and a great opportunity to break some rules (putting a model in the center of the frame, for example). The straight or front-facing pose is becoming increasingly popular in fashion and art photography.

✦ **Silhouette or profile.** As shown in Figure 6-3, the model is turned sideways so that only one eye is visible and the profile is clearly visible against the background.

Tip

If you pose your model in a straight-ahead position for a profile portrait, only the whites of the eyes will be seen. If you want to avoid this, have your models turn their eyes slightly toward the camera without turning their head or repositioning their neck or shoulders. This will show enough of the iris so that the eye is recognizable and does not present as a distracting white spot. Additionally, for profile shots, tip the model's head back or raise the chin slightly to provide a clean line between the chin and the shoulder.

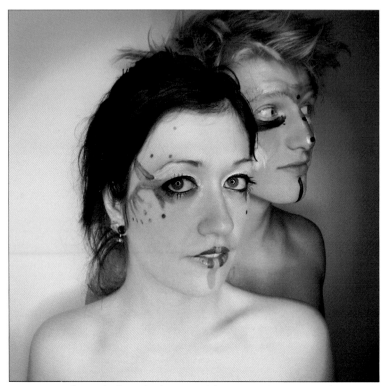

Figure 6-2: The male figure in the rear of the composition is standing in a three-quarter pose, and the female figure in the front is standing in a straight or square pose.
© Istoica.com

A Little Posing History

Although the profile portrait was the most common style in Florence for most of the fifteenth century, artists in Flanders had been painting portraits where the model was turned in three-quarter view since the early 1400s. Finally, in the late 1400s, both Botticelli and da Vinci introduced the three-quarter pose into their portraits. The traditional profile portrait tended to create flat and lifeless expressions, making the viewer feel very distant and detached from the portrait due to the lack of eye contact or potential for eye contact. The three-quarter pose allows the subject to look out of the portrait directly at the viewer, who as a result feels more connected to the portrait.

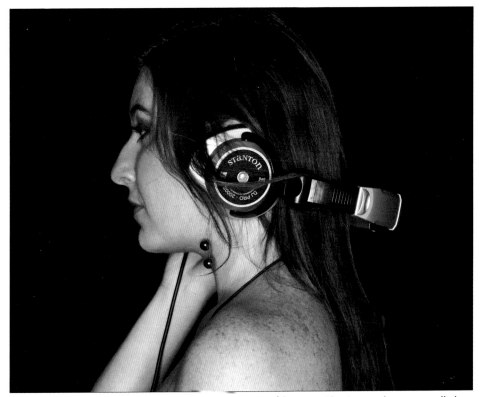

Figure 6-3: Silhouette poses show the model from a side or profile view and are generally best against a darker background.
© *Istoica.com*

Those are the classic poses, the ones that you will use most for traditional and commercial work and that will cover all headshots and most upper or partial body shots.

Cross-Reference Chapter 5 discusses what can be done with hair, hands, arms, and other compositional elements.

At this stage, you should be standing more or less where you will be standing when you take the picture, and the lighting and model should be positioned where you expect they will work best for the contemplated composition and pose. If your planned pose is to show a model wrapped inside a hundred feet of red ribbon, sitting in a knees-to-chest pose in the corner of a dark room, he or she should be wrapped up in the corner right about now. You can't perform these poses or plan them to the absolute accuracy required in advance, so there is a necessary period of waiting while you adjust your lighting, the model, and your camera, if necessary.

Tip

While you make any last minute adjustments, keep your models engaged in the process. Explain what you are doing or keep up a light chatter while you work. Better yet, get your models to tell you some things about themselves while you work. People tend to be animated and lively when telling you things that interest them, and their facial expressions are open and warm. Even the level of usual underlying tension apparent in their eyes and around their mouth diminishes if you can get them engaged in a conversation where they do most of the talking.

The Classic Lighting Styles

If you were to attend a portrait seminar, you'd start with the lighting in a three-quarter position and the model in a three-quarter, short-light position. In order to employ enhancing and corrective techniques you need to have a starting point or a benchmark. Most things you can do to alter a standard portrait scenario are defined as "higher" or "lower," or "more" or "less," so it is quite critical to know what "higher" means in this context.

Lighting ratios

As you know, when using multiple lights, you have a *main,* or key, light and a *fill* light. You measure the difference between these two lights using something called a *light ratio.* The lighting ratio for portraits should usually start at about 2:1 (two parts main light, 1 part fill light — in other words, the main light should be two times the intensity of the fill light). However, photographers often use the ratios 3:1, 4:1, and 3:2.

A mistake sometimes made by photographers who use strobe or flash lighting is called *cross lighting,* and it can frustrate your best efforts to control the way your portrait turns out. Typically, portrait lighting involves one main or key light off to the side (usually at an angle of 45 degrees) that shapes the model's features and helps you bring the character of his or her face to the forefront. Once the main light is in place, you typically add a fill light to modulate the shadows. If you place a second light in the same position on the opposite side of the camera and at the same power or strength, you now have two main lights that will compete with each other. Opposing (weak and muddy) highlights and shadows will occur and the face may even look distorted. Ensure that your main light and your fill light are not of equal strength.

Keep your distance

The distance between the and the subject plays a major role in how it affects the final portrait. Not only does it affect the settings the camera should have, but it affects the overall appearance of the model. Light that is too close, for example, creates too many highlights or *blown-out* spots (spots which appear as white with a complete loss of texture), and light that is too far away create an unclear or muddy-looking portrait with indistinct features.

✦ **Main light.** This light should be about 4 feet from the subject and about 2 feet above the model's eye level. This generates catchlights in either the one o'clock or the eleven o'clock position, which is the right place for them to be. See Figure 6-4.

✦ **Fill light.** Set the fill light about the same distance from the subject either at the same height or slightly lower than the main light.

✦ **Backlight.** If you use a backlight, it should be much lower to the ground than the other lights and much closer to the background by about half the distance.

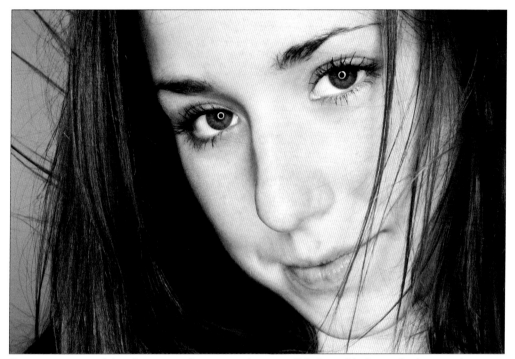

Figure 6-4: Determining the correct distance to place your light is a critical stage in the portrait process. Among other things, correct distance puts eye catchlights where they should be.
© Istoica.com

Due to the remarkable range of face shapes and structures (and poses), almost every sitting requires that you alter the light's distance from the model. All lighting tests should be performed with the model sitting in a square or straight pose and looking directly at the camera.

A good way to test the best distance for your specific model and pose is to start at the standard position with your model and lighting, taking note of the highlight that the main light casts on the model's forehead, and follow these steps:

✦ If you move the light closer to the model, the highlight spreads into a larger, flatter area and begins to wash out into a "blown out" spot. If you move closer the whole forehead is blown out by the light.

✦ If you move the main light away from the subject you reach a point where the highlight on the forehead becomes quite small and bright, like a pinpoint. If you move farther away the light begins to fade.

✦ Between the point where the highlight starts to blow out and where it starts to disappear lies the range where the highlight is pleasing and appealing, not distracting and distorting. Once you have found the distance where the main light gives the desired effect, the distance should remain the same, regardless of the direction you need to move the light. I discuss it further in Chapter 9, but many photographers (myself included) will mark the closest and farthest points where the main light should be placed on the floor marked with a piece of tape to make the rest of the distance calculations easier.

Tip I use the same basic guidelines for placing lighting whether I am using strobe or continuous light sources. If strobe (flash) lighting is used with a diffusing umbrella, as suggested, these settings will be the same. If you are using strobe lighting without diffusion you may find the light sources are a little too close or a little too far away, depending upon the power of your strobe lighting and you will have to experiment. However, I recommend starting the experimentation from the same place as one would start with continuous lighting.

Vertical position

Light is also designated by its vertical relationship to the model's face. North or south, so to speak.

✦ **High lighting.** Typically more than two feet above the subject's eyes, and, in order to reach the face of the model, set at an angle more severe than 45 degrees.

✦ **Medium or normal lighting.** Typically about two feet above the subject's eyes so that when aimed at the model's face it is at about a 45-degree downward angle.

✦ **Low lighting.** Anything lower than 2 feet above the model's eyes and resulting in having to set the light at a less severe angle, at a 0-degree angle (straight on), or at a negative angle (facing upwards).

As with the distance calculation earlier, the vertical positioning of your lighting is very feature- and pose-dependent and needs to be adjusted for each sitting:

✦ Move the light directly in front of the subject while maintaining the distance calculated in the previous distance exercise.

✦ Raise or lower the height of the light until the shadow cast by the nose is just long enough to touch the top edge of the upper lip.

Tip The sharpness or "in-focus" quality is very important for a portrait. For best results, focus on the triangle the eyes and mouth create. If you are shooting a near-profile shot, either three-quarter or straight-on, both eyes of the photographed person should be in clear focus. If they are not, it is best not to alter the model's pose. Simply change the angle of the camera slightly with the tilt/pan function on your tripod.

Horizontal Position

The horizontal position refers to where the light sits in relationship to the model's face along the horizontal plane. East or west, so to speak.

✦ **Three-quarter lighting.** The standard or traditional setup. So called because of the 45-degree angle at which the light hits the model, it is used for both short and broad lighting setups. The difference between the two is the direction the model is facing, not the setup of the lighting. See Figure 4-19, in Chapter 4, for an example. In short lighting the main light is on the side of the model that is not facing the camera (or the "short" side of the model's face), and in broad lighting the main light is on the side of the model that is closest or facing the camera (or the "broad" side of the model's face).

✦ **Side lighting.** When the main or key light is more to the side than the front or the back of the model.

✦ **Front lighting.** Sometimes called *butterfly lighting*, this is when the lighting is directly in front of the model. It is often employed for glamour or artistic shots, as shown in Figure 6-5.

✦ **Backlighting.** Sometimes referred to as *rim lighting*, backlighting is when the main or key light is either directed at a surface behind the model or at the model from behind. Backlighting is usually aimed upwards. Sometimes backlighting is applied, usually from above, to the very edge (or "rim") of the model's head (top-back) or to set the model apart from the background.

To determine the horizontal placement of the main or key light that, as in the previous two steps, needs to be adjusted for each sitting, perform these steps:

✦ Move the main light in an arc so that it always maintains its relative distance and height from the model, to the right or left, around the subject.

✦ The shadow cast by the model's nose is the key indicator to deciding upon main light direction. Move the light around, until the shadow cast by the nose merges with the cheek shadow and leaves a small, triangular highlight on the cheek. When this is done, the main light is in position.

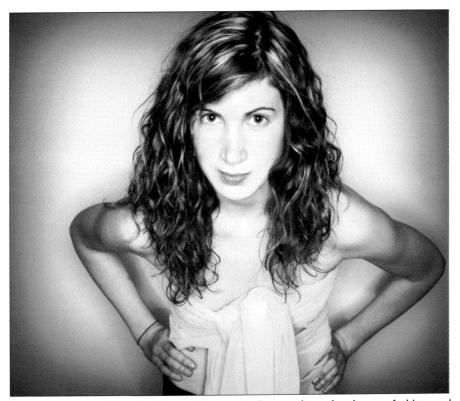

Figure 6-5: Front or butterfly lighting is the most often used type for glamour, fashion, and artistic portraits and usually the best one to use for front or square poses. It is typically the right lighting for very high or strong cheekbones.

© Istoica.com

Hair Lights

After the main, fill, and background lighting (if any is used) is organized and decided upon, additional lighting can be added to the setup to improve the overall composition or enhance the pose. One such light is called a *hair light*. This is usually a small lighting unit that is placed on a boom or other overhead device so that it shines down from above and behind the subject, opposite from the main light.

Used to lighten and highlight the hair and shoulders and distinguish the subject from the background, the hair light varies drastically because it is dictated not just by the color of the model's hair but also by its shininess. If the model's hair is very naturally shiny, you have to reduce your hair light or you will end up with a "gleam" or "glint" instead of a pleasant shine.

A hair light should be used from a distance of 6 to 8 feet and from a position near the center of the composition area. It is important with hair lights that you pay attention to any light spill onto the forehead or tip of the nose and avoid it where possible. Because spill can be a problem with hair lights they normally have a snoot attached so that light from them does not interfere with the camera. As a caution, it's wise to turn off your hair lights when taking exposure readings.

The Common Challenges

At this stage, in a perfect world, you'd stand back behind the camera and take the photograph. But what you really have to do is step back behind the camera, survey the scene, and figure out what needs adjusting. And something always needs adjusting, trust me.

Remember that you're acting in a professional role. Much like how a doctor would not be shy about asking you to undress, a photographer must be able to deal professionally with issues that affect the portrait. As recommended in Chapter 5, a straight-on but tactful approach with clients is usually the best course of action. I keep a full-length mirror in the studio and usually suggest that models take "one last quick look." I take this time to look with them, much like a salesperson at an high-end clothing store would do, and make any minor hair, clothing, or makeup adjustment suggestions that I think are necessary.

If you do not take the time now to address any issues you feel need addressing, both you and your client will be unhappy when the portraits are finished. Like the salesperson whose job it is to make sure you do not walk out of the store with an ill-fitting or unsuitable dress or suit, it's your job to make sure your clients get a portrait that works for them.

Tip Using a stool or bench — or anything with a hard surface and no back — makes models sit up straighter and present better posture, particularly noticeable in the shoulder area. When sitting in a chair, models tend to slouch and round their shoulders inward. To prevent slouching, ask models to arch their back because saying "sit up straight" often causes them to lean back instead of straighten their back.

The most effective approach to challenges such as a heavier model or a large nose is to plan a composition which auto-corrects any issues you and the model feel are important so that you are not left to make a lot of minute lighting and posing changes. If your model has an exceedingly large nose, for example, the chances are very high that they know this already. Discussing it with him or her seems silly. It's your job to simply plan a composition and pose that displays the model in the best way, and taking the nose into consideration is simply part of the process — like gender, hair color, and skin tone.

Caution Keep in mind that corrective posing methods generally look less natural than a standard pose and lighting setup. Corrective poses are usually slightly unnatural (no one goes around with their chin slightly extended, for example) and usually can't be held comfortably for very long.

Costumes, props, and special lighting scenarios can be devised to best present the model, and with a little careful planning, you will not have to do a lot of finicky adjustments at the last minute. You always have to do some adjusting, of course—that's the nature of the business.

Plus-size models

It's important to remember that people come in all sizes and "normal" weight varies from person to person. It's also important to remember that people's aesthetic tastes run the gamut from waiflike to voluptuous. Therefore, do not presume that someone's weight is a problem for them or that it will be a problem for anyone else—whatever your personal tastes. There is, in fact, a fairly substantial market for larger-than-average models, both male and female, and you can expect to encounter people of all sizes and shapes.

I have a good friend who is a plus-size model, earns a pretty healthy income, and has a "Big is Beautiful" mentality that is, at the least, infectious. Like the model shown in Figure 6-6, not only is she happy with herself, she expects you to be as well.

Figure 6-6: Devising compositions and poses to best enhance a model's best features is a critical part of the portrait business. A well-planned composition makes your job much easier when it comes to the lighting and final posing.
© Istoica.com

Waists

Waist problems range from "I can't fit into my size 2 anymore and had to buy a size 5 today!" to "There's nothing big enough at the store!" To further confuse things, the first statement is often uttered in horror, and the last one can easily be delivered with a little mirth. In other words, you can never tell how sensitive people will or won't be to weight issues, particularly this one.

The best way to slim the waistline, from a posing perspective, is by rotating it toward the darker (fill-light side) side of the frame. This presents a side view of the waist that is, depending upon the size of the waist, generally more slimming that a square or broad view. Lower light also decreases the appearance of size or bulk in the waist area.

If the waistline is very large, you could consider not showing it in the portrait at all. There are a variety of ways to manage this challenge:

✦ You can do a headshot or an upper body shot.

✦ Use a pose where the body is turned away from the camera and the head turned back toward it.

✦ Use a pose where one of the subject's appendages is placed in front of the midsection. Bring up one knee (or both knees) and have the model rest one elbow top of it. This sometimes requires a slightly lower camera position.

✦ In a standing pose, you can have models fold their arms over their chest. When doing this make sure the crossed arms are loose and casual and not tight and aggressive in appearance.

✦ In a reclining pose, have the model lay on one side and bring the top arm across the problem area.

Tip Sometimes the answer is not a corrective pose, but a change in equipment. If you are having trouble with a long nose, for example, a good solution is to use a longer lens such as something in the 135mm range (or equivalent with your camera's crop factor as discussed in Chapter 2). With good lighting and a full frontal POV, you can flatten the aspect — the nose will appear smaller.

Hips and thighs

Although you may run into some men who find these areas to be problematic, you will mostly be dealing with women in connection with corrective posing for these two areas. To slim the hip or thigh area, you can do several things:

✦ Coordinate the color of the model's clothing to that of the background so this area blends into the background. With this method you should not use rim or backlighting, and you should take special care that your standard lighting does not create a separation of model and background.

✦ Place models in a seated position and have them put most of their weight on, or lean into, the hip that is closest to the camera. Buttocks, thighs, and a portion of the hip will "roll" behind them and be out of camera view.

✦ Have models place their arm along (and slightly in front of) the upper hip.

✦ Have models pose in a reclining or semi-reclining position and use a shallow DOF to have only their face and upper body in focus. This is most suitable for a creative or artistic portrait.

Caution If you have a model with very wide or large hips or thighs, the worst pose to use is to seat him or her in a flat or square position. A seated pose makes the hips and thighs even look wider.

Getting Clear Focus

As discussed in Chapter 2, depth of field is the range of distances within which the model is rendered acceptably focused and sharp in the photographic image. In other words, the area where you can put the model and still focus clearly. One of the best ways to make a clearly focused image as well as employ corrective measures camera-side is with the use of aperture settings to affect the depth of field.

A shallow depth of field occurs when only a small portion of the image is in focus. Typically this is achieved by using the smallest f-stop number available on the lens. Using the highest f-stop enables you to achieve a fully focused scene within the lens's focal range.

As shown in the figure below, if you set your model in the middle of the focal range (between where you can begin to achieve proper focus and the background) and set your aperture to its widest opening, which is the lowest f-stop number (f/4 in the case of the example), you would only be able to focus clearly on half the model. The other half of the model and the balloons in the background would be quite a blur.

If you set your aperture about midrange, in this case f/8.0, you would be able to focus on all or most of the model, depending upon the pose and POV, but the balloons in the background would be a blur.

If you set your aperture to it narrowest setting (highest f-stop number), in this case f/22, you would be able to focus on all of the model as well as all of the background and, depending upon the lens you were using, quite a bit beyond the background as well.

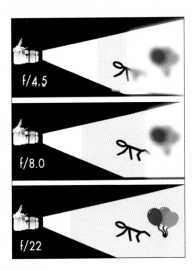

Shine, Gleam, and Glitter

There are some photographers what would tell you that the difference between a professional portrait and an amateur one is the lighting. In fact, this would be a fairly common notion amongst professionals. What they generally mean when they say this is that the lighting has been controlled well enough so that there are no *blow-outs*. Blow-outs are white or bright areas on a photograph that are devoid of texture.

You create blow-outs when the lighting is either too close or powerful, as discussed previously in "Keep Your Distance," or it is directed in such a way that is causes *hot spots* (small areas of blow out) because of some characteristic of the composition, pose, or model. The most common culprits (and the ways in which you can deal with them) for creating unwanted shine, glitter and gleam are listed below.

Heads

Baldness, receding hairlines, and high hairlines often require a two-phase solution. The problem that baldness creates is that it acts like another reflective light source. This diverts attention to the top of the head instead of at the face. This particular challenge has a range of solutions:

✦ Lower the camera so that the angle is more "dead on" than "downwards."

✦ Do not use a hair light.

✦ If the problem is primarily top baldness, use a standard pose.

✦ Have the model adopt a more chin-out than chin-in pose.

Glasses

If a model normally wears glasses, they should be left on for the portrait because glasses are a large part of how the person is identified by the people that know him or her. The problem that glasses create, of course, is reflective glare.

✦ Use standard three-quarter or side lighting to eliminate shadows.

✦ Raise temple piece (ear piece) up slightly to angle the front of the glasses downward.

✦ Use full-face or a pose between three-quarter and full to prevent the lenses from splitting the cheek line.

✦ Use indirect diffused lighting if possible.

✦ Raise lighting higher than standard height (see Figure 6-7).

Noses, foreheads, and chins

Shiny noses, foreheads, and chins are something you encounter often, generally more with men than with women because women frequently wear make up to prevent shiny skin. Simply, the skin is an organ that secretes oil and it does so more on the nose, forehead, and chin than anywhere else on the body. This can cause glare as well as the appearance of uneven skin tone.

✦ Use a neutral or matte face powder (make sure you have disposable applicators and a high-quality loose powder, and that you don't "double dip") and dab the model's face where it is shiny.

✦ Spray the whole face very lightly with mineral water — this gives a uniform sheen to the face and you can light for an even skin tone.

✦ Raise the light and have the model tilt his or her head for a slightly chin-in presentation.

Tip　Shine and gleam are two of the areas where working in digital and having a digital darkroom available are huge bonuses. Without altering the quality or integrity of the portrait in any way you can easily and safely remove things like glint, gleam, shine, and even minor blown-out spots. See Chapter 11 for information on advanced image editing.

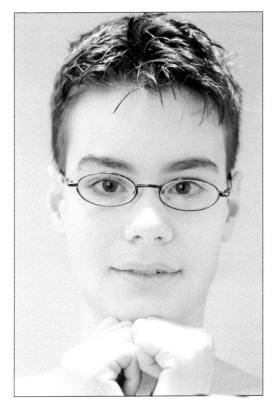

Figure 6-7: Glasses can be tricky to deal with, but if you raise your light slightly and watch for reflective glare, they won't be a distraction.
© *Stephen Strathdee*

All About Faces

The model's face is generally the center of interest and the most difficult area of the human body to "organize." It has many angles and curves, recesses, hollows, and ridges that cannot all be posed or adjusted. You can ask a person to smile, but you can't ask them to move their eyebrows or straighten their nose. Facial issues are generally handled with lighting and camera POV.

Smiles and teeth

The way the cheeks, teeth, lips, and even the nose lay on the face is affected by the type of smile on the model's face.

✦ A wide or big smile broadens the nose, creases the eye area, makes the eyes look smaller, and raises the cheeks.

✦ No smile can cause the chin and jowl area to sag, the cheeks to appear sunken in, and the eyes to seem lifeless.

✦ Smiles showing teeth are usually not appropriate because they cause a distortion of the facial features and often appear fake unless the person has been trained in one of the performance arts. Smiles are usually transient things — born in moments of happiness or glee. They're hard to

reproduce, and professional models work long and hard on their smiles, believe it or not. If you want a big, wide smile from your model, I strongly recommend you find a way to get one there naturally, as shown in Figure 6-8.

✦ If the model has bad teeth, simply do not have them smile.

✦ If a model has buckteeth, use a small smile and pose the model straight or square.

Tip When the planned portrait calls for a big smile, you need to shorten the shadow under the nose. When a mouth is in a smiling position, the upper lip moves upward and the shadow cast by the nose can extend over it, which is distracting, at best. The shadow under the nose should not extend over or touch the top edge of the lip. To shorten the shadow, move the light slightly closer to the face or lower it slightly from the standard height.

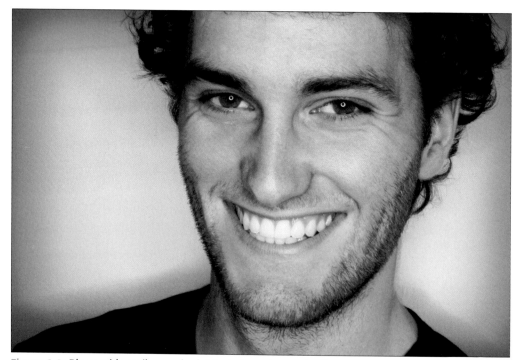

Figure 6-8: Big or wide smiles can look fake in formal portraits. To get a gorgeous, genuine result like this, you often have to create the smile. Talk with your models and get them animated and interested in the process; your portraits will be better for it.
© Istoica.com

Cheeks

Very beautiful, high, or contoured cheeks, which can exist on even a fuller or rounder face, can cause unwanted shadows or create a severe looking portrait.

✦ The best prevention for shadows created by cheek bones is to use forehead-level or slightly lower front or side lighting.

✦ Ensure the model keeps his or her face as level to the vertical plane as possible (the forehead and chin are both the same distance from the camera) — if any angle is used, it should be a chin-out pose.

✦ For very wide cheeks, those that extend wider than the temple area, a three-quarter pose should be used. Forehead-level or slightly lower front or side lighting is best.

Tip 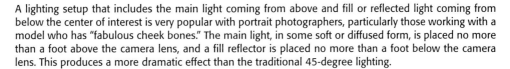 A lighting setup that includes the main light coming from above and fill or reflected light coming from below the center of interest is very popular with portrait photographers, particularly those working with a model who has "fabulous cheek bones." The main light, in some soft or diffused form, is placed no more than a foot above the camera lens, and a fill reflector is placed no more than a foot below the camera lens. This produces a more dramatic effect than the traditional 45-degree lighting.

Chin and neck

Chins and necks are two of the most common problem areas, particularly with women over forty and men over fifty.

✦ For a weak or receding chin, it is generally best to keep the chin in shadow. Have the model look at the camera. The main light should be higher than standard. Tilt the chin upward and use a high camera position.

✦ You can also have models rest their chin on their hand, arms, or shoulders, which obscures the neck from view, hiding a problematic chin or neck area. These poses can be very attractive as long as you ensure that the model does not appear awkward and is, indeed, comfortable in that pose.

✦ In most traditional poses, hands and arms are generally posed away from the face and neck area; and if you want to keep a more traditional pose and still hide a problem area, you have to stretch the loose skin or double chin to minimize it. In the case of only a slight double chin, this is accomplished by rotating the body slightly further away from the main light than normal and then having the model turn his or her face back toward the main light.

✦ If a problem chin area is very evident, you may have to resort to what some photographers refer to as the "turkey neck" pose. Have the model extend the chin out toward the camera, which elongates and tightens the skin along the chin area. Have the model lower his or her entire face, or raise your camera height to hide the double chin.

✦ A model's trick for handling slightly loose chin areas is to press the tongue against the roof of the mouth, which creates muscle tension (and a more taut appearance) under the chin.

✦ If the chin is very long, use a higher camera viewpoint.

✦ If the chin is narrow or pointed, such as can happen with a face that is heart shaped, tilt it upwards toward the camera for a very pleasing portrait. See Figure 6-9.

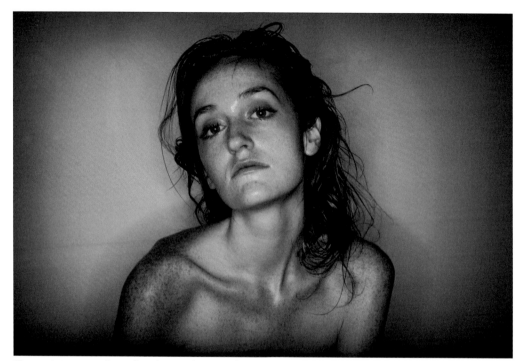

Figure 6-9: Heart-shaped and sometimes oval-shaped faces tend to have a smaller chin area. Having models tilt their chin upward helps keep the forehead and chin areas balanced.
© Istoica.com

- ✦ If the chin is very small or recedes, use a lower camera viewpoint and try a full frontal pose.
- ✦ For a very long neck, use a higher camera viewpoint and keep the neck in shadow by reducing or diffusing the fill light.
- ✦ For a short neck, use a lower camera viewpoint.

Ears

If the ears are large or stick out, pose so only one ear is visible and, if possible, place the exposed ear in a shadow. This is not an issue for children or the elderly, whose ears are an important part of their face's character and generally should not be hidden.

Eyes

Eyes, they say, are the windows to the soul (Figure 6-10). This may or may not be, but they are certainly the windows to a good portrait. In most cases the head or face of the model is the center of interest, and in most cases, the eyes are the natural and logical center of interest on the face. They're important, in other words.

Not surprisingly, they also present the widest array of potential challenges to the photographer:

✦ If the eyes are hooded in a distracting way, have the model tilt his or her chin slightly outward toward the camera. This elongates the face and makes the eyes seem wider.

✦ If the model has bags or dark circles under the eyes, use a light concealer stick (or powder makeup) to mask them and place the lighting in a frontal position.

✦ If the eyes are close together, use a three-quarter pose.

✦ For deep-set eyes, use a low camera viewpoint and frontal lighting to keep shadows out of the eyes.

✦ Eyes that are far apart or wide-set should be posed in the three-quarter pose.

✦ Very large or protruding eyes should be lit with short three-quarter lighting and lowered slightly (the model should be looking just under the camera lens).

✦ If the eyes are very small, use a three-quarter pose and short three-quarter lighting so they are in shadow.

✦ If eyes are uneven, turn the head to one side (between a three-quarter pose and a profile pose) so the natural perspective eliminates an uneven appearance.

Figure 6-10: If a model has a particularly lovely facial feature, such as this model's long lashes, using a wide aperture to create a shallow depth of field is an excellent way to accentuate it. Shallow DOF is also an excellent corrective technique.

© Istoica.com

Tip

Unless you are making a concept or art portrait, the eyes should always be clearly in focus, and all or some part of the iris should be visible unless the eyes are closed. If your models have very small pupils, their eyes may appear beady or "shifty." Have them close their eyes for a moment and open them again just before the photograph is taken. If your models have large pupils, they may appear to have a blank or lifeless stare. Have them look into a bright light for just a second or two before you take the photograph.

Face shape and texture

Face shapes come in every variety, of course, and facial textures can create all sorts of havoc for the portrait photographer. On the other hand, by lighting and positioning the face properly, your portrait will have that extra "finishing touch" that sets it apart as a professional endeavor rather than an amateur effort.

✦ If the face is very broad raise the camera position, use short three-quarter lighting, and turn the face to a three quarter position.

✦ If there are scars or birthmarks that the model does not want seen, you can keep them hidden on the shadowed side of face. Use short three-quarter lighting.

✦ If the face is very narrow, lower the main light and use broad three-quarter lighting.

✦ If the face is very round, shoot three-quarter view. Use short three-quarter or side lighting and raise the camera height slightly.

✦ For a square face, use a higher camera viewpoint.

✦ For a thin face, use a straight or a square pose and three-quarter or side lighting.

✦ For a very wrinkled face, use diffused lighting (soft-box is best), lower the main light, and use a three-quarter pose.

✦ Freckles are usually best "all lit up," with an even front light or standard lighting with a stronger fill light than usual. If your models do not like their freckles or want to diminish their effect, a yellow filter is often used for portrait work because it lightens the skin and blonde hair and softens freckles. Keep in mind when using filters, especially colored ones, that the effect is the same for the entire image.

✦ Five o'clock shadow is an issue for male models, but it depends a lot on your model. For some models, such as the one shown in Figure 6-11, the unshaved look is a component of the character of the portrait, but others (a corporate executive in a navy business suit and a red tie, for example) will not want a five o'clock shadow. The solution is model-dependant.

✦ Blemishes, moles, and other skin marks are best decided on a case-by-case basis after discussion with the model. Generally speaking it is best to light and pose as normal and deal with blemishes in post-processing.

Figure 6-11: Five o'clock shadow and very short hair can present difficulties for a portrait (two similar textures on separate parts of the head) and the best solution is usually to provide more "moody" lighting and aim for a casual style pose or composition such as shown here.

© Istoica.com

Forehead

The forehead occupies much of the facial area and is the largest "unbroken" space on the face with almost all men and most women. Therefore it can present compositional challenges. Luckily, these challenges are easily managed.

- ✦ For a wide forehead, use a high camera viewpoint.
- ✦ For a narrow forehead, use a low camera viewpoint and tilt the chin upwards.

Mouth

In a close-up, headshot, or partial body shot, the viewer's attention is usually given to the eyes first and then the mouth—and then usually travels back and forth between the two facial elements. This is particularly true for portraits of women, and so the line between mouth and eye must be clear and complementary.

- ✦ If the lips protrude, use a lower fill light to eliminate shadows under the lip.

- ✦ If the mouth or lips are narrow or thin, position the fill light high to cast shadows at the end of the lips.

- ✦ If the mouth is uneven or wide, pose the model in a three-quarter view.

Nose

Noses, being the most prominent aspect of our faces, are also one of the most difficult to manage. As a philosophy I tend not to "correct" anyone's nose, being quite pleased with the way we are all unique beings. However, I am just the photographer, and some models are very sensitive about their noses or even dislike them to some degree. If this is the case, there are a variety of corrective techniques for dealing with noses.

- ✦ If the nose is very angular or sharp, use a square or straight pose, reduce your main light strength, and increase your fill light strength.

- ✦ If the nose is broad, use a three-quarter pose with the head slightly more angled away from the camera. This creates a hybrid pose somewhere between a three-quarter pose and a profile pose.

- ✦ If the nose is crooked, shoot from the side to which it curves. Turn the head until the highlights on the ridge of the nose appear straight. Another approach is to lower the camera viewpoint and use strong front lighting and a straight or square pose.

- ✦ If the nose is long, tilt the model's chin upward and position the face directly toward lens in a straight or square pose. Lower the main light and camera position. Alternately, you can use short three-quarter or side lighting.

- ✦ If the nose is short, set the camera viewpoint slightly higher than normal and use front lighting.

You're Ready to Shoot

This concludes the classroom portion of the book, so to speak. You have your camera and lenses, an idea about composition and posing and, of course, an understanding of lighting. In the next section, I cover shooting in a variety of conditions from indoor, mixed-light scenarios to outside in the weather and then back to the studio. It's very likely that you will flip back through this section quite often to determine how to plan a composition, set a pose, or face a model challenge. At this time, I believe the best advice I can give you is . . . get out there and make some portraits! There is no teacher like experience, and it's my suggestion that you endeavor to plan and execute a training portrait session from some aspect of each of the chapters in the next section. Good luck and good shooting.

✦ ✦ ✦

Into Action: Creating Portraits

7 Outdoor Portraiture

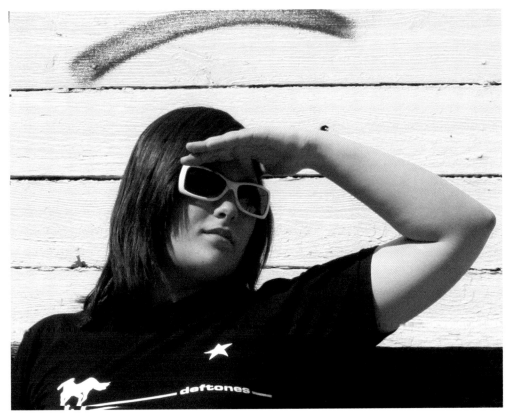

© Carolyn Primeau

There is a certain freedom of feeling in outdoor portraiture. It's an infectious feeling; the subject experiences it when posing, the viewer senses it when looking at the photograph, and the photographer feels it when making the portrait. It might well be that outdoor portraits seem the most natural to people even though, in fact, a lot of outdoor poses are the most contrived of all. For example, have you ever actually seen a young woman crawling up from the surf at the beach as they do in the *Sports Illustrated* swimsuit edition? Of course not. But it *seems* natural.

A great deal of fashion work, a growing amount of private portraiture work, and a lot of commercial portrait work takes place outside. I've done portrait-style work at company functions from tropical paradises to wilderness retreats, and very often I take a client outside to a park or a field to create a portrait.

The joy of working outside is the same as the drawback: although you can explore a wide variety of backdrops and props from the natural world, you have a limited control over how you can use or direct them. You can't, for example, just move the signpost that is in the way or make the wind stop while you expose your shot.

The best advice about working outdoors that I can think of seems the most obvious: think big. Take advantage of the energy inherent in the atmosphere; make your model come alive as a vital part of the world.

Working On Location

As you might expect, shooting portraits outdoors offers some unique opportunities and challenges. Nature provides a spectacular variety of backdrops, an astonishing assortment of lighting conditions, an alarming number of potential disruptions, and that most unpredictable photo prop of all time. I am speaking, of course, about the weather. When conditions work in your favor, you'll end up with portraits that will be treasured; when they work against you . . . well, you can still end up with portraits that will be treasured, you just have to be willing to adapt. You can't overcome Mother Nature, but you *can* learn to dance with her — or leap into the air with her, as shown in Figure 7-1.

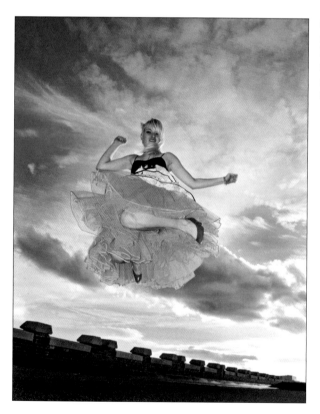

Figure 7-1: Working outside poses many challenges, but it is often the best place to capture the "big picture" so to speak, and the only place that certain things can be done at all.
© Istoica.com

Tip The best thing about the outdoors, I think, is the way you can create any sort of perspective you want between your model and your background. Looking up at your models (the camera being lower than their center of gravity) makes them look smaller, and looking down at them (the camera being higher than their eye level) makes them look larger—in proportion to their environment. Standard height, around eye level, creates a balanced sense of the model and the environment. Groups are often spectacular when presented from a lower POV, with the people around the camera in a semicircle.

Advance scouting

Whenever possible, visit the location of the shoot in advance. Try to be there at about the same time of day as the shoot is scheduled. The reasons for this are fairly obvious: it gives you an idea of the lighting at the scene, provides you with a chance to preselect backgrounds appropriate for the subject, and offers an opportunity to take a few test shots.

Because it is outdoors, you should have a fairly good idea of what sort of traffic or company you can expect to be sharing the space with and ensure that there are no contingencies you haven't considered. Once, I arrived at a public space one sunny day with 30 preschoolers in bumblebee outfits only to discover it was lawn-mowing day. The fact that I got a pretty cool shot of them climbing all over the school bus with ice-cream faces, although a consolation, was not a compensation because it cost me several more hours than I was reasonably able to charge for. And in the business, time really is money.

A great many public, semipublic, and private venues (such as museums, concert arenas, exhibition halls, galleries, historical sites, and so on) require permission or a permit before you're allowed to shoot photographs in them. In this era of hypersensitivity to security concerns, that permission often extends to any exterior grounds associated with the venue. Always be sure to check ahead of time. Nothing is more embarrassing or damaging to your professional reputation than having a uniformed security guard escort you and your subject off the grounds.

Tip For American readers, an attorney named Bert Krages keeps a Web site where he offers copies of a PDF document for download that spells out your legal rights and the limitations you face when taking photographs in public places. Primarily concerned with people taking pictures of public places, the document applies to portrait photographers as well, because when you use the space it becomes your background. Point your browser to `www.krages.com/phoright.htm` and download a copy. I highly recommend that you become acquainted with any laws or restrictions in your area that might affect how you use public venues for portrait work.

That said, a surprising number of places accommodate you if you make arrangements beforehand. Don't dismiss the idea of shooting a portrait at the local hockey rink or a nearby living-history farm until you've checked. The worst that can happen is they'll turn you down.

Be a good guest

Your mother probably taught you everything you need to know about on-location courtesy. Respect the rules; if you're on a beach that requires dogs to be on a leash and your subject wants to pose with his or her dog, you must still keep it on a leash. If you're shooting in a public venue like a cemetery or a historical site, treat it with respect. Even if the location of the shoot is an urban vacant lot, treat it like you would your own yard.

Always be careful to clean up after yourself. Leave no trace behind to show you were there. It's just good manners.

What Should Be In Your Bag

When I talk about your "gear bag" I'm not necessarily talking about your camera bag. I'm using the term figuratively. Your gear bag refers to the non-camera equipment and accessories you'll want to consider taking with you on a location shoot. It doesn't matter if the equipment is loaded in a cardboard box, the trunk of your car, a duffle bag, custom-made containers, or the big plastic utility bins that all home supply stores sell. See Figure 7-2.

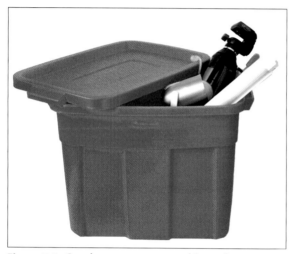

Figure 7-2: Carrying your gear around from shoot to shoot, especially if you work outside a lot, can be very easily done with the purchase of a few cheap plastic containers. Get the kind with lids so you'll be covered for all possible weather conditions.

There are some items that should always be in your gear bag, regardless of whether you'll be shooting inside in a controlled situation or outside in an unpredictable environment. The most critical item in any portrait photographer's bag is creativity and resourcefulness. Regardless of how well you plan and organize your shoots, something unexpected almost always turns up.

When loading your gear bag for an outdoor portrait shoot you also need to give more thought to the uncontrolled conditions under which you'll be shooting. Unlike shooting in the studio where you have control, portraiture out of doors is an exercise is creative adaptability.

Lenses, filters, and attachments

One of the many advantages of shooting out of doors is the sheer size of nature's studio. This allows you the option of using lenses not normally suitable for portraiture. We rarely see lenses of a focal length greater than 135mm used in studio/indoor portrait work. There simply isn't enough room to use long lenses inside. Step out the door, though, and you can unpack your serious telephoto glass. If you have a lens 200mm or longer, I strongly suggest you pack it.

There are both technical and psychological advantages to telephoto portraits. The most obvious technical advantage is the increased control over depth of field. A lens with a small f-stop (such as 1.4 or 1.8) radically narrows the depth of field, allowing you to transform annoying distractions in the foreground and background into pleasing blurs, as shown in Figure 7-3. Or if you prefer, you can widen the depth of field (reduce the focal length) and use the magnifying properties of the telephoto lens to make objects in the distant background appear close to the subject. A horse 80 yards away in a separate field can be made to appear standing nonchalantly behind the subject.

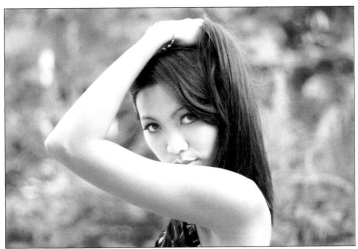

Figure 7-3: Using a long lens, one with a focal length 135mm or higher, is a terrific choice for outdoor work where there is plenty of space and you can take advantage of the great depth of field (DOF) options a long lens gives you.
© Brandon Hoover

Telephoto lenses are also very flattering, especially to subjects who may be sensitive about their nose. Shorter lenses exaggerate facial features. Consider this: if your subject's ears are five feet away from the camera, the tip of his or her nose is only four-and-a-half feet away. Get close, and it looks big. Get far away, however, and it diminishes. If your subject's ears are 35 yards away, then his or her nose is also 35 yards away. With a 200mm lens you could make Cyrano de Bergerac look like a movie star. It's about perspective.

As mentioned earlier, there are also subtle psychological advantages to long lenses. Some subjects can't help striking an artificial pose when they think the photographer is about to release the shutter. They pick up on subtle clues in the photographer's body language and stiffen up at the critical moment. I've seen it a thousand times. The result is a tight, forced portrait. But if you're 35 yards away, those subtle clues are much more difficult to spot. The odds of getting a relaxed, spontaneous, natural pose are greatly increased.

A cable release or equivalent wireless remote is recommended for all outdoor work because your tripod will not likely be on even ground. Even though it may be braced very well, the chances of a slight shake when you press the shutter button are still higher than in the studio. Using a cable release is also an excellent way to eliminate the model knowing when you are about to expose the shot, allowing for a more informal and intimate exchange between photographer and model.

Although I generally prefer prime lenses for portraiture work (they're lighter and faster), a telephoto zoom can be a good idea when shooting outside. With a long lens you'll be working with a tripod or brace, so the weight of the lens becomes somewhat less of an issue.

Filters

Most photographers usually keep either a UV (ultraviolet) filter or a Skylight filter on their lens at all times. This keeps dust off the actual lens and prevents scratches. Both are appropriate for outdoor shooting, but you shouldn't limit your filter options to just those two. Here are some other filters you might want to consider packing into your gear bag.

✦ **Circular polarizer.** A polarizing filter serves several functions. Most commonly, it's used in portraiture to deepen the color of a blue sky or enhance color saturation (see Figure 7-4). However, it can also be used to reduce or eliminate glare from reflective surfaces (leaves, surface of a body of water, glass, and so on). For example, if you wanted to shoot a photograph of the subject through a window, adjusting the polarizing filter insures that there would be no glare on the glass.

There are two types of polarizing filters: circular and linear. They both work in essentially the same way, but circular filters work better with your digital camera's auto-focus function.

✦ **Neutral density.** Sometimes, when shooting in bright sunlight, the effect you want requires a larger aperture or a slower shutter speed. A neutral-density filter reduces the amount of light that passes through the lens while still allowing you to retain a balanced exposure. Many photographers that work outside, myself among them, would not leave home without a set of neutral-density filters. Sometimes these filters are simply the most efficient and effective way of reducing the incoming light. The thing to remember about them is that they reduce and affect the light universally, and can flatten color and soften edges if not used properly.

✦ **Soft.** As the name suggests, soft filters soften the light passing through the lens. This smoothes out some obvious facial imperfections (large pores, wrinkles, and so on) while retaining the general clarity of the image.

✦ **Center spot.** These filters have a clear spot in the center (no filter effect at all) surrounded by an area of diffusion. The subject in the center of the picture is reproduced clearly; the surrounding area is modified. The most common center spot filter offers a diffusion border, which is very handy for reducing distracting backgrounds. Other center spot filters have rims that darken or colorize the image.

✦ **Effects filters.** Some lens filters are useful in outdoor portraiture because they provide a specific special effect. For example, mist and fog filters add drama to the scene by creating a graduated misty or foggy atmosphere. They soften contrast, cause bright lights to flare, and reduce general sharpness. Star filters provide a variety of different variations of bright points of light, turning such things as streetlamps or sunlight filtered through leaves into romanticized rays of light. A sepia filter, of course, attempts to recreate the old-time feeling of the early days of photography.

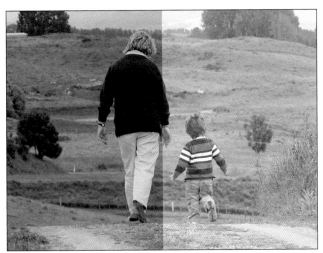

Figure 7-4: The left half of this photograph has a polarized filter effect and the right half remains untouched. Aside from their glare-reducing properties, polarizing filters often modify color in bright sunlight as well as deepen skies and enhance saturation. It is very much a matter of personal taste; some photographers prefer the natural coloration and others prefer the polarized version.
© Brenda Anderson

Tip

Polarizing filters work like polarizing sunglasses, and you can mimic the effect of the filter with a pair of polarized sunglasses if the angles are relatively equal. A few things to keep in mind when using polarizing filters are (1) that the polarizing effect is not universal and depends upon at what angles the filter and the light meet, and (2) you will likely have to open your aperture the equivalent of about 1.5 f-stops more to compensate for the filter's light-altering properties.

There are filters for almost every imaginable effect. It's wise, however, to use them sparingly. If overdone they can make a portrait look gimmicky or cheap. Remember, the point of the portrait is the subject; if the filter doesn't enhance the subject (or, worse, if it draws attention away from the subject), then take if off the lens and put it back in your gear bag.

There are exceptions to this advice, naturally, such as the times you are *trying* (and it does and will happen) to create an effect which is not at all natural — such as a star filters (they're the ones that give wedding rings the sparkle effect) and vignetting filters for commercial-art shots. The point is, of course, that the effect must be right for the portrait.

Tripods and braces

A good tripod should be a permanent fixture in your gear bag. You should no more consider going on a location shoot without a tripod than you would leave home without your wallet. If you're shooting on a bright, sunny day you might not need a tripod, unless you're using a telephoto lens. Or unless you need a free hand (to hold a reflector, for example). Or unless it's very windy. Or unless . . . but you get the idea. Just because you have good, bright sunlight to work with, don't assume a tripod will just be extra weight in your gear bag. I like a tripod no matter the venue or lighting simply because it frees up my hands and gets my camera from around my neck. Anyone who has spent a day shooting with a camera hanging around his or her neck knows exactly what I am talking about — it can be very uncomfortable after a while.

Tip If your tripod doesn't include a built-in spirit or bubble level, then consider buying a small carpenter's level at a hardware store. They're inexpensive and invaluable in the field. If your camera isn't level, the image will need to be straightened and cropped before printing. Although this is less important today with so many post-processing options, a number of smaller issues come into play with an uneven tripod, notably that your composition is actually skewed to the angle, and when you straighten it out you may find it feels a little "off" to you.

A monopod is useful if the photo shoot is going to be in a location that's difficult to access — a mountain trail, for example, or rocky terrain that would make setting up a tripod awkward. Some monopods, in fact, double as hiking staffs.

Reflectors

It's always a good idea to toss a couple collapsible 5-in-1 reflectors (as discussed in Chapter 3) and a couple of diffusers into your gear bag. The reflectors are very useful if you find yourself having to shoot in a shaded area — beneath a tree, for example, or in a gazebo. In those situations you'll want to be able to refocus some light on the subject to get proper definition.

Diffusers can be used to take the harshness out of direct sunlight. If you're fortunate enough to have a well-stocked studio and an assistant to tote your gear, take along a diffuser panel and a frame. Most likely, though, it'll just be you and the subject, so you'll have to make do with a handheld collapsible diffuser. It does the job nearly as well (and it'll make you glad you packed that tripod).

Diffusion can occur in many ways — and if you don't have a frame you can use a white garbage bag. I have used a solid white tablecloth, a bunch of cellophane film wrapped around an empty window frame, and, once, the wide skirt of another model. You use what's there, and it's a good idea to consider yourself and the light to be in a good-natured competition.

Props

Props are not just for kids, as the wonderful portrait in Figure 7-5 shows. Props are not necessarily cute toys or shiny cowboy hats. Every gear bag should include a few props that are suitable to the setting and the subject. Before heading out, take some time to think about appropriate props. If you plan to shoot in a rural situation, for example, consider tossing in an old three-legged stool or an orange crate; you won't want anyone to sit on it, but you might get a more relaxed pose if the subject rests a leg on it. Whatever the setting — alleyway, picnic grounds, urban park, ballpark, ice rink — you shouldn't have too much trouble finding a few props that will fit in. Props can also be trees, rocks, picnic tables, and surf boards. If you stand your model next to a birdbath or drinking fountain, you have turned those things into props. For a more detailed discussion of props, see Chapter 9.

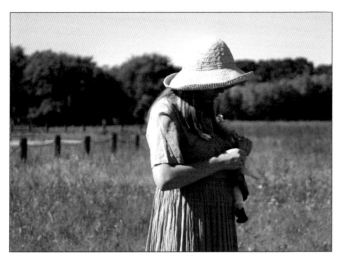

Figure 7-5: Don't think of props simply as costumes or toys. Among the most effective props are often those that belong to the models and represent some important aspect of their personal lives.
© Utata Photography

Miscellaneous gear

Your digital camera probably has an integral flash unit built into it. This is handy for those situations in which you have no other form of lighting available to you. At some point, if you want to get exactly the shots you want, in any venue and under any condition, you're going to need to buy an external flash of some type. And you'll always want to keep it in your gear bag. Always.

Even when you know you'll be shooting outside on a lovely sunny day, bring along your flash unit. I'll discuss the role of fill flash later in this chapter, but I can't stress enough how important it is to always take your flash. In fact, you could take two. There are some other items that should *always* be in your gear bag:

✦ At least one extra battery for your camera.

✦ At least one extra CF card in case of card failure (CompactFlash memory cards are discussed in detail in Chapter 2).

✦ At least two alligator clips and/or two all-purpose clamps. These are indispensable; you'll be surprised how often you'll need to clamp or clip something in place.

✦ Lens cloth, compressed air canister, and a blower/bulb brush to keep your lens free of dust. Shooting in the field exposes your equipment to dirt, grit, grime, and grunge. It's important to keep an eye on your glass to prevent specks from appearing on your photographs.

✦ A few model release forms (you need them if you want to use the photographs for any purpose other than portraiture, such as advertising or on your Web site).

Tip

Having two flash units can give you a great advantage in the field. Two flash units slaved together dramatically expands your command over light and shadow, especially if you're shooting in a shaded area. You could add a coil cord for your flash unit so you can get if off the camera and use it as a handheld. This can triple the versatility of an external on-camera flash.

You'll also want a few things in your gear bag to help you cope with adverse weather situations. Buy yourself a cheap, clear plastic shower cap. Not for your head, but for your camera. When shooting outside on misty/rainy days, a shower cap protects your digital camera and still allows you to see all the LCD displays. Shower caps are usually flexible enough to cover both the camera and the lens, and they can be quickly removed and replaced for taking the shots.

Keep a couple of soft towels in your gear bag. They're not only handy for drying your camera if it gets splashed, but they can be used to provide some extra padding for your knees if you need to kneel.

Pack an umbrella or two. Real umbrellas; studio umbrellas are designed to deal with light, not with rain. Even if your subject is safely under the shelter of a majestic oak tree, you may need to be far away to get the correct composition and will become exposed to the elements. In addition, a colorful umbrella is a wonderful prop, as shown in Figure 7-6, *and* a great way to soften light at the same time.

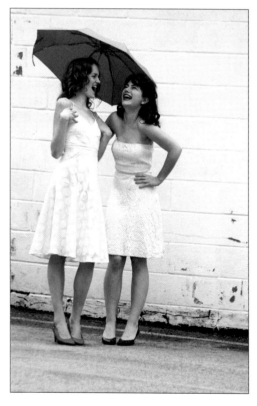

Figure 7-6: An umbrella is a good choice to carry along with you — if it rains, you have protection. If it doesn't, you have a prop. If it does both, you have a great portrait opportunity.
© Istoica.com

Caution Don't take chances with lightning! The moment lightning appears in the sky, or you hear approaching thunder, it is generally unwise to continue shooting—and especially not under an umbrella or a tree. Standing under a tree or an umbrella increases your odds of staying dry and getting hit by lightning. If you cannot find a shelter (a building or a car with the windows rolled up), get in to the lightning safety position. To do this, squat down near the ground with your heels touching and put your hands over your ears.

You'll want to include some small plastic trash bags, in both white and black. These make very good impromptu diffusers and scrims when on location, and, of course, they're just what you need for disposing your trash. As noted earlier, you should always clean up after yourself.

Tip In the summertime you'll want to include some bug spray in your gear bag. It's difficult to shoot a good portrait while your subject is swatting at mosquitoes. A word of caution: some photographers claim that the chemicals in DEET-based bug spray can be harmful to the plastic grip of your camera (or any other plastic components), so be sure to wash your hands after applying it.

Shooting in Direct Sunlight

Many portrait photographers, including some very good ones, will warn you to avoid shooting portraits in direct sunlight, especially direct sunlight in the middle of the day. The light, they say, is simply too bright and too harsh. They have a point. But as with all conventional wisdom, there are times when you should feel free to invent your own. The fact is that direct sunlight can be used to create powerful and compelling portraits.

Before delving into the mysteries of direct sunlight, though, I need to discuss an aspect of portrait photography that is so common, it's often overlooked. Fill flash.

Using fill flash

When photographers use a flash unit as a secondary light source to fill in the shadow created by the primary light, it's called *fill flash*. When shooting outside in sunlight, the sun acts as the primary light source; therefore, any flash light you add to it is automatically going to be fill flash. It means something slightly different in interior or studio shooting. In that case, it typically means that you are using your flash on a very low setting to assist some other form of light.

Many digital cameras offer several flash modes for their built-in flash unit, often including a mode called "fill flash." Very often this is simply called "low." This mode usually ensures the flash fires even in bright sunlight (some digital cameras automatically turn off all flash modes in bright sunlight). Many digital SLR cameras fire the flash whenever you tell them to, without changing modes, by simply turning the flash on. As with all flash photography, of course, an external flash unit is usually preferable.

Tip Learn the range of your flash unit, whether it's an external flash or the one built into your digital camera. One of the most common flash mistakes is attempting to shoot beyond the flash's range, resulting in an image that's too dark. For many built-in flash units the maximum flash range is around 15 to 20 feet. That's only about five or six steps away. Check your individual flash (or camera) specifications as the lens you are using (and the aperture setting) will affect your flash range.

Because the light emitted by your flash attachment is the equivalent wavelength of sunlight, there should be no problems with color balance. Fill flash also tends to brighten up and animate facial features, as well as removing unwanted shadows.

As noted in Chapter 3, it's always preferable to use a flash that is not attached to the camera when shooting portraits. Your digital camera's built-in flash is passable, but limited. When buying an external flash unit such as the handheld unit shown in Figure 7-7, look for one with variable flash output. VFO gives you more control over the amount of light the unit delivers. Instead of relying on the automatic/recommended setting, you can choose to deliver more or less light. Automatic camera settings tend to err on the side of too much rather than too little and can wash out the subject's color.

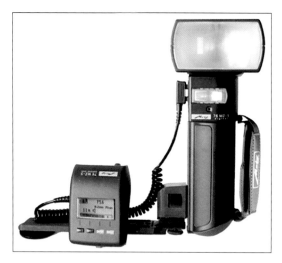

Figure 7-7: Handheld flashes, like the Metz unit shown here, are a good accessory to have and perform much better than an in-camera flash, which cannot be used to add fill anywhere except where the flash is specifically pointing.

Morning and evening light

I know you know this, but it's an important part of the preamble: the earth rotates. This is a good thing for portrait photographers who enjoy shooting outside. The quality of light depends on a number of variables, of course, but one of the most important variables is direction. In the mornings and evenings, sunlight arrives at a slant — on an angle, in other words, just like the lights in your studio.

There are two primary benefits to this, one obvious and one not so obvious. The more subtle benefit is that sunlight coming in at an angle necessarily has to pass through more of the earth's atmosphere. This acts as a natural diffuser, giving you a softer, gentler light than you'll find at midday.

The obvious benefit, of course, is that directional light is more revealing of the subject and more versatile for the photographer. In the mornings and evenings, you'll be able to work with three very different types of natural lighting: front lighting, side lighting, and backlighting. These are the same types of lighting you'll work with in the studio; the only difference is that when you're outside, the world is your studio. And you can't shift the sun around to get it in the right spot.

Tip When shooting in direct sunlight, use a hood on your lens. Hoods act rather like a visor on a hat, keeping the sun out of your camera's eyes. This reduces the chance of lens flare. If you don't have a lens hood or if your digital camera doesn't accept a hood, you can improvise with a magazine, a small piece of thick paper rolled up and taped together, or even your hand.

Front lighting

This is traditional lighting. This is the lighting you grew up thinking was necessary for a good photograph. The sun over your shoulder, shining directly onto the subject and providing unambiguous, even illumination. Everyone remembers standing in front of someone at the beach, waving while a Kodak clicked away in the blinding light and someone yelled, "Say cheese!"

But, as discussed in Chapter 3, direct frontal lighting is probably the least interesting form of portrait lighting. It tends to reveal very little about form or texture. The absence of shadowing renders a flat image, lacking in depth and generally erasing most signs of the subject's personality. On top of that, it often causes the subject to squint. Squinting works if you're Clint Eastwood, but it rarely makes an attractive portrait for the average person.

You can correct some of those problems by using diffusers and reflectors to bounce the sunlight onto the subject's face at an angle. But it's so much easier to simply reposition yourself or the subject in order to get some aspect of side lighting.

Side lighting

This is the form light portrait photographers are most familiar with. Angled light, creating a marked contrast between the sunlit areas and the shadows, is what gives a two-dimensional photograph the illusion of depth. However it is produced, with sunlight or studio light, it's the most evocative light when it comes to revealing form and personality, as illustrated in Figure 7-8.

Side lighting, of course, can be enhanced by the use of fill flash. But just as some of the masters of portraiture rely on only a single studio lamp for their light source, so too can you rely on the sun for your single light source. And just as the masters use strategically placed reflectors and diffusers to control and reshape the light, you can do the same.

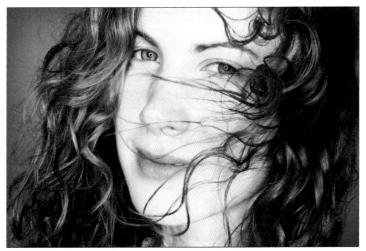

Figure 7-8: Lighting that comes from the side, whether the angle is shallow or severe, provides the photographer with the best means of exposing the character in the model's face.
© Istoica.com

Backlighting

Backlighting occurs when the light source is behind the subject. It's very dramatic lighting and so simple to arrange. All you have to do is locate the sun and then position your subject in between the sun and you. Nothing to it. This style of lighting, in whatever mode it is performed, produces very dramatic portraits, as shown in Figure 7-9.

Of course, the extreme contrast between the bright sunlight streaming around the subject and the dark shadow engulfing you makes composition and exposure more complicated. You must be doubly cautious about lens flare. In general you want to avoid flare, but it *can* add an interesting effect to a portrait. You want to be sure that if it appears, it's deliberate and enhances the image. Fortunately, your digital camera gives you immediate feedback, so you can experiment with a variety of exposure settings. If you don't want flare, then you need to use your lens hood to avoid ruining your portrait.

Backlighting doesn't necessarily limit you to silhouettes, however. Again, the judicious use of fill flash and reflectors can be used to give shape and form to your subject. If you have 5-in-1 reflectors, try experimenting with the silver, gold, and white sheaths to achieve different (warmer or cooler) skin tones. Incidentally, backlight is also very forgiving in regard to wrinkles and complexion problems.

With the clever use of fill flash and reflectors you can, in effect, turn the sun into rim lighting. The resulting high contrast and the extreme tonal range gives you bold and visually dramatic portraits.

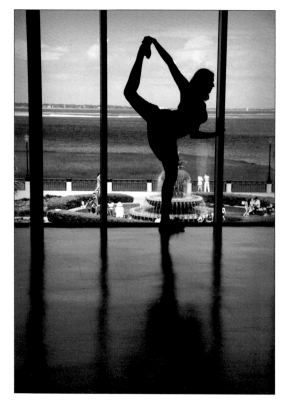

Figure 7-9: Backlighting provides many wonderful opportunities for dramatic silhouette portraits, and with a little clever composing, you can add interesting detail and context to backlit scenes.
© *Istoica.com*

Midday light

They say that only mad dogs and Englishmen go out in the noonday sun. Portrait photographers aren't on that list, but they probably should be. There's no reason you can't shoot good portraits in the midday sun. It's just not done very often.

The reason for that, of course, is that overhead lighting is exceedingly harsh, and the shadows it casts are severe. Light at that angle can cast some truly ghastly shadows on your subject's face. This is especially true if your subject has a prominent nose or deeply set eyes.

Again, you can take steps to minimize the potential damage. Use those reflectors you've been toting around. If you're shooting close-in, you can have an assistant hold a reflector or a diffuser over the subject's head. It should also be noted that, unless there is a specific reason for it, your subject doesn't always have to be standing up. If you can't change the angle of the sun, perhaps you can change the angle of the subject.

The simplest — and almost certainly the best — solution to shooting portraits outside at midday, however, is to move into the shade.

But don't run off right away! Taking portraits with direct overhead light can be done. Although this sort of light can seem harsh, it can also be like a secret weapon that you wield to show off a vibrant model, colorful costume, or both (see Figure 7-10). Additionally, you can use a sheer curtain fabric, a thin white bed sheet, or even a torn open white garbage bag to provide diffusion and/or reflection. I once draped a very large sheer curtain over the tops of two trees to create a makeshift scrim and I worked with a photographer who had me chase down an old panel from an overhead fluorescent light in a nearby abandoned building when nothing else could be found on location to diffuse the bright light. As with any general rule, you must be prepared to take advantage of the exceptions when you find them. The results, as you can see, can be well worth the risk.

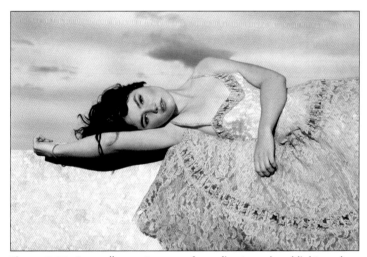

Figure 7-10: Generally we stay away from direct overhead light, such as happens outside at midday. However, there are times when it is the exact right thing, and what might appear harsh looks instead *alive.*
© *Istoica.com*

Shooting in Open Shade

Open shade refers to the lighting conditions of any outside location removed from direct sunlight, such as a porch, gazebo, or canopy, or beneath a tree (see Figure 7-11), umbrella, or awning. The conditions of open shade generally mimic the condition of overcast skies, having the effect of turning the entire sky into the mother of all soft-boxes.

These are ideal outdoor portrait lighting conditions. The ambient sunlight is filtered or diffused; it evens out and softly wraps around the subject. Under many circumstances the light doesn't seem to come from any specific direction at all. The strong, often unflattering shadows we see in direct sunlight disappear. Subjects relax in open shade; they stop squinting. This is the light that photographers try to recreate in the controlled environment of their studios.

So if we could just shoot our portraits in open shade, all would seem to be perfect, but, of course, there are always potential challenges.

Figure 7-11: Taken beneath a tree with reflectors placed under the model's chin, this is a lovely example of the softness that shaded sunlight adds to a model's face.
© *Nancy Ward*

Backgrounds

Abandoning direct sunlight for open shade necessarily narrows the stage. Out in the open, in direct sunlight, we had tremendous freedom in selecting the background for our portraits. From a brick wall (Figure 7-12) to an inner cityscape (Figure 7-13) to half open sky and half glass and steel (Figure 7-14), the possibilities are very big indeed. When we move to areas of open shade, our choices become limited. In addition, the backgrounds are more likely to be near the subject, meaning they can influence the portrait in several ways.

Figure 7-12: The possibilities for background choices when working outdoors are excitingly huge — and if you're willing to take a few chances, you can likely come up with some very interesting backgrounds of your own.
© Istoica.com

Figure 7-13: By experimenting with various types of backgrounds (full and partial, and neutral ones such as snow and sand), you can find many wonderful and sometimes surprising possibilities.
© Carolyn Primeau

Figure 7-14: Very often you can add interest to an image by varying the texture or type of background, or by using a "half background" — one where negative space occupies more or less half the background space.
© *Mitch Eaton*

For example, in open shade a wall is more than a background. It acts as a really large reflector: ambient light bouncing off a yellow stucco porch wall gives a yellow cast. In some circumstances this may add warmth to the subject's face; in other circumstances, it gives the subject a sallow appearance.

Tip
If you use fill flash in open shade, be sure your subject isn't standing too close to a wall. The flash casts a dark, unappealing shadow. If you're in a situation where you must use fill flash but cannot avoid being close to a wall, diffuse the light of the flash with a diffuser card or by covering the flash with a bit of gauze or tissue.

You'll need to keep a wary eye out for unwanted shadow lines appearing in the background. An abstract shadow can add a dramatic quality to a portrait, but the inclusion of such a shadow should be a deliberate decision, not an accident. The dappled light of sunlight filtering through leafy branches can be an attractive background, but it needs to be a conscious decision and fit in with your plan.

Speaking of dappled light, it's fine for backgrounds, but not for faces. Whenever you're shooting under a leafy tree on a sunny day, stay alert. The patterns aren't always very bright or obvious to the eye; but the sensor on your digital camera records them all the same, and they show up when you enlarge the image.

Just because the lighting conditions of open shade are considered ideal, that doesn't mean they can't be improved. Tip those 5-in-1 reflectors and your flash units out of your gear bag. Use them just as you would in the studio. Redirect light, block light, shade light, and change the color of light.

Shooting at Night

Don't put your digital camera away when the sun goes down. There is something exciting about portraits shot at twilight, or in deep night—an element of adventure. Portraits in urban settings, with the bright lights of the city in the background, can be very exciting and glamorous. Although many of your portraits will take place in the studio, any professional has to be prepared for work in a wide variety of venues. I've been hired to take evening pictures for a symphony's promotional materials, by a child's parents to take shots of a special performance, and by a dance troupe to take performance shots. The portrait photography business comes in all sizes and shapes, and when you start one you need to be prepared for a wide variety of scenarios. It's entirely possible that you will be making a variety of portrait types, from basic headshots for company brochures to portraits where clients want you to cast them in a work of photographic art. And sometimes you need to walk the fine line between that which documents and that which idealizes, such as the portrait shown in Figure 7-15.

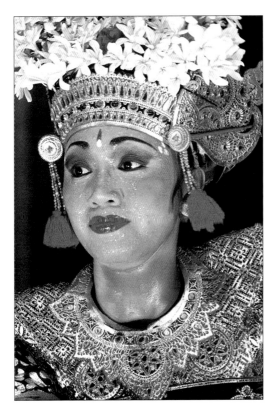

Figure 7-15: Shooting at night can be challenging, but with the right lens, the right metering, and the right exposure, you can manage to capture the important details and present a portrait that is both artistic and archival.
© *Brandon Hoover*

Shooting at Night — Front and Rear Curtain Flash

Night portraits are going to require slow shutter speeds synchronized with flash illumination. The two basic modes of flash synchronization are *front curtain* and *rear curtain*. The terminology comes from the world of film cameras, which actually used two curtains (or shutters) — the first to expose the film, the second to stop the exposure. By linking the firing of the flash to whether it fires at the beginning or end of the exposure, you can achieve different effects.

As an example, say you want to shoot a portrait of your subject standing on a city street as a car passes by. Your camera is on a tripod and you're going to expose the scene for half a second. You have two options:

✦ **Front/First Curtain Flash.** This is the default mode for most flash units. The flash unit fires immediately when the exposure begins. The flash freezes the motion of both the subject and the car. The exposure continues for half a second, during which the car continues to move forward. Then the exposure stops. Because the flash took place at the beginning of the exposure, the resulting image shows the line of the car's taillights in *front* of the car. The photo below provides an example of front curtain flash in similar circumstances. This style of flash can be appropriate for entertainment and artistic shots because you can generate some very interesting effects. It is less appropriate for standard personal portraits.

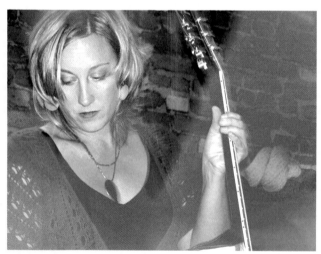

© *Linus Gelber*

✦ **Rear/Second Curtain Flash.** Rear curtain flash fires at the end of the exposure, just before the shutter closes. The car is moving at the beginning of the exposure and for half a second the camera captures the bright line of its taillights. As the exposure ends, the flash illuminates the subject and the car, freezing both in place. The resulting image shows the line of the car's taillights *behind* the car.

Each image will be exposed for half a second, and both the subject and the car will receive the same amount of flash illumination. The only difference is whether the flash fires at the beginning or the end. But it's a big difference.

Taking portraits at night used to be limited mainly to professional photographers shooting jazz or rock musicians for album covers, or news photographers shooting villains and bodies at crime scenes. With the advent of digital imagery, night portraiture has become a lot easier and a lot more accessible to the amateur portraitist. To be successful, though, you need to understand how your flash unit works.

Playing with light

One of the advantages of shooting portraits at night is that the longer exposures allow you and your subject to be very creative with light. You can put as much or as little light as you want on any part of the subject. You can, for example, use a flashlight to illuminate just the subject's face and one hand. You can illuminate the subject with a bonfire. You can cover your flash unit (or a flashlight) with different colors of lightweight cloth and paint your subject with color. Many outdoor portraits look spectacular in the muted colors of a storm, for example, when a moody sky and low light is needed, as shown in Figure 7-16.

Experiment. Try crazy things. See what works, see what doesn't. Build on what you learn.

Problems with shooting at night

Clearly, shooting portraits at night poses a number of problems. If it were perfectly easy, everybody would be doing it. Some of the problems are technical, and some of them are circumstantial.

Noise

A potential problem with all night photography, noise is a sort of photographic "static" that tends to increase when the camera's ISO setting, or "film speed," is set to a high number. Anything over 400 ISO is considered "fast." Static or noise can also happen when a long shutter speed is used with a lower ISO setting, but it is not as prevalent a problem. In that case, camera shake and model movement is more likely to be your nemesis.

So here you have a paradox: you can try to reduce noise by using a lower ISO setting, but a lower ISO setting requires a longer exposure. Or you can try to reduce noise by using a higher ISO setting to reduce the length of the exposure, but a higher ISO setting increases noise.

There's no correct resolution to this problem. It's one you need to experiment with using your camera. You need to learn how your equipment handles each of the concerns.

Most digital cameras have a noise reduction setting. Indeed, most digital cameras have a "night" setting that includes noise reduction. But notice that the term is noise *reduction*, not noise *elimination*. Noise remains a problem.

Tip Opening or closing the aperture affects depth of field, and increasing or decreasing shutter speed affects the freezing or blurring of motion. Changing the ISO speed affects the picture quality. The ISO speed affects the graininess or noise in the photograph. The latest digital SLR cameras use various technologies to reduce this noise, so the image quality is still quite good even at very high ISO speeds. An ISO speed of 100 or lower has virtually no noise. If noise is unavoidable, you can use noise reduction software, which is covered in Appendix B. When images are reduced in size for printing and viewing on a computer, the visual presence of noise is often barely noticeable.

White balance

The lighting you encounter at night isn't going to be color corrected. You're going to be dealing with the halogen street lamps, tungsten lighting, and neon signs (many of which are actually filled with argon or xenon gasses). All of this mixed lighting plays havoc with the color of your portrait unless you correct the white balance. See Chapter 3 for a discussion on how to handle white balance.

Working in the dark

One of the problems of shooting portraits at night is the fact that it's just difficult to work with your equipment in darkness. It's more difficult to be sure your camera is level on your tripod, more difficult to see the dials and settings on your camera, more difficult to do all those little chores and tasks associated with setting up a photograph. You can use flashlights, of course, to reduce the problem. But just assume that everything is going to take longer in the dark.

In addition, being out late at night with expensive camera equipment, especially in some parts of the city, exposes you to other risks. It's always a good idea to take along at least one assistant when shooting portraits at night. And no, the subject doesn't count as an assistant.

Shooting in Adverse Weather Conditions

No matter how much you prepare for a shoot, there will be times when the weather refuses to cooperate. The clouds come out, the wind begins to blow, the rain comes, the snow falls. In that situation you have a few options: you can reschedule the shoot, you can adjourn to an interior location, or you can adapt and keep shooting.

It depends, of course, on the type of portrait you're shooting. Obviously, you don't want to shoot a wedding portrait outside in the rain, and you wouldn't try to get a graduation portrait in a snowstorm. But if you're shooting an informal portrait or you have an adventurous subject, don't put your camera away when the weather is less than perfect. You might miss an opportunity to capture something wonderful and dramatic, as shown in Figure 7-16.

Tip The portrait shown in Figure 7-16 is one of those where breaking the Rule of Thirds, as discussed in Chapter 4, was made as a conscious decision. Due to the complementary nature of the sky and the model's eyes, it makes compositional sense to show a bit of this background on each side of the model's face. This requires putting the model close to the center of the frame which is generally not recommended but which, in this case, seems to be exactly the right decision based upon the appealing result. Note that the eyes remain in proper Rule of Thirds position.

There are also times when you simply must get the portrait photographs even if the weather won't cooperate. I once had to shoot a Scouts event over two days and was paid in advance to take portrait-style shots of some of the 3,000 people attending. It rained the entire first day and the wind blew like a dickens for the second day. Taking your camera to the repair shop because it got wet in the rain or the tripod blew over in the wind is not funny even once, let me tell you.

Note If you think that being a portrait photographer is all about working in the comfy studio under perfect conditions all the time, you should probably put that notion right out of your head. Chances are that no matter what style or niche of portrait photography you end up doing, you will have to schlep around in the rain a bit to pay for that privilege.

When working with customers where it is possible to reschedule, I do urge you to do this (after you've exhausted all possibilities of working while the elements are in an agitated and animated state, of course).

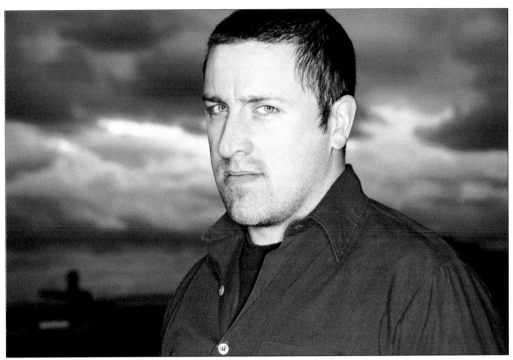

Figure 7-16: The deep, muted colors of a storm are duplicated in the clothing and tones in this portrait, and the model's eyes brilliantly mirror the storm in the sky. Don't think you need clear, blue skies to do outdoor portrait photography.

© Istoica.com

Rain, mist, and fog

If you have the good fortune to visit (or live in) the Pacific Northwest of the United States, Southeast Asia, Ireland, some parts of South America and Africa, you'll notice two things. First, they're very wet. Rain, mist, and fog are common. The second thing you'll notice, though, is that they seem full of color.

The amount of moisture in the air influences the way light refracts, increasing color saturation. That's good news for the intrepid portrait photographer. Backgrounds become indistinct and mysterious, the sky becomes dramatic, color intensifies, but contrasts soften. A portrait on a dark, misty day — what the Irish call a "soft day" — can be spectacular.

The same is true immediately after a storm. You'll rarely find natural light quite so dramatic as sunlight sliding out behind dark clouds. Even if your summer photo shoot is interrupted by a sudden thunder-shower, don't go home too soon. Wait a bit because you may have an opportunity to take some remarkable portraits.

And let's not forget that other extraordinary artifact of rainy weather: the rainbow. The ephemeral quality of a rainbow captured permanently in a portrait makes it a prizewinner, both for the subject and the photographer.

Perhaps the most important thing to remember about shooting in the rain is that, as Figure 7-17 clearly shows, some people look pretty cool when they're wet. I've had to shoot sports and entertainment events that were rained upon, and because the event wasn't canceled, I couldn't cancel. Sometimes you simply have to make do.

Figure 7-17: The rain, in and of itself, does not need to stop you — and some people can look very engaging when wet.
© *Istoica.com*

Potential problems with shooting in the rain

The main problem with rain, of course, is that it's wet. We worry about the effect of precipitation on our cameras, and rightly so; they're expensive pieces of technology packed full of complicated electronic circuitry. But the fact is most digital cameras, especially digital SLRs, are more weather-resistant than you'd think. This doesn't mean you shouldn't take some sensible precautions. You'll almost certainly be fine in a light fog or mist, and you'll probably be fine when it sprinkles, but you need to take safeguards when the sprinkles turn to rain; if the rain becomes heavy, go inside. There's no point in being foolish about it.

Before you go out in potentially wet conditions, give some thought to the more vulnerable points of your camera: the input jacks, the case seams, and the buttons. If you protect those (and, of course, your lens) you should be fine. You can also try these suggestions:

✦ Use a clear shower cap or a sandwich-size baggie to protect your camera's body from excessive moisture. A lens hood prevents water from getting on the lens.

✦ Use a soft towel to dry your camera as soon as possible. Towels are incredibly handy even on dry days and should always be included in your gear bag.

If you have the distinct misfortune to have your digital camera immersed in water, there are some things you should do as soon as humanly possible:

1. **Get it to a dry spot.**

2. **Wipe the camera dry with a soft towel.**

3. Remove all batteries and memory cards.

4. Open every compartment, slot, and cover. Use a Q-tip to reach inside to absorb any residual moisture.

5. Expose the camera to a passive heat source; avoid using a blow dryer (you never want to blow super-heated air into your camera body).

Cold

If you live and take all your photographs in tropical climes, you can skip this section. But for the rest of us, part of every year is spent coping with the cold. Cold weather, however, shouldn't necessarily stop you from shooting portraits out of doors. One of the purposes of portraiture, let's not forget, is to reveal something about the subject. A portrait taken outside a ski lodge or on a mountaintop or romping with a dog in the snow can be a lot more personally revealing than any trick of lighting performed in the warmth and security of the studio (see Figure 7-18).

Figure 7-18: From kids tobogganing to ice skaters, there are a lot of great scenarios that you could dream up for cold-weather shooting, such as this portrait of a beloved family pet named Freddie. Pet portraiture is a rather substantial niche of the portrait market.
© Christine Acebo

Somewhere in your camera's manual is a specification that details the temperature range at which your camera is designed to operate. It's a fairly wide latitude, usually somewhere between 0°C and 40°C (32°F to 104°F). In fact, your camera will probably operate in a slightly wider range of temperatures, but your manual's specifications are a good estimate.

Cold-weather camera care

When you take your camera outside into the cold, the first casualty is your battery. Cold weather is to a battery what vampires are to the circulatory system. Cold weather sucks the lifeblood out of your batteries, and because digital cameras are entirely battery-dependent, that means trouble.

You should, of course, have spare batteries in your gear bag. If you're shooting in the cold, take them out of the gear bag and put them in your pants pocket (or some other place close to your body) because body heat retards the battery degradation.

Tip

To extend your shooting time in cold weather, turn off all unnecessary camera functions. Use the camera's viewfinder instead of the LCD monitor; rely on manual focusing rather than your camera's autofocus. Many digital cameras allow you to preset some changeable attributes (such as white balance, contrast, saturation level, and so on). Presetting those variables in advance uses less battery life than changing the settings individually.

You should keep your camera relatively warm until you start shooting. If possible, keep it inside your coat or in a deep pocket when not shooting. The key here is *relative* warmth, not absolute warmth. Do not keep shifting your camera between a cold place and a warm place because doing so causes condensation on the lens and fog in your shots. You merely want to shift the camera between a cold place and a less cold place.

Caution

The lens is not the only at-risk component of a wet camera. Condensation can form on the microprocessor and some of the electronic components can be damaged. If your camera has become completely submerged or gotten very wet, I recommend that you take it to a professional service center where it can be properly cleaned and conditioned.

This is one of those moments when it's worth having invested in a tripod with a quick-release head; you can set up the shot, pop the camera onto the tripod, take a few exposures, and quickly return the camera to your coat pocket.

Cold-weather model care

Condensation isn't just a problem for the camera; it can also be a problem for the subject of your portrait. As breath leaves the warmth of your lungs and hits the cold air, it condenses and turns into a visible mist. You probably won't want that mist to appear in the portrait. To make matters worse, if your subject has a mustache or beard, that mist collects on it. At best it will look unattractive; at worst it will actually freeze.

The cold weather can play a great deal of havoc on skin as well and many models, particularly those with very fair skin or light hair. While you want "rosy" cheeks, you don't want splotchy cheeks and you definitely don't want a red nosed model. The best method to deal with this is to keep your model out of the elements for as long as possible and to be ready for the shoot when she is in the posing location. If your model's skin is very sensitive and redness occurs quickly, don't be discouraged because you can always even skin tones in post-processing.

Post-shoot precautions

That same concern about condensation applies to your camera at the end of the shoot. By the time you're done shooting for the day, your camera is going to be physically cold. Bringing it into a warm place causes moisture to condense on it.

There are two simple solutions to this problem. You can wrap your camera in one of those soft towels you cleverly placed in your gear bag (as mentioned earlier) and allow it to come to room temperature inside the towel. You can also do the same thing with a plastic baggie. Keep the baggie in the same coat pocket where you carry your camera. This allows it to adjust to the ambient air temperature. When you're done shooting, put the camera inside the baggie and seal it. When you return to the warmth, the condensation forms on the outside of the baggie and not on your camera.

Heat

Digital cameras are pretty tolerant of the heat. Unfortunately, portrait subjects generally aren't. Shooting an outside portrait in the heat of summer requires a bit of forethought. Obviously, the best way to avoid

issues of extreme heat is to schedule the shoot early in the morning or late in the day. The heat is more tolerable and the light is generally more conducive to portraiture. Generally where there is heat there is light, and sometimes you don't mind putting up with a little excessive heat to be able to use the beautiful light, as shown in Figure 7-19.

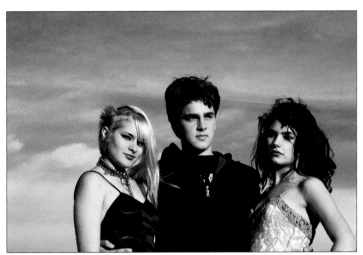

Figure 7-19: Working in the heat presents unique challenges and carries with it unique rewards.
© Istoica.com

But on those occasions when you must shoot in the heat of the day — or if you find yourself in a part of the world where the heat is incessant — then you must make do. You have three problems to cope with:

✦ **Your subject must be kept as cool as possible (unless, of course, you're shooting a grittier style of portrait).** This means hydration. Keep plenty of bottled water at hand, along with a thermos of ice chips. A hand fan (of either the kind you make from paper or which is battery powered) is also useful; it's less likely to disrupt your subject's hair while still providing some relief.

✦ **Although the appearance of the photographer isn't an issue, you still need to take care of yourself.** You can't complete the shoot if you develop heat stroke. You'll also want to take along a light pair of gloves; you'll likely be handling a few hot metal items, such as clamps or your tripod. And yes, you'll want to use a tripod; camera bodies get hot too, and you don't want to press hot metal or plastic to your face.

✦ **As noted earlier, your camera is subject to damage from extreme temperatures.** If you think back on your high-school physics class, you'll remember that heat excites electrons, and your digital camera is basically a box of electronic circuitry. Your camera's LCD screen could fail to operate in extreme heat. The sensitivity of the camera's sensor fluctuates with acute changes in temperature, and that can have some strange effects on your camera.

In extreme heat situations, keep your camera in a small cooler and take it out only when you're ready to shoot. If you regularly need to shoot in high heat, get a camera with a decent viewfinder so you don't need to rely on the LCD monitor.

Wind

Whenever you're shooting out of doors, wind is a potential problem. It disturbs your subject, mussing hair and blowing dust into the eyes. The wind can blow unanchored reflectors and diffusers out of position, or just blow them away. It can sweep against the body of your digital camera, or catch hold of a camera strap or a tethered lens cap at the critical moment, causing your shot to be blurry. Even if you're using a tripod, the wind can make it vibrate just enough to ruin a shot.

You can deal with rain and mist, you can cope with the cold and the heat, but unless you have a couple of sturdy photographic assistants, the wind is a location-killer. Pack up your gear and wait for another day.

But. Before you go, just make sure the wind hasn't presented you with more drama than you could have wished for in your wildest dreams. Sometimes, just before it's time to go, there's time to take a few quick shots. As Figure 7-20 illustrates, you might be glad that you did. Although wind effects are best done in the studio with an electric fan, sometimes the combination of wind and environment creates a rare moment of opportunity.

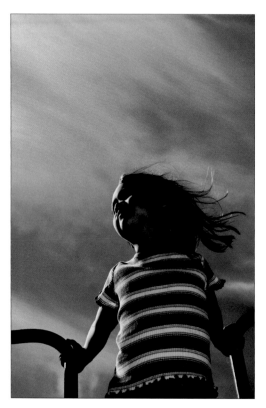

Figure 7-20: Captured while the wind was, literally, whipping around the model's hair, this portrait is a testament to the beauty you can capture in an outside portrait.
© *John Watson*

✦ ✦ ✦

8 Interior Existing Light Portraiture

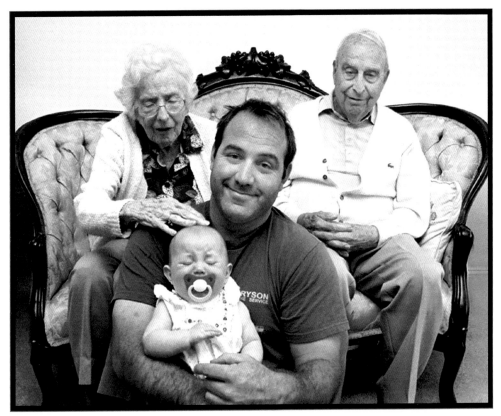

© *Siobhan Connally*

Existing light is composed of the combination of natural sunlight and artificial lighting found in normal situations outside of the studio. Simply, it is the light that is there when you arrive, before you plug anything in, turn anything on or emit a flash. In fact, the digital photographer is at a particular advantage in mixed light situations because most digital cameras allow you to set the white balance so that you can make the most out of any lighting situation.

There are many portrait situations where the photographer will find the setting or location does not lend itself well to using specialized photography lighting, and other situations in which natural lighting is, in fact, preferred. Natural light can provide depth with a soft, flattering quality that cannot be duplicated with lighting equipment. Not only can an open door or window provide a flattering light source when directed at the subject, it also can offer tremendous opportunities for making interesting, compelling portraits using backlighting and silhouetting techniques (discussed later in the section "Stunning shots using backlight").

Existing light can include street lights, car headlights, traffic lights, table lamps, ceiling lights, firelight, or in the case of a performer, spotlight. For example, a wedding party may ask for shots of them arriving or leaving the church or reception hall. In such a situation, the existing light could include the interior lights of the church in addition to the setting sun and nearby halogen streetlights. Harsh or unflattering light sources should be avoided of course, but many mixed or existing light situations can provide excellent opportunities to create portraits that genuinely capture and reflect the subject without being overly posed, as shown in Figure 8-1.

Figure 8-1: Available light portraits, such as this one taken in a coffee shop using the shiny tabletop as a reflector, can achieve an attractive soft quality. Camera: F2.5, $1/60$ sec., ISO 800. Evaluative metering with -2 stops exposure compensation. Lighting: Available tungsten and fluorescent light in a coffee shop at night. No flash.
© Stephen Strathdee

Although there are other important technical aspects to using existing lighting, as discussed in Chapter 3, the key when you are standing behind the camera is to ensure that it does not create unflattering shadows on the subject, that it is not directed or used in such as way as to create harsh breaks between dark and light areas. By paying attention to these things, you avoid making the light source itself the subject of the photograph or allowing it to cause visual distractions. Using existing light can be a challenge, no doubt, but the results can be spectacular.

Working on Location

Working at a client's home or place of work, at a wedding hall or inside a church — or any other place where you have limited control over lighting and cannot easily set up your own — requires that you come prepared for a variety of conditions and situations. Being prepared includes bringing both the proper gear and the proper attitude. The section "What Should Be In Your Bag" gives you a general idea of the equipment you should take to cover most situations, and reminds you of a few other things you should keep in mind about working on location.

Advance scouting

It's always a good idea to scout the location prior to the shoot date, if possible. Knowing what to expect will both stimulate your creativity and answer some of the questions you may have about what gear you should bring. You can get an idea of the lighting available and will be able to determine if there are any outstanding opportunities for backdrops and props, such as illustrated in Figure 8-2.

If your photo shoot is to take place in the client's home, this is the best possible opportunity to develop a feel for their tastes and personality, helping you produce a portrait they will be enthusiastic to hang on their walls and share with their friends and family.

Follow the rules

Whether you're in someone's home or the Elk Lodge, the office tower on Main Street or the public park near the government buildings — you are a guest of that space and you should always be respectful, polite, and mindful of any regulations or rules in place. If the sign says "Please remove shoes," then remove your shoes. Your clients will appreciate your courtesy and professionalism if you are respectful of their personal space. This will translate to a warmth that everyone who views the portrait will notice.

As discussed in Chapter 7, many outdoor locations require permits before you may conduct a photography session, and it is the same with interior locations. Many churches and public buildings such as museums, galleries, and conservatories require formal permission for such activity or they impose restrictions about what equipment you can use and under what circumstances. In any case, it is polite and professional to ensure that anyone who *should* know about it *does* know about it.

Figure 8-2: Advance scouting is important if you are able, but even if you are not, keep a sharp eye for opportunities such as this photojournalistic one where the subject's clothing seems to be tailor made for the graphic decoration of this New York City club. Camera: F3.2, 4 sec., ISO 100 with a tripod (and a still model). Lighting: Available light in the anteroom/hang space of a Manhattan nightclub.

© Linus Gelber

Take only what you need

Seems obvious, I know, but I will confess to a cautionary tale. My first few location shoots were like a socialite going to Paris for a month—I took more bags and bins than you can imagine. Pretty soon I learned to stick backdrops to walls with Silly Putty and use white garbage bags as diffusers. Not only was it difficult to carry around so much gear, but it makes clients cranky if you show up with too much equipment that you have to drag in and then out again. Take what you need, of course, but consider what might be there already that you can use to good effect. A white ceiling or wall, for instance, can be a great reflector for you to bounce your flash from, and there are smaller accessories such as flash diffusers that you can attach to your camera for situations where you face lighting challenges.

What Should Be in Your Bag

To some degree, the contents of your bag will vary with each shoot. If you have a glamour portrait planned, for example, you may be carrying a few special effects filters or a kit bag full of faux diamonds. If you plan on shooting a marching band at the end of the gymnasium, you need a wide-angle lens. If you're shooting children, you need as fast a lens as you own. However, you should pack certain items in your traveling kit for each and every existing light shoot.

Tip There is virtually no circumstance or professional job to which you should not at least carry a basic flash unit.

The most important thing to pack in your gear bag is your imagination. On a location shoot, you're very likely to encounter something unexpected. On those occasions, your ingenuity will be the first thing you'll need to unpack. After that, you can haul out the more mundane items. Figure 8-3 provides a very good example of this exact sort of ingenuity at work.

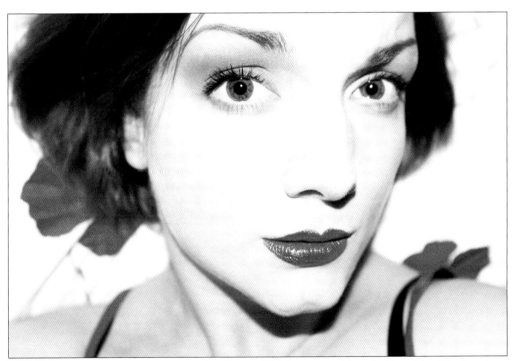

Figure 8-3: This stunning portrait, intentionally very high key, was achieved with a light-diffusing piece of semitransparent white plastic stuck over the built-in flash of a Canon 350D. Camera: F4, ¹⁄₆₀ sec., ISO 800. As the photographer said, "I was hoping to achieve a high-key portrait that maintained details in the skin and hair without being totally blown out or having distractingly harsh shadows." Success, I'd say.
© Laura Kicey

Lenses, filters, and attachments

You can add a large number of accessories and attachments to your digital camera to help it function in specific circumstances. Although you do not need a bag full of gadgets to make outstanding portraits, there are a few accessories that can help with some of the conditions you may encounter while shooting indoors in mixed light. In particular, a lens hood is a good investment for portraiture because it allows you to take advantage of bright streaming light, as explained later in the section "Stunning shots using backlight."

The vast majority of formal and informal portraits are shot with a medium telephoto lens with a focal length of anywhere from 85mm to 135mm. Obviously, you must balance your lens choice with your environment; if you're going to be shooting in a gymnasium or concert hall, you'll want something longer.

Many portrait photographers like to keep a prime lens (see Chapter 2) in their bag, and if you own one, it is a good idea to carry it with you to all portrait sessions. They generally produce the best results if you are able to arrange your working space to allow for the proper distance and lighting conditions for their use. Even though a zoom or telephoto lens offers greater flexibility under a wider range of conditions, if you have good control of the environment and the subject, it's generally a good idea to use the best prime lens you have for the job.

Many photographers keep either a UV filter or a Skylight filter on their lenses full time, not only to reduce unwanted ultraviolet light, but also to prevent the actual lens from being scratched. If you use a Skylight filter for that purpose, remove it for interior shots; they're better suited for shooting outdoors.

Depending on the type of portraiture you shoot, you may want to consider the following filters:

- ✦ **Soft or warm/soft.** These soften and smooth out facial imperfections while retaining general clarity. The Warm/Soft filter also creates a warmer skin tone. Both come in a variety of grades.

- ✦ **Center spot.** As the name suggests, this filter has a clear center area enveloped by a circle of diffusion. This allows you to minimize an unattractive background. It also comes in a Warm Center Spot version that creates warmer skin tones.

- ✦ **Contrast.** These come in both high and low versions. The high-contrast filters redistribute the ambient light in a way that allows details otherwise lost to shadows. The low-contrast version shifts light to darker areas and lowers contrast.

- ✦ **Sepia.** If you want to create a portrait with a more "old-time" feeling, a sepia filter is very handy. These come in several grades.

- ✦ **Color correction.** There are a number of filters that produce natural colors for a variety of artificial lighting conditions. Generally, however, it's best to rely on your digital camera's own color conversion technology.

Tip

There are a wide variety of filters available for use with photographic equipment. Some are special effects (such as center spot and starlight, which are most often used for portrait work), some are corrective, and some are for specific color or light enhancements. If you point your browser to www.digicamera.com/features/filterprimer/index.html, you will find an excellent primer on the topic with a comprehensive listing of filter types and their uses.

Filter Now or Filter Later?

Digital photographers have the wonderful advantage of being able to decide where in their workflow that they would like to perform certain tasks such as filtering. Filters can either be applied to the end of a lens and used before the photograph is taken or they can be applied later in the digital darkroom with photo-editing software. Conventional wisdom, however, does not entirely agree that the effects of all physical filters can be duplicated with software. My personal experience is that most effects can be, if not duplicated, approximated closely enough.

Deciding when you will use a filter is entirely up to your own preference, but there are a few things about each method that you will want to consider.

On the Camera

✦ When you choose to use a filter on the lens before you shoot the picture you are committed to that choice as you cannot undo it with software.

✦ A filter will often slightly soften the image's quality. In some cases even a protective filter can cause an image to be slightly softer and subject to vignetting and flare.

✦ Filters can be very expensive and a cheap filter will further degrade your image quality.

✦ It can be helpful to see what the camera sees and a filter applied during the shoot can aid you in making exposure decisions.

Off the Camera

✦ You need fairly advanced processing skills to perform many operations a filter (such as a starlight or a polarizing filter) can perform on the camera.

✦ While you are taking the photograph, you must make educated guesses as to the effect of a software filter.

Some professionals believe that a lens hood will protect a lens as well as a filter and whichever method you use will be entirely up to you – but in the case of extreme circumstances such as high winds, a beach shoot or a trek through the forest, the use of a protective filter is recommended.

My preference is to use software to deal with most things that a filter might normally do. The physical filters that I find to be useful and keep in my bag at all times are:

✦ UV protective filter

✦ A set of neutral density filters: neutral density filters decrease the brightness of light across the color spectrum and are very useful for shooting outdoors, particularly with low aperture settings.

✦ A Polarizing filter: although describing how these filters work would take a great deal of this chapter, suffice to say that they assist in controlling glare and reflection from sunlit surfaces. They are also used to increase color saturation in outdoor scenes and are available in linear and circular styles. I have seen a few tutorials on the web for creating a polarizing filter in Photoshop but I have not been tempted to try it. I recommend that if you are only going to have one filter and you plan to shoot outside, that it is this one.

Tripods and braces

It's always a good idea to stow a stable tripod in your gear bag. In fact, I would go so far as to say, "Never leave home without one." You'll need it for those low-light situations so common to interior shots. If you're shooting in a larger venue, an auditorium or concert hall for example, you'll need a stable platform for your longer lenses. If you have one, it's also handy to toss in a tabletop tripod; these small units can allow you to set up in situations where a large tripod would be impossible. A collapsible monopod, which can easily fit into a pocket of your gear bag, is a good addition. Also consider a couple of beanbag braces. These can be incredibly helpful; not only do they make excellent improvised tripods, but they also can be useful in other ways—as weights to steady things, for example.

You'll also want a couple of all-purpose clamps and alligator clips. These are invaluable tools for holding things in place, like a sheet for an improvised backdrop or a reflector to a tabletop or floor lamp.

Reflectors

If possible, add some reflectors to your gear bag. These useful devices redirect and modify both the amount and the direction of light, allowing you to fill in shadows, add highlights, and increase or soften contrast. As discussed in Chapter 3, these come in white, silver, and gold. Gold reflectors add warmth to the light, and silver reflectors provide a cooler feeling. Reflectors are made in a variety of sizes and are relatively inexpensive. However, if you don't have manufactured reflectors, you can always create your own at the scene using materials at hand such as poster board, white trash bags, mirrors, silver platters, and the bottom of a cardboard pizza box.

The importance of reflectors should not be underestimated because they can make a crucial difference between an unclear or muddy shot and one in which the subject's features are clear, as illustrated with Figure 8-4. The picture on the left was taken in fairly bright existing mixed light with no reflection or flash assist. The picture on the right, taken a few seconds later, relied on the use of a white reflector about two feet from the model's face. A reflector's sole purpose is to bounce light to a place where you need it and to generate a more even field of light around a subject. Therefore you will likely need more than one to generate even light, so be sure to carry several with you.

Figure 8-4: A reflector made the difference between unclear and indistinct features and a clear, interesting portrait. Camera: F4, ¹⁄₅₀ sec., ISO 100. Lighting: (left) none and (right) a white reflector.

Tip While you can use the bottom of a pizza box, a much better solution is a set of portable and collapsible reflectors such as those sold by Photoflex (www.photoflex.com), which are sold in complete sets with a nifty carrying case and a clever design. They're light, easy to carry, and it won't surprise you to know that they work better than the pizza box.

While we're talking about bouncing light around using reflectors you position yourself, it's likely a good time to talk a little about using stationary surfaces as reflectors. By *bouncing* a flash off a reflective surface such as a ceiling or a wall you can generate a more diffused and gentle, but still direct, light that often lends a more natural appearance to portraits. This is achieved, as you might expect, from aiming the flash unit or light source at the reflecting surface in such a way that it "bounces" back at the subject. Don't forget, when using a wall or ceiling to reflect light that the light that bounces back to your subject may be tinted with whatever color the surface is painted. If it's white or most pale non-red based colors, this won't present a large problem, but anything with a red base may create a distracting color cast.

Of course, you will need to practice in order to get an understanding of how light reflects from surfaces. As discussed in Chapter 3, it is a function of the simple physical law: The angle of reflection is equal to the angle of incidence. Once you have these angles down, you'll find a remarkable improvement in your portrait photography. The control of light is key. "I just wanted a nice portrait of my wife. We're both happy with it, so I guess I succeeded," remarked John Watson when asked about the beautiful and luminous portrait shown in Figure 8-5. Taken with a single flash bounced off the ceiling, the effect is a gentle illumination whereas a direct flash would have proven too harsh.

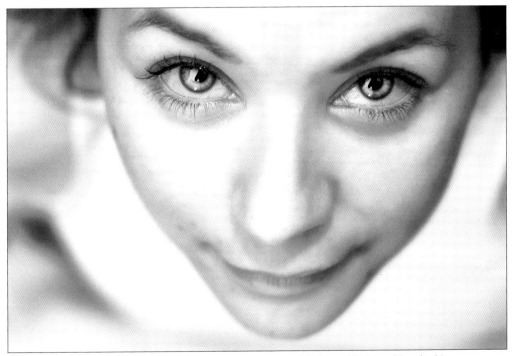

Figure 8-5: Camera: ¹⁄₆₀ sec., F2.8, (lens: 50mm), ISO 200. Lighting: With the subject looking up, an off-camera wireless flash was bounced off the ceiling, triggered by a master on-camera.
© *John Watson*

Beanbags, You Say?

World-famous Bogen Imaging, makers of the popular Manfrotto tripod series, manufactures a product called THE Pod. Only 3.75 inches in diameter, 1.75 inches high, and weighing 7 ounces, THE Pod is easily packed and carried, and can be used almost anywhere. Its centrally mounted ¼–20 screw fits most tripod sockets. According to Bogen, its maximum capacity is "Lots. The Pod can be stepped upon by an average male and come out smiling." Point your browser to www.bogenimaging.us/thepod to see this nifty little accessory.

Backdrops

Two or three cloth backdrops (a large cream or off-white cloth and a black or very dark blue cloth) can be folded neatly and easily contained within your gear bag. If you have a professional backdrop frame, include it. Otherwise be sure to include some supplies for hanging backdrops that do not make holes in walls — painter's tape, sticky tack, clamps, a makeshift clothesline, or an old fold-up projection screen. Backdrops, cloths, and basic color theory are discussed more fully in Chapter 9.

Props

I suggest you consider including a few appropriate props in your bag whenever you go on a location shoot. Obviously, these should be tailored to the age of your subject and the type of portrait you're shooting. You probably won't want to offer a yellow rubber duck to your subject in a formal portrait situation — although I wouldn't entirely rule that out.

Although I do not recommend dressing all your clients in Wild West outfits or suggest that every woman wants a glamour portrait, many clients want to create something special and unique, and you are there to help them achieve this goal. Most complicated scenarios will take place in your studio, which is covered in Chapter 9, but you may still need to consider basic props while shooting on location.

If you're photographing a young teenage girl, for example, take a collection of cool hats. If you're working with a group of little girl ballet dancers, take some brightly colored chiffon scarves and have them perform an impromptu ribbon dance for you. Or if you're photographing a team of old-timer hockey players, take a fake Stanley Cup. Props, even those that seem "too done" or stereotypical to you, can make a fun and interesting portrait like the one shown in Figure 8-6. Aptly entitled "Alive with the Energy of Love," it will not seem at all "too done" to the client — after all, *he* doesn't do this all the time.

To help models feel comfortable when handling props, I suggest keeping them engaged in a casual conversation. This will keep them interested and animated in between moments when you ask for stillness or request a pose change. A model will assume a blank stare when asked to simply hold something or to assume and hold a pose. Keeping people engaged in the process helps create, not surprisingly, engaging portraits.

Portable props suitable for taking to location range from things the subject can hold, such as silk flowers or books of poetry, to things to place inside the frame as part of the composition, such as a wall hanging, a colorful sculpture, or a birdcage. I recommend you routinely visit flea markets, used clothing stores, antique and collectible shops, and vintage boutiques to find unique and unusual things with which you can add interest and value to your portraits.

The Comfort Zone

It is very important to be prepared before going on location because your client's time is as valuable as your own and they will not want it squandered. Plan your shots and poses and create a few contingencies for less-than-perfect light conditions. However, it is important to enter into any creative endeavor with an openness to new ideas and possibilities. I did a portrait of a lawyer and his wife once, and when I arrived, all ready for an in-front-of-the-bookshelf shot, I found them raking leaves in their massive oak-filled yard. We ended up with a shot of them throwing leaves at each other while their crazy-legged terrier ran around in circles and barked like mad. Turn a staid portrait of an elderly couple sitting beside each other on a sofa into a portrait of them walking towards you holding hands or washing dishes together in the kitchen. Take chances, go with your instincts, and work at encouraging your clients to be themselves with you.

Props are especially handy when photographing younger subjects and pets. Be sure to remember to get permission from the parents of children and the owners of pets before giving them any of your props to wear, play with, or chew.

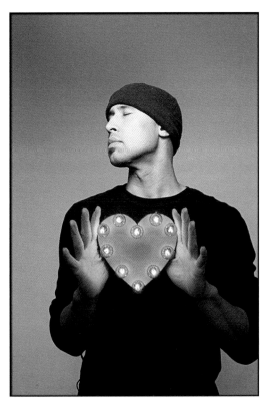

Figure 8-6: Props can add interest and appeal, and clients usually love to work with them. Camera: F8, ⅛ sec., 100 ISO. Lighting: single strobe.
© *Carmon Rinehart*

Makeup

A small compact of theatrical or cosmetic face powder (neutral color) with disposable applicators to deal with shiny spots on noses and foreheads — especially if working with hot light — can come in handy.

Makeup is a little tricky to work with, and if you are using other makeup — particularly one that is applied to the eyes or the mouth — ensure that you use a fresh applicator for each model and that you do not "double tip" with such items as mascara, eyeliner, or lip makeup.

Portable lighting

Why are we talking about adding lighting to your gear bag in a discussion of shooting with available light? Because, as the well-known portrait photographer Arnold Newman said when asked if he worked with available light, "Available light is any light that's available." It's better to have a flash attachment in your bag and not need it than to need it and not have it.

Most gear bags will also have room for a small flashlight. (I'm particularly fond of the Mini Maglite). A flashlight is surprisingly useful for fill light and can be very effectively used to "paint" with light. Painting with light is a photographic technique in which you direct light to certain areas of the subject while it is being exposed and not necessarily for the entire exposure. I've seen this method put to very good use with backlit portraits where painting with light is used instead of flash-fill. It allows you to add soft high-lights and gently bring attention to specific areas. Always be sure to experiment and review the results using your digital camera's playback function. Digital gives you the advantage of being able to check your work until you have the exact results you are hoping for, and it's wise to take full advantage of this ability.

Small clip-on lights such as the type often used as bed reading lights are great for quick fixes. There are many inexpensive lighting possibilities, such as high-powered flashlights with flexible stands, gooseneck lamps, and portable work lights that you can purchase to carry with you on your photo shoots. You should fit your lamps with as wide spectrum a bulb as you can find, such as a gro-lite, but there is no need for a special bulb. You will use these units only to provide a small amount of fill or to reduce faint shadows.

Toss a few electric extension cords into your bag. They allow you to reposition any lamps in the room to give you better control over the light.

Tip

One particular area where digital photography has an advantage over film work is that you can make so many changes and adjustments to the photograph before you take it by simply making setting changes to your camera's built-in functions. White balance, color correction, and focusing modes are often adjustable. I highly recommend that you take the time to run through a series of tests with your camera's settings so that you are intimately aware of how each setting reacts to each circumstance. Knowing your tools is the best way to ensure you can make exactly what you want with them. It's also good to note that, if you are shooting in RAW mode (recommended for professional work), white balance correction in particular is one of the most powerful and simple functions you can perform in post-production.

Working with Natural and Mixed Light

The starting point for all photographic decisions, from the lens to the lighting, is what is known as *ambient light.* Simply, ambient light is the combined or active light in any given area. If the lights are turned off but the sunlight is streaming in, the ambient light is 100% natural. If the lights are on and it is dark outside, the ambient light is 100% artificial. Most daytime, interior ambient light is a mixture of natural and artificial.

To give you a good idea of how this translates to the actual portrait, consider the close facial portraits shown in Figures 8-7 through 8-9. Figure 8-7 was taken in 100% natural, non-diffused or reflected light (streaming sun). Figure 8-8 was taken in 100% artificial light from a normal household environment. Figure 8-9 was taken with a mixture of artificial and natural light.

Figure 8-7: F8, ¹⁄₆₀ sec., ISO 400
© *Mindy Mooney*

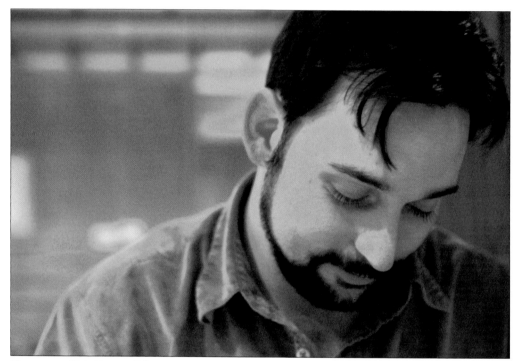

Figure 8-8: F2.8, ¹⁄₂₅ sec., ISO 800
© *Laura Kicey*

Common problems and solutions

As discussed in Chapter 6, each type of light has different qualities, produces different results, and comes with its own set of problems. The flip side is, of course, that each also presents opportunities and advantages. In a way, relying on available light gives the photographer more freedom simply because you're not burdened with all that lighting equipment. You must make do with what you have. With a bit of creative thought, however, you'll be surprised at how much you have. As the following sections explain, you can solve most common problems with ready solutions.

Where to shoot?

When working outdoors or in a studio, one of the first inclinations of the portrait photographer is to locate the best background for the subject. In situations where you must rely on existing light sources, however, your first priority must be to locate the best light. If the background is less than attractive, you can always work with a wide aperture to blur everything behind the subject, or use a Center Spot filter, but there is no cure for bad light.

The photographer's natural response to existing light situations is to find the brightest source of light and place the subject directly in it. But remember, it's not the amount of light that matters in portraiture: what matters is the control of the light. The challenge of working inside without studio lighting is in creatively managing the available light. This means training yourself not only to be aware of the various sources of light in a room—windows, lamps, fireplaces—but also to notice how the light interacts with any reflective surfaces in the room.

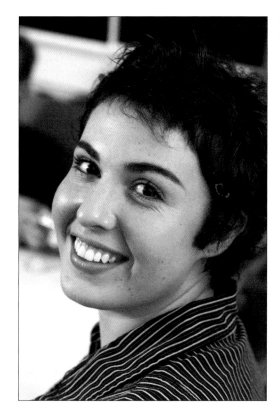

Figure 8-9: F4, ⅟₅₀ sec., ISO 1600. A prime (fixed focal length) 50mm lens was used.
© *Vida Morkunas*

So before you set up your tripod, scout the area for the best lighting situations. Note how the light reflects off the wall, how it bounces around in an arched doorway, how the low roof of a porch holds the light. Individually turn on any lamps in the room to gain an idea of how they can be used to fill or control the natural light.

Not enough light?

Unless you're shooting portraits in a cavern or a completely dark room, there is almost always some ambient light bouncing around randomly. The challenge is in redirecting and modifying that light and, when possible, adding to it to provide you with the best portrait possible. Indeed, location photographers often talk about low-light shoots the same way big game hunters discuss a particularly grueling hunt — usually with the same child-at-Christmas enthusiasm.

This is where your reflectors come in handy, and all those clamps and clips you've been toting around in your gear bag, and those extension cords you cleverly stashed away, and of course that flash unit you always carry. The light is there; it's up to you to control it.

Of course, your digital camera very likely has some features that can assist you in this situation. If your camera has a Night setting, consider using it. You can also increase the ISO rating and slow down your camera's shutter.

Another option is to choose a prime or a wide-angle lens when the light is too low for comfort and you can't affect it easily with portable lighting. A wide-angle lens lets you shoot at a slower handheld shutter speed than a telephoto lens, which exaggerates the slightest camera shake. The improved DOF of a wide angle is also a benefit in low-light circumstances. Additionally, a prime lens will usually allow a wider aperture than a zoom lens, which lets in more light and allows a higher shutter speed.

Finally, consider using the low light as an ally. Not every portrait needs to be perfectly crisp and sharp. Sometimes a little bit of blur in an arm or hair can add depth to the portrait. The portrait in Figure 8-10 is a perfect example where the available light was low but the resulting portrait, complete with a little blur on the subject's hair and the cat's ear, has a pleasing result.

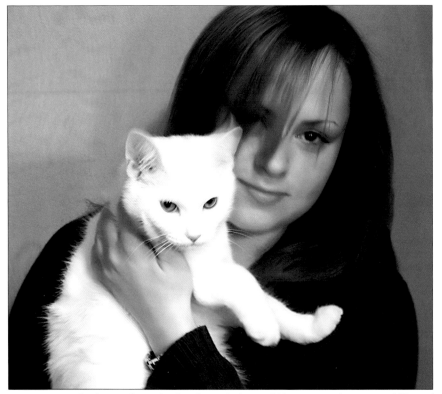

Figure 8-10: Blur is not always bad and can, in fact, add interest and a sense of life and animation to a portrait. Camera: F5.0, ¹⁄₁₃ sec., ISO 100. Lighting: small incandescent lamp 10 feet to camera left, natural light on the right side.

Too much light?

This is usually the best of all problems to have in an existing light situation. It's generally easier to reduce the amount of light than it is to redirect it. But it's still a problem. Too much directed light can result in a very harsh portrait, and too much undirected light can give you a rather flat and unflattering portrait.

The general solution is obvious: reduce the amount of light. The trick is to decide which light to reduce. If the light is a combination of natural and artificial light, try a variety of different combinations. Turn off some of the lights, or close the curtains on some of the windows. Figure 8-11 shows a shot where the natural light was too bright so the photographer pulled the sheer curtain across the window resulting in this natural and lovely portrait. Experiment until you find the best combination.

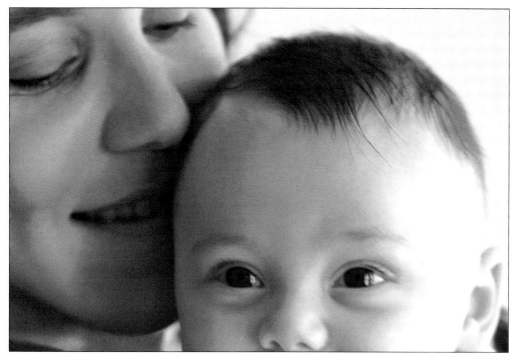

Figure 8-11: One of the things that you might consider carrying in your traveling studio is a length of the sheer nylon fabric used to make sheer curtains. Camera: F4, ¹/₃₀ sec., ISO 100, Evaluative metering.
© Stephen Strathdee

On rare occasions you'll find too much all-natural light — too much sun streaming through too many windows with no curtains or blinds to reduce it. This happens sometimes in industrial settings or in New York loft-style apartments. In such cases, because you can't move the sun, you must move the subject. Place the subject as far away from the windows as is feasible. Consider constructing a makeshift scrim out of an old sheet or white plastic garbage bags to diffuse the light. In addition, even though you can't move the sun, you may be able to let the sun move itself. Wait a while; the sun will shift and the light will change.

An interior situation with too much light can be an opportunity to shoot more dynamic and active portraits. Get your subject off the chair, get him or her moving. Some of portrait photographer Philippe Halsman's most famous portraits are of people in the act of jumping — including such unlikely figures as President Richard Nixon and the Duke and Duchess of Windsor.

Too much light? Make the most of it.

Taking advantage of the conflict

Inherent in all mixed-light situations is a certain conflict: light always comes from one direction and everything is three dimensional—where there is light, there is shadow. While the goal of certain portraiture (the head shots for a company's annual report, for example) is to provide a journalistic recording of the person's likeness for posterity and the absence of shadow is a necessity for this clarity, most portraits benefit from the added contrast of a little directional light.

The casual-style portrait shown in Figure 8-12 uses mixed light very effectively and dramatically with an extreme variation between the light and dark areas. The result is a very compelling likeness of a young man with whom you might like to sit and have a coffee—a fine compliment to any model. This photograph was achieved by placing the subject in the direct path of the light and being focused closely enough to eliminate virtually any background save the portion of his face in shadow. There is nothing in this portrait to distract us from the presence of his personality, and thus it is a success.

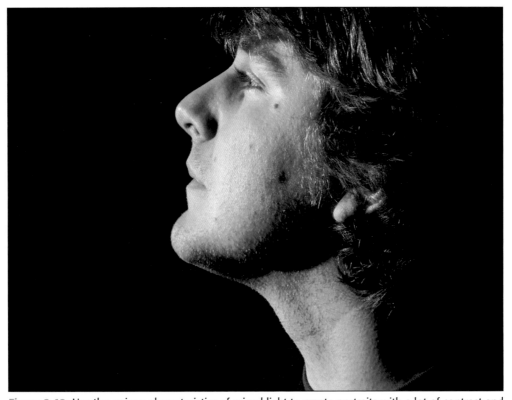

Figure 8-12: Use the unique characteristics of mixed light to create portraits with a lot of contrast and character. Camera: F3.5, ½ sec., ISO 64. No flash. Ambient natural light.
© *Greg Fallis*

Tip

Close-ups and extreme light such as Figure 8-12 shows can be used with anyone, of course, but they are particularly suited to round-shaped and fuller faces that have a softer appearance. Chiseled, thin, and angular faces can be done close up as well, but tend to become very severe in appearance when subjected to lighting that generates deep or extreme shadow. A rule of thumb is the thinner or more angular the face, the closer to dead-on the direct light should be. This generates the least amount of shadow on the portion of the face not being directly lit and produces the most even light, which softens the appearance of the face.

Choosing the light direction

The technical as well as the aesthetic and mood quality of a portrait is greatly affected by the direction and intensity of light. I've already talked about increasing and decreasing light and using the presence of both light and shade to your advantage. Now I need to talk about controlling light and the direction from which it comes.

Those who study the subjects of art and photography recognize that the direction and angle from which the light comes is as important as the light itself. It's worth a more comprehensive study if you plan to get into formal and classic portraiture. Chapter 3 covers how to achieve the basic styles of directed-lighting portraiture inside the studio, but when you are using available light you need to be particularly attentive to and informed about light direction because you often cannot alter it.

The direction of the light source is revealed by the shadows it casts as well as the angle at which it reflects. Light travels in a straight line and it always reflects off a surface at the same angle at which it strikes it.

When the main light source is directed at the front of the subject's face it is called, as you might expect, *front light*. It is generally the least appealing direction of light source because it can produce a flat, overly lit subject where little is revealed in terms of texture and form. There is no shadow to produce depth, but there will be a strong shadow directly behind your subject.

Side lighting, which is the standard photographic lighting and includes both short and broad light, is when the light source appears at an angle to the photographer's viewpoint. The variations available in this range of angle can generate interest in your subject, as shown in Figure 8-13. Side lighting brings out surface textures, creates depth in backdrops, and, often, exposes character in a face.

On sunny days, it can be difficult to keep your subject from squinting, and the use of broad light should be avoided, or at least postponed until the sun is lower in the sky at mid afternoon. Even inside, if you are using natural light from a window or door, too-bright light can be difficult to overcome, not necessarily because the equipment will fail, but because the model will. Eyes will have an unnatural dilation and the brow line will be in distress.

You can still use the bright light as your main light source by shifting either the subject's position or yours so that the relative positions of the light, subject, and camera are altered. When making handheld test shots or shooting event backgrounds such as wedding preparations at the bride's home, it's a good idea to take several shots of the same subject from varied points of view (POV), being careful to meter for each new perspective (while staying out of the way of the preparations or event).

Sometimes only five degrees exist between the angle that results in a terrible picture and the angle that results in a spectacular one. Depending upon how you position yourself in relation to the subject and the light and how you set your exposure, you can create several images with completely different qualities and appeal without moving the subject at all. When placing subjects or planning a shot, always try to leave some working room so you can move around and find the best angle and distance for the shot you're after.

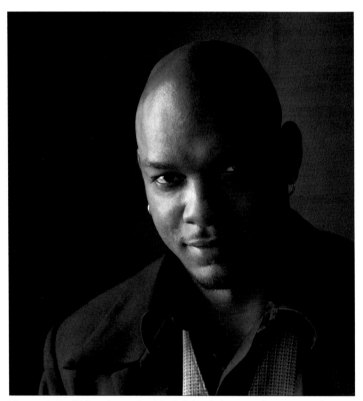

Figure 8-13: Using dramatic side lighting brings out features and character in a face and provides visual interest and drama. Camera: F8, ¹⁄₆₀ sec., ISO 200.
© Sean Harrington

Some of your best opportunities for portraits that your client will love come during casual or unguarded moments — particularly with couples, children, and pets. When asked to produce a casual or "real-life" style portrait, which happens more and more, I like to follow them around a little until I am a familiar presence to them and then wait for good moments.

Sessions taking place at midday can be challenging to handle with natural light because the sun is so bright and the shadows so dark. Even on interior locations, streaming midday sun is often too strong to use "straight up." Position the subject outside of the direct stream of light, so that the light is to the side and slightly behind the subjects, as you would position a traditional softbox. See Figure 8-14 for an example of how this lighting technique can be used. In all shade conditions, make sure you take the exposure reading off of the shadow side of the face.

Figure 8-14: This portrait of the Mettawee Theatre founders, taken as part of a journalism assignment, uses light to the side and slightly to the back of the subjects to add interest to the portrait. Camera: F3.5, ¹⁄₁₀₀ sec., ISO 400. Metering was averaged between the dark and light portion of the model's face.
© *Siobhan Connally*

Stunning shots using backlight

Backlight is when the light source is directly facing the camera. When you place the subject between the light source and the camera you have backlit the subject. Backlighting is the technique that is used to produce the very popular silhouette effect. When you take a meter reading from the light, but position the subject in front of it, you create a silhouette. Turning the subject toward the light and taking the exposure reading from the face creates a more traditional-appearing portrait with a soft, natural look.

Backlighting is the most often used lighting technique in product shooting because it separates the subject from the background and adds drama and impact. These qualities sell products, and they will sell your portraiture, too. Although you may not choose to use silhouetting in particular, I recommend that you make it a practice to generate at least one out-of-the-box or dramatic portrait at each of your sessions. Not only will you learn a great deal about your craft, but the results are very often pleasantly surprising for both you and the client. Your job is not simply to create a likeness, but to capture as much of the subject's personality as possible. And there are, of course, no two of those that are alike, so it makes sense that portraits cannot be generic or cookie-cutter in nature. A backlit or silhouette portrait is a good start for that dramatic portrait that will get the big gasp when you show it to the client the first time. As shown in Figure 8-15, using strong backlight as your primary light source can still result in a fully visible portrait if the ambient light is good.

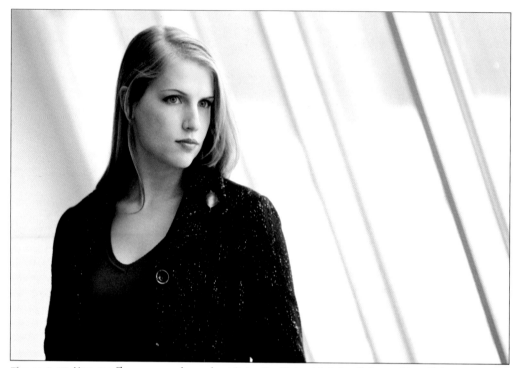

Figure 8-15: You can "have your cake and eat it, too" with backlighting if the ambient light is also of good quality. Camera: F1.4, ¹⁄₁₂₅ sec., ISO 320.
© Ryan Brenizer

Backlighting tips

Backlighting is one area where you may need to use that flash you always carry in your bag (or your camera's built-in flash), and it may also require the use of a reflector or fill-in flash to brighten up the dark shadows and improve subject detail. If you want a very dark, absolute silhouette, then provide no front light whatsoever, not even a reflector or a flash fill. If you want to show some of the detail of the subjects, such as facial features or clothing, you will likely need to assist your camera with a reflector or flash.

To make effective use of backlighting, try this:

✦ Take special care that the sunlight does not fall directly on the lens (except for intentional special effects). A lens hood or a makeshift barrier should be used to prevent lens flare. Ensure you are far enough from the subject so that none of the direct light is part of the composition — it is a lighting tool, not a subject.

✦ Your subject will be in stark relief, so ensure that you have captured a flattering angle because any lumps and bumps, stray articles of clothing, and even messy hair can create an unappealing silhouette. Another side of this same coin is that silhouettes are often the easiest photographs to repair in post processing.

✦ A backlit portrait is effectively a graphic image, and it is quite important that you pay attention to the Rule of Thirds and avoid placing your subjects in the center of the photograph unless, as discussed next in "Using windows, doors, and other frames," you are framing intentionally with a secondary subject.

✦ Backlit images use the brightest light source, usually the sun, behind the subjects. The correct meter reading is taken from the shadow side. If you are using the in-camera metering, aim at the shadow portion and lock your exposure before refocusing on your intended composition.

Using windows, doors, and other frames

Photographers have a soft spot for frames, naturally, and so it should come as no surprise that one of the most enduring techniques of portrait photography is called *framing*. This is where you use something, usually a window or door, to surround your subject so that it is visually "framed."

These shots force the attention to the subject but provide a lot of visual interest. They have an edge of glamour to them; this style and posing technique was very often used in traditional glamour or Hollywood portraiture. Framed shots provide an excellent opportunity to display the human form in a more graceful position than simply sitting or standing, as shown in Figure 8-16.

Figure 8-16: Windows, doors, and other frames provide an excellent opportunity to display the human form in a more graceful position than simply sitting or standing. Camera: F3.5, ½₅ sec., ISO 1600.
© *Beckett Gladney*

When using framing techniques with back light, your ISO choice is very important; you should use ISO settings between 400 and 1600 if possible. Even with a tripod and cable release, slower ISO settings catch some movement in the subject, which might cause an unwanted blur. While the higher ISO settings have more noise (the equivalent of "grain" in film) than the slower settings, this is acceptable for a framed style of photograph. Note that capturing a portrait that is framed by a darker environment or that will include movement, is one of the few indoor portrait circumstances where you would raise your ISO level beyond 400.

To use this technique have your subject or model lean against a doorframe, stand in an open door, or stand near a window and locate the best vantage to create the shot with the light either directly behind the subject, or to the left or right and slightly behind the subject. If you want to use this technique but

still show some facial detail, get in close, measure the exposure on the face, and then back up. Lock that exposure or go to manual mode on your camera.

You can also use the framing technique with other large props such as a wall that separates a dark room from a light room, an architectural column, or a piece of furniture that acts to completely block out light from a single direction. A person stepping out of a vehicle or coming from a church, for example, is said to be framed, and you can create many interesting portraits by finding ways and means of framing your subjects inside of something else such as the branches of a tree, as shown in Figure 8-17.

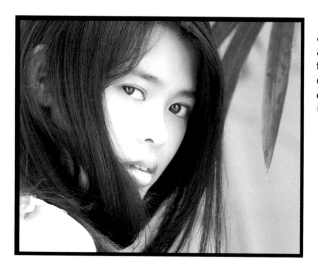

Figure 8-17: Framing a subject — using another major element to lean them against, put them inside of, or have them coming from — is a great way of creating dramatic and unique portraits, especially with children.
© Brandon Hoover

Working with Artificial Light

Chapter 3 discussed the various types of light you will encounter, so you should have a fairly good idea of how to compensate for most common types of inside lighting. The primary thing to keep in mind when encountering lighting on location is that you typically cannot do anything about it and must be prepared to work around it. You will undoubtedly encounter many bare incandescent bulbs, flickering fluorescent tubes, and flashing neon signs.

Common problems and solutions

Assuming you know how to handle the different types of light sources (fluorescent, halogen, and so on) discussed in Chapter 3, the vast majority of problems involving interior artificial light situations revolve around situation-specific informal portraits. If you want to shoot the Rolling Stones in concert, for example, or the dancers on stage at a night club, or your daughter's gymnastics meet, each type of situation presents slightly different problems and requires slightly different solutions.

Distractions

A common problem you will encounter with artificial lighting is that it can distract from the image you are trying to produce. I always carry two or three thick black poster boards with me to deflect light away from my subjects if I am photographing them outside of the studio. As much as you need reflectors to

bounce light back to the subject, you may need a device to keep light away from the subject if it is undesirable, such as that from a yellow cast table lamp or an overhead fan-light. Without a doubt, the quickest and often best solution for a distraction in the background, particularly a lighting one, is to simply crop closer to the subject's face, as shown in Figure 8-18.

Figure 8-18: Very often the best method of avoiding distractions is to crop closer to the subject's face and allow the light to act as an enhancer. Camera: F2.2, ¹/₁₅ sec., ISO 200. It is not only the light source that can be distracting, but the color and quality of the light can affect your meter readings, throw an unattractive hue on the subject's face, or create unwanted shadows.
© Amy Stanton

Coping with unwanted color cast

Often you will find yourself working in a client's home or place of business. Although there is plenty of light, the color it throws or creates when combined with your own lighting may be unpleasant and unflattering. Being careful not to set fire to anything or cause any damage to your client's property, you can do a few things to correct poor color cast.

You can simply use photocopy or printer paper and cut disks the approximate shape of lighting fixtures that will accept them to use like gels or color filters, fitting them over the opening (but not touching the bulb). This reduces yellow cast from desk lamps, overhead pot lights, and all manner of standard or pole lighting fixtures.

Similarly, you can use white garbage bags (the small kitchen size ones are perfect) to place loosely over table lamps, and a white sheet draped across a large open doorway from which strong artificial light is pouring can create a semi-lightbox effect in the room you are in. The objective is to create even and nondistracting light, and the best way to do this is to spread it out through diffusion and remove it through deflection.

I sometimes travel with an 8-pack of full-spectrum bulbs, which I use in the client's existing household lighting if I cannot correct the ambient light cast in any other way.

Note Most cameras and all good photo editing software allow you to make color corrections anywhere from a minor shift of red balance to the complete removal of a color from the image. When faced with artificial lighting conditions, I recommend living with poor color cast in favor of good lighting quality (enough light) because this aspect of the photograph can be so readily and expertly changed and corrected in post-processing or, in many cases, in the camera itself with the use of white balance and programmed exposure settings. To make most corrections in the camera, you can use the white balance setting (see Chapter 3) to match the lighting situation. Most interior lighting situations benefit from having your camera set to its tungsten or indoor setting, if it has one.

Special Lighting Conditions

You will doubtless encounter situations in which you are required to shoot under conditions that are out of your control. You must learn to make do with what is available. Two common situations you will run into as a portrait photographer are shooting in public performance venues such as theatres and clubs, and shooting fire or candlelit scenes. It is hard to imagine the newly married couple who does not want a romantic mood photograph that involves candle- or firelight, and it is impossible to imagine you will not have to, one day, shoot in a theatre, arena, gymnasium, or club.

Stages, theatres, and clubs

Most performance venues share one distinct advantage. Generally, the stage area is well-lit, and the lighting is concentrated on the subject. Given that lighting won't be a problem, the most common problem will be that you're either far from the stage or too close to the stage.

Photographing from a distance

Unless you'll be satisfied with establishing shots (those shots that reveal the entire stage area, establishing the scene of the event), being far from the stage means you'll be shooting with a telephoto lens. If you have the option, select a fixed focal length lens rather than a zoom lens. Although the zoom lens offers more variety, prime lenses are lighter and generally faster (a wider aperture allows more light through more quickly). The lighter weight makes it easier to keep the lens steady, and the larger aperture permits a faster shutter speed and provides a better viewfinder image.

It's unlikely you'll be permitted to set up a tripod in these sorts of venues. This is where the collapsible monopod pays for itself. A monopod gives you the necessary stable platform for using a long lens without being disruptive or taking up a lot of space.

If your digital camera offers a spot meter option, I suggest you use it. Because of the distance and the fact that the stage area is usually much more brightly lit than the surrounding area, any sort of matrix metering might be misleading. With spot metering the exposure is determined by target area. This permits optimal exposure regardless of the background lighting, as shown in the stage portrait in Figure 8-19.

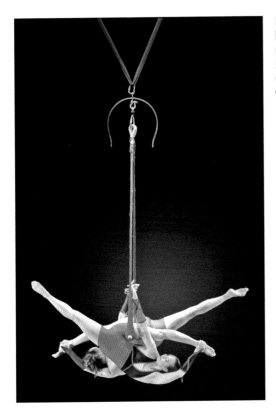

Figure 8-19: Pick your subjects out of the background and get the right exposure with spot metering in stage lighting conditions. Camera: F2.8, 1/160 sec., ISO 1600.
© *Stephen Strathdee, courtesy of Air Dance Bernasconi, Cirque du Soleil*

Photographing up close

Photographing near the stage gives you the possibility of using your flash (obviously, not every venue permits flash photography; it can be distracting to the audience and, more importantly, to the performers). If the venue permits flash photography, you must then decide whether to rely on front curtain or rear curtain flash. This is discussed in more detail in Chapter 3, but as a reminder, front curtain flash fires immediately after the shutter opens fully, whereas rear curtain flash fires just before the shutter closes. Each type of flash gives a different effect.

Again, it's generally preferable to use fast, fixed focal length lenses in these interior situations. When close to the stage you'll probably want medium-to-wide-angle lenses, say anywhere in the 37mm to 72mm range. In addition, unlike being far from the stage, you have a wider range of light metering options.

The universal solutions to shooting performance venues

In either situation, close to the stage or far away, there are camera settings and techniques you can use to increase the odds of getting the portrait you want. Most importantly, set your ISO to a higher rating. As you know, the higher the ISO value, the greater the camera's sensitivity to light, giving you an increased ability to shoot in low-light conditions. However, higher values also introduce graininess and increased noise to the image. For most portraiture I would not recommend using an ISO above 400 (unless, of course, you want a grainy image).

If your camera has an automatic bracketing feature, consider using it. The additional exposures eat up memory, but that's a small price to pay. The same applies to a continuous capture mode. If your camera allows you to shoot multiple consecutive frames in a burst, consider using it. After all, you may only have this one opportunity to take the photographs.

Finally, anticipate the action on stage. Whether you're photographing a dance recital, a burlesque act, or a rock concert, you should be able to foresee where much of the action on stage is going. If you're prepared, you should be able to capture the decisive moments, as shown in Figure 8-20. This is particularly true with digital photography because many DSLR cameras have focus and exposure lock, and you can follow the action in your viewfinder and be prepared to press the shutter button when it "hits your mark." It's worth checking your manual to see which of these, if any, your camera offers.

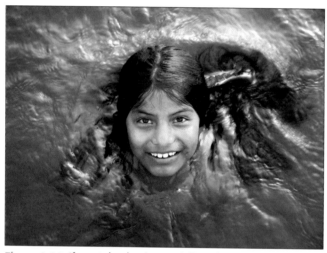

Figure 8-20: If you take the time to follow the action and get a feel for how the motion is going to go (the same technique you use in panning), you can be ready for the right moment.
© Ryan Brenizer

Portraits with fire and candlelight

There is nothing more romantic and intimate than candlelight or the cheery light of a fireplace. For the portrait photographer, however, there are few settings more fraught with difficulty.

The primary factor to be considered when shooting by firelight is the fact that the intensity of the light drops away incredibly quick. The nature of fire is such that every foot the subject moves farther away from the open flame, the level of light decreases dramatically. For example, there might be enough light to photograph a person sitting two feet from a fireplace, but not enough to photograph a person sitting three feet away.

In addition, flames flicker. To the naked eye, that shimmering light is attractive and romantic. To your digital camera, however, it means a long exposure, and what you see as flickering is recorded as an omni-directional blur of light. If that's not trouble enough, the long exposure radically increases the odds of the subject moving, which results in unwanted blur.

So, how to shoot a firelit/candlelit portrait that renders a crisp, clean image of the subject *and* captures the romantic essence of firelight? As might be expected, use the fastest prime lens you have. Set the ISO rating as high as you dare without sacrificing the image to grain. But that's usually not enough. That leaves only one other option.

You cheat, of course. One way you can cheat is to light a lot more candles and place them away from the main action, but close enough to provide more light. You can also place reflectors or, better yet, mirrors, off to the side to catch the firelight and redirect it back at the subject. This technique was used to capture the portrait shown in Figure 8-21.

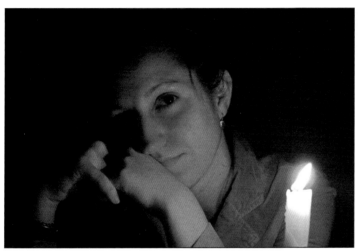

Figure 8-21: To improve a candle or firelight portrait, you can use reflectors or mirrors to the side to catch the firelight and redirect it back at the subject. Camera: F4.5, ⅕ sec., ISO 200.
© Cam Barker

Finally, you can use indirect fill flash. By bouncing the flash off the ceiling or a nearby reflector, you can illuminate the subject and freeze the motion of the flames without losing that special warmth provided by the firelight. It's a bit more work, but the result is well worth the effort.

✦ ✦ ✦

9 Studio Portraiture

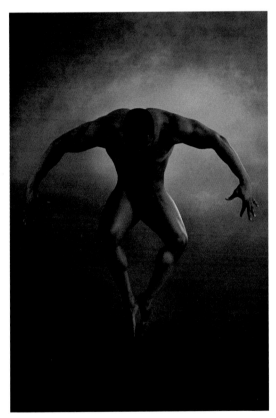

© Stephen Strathdee

While it's fun and often interesting to go to location shoots, making portraits in the studio is where you can really shine and put all of your technical and creative talent to work. Chapter 3 covered many of the basics of composition, including backgrounds, for many typical portrait situations, and this chapter will help you go beyond the traditional head shots and other "bread and butter" portrait types.

More and more often people ask me to create nontraditional portraits of them for their own or their loved ones' enjoyment. Among other things, I have found myself dressing a girl in a sundress, placing her in a field of tall grass, putting an antique frame around her upper body and taking a photograph. There is a requirement for creativity and inspired solutions for the successful portrait photographer. Digital cameras have made this more and more possible—you can try a hundred things without the substantial cost of film and processing. And in your studio you are King or Queen; this is your space, you're in control, and you can make whatever you want to make.

It sounds corny, but it happens to be true: in photography you have all the elements of magic at your disposal, and you can not only pull rabbits out of your hat, you can also pull them out in seven colors, if you want. And I am not talking about so-called trick photography or fancy effects using digital imaging software. I'm talking about taking your basic tools and running with them. Your basic tools are your camera, your lighting, yours props, and most importantly, your imagination.

I urge you to keep in mind while doing any portrait work (and particularly in the studio), that portrait photography is a relationship, however short, between yourself and your model. The quality of that relationship has a direct and significant impact on how your portraits will turn out. Simply, stress or tension and especially discomfort will cause a subject's facial expression and body language to undergo subtle but discernable changes that will reflect badly in the finished portrait. If you are able to put your models at ease and create a warm, comfortable environment, you will make better portraits and everyone will be happier.

Studio Backgrounds

Aside from the models themselves, the background of a portrait is the most critical aspect to consider when planning a composition. By "background" I do not mean only the backdrop itself; I mean all of the elements that are neither the model nor the subject but still part of the composition. As shown in Figure 9-1, these can include backdrops, clothing and accessories, scenery, other people, or lighting effects and props that you purposefully include. Aside from lighting (see Chapter 6), those that will mostly concern you are backdrops and props.

In all cases, no matter how you arrange or block out the area around and behind the model, there are a few basic guidelines you can follow for arranging the backgrounds of your studio portrait compositions.

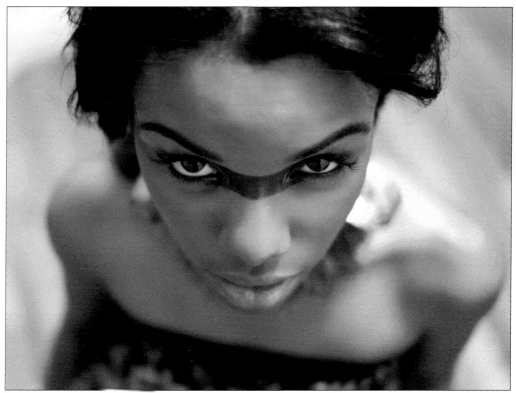

Figure 9-1: This Cindy Blu portrait uses well-placed bits of color and a dramatic streak of complementary facial color to harmonize the subject with her surroundings without overwhelming her face. Aperture: F1.4 ISO 400. No external lighting. Room was lit by incandescent light.
© Ryan Brenizer

Enhance, never overwhelm

A background is meant to provide context and interest, but in no way should it overwhelm the subject except in rare cases where you may want it to (such as posing a ballerina so she is slightly more vague than the ballet slippers she is holding up in front of her). Keep in mind that you can have more physical background than model in a composition and not overwhelm the subject; you will just have to balance the elements carefully using light and color. It is not the amount of background space versus subject space that is most important; it is the value of those spaces and whether they meld together to create a unified whole. The portrait shown in Figure 9-2, two-thirds of which is background and one-third of which is subject, maintains good overall balance and is very visually interesting. It is not a matter of strict mathematics, but one of context and visual value. How does it *look*?

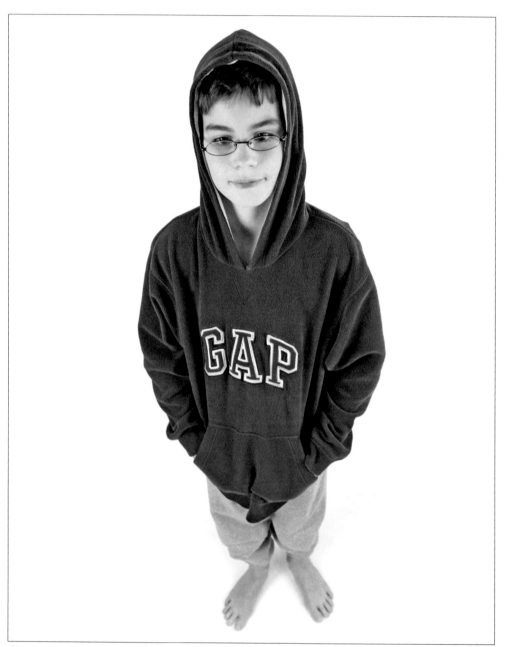

Figure 9-2: By using the Rule of Thirds and paying attention to light values, this unusual portrait is a definite success. Camera: F5.6, 1/30 sec., ISO 100, Evaluative metering. Lighting: two 1,000W tungsten softboxes (1) front, to the left, and (2) rear, on backdrop. One 500W tungsten softbox used as right side fill. No flash.

© *Stephen Strathdee*

Background color counts

The reason that most portraits are performed with black, off-white, or neutral backdrops is that there is less chance of a clash with the model's skin tones, hair coloring, and clothing. The on-location photographer often has only those colors available. In your studio, however, you can have any colors you want, and I cannot recommend highly enough the value of owning as large a collection of cloth backdrops, tarps, dividers, posters, and old rolls of wallpaper as you can manage. All of these things can be found inexpensively at discount and department stores (and don't forget Goodwill and used clothing places). You can tailor your portraits more closely to your model and avoid a generic look if you have clever and unique backdrops — and I think it's safe to say that very few people want to look generic in their portrait.

The human eye needs contrast for visibility and legibility; contrast creates interest and helps deliver accurate information. The background tone establishes the basis for contrast in a portrait and must be balanced with what you are putting in the foreground. A *low-key* (dark) background attracts attention to lighter areas such as the face (Figure 9-3). If the background is *high key* (light), the viewer is attracted to the darkest or most colorful areas of the portrait, usually the hair and clothing (Figure 9-4). A middle-toned background causes the dark and light areas to compete for attention, which can be used as an effective device for guiding the eye, or which can become a problematic distraction (Figure 9-5).

Do a Background Check

✦ Background color should contrast with the skin tone of the subject. Two ways to obtain contrast are by using colors that are opposite one another on a standard color wheel, or by using warm/cool colors in combination with one another. See Table 9-1 for descriptions of color types.

✦ Bluish or other cool-toned backgrounds create needed contrast with warm Caucasian skin tones, while red or other warm colors make good choices for skin tones with a yellow cast.

✦ Red is both a primary color (which causes a strong sensory response in people) as well as a warm tone, similar to a Caucasian skin tone. Subsequently, a red shirt or background in a portrait can overwhelm the face. Red should be used very carefully and, generally, sparingly, and care must be taken to use the right hue of red when working with it as a photographic element.

✦ Analogous colors, or those that are close in value, tend to blur together, causing an indistinct, unfocused edge. A black shirt against a dark blue background is hard to read. When the color value is too close between the model and background, it can create legibility problems. Alternately, when the color value is close, but not too close, you can create extremely compelling photographs that have the general characteristics of a sepia or black-and-white image.

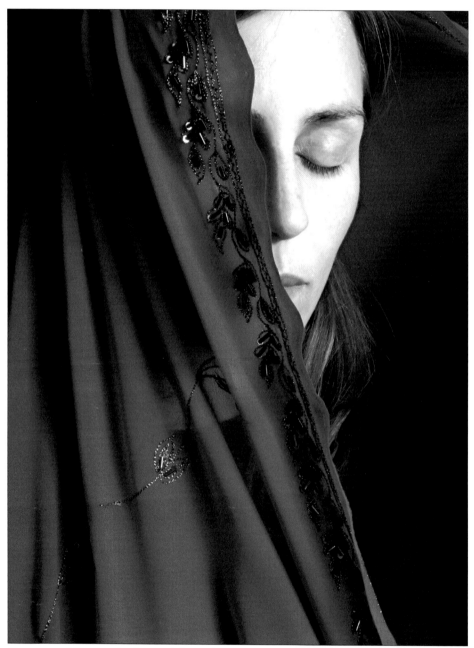

Figure 9-3: A low-key background draws the viewer's attention to the model's face and keeps the subject area distinct. Camera: F8, $\frac{1}{60}$ sec. Lighting: single self-contained studio strobe with umbrella, placed to the right of the subject and angled downward.
©Rachael Ashe

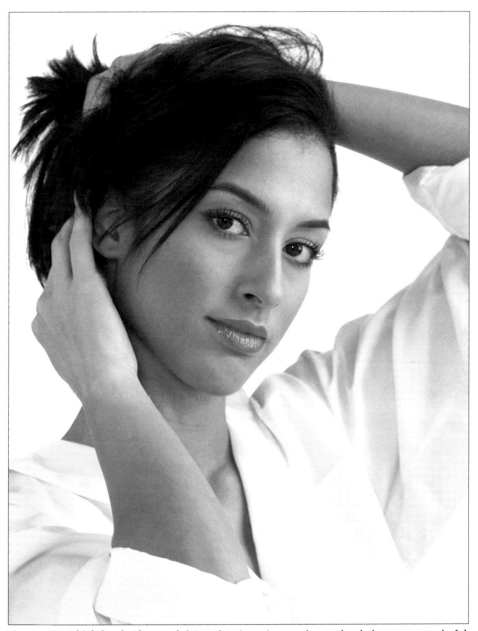

Figure 9-4: A high-key background draws the viewer's attention to the darker or most colorful areas of the composition, which is often the hair, eyes, or clothing. Lighting: two heads bouncing into v flats shooting thru 4-x-8-foot tough Rolux scrim on her left, filled with foamcore on her right and black foamcore behind her to retain an edge on both sides. Directly over camera is small softbox at low power to open up shadows. Camera Settings: F8, 1/60 sec.
© *Sean Harrington*

Tip

Light-colored clothing and props are usually best for high-key portraits because if they are too dark they will compete for attention with the model's hair and eyes. In that same vein, high key portraits are best suited to dark haired and, in most cases, dark-eyed people.

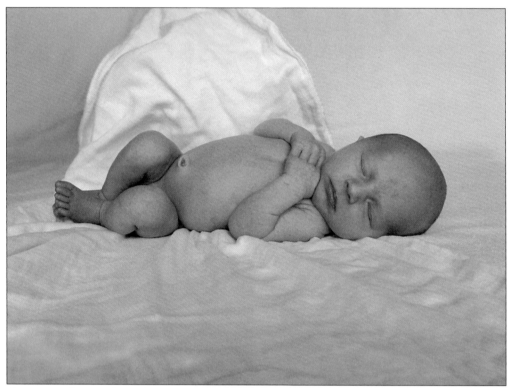

Figure 9-5: The use of a mid-tone backdrop is a very effective way to photograph unclothed infants and other subjects where the model is showing a lot of a single. Camera: F3.4, ¹⁄₆₀ sec., ISO 100. Lighting: existing light from a large window facing the baby. A white sheet was placed behind six-day-old Anna to lighten the photo.
© *Janet Leadbeater*

	Table 9-1: **Color Types**
Type	*Description*
Complementary	Complementary colors are opposite from each other on the color wheel. They contrast pleasantly because they do not have any common or shared colors. Green is made by mixing yellow and blue, so it will complement red, for example. As a rule of thumb, try and orchestrate portraits so that there are at least one set of complementary colors inside of the background and subject area. Usually the easiest way to achieve this is to have the background or some element in the background be a complementary color to the model's skin tones or the largest part of the model's outfit.
Analogous	Analogous colors are right next to each other on the color wheel. They do not provide a lot of contrast because they have a color in common. Red, orange, and yellow are analogous because red and yellow make orange, for example. These colors can be used very effectively in creative portraits, but you must be cautious not to allow the subject to get lost in the background or inside a palette of too-alike colors. In some portraiture (babies and young children, for example, where the intent is to provide a very soft environment) you may choose to use analogous colors to very good effect. Generally, light analogous colors will work better than dark ones. Use back/rim accent light to provide separation as needed for these setups.
Cool	Cool colors are made primarily of greens, blues, and purples. They remind you of cool things and make you feel cooler and refreshed. If you plan to show a lot of skin detail or to create a muted, pastel-style portrait with a lot of diffusion, cool colors will often work best.
Warm	Warm colors are made primarily of red, orange, and yellow. They remind you of warm things and make you feel peaceful. They are most often used in backgrounds and backdrops because they provide a sense of comfort and safety.

You should have a destination in mind for the viewer's eye when you compose and light a photograph. This will be what is commonly called the *center of interest*. The overall tonality (the relative darkness or lightness) of the photograph plays an important role in attracting the eye, but it is typically the background, not the light on the center of interest, that controls where the viewer's eye is attracted. The secret of predicting and controlling eye movement, and thus interest, is in careful control and modulation of the background.

Background light on a dark background is used to modulate the appearance, not illuminate it evenly. As illustrated in Figure 9-6, keep the edges of a low-key (dark) background dark and out of focus, and the center area behind the model's head brighter. This will draw attention into the photo from the edges toward the face or center of interest. The dark, poorly defined edges create a visual buffer of negative space that prevents the viewer's eye from wandering out of the photo.

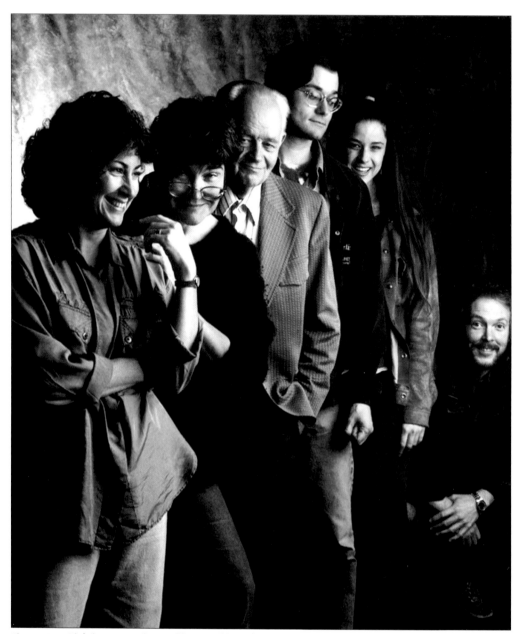

Figure 9-6: Lighting: 4-x-6-foot softbox positioned camera right, with a fabric reflector to camera left. A second light was directed onto the background from the opposite direction. The result is a buffer of negative space around the edges of the portrait.
© Patrick Power

Props

You could fill an entire book, or a shelf of books, on matters related to props. For the sake of easy discussion, let's identify *props* as being all things not the subject, the actual background, or the light. Some props you move (columns, silk plants, and wall hangings), and others are part of the model's attire (make-up, clothing, or accessories). Things attached to the models are covered in the section "Clothing," and this section, necessarily brief, covers basic children's and general props.

Note

> All fine-art students and photography students have something in common: they study composition and color theory and generally work on the same principals. One of the best ways I know to improve your skills as a portrait photographer is to study fine-art paintings, particularly those of the old masters such as Vermeer and Rembrandt and Kruger. From these geniuses of the form you can learn about lighting, color, composition, and the use of props. While you're studying, don't discount women's fashion magazines, because some of today's most innovative portrait work is being done under the guise of advertising and fashion photography.

The things you might want to keep in your studio depend upon the sorts of portraits you want to create. If you'll be creating passport photos, corporate work (head shots for company materials), or other formal work, you will not need much more than a light, a dark backdrop, something for the model to sit upon, and something for them to lean upon.

Children's props

If you photograph children, I recommend you endeavor to keep the following items in your studio:

+ **Carpet- or soft-cloth-covered posing box.** Generally these are best in a slightly off-white color. Be careful not to use a yellow-based shade of white.

+ **Light-colored or white cloth background.** Use one that can be folded and draped (hung loosely) and which, optimally, is slightly transparent.

+ **Small toys in each of the primary colors.** For babies and toddlers, other good selections for holding or composition props are balls, sets of blocks with letters and numbers, and natural-finish wooden toys. (Please make sure the toys are washable and do no present a choking hazard.) For older children it is often best to get them to bring a prop of their own suitable to their interests or hobbies such as a guitar, telescope, or a chess board (this applies to adults as well).

+ **Costumes.** Although effective for children's portraits, buying costumes can lead to a lot of expense and trouble. If you want to have options for customers but don't want to build large costume inventories, you can keep a selection of hats and solid color t-shirts on hand (see Figure 9-7). Children's portraits often look best and have the most impact when the facial features are surrounded by bright primary colors. This is where the colorful hats and t-shirts in your prop closet can come in handy.

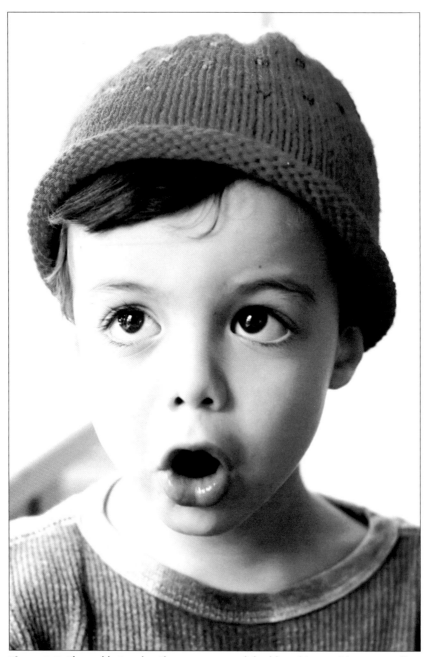

Figure 9-7: The red hat makes the eyes pop, and the blue shirt provides an excellent balancing effect. Camera: F2.8, ¹⁄₁₀₀ sec., ISO 800. Lighting: 100% natural from a large window.
© *Myra Klarman*

Multipurpose props

Some things are always useful to have in the studio because they suit a variety of situations. As a caution, couples are the easiest to shoot because there are two of them in the composition already, and props tend to be inappropriate. Obviously this is not the case with special functions and the in-studio portion of a wedding or event package, but as a rule, couples tend to work best without any other elements in the image. Keep in mind the following studio props the next time you're in the part of town that houses the pawnshops, discount stores, and Goodwill locations.

✦ **Hats, headscarves, high heels.** Obtain these in as wide a variety of colors, styles, sizes, and models as suits your existing clientele or your desired clientele.

✦ **Feathers, gloves, antique glass "bauble" jewelry, a string of colored lights, hair pieces and wigs, small sculptures and confetti.** Using props is a lot like cooking: once you become comfortable with the ingredients you tend not to worry so much about the recipes. You will be able to make an amazingly large number of unique portrait compositions from the same individual props if you are willing to be a little adventurous in the way you put them together.

✦ **Miscellaneous items.** Old leather- or clothbound books, colorful decanters and vases, wax fruit, silk flowers, and odd items like parasols, umbrellas, and embroidered silk robes are always useful. Items such as these give you a lot more options when planning portraits with clients who want something other than a traditionally posed portrait.

Props are very fun and engaging to work with, and clients tend to love being a part of a process that feels artistic and creative to them; however, not everyone will want anything "fancy." Starting with a simple prop, such as the black cowboy hat shown in Figure 9-8, may make the model feel more comfortable. In the figure, Darah's portrait — beautifully presented with a splash of bright, positive solid color — is taken a notch higher with the addition of a simple prop. The black cowboy hat presents as negative space, but her hands on top brings the viewer's attention back down to her face again. The effect is compelling and interesting and beautifully suits her elegant features.

For some people, however, any props and devices like layered backgrounds — or even a simple hat — will make them feel silly or uncomfortable. In these cases, the props you use must be compositional and positioned in the background. Be sure that you are creating a portrait the model will appreciate. A tense or uncomfortable model creates a tense and uncomfortable portrait.

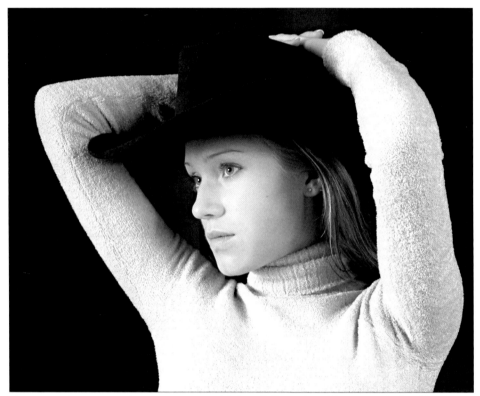

Figure 9-8: Camera: F9, ¹/₂₅₀ sec., ISO 100. Lighting: (left) strobe with 48-x-36-inch white softbox shot at minimum power; (right) strobe with 36-inch silver umbrella reflector at about one-third power. An assistant held a 36-inch white reflector to the front and under the model's chin to fill in shadow under her hat.
© *Gary S. Evans*

Clothing

In portrait photography, you usually want to draw attention to the model's face. At the very least, you do not want to distract from the model or create a diversion inside the portrait. As discussed earlier, color, backgrounds, and props all affect the impact that the final portrait will have, but clothing and other accessories deserve a special mention.

The rules for clothing (considering the previous color advice) are generally very simple:

✦ Clothing choices should be made carefully with the objective of flattering the subject while maintaining focus on the face. Avoid clothing that distracts the eye, such as overly bright or neon colors, busy or graphic patterns, strong stripes, or noticeable texture or sheen.

✦ Except for infants, where we are conditioned to expect to see a lot of it, large areas of visible skin can distract from the model's face. In some cases, such as a dancer or athlete, this is acceptable, but in other cases it is not. Generally it is a good idea to avoid sleeveless clothing. Poses that are usually flattering may also cause bare arms and shoulders to appear larger than they are.

✦ To accentuate a model's face, limit the number of colors in the composition, particularly those in the clothing. A single color for all clothing accents the face most dramatically. Two or, at most, three colors for larger groups are also effective. For black-and-white photography, treat tones like colors and limit the number of contrasting tones.

✦ Focus attention towards the faces by having the model wear a contrasting color or tone on the upper body, but a tone or color similar to the background on the lower body. By blending the color/tone of the lower body and background, the eye is drawn away from legs and hips.

✦ When making group photos, any color used should be repeated at least once. No subject should wear a color that is not worn by at least one other person unless the whole intention of the portrait is to draw that one person to the viewer's attention. Alternately (and especially when using black-and-white, as shown in Figure 9-9), you can choose to have analogous color tones amongst a group of people.

✦ With children's portraits, slightly different guidelines apply. Children, especially babies and toddlers, can draw more attention — even in a group — and it's perfectly acceptable to dress or costume them in stand-out clothing. Brighter colors, playful and even slightly busy patterns, and bare skin are all acceptable for children.

✦ Unless intentional, avoid the use of contrasting textures (such as satin and canvas) or patterns with opposing directions.

✦ Any distracting jewelry should be removed before the portrait is taken, particularly necklaces which can severely alter the flow of a portrait.

Gender Differences

If women are dressing themselves when coming for a sitting, they should choose a simple, flattering neckline and a hairstyle that is natural for them. If they wear eye make-up, it should be applied heavier than what is normal for them because the camera has the effect of removing eye make-up. Hair that surrounds the face, rather than hair that is pulled back tightly or set in a severe style, generally provides a softer framing effect.

For the male portrait, a close shave is usually preferred, and a five o'clock shadow should be avoided unless you wish to intentionally capture a more casual-appearing portrait. Because men do not usually wear cosmetics or apply oil blockers and sunscreens, it is usually a good idea to pay special attention to lighting and have neutral face powder on hand for shiny spots.

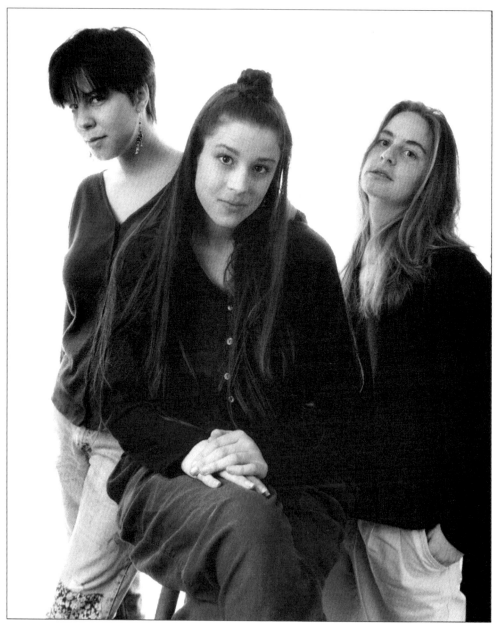

Figure 9-9: Shot in the client's living room with a softbox as a backlight, the analogous color tones create a cohesive portrait where there is a strong sense of "group." Lighting: 4-x-6-foot softbox served as the backdrop and power on the flash was turned to its lowest setting. The flash was then bounced off an umbrella and the ceiling from over the photographer's left shoulder. A fabric reflector was placed to the right for additional fill.
© Patrick Power

Vignetting in the Studio

You arrange the backgrounds and the model. You set up props and lighting. You crop the finished image and the customer mattes and frames it. These are all *vignetting* processes and are very important when creating a portraiture portfolio.

Simply, vignetting is a putting a softer, lighter, or darker area of negative space around a portrait so that the subject is clear and compelling to the eye. In the old days, portrait photographers carried vignetting cards that they would attach to the front of the camera lens to provide a soft edge or "frame" to the portrait. As discussed in Chapter 8, this effect can be achieved on your digital camera by using a center spot filter. It can also be done, as discussed in Chapter 13, in the digital dark room with software. Many or most portrait compositions can be improved in the darkroom, and many will need to be balanced with cropping and vignetting.

Vignetting is not only a style of portraiture — a "trick," if you will — it is also a fundamental part of composing a portrait. All photographs need a negative space buffer; it is very important to keep leading lines and other distractions away from the edges because they will draw the viewer away from the center of interest. Arms and legs, or anything that creates a leading line, can cause all sorts of compositional problems. A very good way to ensure that nothing "falls off" the edge is to use leading lines (such as those created with the model's arm in Figure 9-10) to your advantage. Place them so they direct the viewer's attention back to the face and not away from it. If you pose your subject with one arm gracefully laid over a chair and then cut the hand in half with the edge of the photo, the viewer will follow that leading line right out of the photograph. Think vignette even if you don't actually create one.

You've heard of thinking outside the box? Well, in this case I am advising you to think inside it. A photograph has a finite edge — a specific dimension — and controlling the edges is every bit as important as controlling the main action.

By far the most important way you will vignette your portraits is while you are setting them up, as part of the composition. Planning for a little empty or negative space around a subject provides balance to the portrait and a visual buffer for the viewer. This negative space or buffer is the vignette and can be achieved with color, texture, or a loss of focus. A natural vignette can easily be created around a subject by using a wide aperture to create shallow DOF (only the face itself is in clear focus), as illustrated in Figure 9-11.

It is not always possible to vignette or provide negative space (a tight facial shot, for example) around a subject in a portrait. In situations like that you can create the same effect in the finished product with a color matte which closely matches the background color, or which is slightly darker (for dark backgrounds) or lighter (for light backgrounds). Balance is then achieved by applying the rule of thirds while cropping the combined portrait and matte.

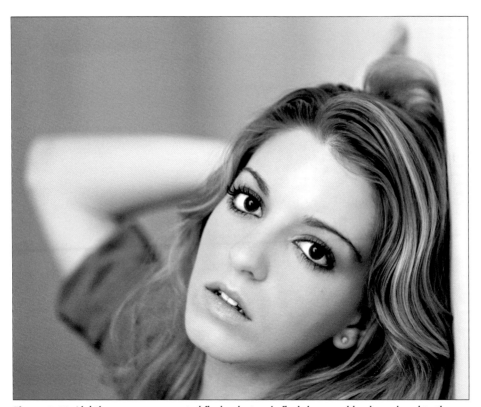

Figure 9-10: Lighting: camera-mounted flash, electronic flash bounced backward and to the upper left to use white hallway as a makeshift softbox. Camera: F1.4, ¹/₁₂₀ sec., ISO 100.
© Ryan Brenzier

Figure 9-11: A natural vignette effect created with a wide aperture is very popular with children's portraits because of the dreamy, angelic quality it can add to the photograph. Camera: F2.8, ¹/₁₂₅ sec., ISO 200. All natural light.
© Timothy Stratton

Theme, Art, and Abstract Portraits

This is an area where you can really have some fun. Theme, art, and abstract portraits are not for everyone, but they are usually the ones everyone remembers. When creating your portfolio book—the one that you show prospective clients—I recommend having a separate section for the work that falls into these categories; for every person who says, "Hey! That's cool," other people will run away in fear if they think you're planning on dressing them up in a boa and putting them under multi-colored spotlights with a top hat and a pair of four-inch heels.

Tip Your extreme props can be used here—the blazing red chiffon scarf, the leopard print raincoat, the old beaded curtain from the sixties

A large part of my portrait business is with these exact shots, and the typical customer arrives saying, "Let's do something fun!" They're not after an exact likeness or a representative headshot; they want pizzazz and fun. They want something to hang on their wall that is artful and interesting. The best compliment I may have ever received was from a client who, upon receiving her finished portrait, happily exclaimed, "People will not believe that is me!" See Figure 9-12 for an excellent example; you cannot identify the model in this portrait, and thus it becomes an abstraction, a photograph of an archetype. These styles of portraits are very popular with people who work in the arts and are very compelling as pieces of hanging art in addition to their value as a representative portrait.

Tip Plan on using extremes. Generally you light more (or less) than you would normally because these shots are all about dramatic effect.

Not that I recommend making all of your portraits so that the subject is not recognizable or altered so much that they do not look like themselves (I've spent all of this section explaining why *not* to do that!), but sometimes this is, indeed, exactly what you will be aiming to do. I have created portraits for people that showed none of their face, only their legs, their hands and feet only, the backs of them and, once, the soles of their feet and their eyes/forehead only.

Figure 9-12: For some people, the essence of them is not contained in their facial features. Camera: F2.8, ¹⁄₆₄₀ sec., ISO 3200. Evaluative metering with -²⁄₃ stops exposure compensation was used. Lighting: dual backlight spots. No flash.
© Stephen Strathdee

In these cases, the model is typically treated like a prop. This is not meant disrespectfully, but practically. The aim of most abstract or art portraits is to provide a representation of some aspect of the client, not the client's exact physical form. A silhouette of a teacher at a blackboard, a basketball player in the middle of a lay-up, and an actress in front of a make-up mirror are all simple ideas in this theme. The portrait of a teenager shown in Figure 9-13 was taken after an hour-long brainstorming session with the client and her mother where the daughter wanted something "cool" and the mother wanted something "soft and sweet." The pose shown here became the compromise after the mother exclaimed, "We have to see your eyes! They're so pretty!" and the daughter said, "Okay, I could live with daisies."

Note Portrait photographers often use the style of another well-known photographer as inspiration for creating portraits, as shown in the Loretta Lux homage in Figure 9-14. Check out the library and the Internet for other examples.

A few hints for planning and executing art or abstract portraits:

Using Graphic Shapes

Graphic shapes and compositions (chunks of color, leading lines, background texture) work very well with nontraditional portraits, and sometimes the rules are bent backwards — such as outfitting a model

in black-and-white striped pants, a black-and-white checkered jacket, and a black-and-white polka dot hat against a bright red or yellow background. Think big. Think bold. Think innovative.

Creating Shapes with Light

Using light effectively is one of the best ways to create dramatic effects in photographs. A bright side light at 90 degrees (perpendicular) creates a "half face" look. A light aimed directly down on top of the model creates extreme shadows and an elongated appearance to the face. A light aimed upward creates thick shadows and a shortened appearance to the face. Light aimed directly at the middle of a model's face flattens and broadens its appearance.

Figure 9-13: Lighting: Single softbox in front of subject, angled down at 45 degrees, silver reflector under subject's chin. Camera: F2.8, ¹/₂₀₀ sec., ISO 200. Lighting: small softbox directly in front of model.

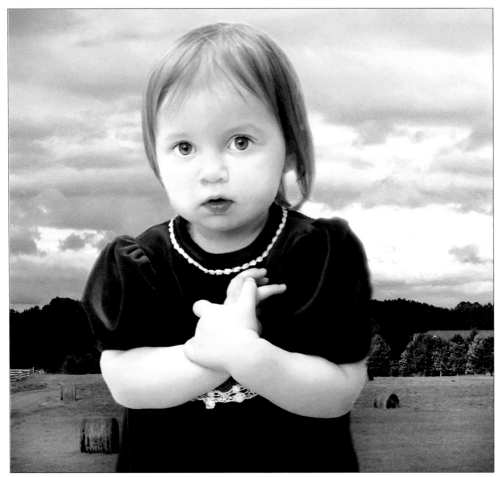

Figure 9-14: Inspired by Loretta Lux, this lovely portrait combines traditional elements, such as the formal dress and pose of the child, with a few creative twists, like the extreme perspective and background that looks like an oil painting, to create a wonderful and refreshing portrait. Lighting: all available mixed-light.
© *Siobhan Connally*

Black-and-White and Toned Portraiture

Black-and-white portraiture is not coming back in style—it never left in the first place. It's a classic and will often be requested for corporate head shots; and, of late, I have noticed that many people want at least some black-and-white or sepia work done for events and weddings. Although black-and-white digital photography is not the same as applying a sepia tone in post-processing or using the sepia setting on your camera, they function in a very similar way in that they each use tones instead of color for basic compositional contrast and interest. Portraits performed in this style follow all of the same rules as every other style except that you plan for tonal variation instead of color variation.

The advantage of black-and-white and other tonal portraits is that they provide a very balanced canvas, generally, and the character of the individuals can often be more evident. In particular, black-and-white and tonal work is very well suited for small groups. Figure 9-15 captures the band Woodswork just before their first set. A bright center spotlight provides contrast and works like a gathering place for attention. The eye comes back to it over and over again and travels outward toward the faces of the individuals. Expert compositional vignetting leaves a buffer of negative space and the portrait is a stunning success.

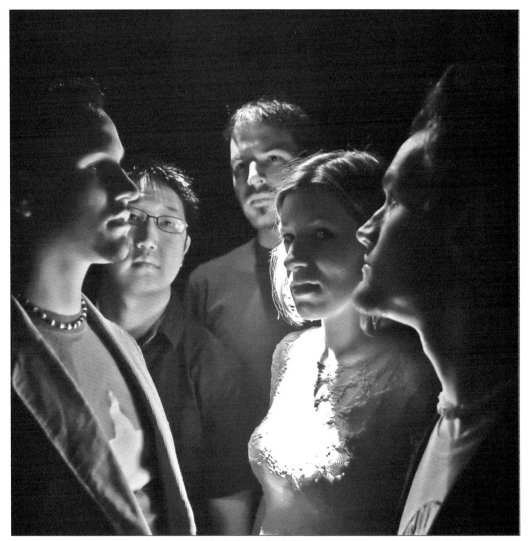

Figure 9-15: The photographer, when asked about the lighting, replied, "Lighting was a single overhead spot, directed at an angle on the girl. Might have been nice to have it diffused a bit, but I liked the edginess it provides." Camera: F2.8, 1/80 sec., ISO 3200, Evaluative metering. Lighting: one 200W overhead tungsten spotlight. No flash.
© *Stephen Strathdee*

Black-and-white mode, which is really a spectral range of gray tones, can give portraits a more refined and ethereal appearance. Many cameras offer a sepia mode that takes pictures in varying brown tones, which are warmer than the grays of black-and-white.

Shooting in black-and-white can become more interesting, ironically, when used with color filters. I urge you to experiment with how particular color filters affect the tonal range of non-color photos and how lighting effects are altered when color is absent from the image. A red filter, for example, lightens any red color in the picture and makes it appear as a lighter shade of gray than blue or green. If you can't experiment with actual filters, you can do it in most processing software by applying desaturation and tinting processes. The latest version of Adobe's Photoshop, for instance, contains a collection of filters which give the same or similar effect as the ones you attach to your camera.

Black-and-white is considered a special form of the art by many photographers and cannot be covered in any great detail here. My experience over the years has led me to the following general conclusions about it:

The elderly and those with a very dignified appearance are often best suited for black-and-white or tonal images (see Figure 9-16). "Eduardo plans his life around movies," the photographer says about this model, and adds that this is an unusually restrained outfit for him. A tonal image like this one, analogous in nature, is perfectly suited to his wise face and gentle but playful smile.

Tip Take one or two black-and-white options for keepsake portraits such as first communions, all manner of graduations, and weddings, because many people consider them "serious" and appreciate the option.

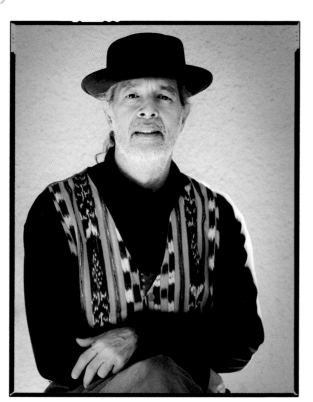

Figure 9-16: Black-and-white and other tonal styles such as sepia tend to really make you look at the model's face and consider the character, beyond simple appearance.
Camera: F2.2, ¹⁄₂₀₀ sec., ISO 200.
Lighting: 100% natural light.
© Jeremy Sheldon

Tip Pay attention to contrast levels when creating black-and-white portraiture. There should be none of either color (no actual black and no actual white) in a black-and-white portrait. This generally means that you need to provide more indirect or diffused light than you might for the same portrait done in color.

From Pose to Print: The Portrait Sequence

You've learned about basic equipment, posing, lighting, and working with models in general, and now it's time to walk through an actual portrait session. Although this section is written as if the portrait was being taken in a studio, the basic steps and stages are all the same, no matter where you are and what conditions you are working with.

Plan and plan again

Planning the portrait is by far the most important aspect of creating something that the intended audience will appreciated. Which leads me to the first cautionary note: make sure you are not satisfying your own creative sensibilities at the expense of the client. You may love a glamorous edge, but some people don't want to be glamorized. They want to be represented. As discussed in Chapter 5, talking to your clients and finding out what they want is important. Here are a few other guidelines you can follow for planning a successful portrait:

✦ Sketch or draw the basic layout on your computer. I find that leafing through art books, magazines, and portrait books helps get the creative juices flowing.

✦ Test and test again. Use yourself or a willing (and suitable) model as a test subject and experiment with lights and colors in your own studio or work area. It's often good to offer up a few ideas and the illustrated examples to show people when they are making their portrait decisions.

✦ Try several variations of your original idea, especially with lighting. Often original and innovative ideas are buried underneath old patterns and habits.

✦ Once you have your general plan you can make sure you have the right color backgrounds, props, or costumes you may need as well as the right lighting, the right lens, and the right camera equipment ready to use.

✦ You can't always plan everything, of course, and in portraits such as the one shown in Figure 9-17, you are waiting for the moment. However, you can still have the model sitting in exactly the right place, with the right lights, so when the moment does arrive, you are ready.

Inform Your Customers

It's a good idea to create a brief and informative pamphlet or handout to give to your clients. Even though you will have talked with them and told them many of the things they will need to know, you shouldn't forget that this is an unusual and often daunting process for many people, and that having a clear reminder of the things they need to know will make the process go more smoothly. You can explain about make-up, clothing, jewelry, and props. Also include information about how long sessions might take, what appointment time and date you have set, and so on.

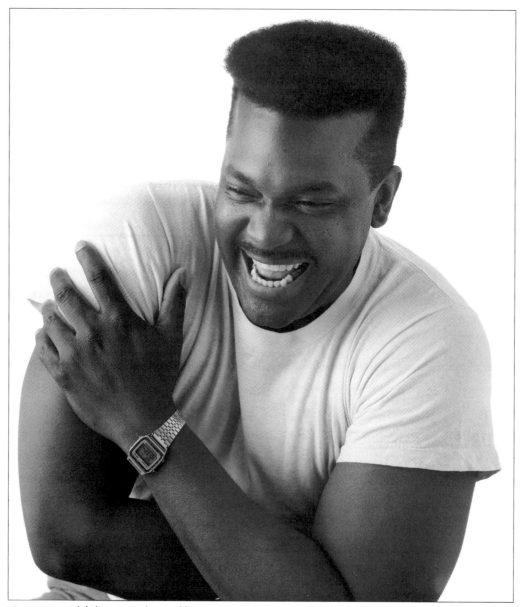

Figure 9-17: Lighting: 3-x-4-foot softbox positioned above and to the left of camera. A second light with a narrow reflector was positioned on the floor behind the subject and pointed up at the backdrop. A 4-x-6-foot fabric reflector was positioned to the right of the camera to add some fill to the shadows.
© Patrick Power

Tip Take a color swatch or wheel with you to the initial consultation so that you can get a good idea of the color families you should be considering for a client's portrait.

Get your lighting set

Choosing the light for a portrait is covered more fully in Chapter 3, which you should read in order to make basic lighting decisions as part of planning a portrait. However, in all cases, you need to arrange your lighting and set it for use. Follow these guidelines:

✦ If you are using continuous lighting such as softboxes, normal household light, daylight, or mixed light, set your props, posing stools, or devices where they will be needed. Ensure everything is at the right height and angle and at the correct distance for your planned shots. It's difficult and distracting to start moving most continuous lighting around in the middle of a session.

✦ Be prepared for anomalies, such as an overcast day or a lot of dark clothing, with a little extra lighting available if you need it.

✦ Test all lighting you plan on using to make sure it is all in working condition (check all batteries and cords at this time as well).

✦ If you have planned your shot carefully and/or have made test shots with yourself or another model, you will be able to create marks (I use masking tape) on the studio floor. Doing this gives you the ability to precisely control light, and your sessions will go very quickly and efficiently. When you are first learning to shoot portraits, I cannot stress enough the value of practice shooting using yourself or another model, and using devices like posing marks to create great portraits with a minimum of fuss and commotion.

After the model arrives

Making the model or models comfortable is one of the most important things you can do to ensure the success of your portrait session. You don't have to become best friends, but you do have to be warm, friendly, and welcoming. In a word, you must be hospitable. Even if someone arrives in the most horrendous shiny striped blouse you have ever seen, do not register disappointment or annoyance — simply find the simple white blouse you keep in your costume cupboard, plan a close face shot, or find a way to deal with the problem after you've had a moment.

Note Most likely, your models have the jitters and are nervous and a little anxious.

I have found that a very good ice breaker is to sit down together and go over the plan you have made, and explain the sorts of poses you think will work and what, if any, costumes, props, or unusual background you will be using. This is a good time to talk about posing expressions, being relaxed, and, above all, having fun.

Tip Be sure to have something to drink on hand; bottled water is always a good bet. It can get very hot inside a photographic studio.

Costumes and props

If you are using any costumes or props, have your model change into them or become familiar with them while you make any final preparations for the portrait. Naturally, if a model needs to change clothing, you need to have a private and secure location for them to do so. It is usually a good idea to get the model posed or onto any mark you have made on your studio floor while continuing whatever conversation you began to have at the start of the session. This is when the models become the most nervous, and any time they have to sit or stand in a posed position while you are silent and occupied with equipment increases any anxiousness that exists. While taking shots with props, it is a good idea to mingle prop shots with shots without the prop so that the portrait does not become too staged in appearance. The collection of shots in Figure 9-18 illustrates how you can keep a model fresh and interested by mixing the props and the poses.

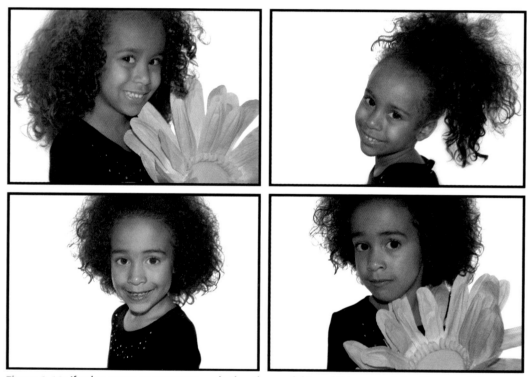

Figure 9-18: If using props or costumes—whether the model is a child or an adult—it's a good idea to alternate poses with and without the prop to keep the model fresh and interested. Camera: F1.4, ¹⁄₆₀ sec., ISO100. Lighting: on-camera flash, backlit by window with white shade.
© Betty Schleuter

Perfecting the pose

Even though posing is covered in more detail in Chapter 5 and lighting in Chapter 3, using the information in those two chapters should enable you to properly pose your model for the shot you have planned. Once you have the basic pose in place, it's time to take some meter readings to ensure that your lighting is set properly and to make any last-minute adjustments to the background or costume arrangement.

The best advice I can give you here is to step back. Literally. Step back so that you can see the entire scene and look at it from a variety of directions. Is the lighting exactly right for this model? Have you posed to best advantage?

Here are several things to watch for at this stage, just before you are ready to start taking photographs:

✦ Are any facial shadows either subtle enough or arranged so that the effect is pleasing and representative?

✦ Squint and look from a distance — do the melded colors and tones seem pleasing when blurred together? This is a surprisingly accurate test for overall compositional balance.

✦ Are all arms, legs, tops of heads, and hair inside the frame and lit the way you want? Sometimes you won't want everything inside the frame; just make sure that it's placed where *you* want it. See Figure 9-19.

✦ Are there any hot spots (spots of bright white/light)? A piece of fabric that catches the light badly? A shiny spot or reflection?

✦ Are the eyes reflecting something that will distract from them?

✦ If you're showing teeth take special care that they catch the light well and that the angle is pleasing. Teeth can easily look crooked or in poor shape with bad lighting. Make sure the models are smiling wide with teeth showing when you meter, if you are planning to show the teeth in the portrait.

✦ Pay special attention to any hair lighting, because many people process and color their hair and the results can vary under light — ensure that hair does not look metallic or "brassy," particularly if it has red tones.

✦ Never shoot around blemishes. They are easy to repair in post-processing, and poses should be performed as if every model had perfectly clear skin.

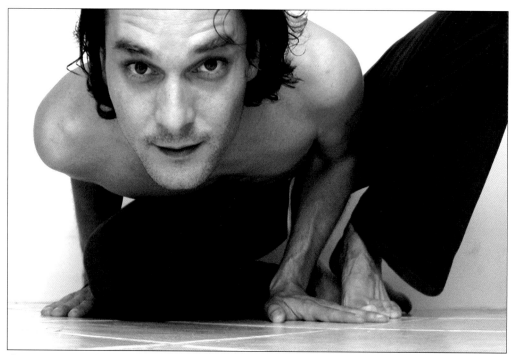

Figure 9-19: You don't always want everything inside the frame or evenly distributed. Sometimes it is the off-center placement of elements or the way you choose to create a slight imbalance in background and model that adds interest, such as in this low-key portrait. Camera: F1.8, 1/25 sec., ISO 191.

© Phil Hilfiker

Metering and taking test shots

When you have all the costumes and props in place and your model is posed in a close approximation of the intended result, it's time for you to step back behind the camera and begin to make portraits.

Chapter 6 talks more fully about meter readings, but no matter which type of metering you are doing, you should take meter readings and make any last-minute adjustments to your camera settings, or put your camera into the appropriate programmed or automatic mode. If your camera is set to an automatic or programmed mode, the last thing it does before it engages the shutter is to take a meter reading. And it should be the last thing you do before you take the portrait if you are using manual settings. Table 9-2 gives you an at-a-glance assistance with the matter of metering for basic portrait setups with single, dual-front, or side-lighting scenarios.

It's interesting to note that one of the ways that you create artistic and creative portraits, as discussed in "Theme, Art, and Abstract Portraits," is to purposefully break metering and lighting conventions. However, this is like many other things: it's very good to know the rules and why they are rules before you set out to break them.

Table 9-2: **Creating and Controlling Effects Using Metering**

	Meter on the lit side of the face — or the whole face in the case of full light	Meter on the dark side of the face or the background
Full Light — Dark Background	Very dark, almost black, background, evenly exposed face. Recommended.	An extremely overexposed face.
Full Light — Light Background	Analogous-appearing portrait with very even tonal range. Recommended.	The whole image will be very high key, possibly overexposed.
Side Light — Dark Background	Black or near black background, extreme contrast between sides of face, properly exposed lit side. Recommended.	An overly bright-lit side and a neutral dark side.
Side Light — Light Background	A two-tone image — the light side of the face melts into the background and the dark side falls off the edge.	A bright-lit side and a neutral dark side. Recommended.

Review, repose, and shoot

When you are done metering and your camera is set, take several shots with minor variations achieved by asking the model to make slight adjustments to head or body position. If your shots are set so that the shutter speed is fast enough, carry your camera around and take a few shots from fresh angles, or move your tripod and take a few shots from several points of view. Make sure you remember to meter and/or make setting adjustments if you change your position sufficiently.

Using the burst function of your digital camera is not necessary or recommended in studio settings because it is not necessary to "capture a motion," and you will end up with many shots so similar that you will not be able to tell them apart. If there is motion in your shot, such as a hair fan or a bouncing ball, then burst mode is recommended.

Using your digital camera's playback function, review your shots and determine whether you need to make any changes to your original lighting, posing, costume, or prop plan. Working with your model, select the shot you feel is best, arrange the model into the pose variation you preferred, and take the final portrait — with one or two extras for insurance.

When you are done, make sure that you thank your models, and advise as to when they will hear from you or what, if anything, they should do next. End every session on a positive note and make sure the models take a business card or two with them when they leave. If they've had a positive experience, they will want to share it with others, which is good for your business.

Show Them on the Big Screen

Almost all digital cameras come with a jack for setting up a video feed to a video device such as a television or a laptop. Not only is this an excellent method of reviewing your shots from a comfortable location, but I find that using one during portrait sessions to review test poses with clients and to discuss ideas and options while the shoot is in progress is a great way to share the process without trying to fiddle with a small LCD display on a camera that is attached to a tripod. If you don't have a television you can wheel into your studio, most laptops perform the same function. Small 5-inch and 7-inch televisions are available very cheaply, and if you don't have a laptop to tote around, a small television might not be a bad investment.

After the model is gone

As soon as your model has departed, I recommend that you deal with the immediate business of extracting the shots from your camera and storing them in the file or folder you have set up for this client/job. Do not erase or delete any images except those that are clearly inappropriate or of obvious poor quality. Wait until the next day to go through them, when you will be more detached and less likely to have inappropriate reactions, either good or bad, to your work.

Make sure your lighting is turned off, your batteries are on the charger, and your lens cover is safely on the front of your lens, because you're done for the night.

When you do look at the images from the session, the most important thing is to whittle your collection down to a manageable number of negatives or originals that you want to work with. I do not recommend deleting any of your negatives until the job is finished and the file closed, but I do recommend keeping them in a separate place "just in case."

Virtually all photographs need some form of post-processing, even if only to correct dust, hairs, and small tonal or color imperfections. The next section takes you through the many interesting and important phases of post-production. Pick a few of your favorite shots from this session, and let's get started.

✦ ✦ ✦

Post-Production and Presentation

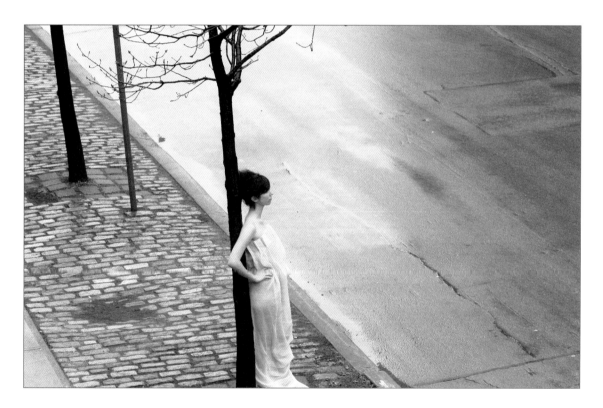

10

The Digital Darkroom

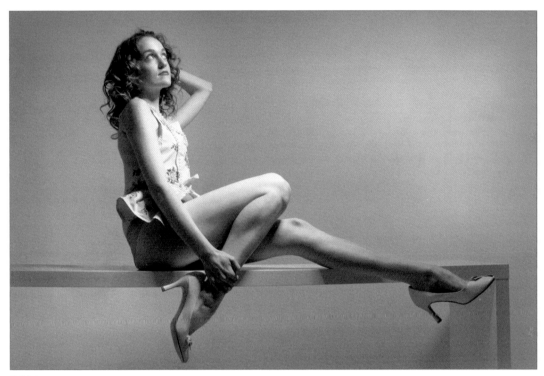

© Istoica.com

Just as you need to have cameras and lenses and lighting to shoot a photograph, you need darkroom equipment to develop it. Although at one time that sentence would have meant that you would need chemicals and an actual dark room, what it means for the digital photographer is that you need the electronic and software equivalents.

Your computer needs to be able to do the job, you need the correct type of software, and you need a good understanding of how to work with the actual photograph files that come from your camera. If you're shooting in RAW, for example, you need to know how to prepare your files for basic image editing.

About Image-Editing Software

The most popular image editing software is made by Adobe Systems (www.adobe.com) and is called Photoshop. It comes in two versions: a high-end version intended for professional photographers and graphic designers, and a consumer version marketed to the casual user. The full-featured version is very expensive but includes a level of functionality that many professionals cannot live without, such as the ability to automate common tasks. The consumer version, known as Photoshop Elements, retains roughly 80 percent of the functionality of the professional version while selling at 20 percent of its cost (around $100).

Note When I mention "Elements," I'm referring to Adobe Photoshop Elements. When I mention the name "Photoshop" by itself, I am referring to Adobe's full-featured professional image-editing software.

Many professionals use both Photoshop and Elements because Photoshop needs a more powerful computer, but Photoshop Elements can easily be used on a laptop or a less sophisticated computer. In addition to being less expensive than the professional version, Photoshop Elements is a bit less demanding of your hardware. One of the ways that Elements restricts functionality is in the number of layers it allows to be used on any open document, which is also one of the ways that it reduces demand on your operating system.

Tip Elements is fine for most simple and even mid-level editing jobs, and purchasing the full version of Photoshop will not be necessary. For the difference in cost, Elements is the much better buy for most people.

Try It Before You Buy It

Adobe offers fully functional trial versions of their software, allowing people to take a program for a test drive before committing to a purchase. You can use this limited software for 30 days, after which point the product stops working and requires you to purchase a copy within that time frame.

Download your trial software from www.adobe.com/downloads. Beware: these are *large* files in excess of 200 megabytes (MB). You'll only want to go this route if you have a high-speed Internet connection.

The Darkroom Hardware

It takes more than a few sticks of memory and a fast CPU to build a decent workstation for editing images. Here is a quick look at a few other pieces of hardware that you may want to consider.

Adobe system requirements

What kind of computer will you need to run all this? Honestly, that depends on how patient you are. I've seen images edited on an old 350 MHz Pentium II system with 256MB of RAM using Photoshop Elements 2. It's doable, but is ever slow. A machine along the lines of a Pentium 4 2.6 GHz with 2 gigabytes (GB) of RAM runs the full version of Photoshop quickly enough for most people's liking. The system you use may be faster or slower depending on what you can afford or what kind of wait you are willing to put up with.

As shown in Figure 10-1, virtually all software lists the specific system requirements for both MAC and PC systems on the side or back of the box. Always be sure to check the hardware requirements of any image-editing software you are thinking of purchasing to make sure it will run on your system. In particular, the amount of memory and storage space you have available is important. Although you may not mind sacrificing some time to a slower processor speed, a lack of adequate memory may cause program failure.

Display

You've seen those new flat-screen *liquid crystal display* (LCD) monitors on the market and you want one. Not so fast. Did you know that many of the cheaper models have difficulty displaying a large contrast ratio and are limited in the range of colors they can render accurately? You might have to spend upwards of $1,000 to find an LCD capable of the same accuracy as a much cheaper tube-based (aka CRT) monitor that sells for around $150. You may find that you'll be better off buying the less expensive monitor and spending your money on one of the following items instead.

Tip Most good electronic stores allow you to test their computers when you are planning on making a purchase. Although they are not likely to let you insert a disk or CD into their equipment, they will let you view materials on the Web. A very good idea is to point the browser to one of your own images or one that you know is properly calibrated for print so that you can test monitors with a known commodity. Although it will look different on the monitor (a monitor is reflective, paper is absorptive) than it will in print, it should look similar in tonal range and general color distribution. This will aid you immeasurably when you are preparing digital images for printing, because you will have to use the monitor to do it. You should be aware of the general differences in how a photograph will appear in both formats so you can make the best prints possible. It's like taking a CD you know to the stereo store when you're speaker shopping.

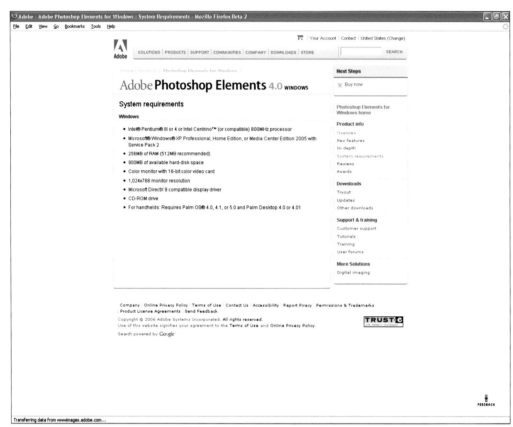

Figure 10-1: Most software lists the specific system requirements on the side or back of the box. Be sure to check carefully and ensure your system can handle the software.

Monitor calibration tool

It happens to all of us at some point. The portrait looks fantastic on the monitor, but it prints with a strange color cast. The reason for this is very likely that the color on your monitor needs calibrating.

To calibrate a monitor you have a few choices:

✦ Purchase a tool such as Huey, which is a Pantone and Gretag MacBeth collaboration and which will cost approximately $90.

✦ Use Adobe Photoshop's built-in monitor calibration tool, which is called Adobe Gamma to calibrate your monitor (see Figure 10-2).

✦ Use the very simple (and much less accurate) method of placing an actual print beside the monitor on which you are displaying its digital equivalent and use the monitor's own calibration tools.

Calibrating Your Monitor with Adobe Gamma

Adobe ships a version of their monitor calibration software with every copy of Photoshop. Adobe Gamma gives your monitor an ICC profile, which is a file that includes a description of the specific characteristics of your monitor. This profile can then be used by any application that uses ICC profiles to identify your monitor's color-display limitations and characteristics.

Adobe Gamma is generally located in either the Control Panel folder or in the Program Files ⇨ Common Files ⇨ Adobe ⇨ Calibration folder on your hard drive.

To calibrate your windows-based system monitor, perform the following steps:

1. **I recommend that you use the version of the program that guides you through each step. To do this select Step By Step (Wizard) as shown in Figure 10-2, and click OK.** The instructions provided are very clear and self-explanatory.

2. **I recommend that you begin with the default profile for your particular model monitor if one is available from the list.**

3. **If you do not have a default profile, contact your monitor manufacturer for appropriate phosphor specifications, or research the manufacturer's Web site because they often publish specifications for just this purpose.**

To use a quicker and more efficient version of the program with all the controls in one place, select Control Panel and click OK. Adobe recommends this version only if you have experience creating color profiles.

It should be noted that Adobe Gamma cannot calibrate monitors used with Windows NT. Adobe states in their documentation that the program's ability to calibrate settings depends on the video card and video driver software. Certain calibration options listed on the utility may not be available to all users, depending upon their hardware configuration.

Mac users, of course, are the beneficiaries of a built-in monitor calibration tool.

Adobe's Support Knowledge Base URL for Adobe Gamma is www.adobe.com/support/techdocs/321608.html.

| Tip | The Digital Media Designer site (www.digitalmediadesigner.com/articles/viewarticle.jsp?id=36836) not only has an excellent review of the Huey monitor calibration program, but it also contains an in-depth discussion on monitor calibration. |

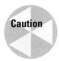

| Caution | Before calibrating your monitor ensure that your display has been on long enough to be warmed up. Usually, this means having the display on for about an hour. Also, ensure that any screen savers or power saving modes are turned off and that that there are no lights shining directly onto the screen. |

Figure 10-2: Adobe ships their monitor calibration software with every copy of Photoshop and Elements. It's easy to use, immediately available, and there is a lot of support for its use on the Internet.

Video card

It's almost impossible to buy a new computer these days without it having a video card integrated right into the system main board. If your computer is less than a year old, you probably won't have to worry about upgrading your video card. Your main concerns are the display resolution and refresh rate.

Realistically, it's impractical to work with software like Photoshop at desktop resolutions lower than 1024 x 768 pixels. You'll want to work at resolutions of 1280 x 1024 or higher because they give you more desktop real estate.

Owners of CRT monitors will also want to make sure their video card supports a refresh rate of 70 Hz or higher at their chosen resolution. The refresh rate is the speed at which the video card redraws the screen on older CRT monitors. At the lowest rate, 60 Hz, this refresh is barely perceptible as a constant flickering. It can be migraine-inducing. Consider upgrading if your current video card does not meet these minimum requirements.

Hard drives

Digital images eat up hard drive space—*a lot* of drive space. Make sure that you have enough spare drive space to save your current work. I recommend buying the biggest hard drive you can afford, given that Photoshop files can easily grow to several hundred megabytes in size as your edits pile up.

Moving Photoshop's *scratch volume* (where it writes temporary files) to a different drive also dramatically increases its performance. This alone can justify the addition of a second hard drive.

Tip

A good option if you are not absolutely concerned with the latest top speeds is to look for large drives with lower rotational speeds. They can often be had at deeply discounted prices, and if the primary objective is storage, even the slowest hard drive is faster than most other options and keeps things very handy for quick retrieval. If you do any sort of stock work at all, this is a very good idea.

DVD burner

You can't keep adding hard drives to your system forever because you'll eventually need somewhere else to archive your photos. A good idea is to purchase a good dual-layer DVD burner or, because most systems have a built in CD burner, to use CDs. DVDs are recommended because they hold many more files, but the point is to have safely stored files, and you may have to use your CD burner.

Alternatives to Photoshop

Adobe isn't the only company that makes image-editing software, of course. Other packages, however, have not achieved the following that Adobe Photoshop has. One notable exception is Paint Shop Pro X by Jasc software (recently bought out by Corel — www.corel.com), which has a very large user base. Paint Shop Pro combines powerful image editing with unique artistic image-styling tools. See Figure 10-3.

Figure 10-3: Paint Shop Pro X, an "indie" favorite for years, has been purchased by Corel (owners of CorelDraw, Painter, and WordPerfect) and still sells for under a hundred dollars.

You can also use Corel Painter, which has garnered itself a small but devoted following of portrait photographers who specialize in the extreme styling of digital portraits.

For this chapter, I assume that you have access to Photoshop Elements, because it comes bundled at no charge with many digital cameras nowadays. I provide instructions for Elements and occasionally reference the useful features available in the full-featured Photoshop.

Adobe releases their Photoshop software for both the Windows and Mac OS X operating systems. Don't get thrown by the fact that most of the screen shots come from a Windows desktop; you'll be relieved to know that Adobe's products function identically on both platforms. The examples provided work for both Windows *and* Mac users.

Note In September of 2005 Adobe released Photoshop Elements 4.0 for Windows and said, in part, in their press release that it "delivers more editing power" and has "one-click skin tone correction and Face Tagging, which allows consumers to keep photos at their fingertips with new ways to find and view them." MAC users were added to the 4.0 fold in February of 2006.

Getting to Know Photoshop Elements

The Editor workspace of Elements, as shown in Figure 10-4, is where you make all of the improvements to your images. The configuration you see is my preferred working setup when editing my pictures. You need access to the tools and palettes shown here to follow the examples I provide further into this chapter.

Here are the main areas you'll need to be aware of, so you can follow along:

✦ **Toolbox:** These are the actual tools you use to edit your images.

✦ **Options bar:** Contains options for the active tool that you have selected in the Toolbox.

✦ **Menu bar:** Contains menus organized by topic. Each menu contains commands.

✦ **History palette:** This window contains an undo history for each image. It shows the last 50 steps by default, and can be configured to display up to 1,000. The original state of the image always appears at the top, and you can create reference snapshots along the way. The History palette is your friend, so be nice to it.

✦ **Color swatches:** Use this window to change your foreground and background colors quickly. I use mine a fair bit, so I always want it handy.

✦ **Layers palette:** I *always* work with layers, and I give over a large chunk of my monitor to this particular palette.

If you'd like to become a Photoshop expert, I recommend *Photoshop CS2 Bible,* Professional Edition, also published by Wiley Publishing.

Toolbox

Options bar

Menu bar

History palette

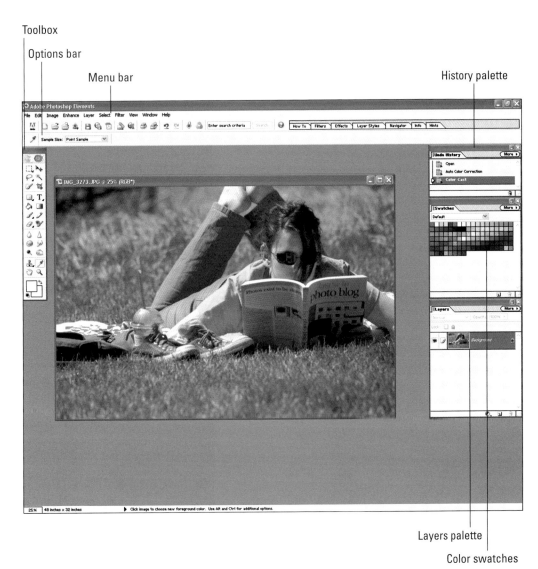

Layers palette

Color swatches

Figure 10-4: A screen shot of the Adobe Photoshop Elements 3 image editor in Standard Edit mode

Best Practices

Best practices are those methods that usually work and produce the best results according to either conventional wisdom or empirical testing. Being organized and consistent in the way you process your work product makes for a better result. In fact, it's exactly like following a recipe—the end result just works better when you do the things according to "best practices." You make a chocolate cake, a white cake, and a lemon cake all the same way—it's the ingredients that change, but the methodology or best practices remain constant.

Use the layers, Luke

Layers are a difficult concept for many Photoshop users to grasp. To put it simply, you can place multiple versions of the same image on different layers and perform different actions on each of them. You can create openings in upper layers in a stack to allow portions of lower layers to show through. All of the layers can be flattened to produce the final image. See Figure 10-5.

It's a good idea to copy your picture onto new layers as you go, and keep all of the layers you're making changes to as you work on the image. This lets you go back to a previous stage in your work if you find you're going in a direction you don't like, so you won't have to start over from scratch. Many novice Photoshop users flatten the layers after they make their changes, and this can come back to haunt them when they want to go back farther than the saved history of the image allows.

Tip

I'm sure it goes without saying, but I'm going to say it anyway: you should never work directly on the original or "negative" of an image. Either open a copy or make a layer copy on which you can perform your edits. There are two reasons for this. Primarily, it's nice to be able to go back to "scratch" if your edits are displeasing to you or your client. But a secondary benefit of this practice is so that you can compare the original to the finished product to make sure that none of your edits have significantly altered the aspect or character of the model's appearance.

Nondestructive editing

Both versions of Photoshop feature *adjustment layers*. These are intermediary layers that can be used to adjust the lighting, color, and contrast in an image. Adjustment layers don't modify the image itself; they just alter the appearance of the layers that sit below them. These layers are referred to as *nondestructive* because using them preserves the integrity of the original image. They are also tiny and don't add appreciably to the file size, so make a habit of using them whenever possible.

Free Layers Tutorial

Adobe Photoshop Elements 3 contains an excellent online tutorial that walks you through using layers. Follow these steps to access the tutorial:

1. **Click Help from the Editor's menu bar.**

2. **Click Tutorials. Adobe's Help dialog box appears.**

3. **Click "Harness the power of layers" and the tutorial begins.**

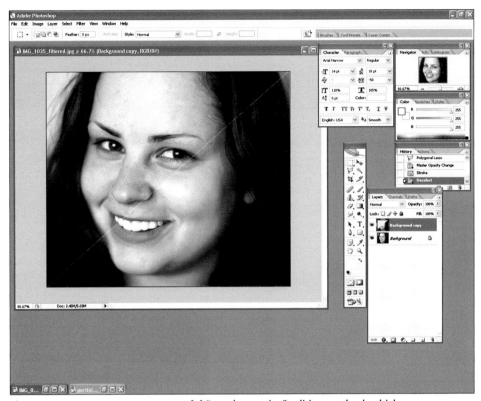

Figure 10-5: Layers are a very powerful "nondestructive" editing method, which means you can simply remove changes you've made by deleting the layer, leaving the original intact.

To use an adjustment layer, select the Layers menu and then click the New Adjustment Layer button.

Tip — Whenever you need to make a change to your image that cannot be done on an adjustment layer, make sure you copy your image onto a new layer and do it there instead.

Saving multiple versions

Building your document up to a hundred layers is workable if you're running a beefy system, but those with less-powerful systems will notice their computers slowing down with each new layer they add. At this point it is simply better to save a version of your file with a new filename (that is, image_a, image_b, and so on), flatten the layers to free up some memory, and carry on.

Saving regularly is particularly important for those of us running Windows, because there's nothing more aggravating than encountering a this-program-has-performed-an-illegal-operation-and-will-be-shut-down error before you've had an opportunity to commit the last hour of work to disk. Saving often reduces the amount of data lost when the inevitable software lockup occurs. I'm careful to save to a new filename just in case my computer malfunctions while saving my file and causes me to lose all of my work on that image. This way, I can recover some of my work if my computer fails while writing to the hard disk.

File formats

JPEG is the most commonly used file format, primarily because it is the only format universally recognized. JPEG files can be posted on the Internet, sent to a professional printer, and printed on your own home printer. Devised by the Joint Photographic Experts Group, the JPEG was created as a way of saving high-quality images containing a wide range of tones and colors in the most efficient, smallest file size possible. The end result was the JPEG format, to which they lent their name.

JPEGs use a lossy type of compression, or shorthand, to pack a large amount of data into a small file. This is like trying to pack enough food for three people into a picnic basket that was designed to hold food for two. You can only squeeze the extra in if you take something else out, like the mustard or the relish. When your image-editing program saves a JPEG, it discards small bits of data that it thinks you won't notice missing and degrades the quality of the image. How much data is discarded depends on how much compression you told the program to use when creating the file.

You can usually save your data to a high-quality (low compression) JPEG file once and get away without the picture quality being noticeably affected. The real problem occurs when you repeatedly open and save the same JPEG document.

Tip

Each time you resave a JPEG, the file is compressed a bit further and more data is discarded. You eventually wind up with a severely degraded image that is chock-a-block full of odd-looking little defects called *JPEG artifacts,* as seen in Figure 10-6.

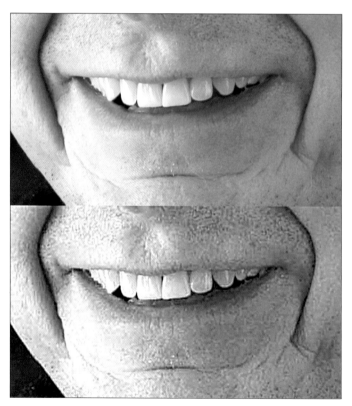

Figure 10-6: A magnified view of a degraded image suffering from JPEG artifacts. Notice how badly damaged the image on the bottom has become?

JPEGs are small and easy on the free hard drive space, so it's tempting to save the image in this format. However, whenever you save archival copies of your work, you should be using one of the following formats instead:

✦ **PSD.** Photoshop data. This is Photoshop's native file format, and it preserves all the separate layers in your document. This produces a large file, but it is nice to have if you need to go back to an image and do more work.

✦ **TIFF.** Tagged Image File Format. This is an almost universally supported format that produces very large files. TIFF also preserves the separate layers in your image if you select that option, but doing so reduces its compatibility with non-Photoshop applications. TIFF files can be compressed using what is called the LZW compression scheme without harming the data. Keep this in mind if you're running out of drive space.

✦ **BMP.** Bitmap, the standard Windows image file format. You can choose between saving in Windows or OS/2 format. You can also select the bit depth (see the section "Working With RAW Files"), but you should always set this to 24 bit or higher when archiving high-quality versions of your work.

If you've been taking all of your pictures and saving them to your camera's memory card in JPEG format, you might be feeling a bit worried right now. Don't be. I take pictures in JPEG all the time as well. The important thing to remember is to always save your image project files in an archival-quality format like PSD, TIFF, or BMP after you've taken them from the camera.

The only time you should resave a digital photograph back to a JPEG is if you are sending it to a printer that only accepts JPEG files, uploading it to your Web site, or e-mailing a copy of it to someone.

Working with RAW Files

As discussed in Chapter 2, digital cameras write images to their memory cards in one of two different formats: JPEG or RAW. Some cameras will allow you to write in TIFF mode but this feature is not as widely offered as RAW. If your camera is capable of writing files in RAW format, I would encourage you to take advantage of this whenever possible.

What is a RAW file, anyhow? Is it called a raw file because it's uncooked? Actually, yes, that's fairly close to the truth. Virtually all digital cameras do some amount of in-camera processing of an image whenever you have it set to save files as JPEGs. This processing usually includes adjusting light levels, bumping up the amount of color saturation, and sharpening the image to make it look crisper. A large percentage of digital-camera users don't bother to post-process their own images before having them printed. Without this in-camera processing, they would wind up with extremely flat, boring pictures. This wouldn't be good for camera sales, and that's why almost all digital cameras come set up to do all this work behind their owners' backs.

RAW pictures, on the other hand, look rather blah without a bit of tweaking before being printed (see Figure 10-7). They haven't been "cooked" yet and are still raw. This is literally the raw image data as recorded by the camera's sensor. Just like the serious gourmet prefers to cook his food to suit his own tastes, many advanced amateur and professional photographers also prefer to manipulate their images to suit their own artistic temperaments instead of having a one-size-fits-all look applied to their photographs. Camera manufacturers make this raw data available to users who prefer to do their own cooking.

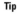

Tip Most digital cameras that allow you to shoot in RAW come with software that enables you to convert those RAW images into editable JPEG or TIFF files. If you do not have any other conversion software or you prefer to use proprietary software where possible, most of these programs can be set so that you can save to a JPEG or TIFF file that you can work with in your photo-editing software.

Bit Depth a Bit Confusing?

I've already explained how you throw away data each time you save a photograph as a JPEG file. This isn't the only issue to worry about; the larger concern is *bit depth*. JPEG files are 8-bit files. This is a photography book, so I don't want to spout a bunch of computer-geek mumbo jumbo at you, but the important thing to know is that an 8-bit file can display a tonal range (going from white to black) with only 256 levels. That sounds like a lot, right? It is, but only if you have all 256 levels.

At some point someone will come along and say to you that a JPEG image is *really* a 24-bit file. It is and it isn't. JPEG images are RGB images. That is, they are composed of red, green, and blue pixels (thus the RGB moniker). Each type of pixel is capable of displaying 8 bits of tonality from darkest (black) to brightest (white). This translates into 256 discrete levels of brightness numbered from 0 to 255. When you combine all three pixels together you get an entire rainbow of colors. RGB values are expressed in numbers like 255,255,255 (white).

When you hear of a JPEG being referred to as a 24-bit file, what is really meant is that it is 8 x 3 bits, one for each primary color. The 24-bit notation refers to the range of colors the file can display, not its tonality, which is still limited to 256 levels.

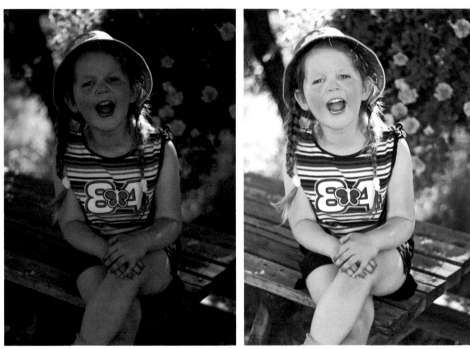

Figure 10-7: The original RAW image on the left suffers from severe exposure issues, and the image on the right was processed in Adobe Elements.

Extra Bits

If you were paying attention, you noticed that I mentioned opening 12-bit and 14-bit images in a 16-bit working space—which is simply the settings profile that you are using in your image-editing software. Does this mean I've increased the number of bits in my images? No, I haven't. A 16-bit working space is simply a space large enough to accommodate the larger number of levels; this doesn't add any extra information to the file. Opening a 12-bit image in a smaller space, however, such as an 8-bit working space, causes your photo to lose data. There is an excellent tutorial on this topic at Digital Output. To see it, point your browser to www.digitaloutput.net/content/ContentCT.asp?P=350.

Not every picture you take will be perfectly exposed, and you're going to need to perform extreme corrections to the lighting on some of them so they look presentable. You start to lose data when you make severe level corrections to an image. Sure, you started out with 256 levels, but your tweaking could have taken you to less than 100 discrete levels of tonality. This is where the appearance of your image falls apart.

As you lose tonality, the transition from one tone to the next becomes visible (and ugly). Called *banding,* this is especially noticeable in the darker areas of the picture. What should be smooth sky behind your subject looks streaked. Pink rings appear on your subjects' cheeks, as shown in Figure 10-8. This just doesn't look good, especially when it shows up in an 11 x 14 enlargement.

When you shoot in RAW mode, your camera should be recording at least 12, and possibly up to 14, bits of data (consult your camera's manual to find out). With a 12-bit image you have 4,096 brightness levels, or tonal steps. You have 16,384 levels of tonality to play with if you are one of the lucky few with a camera that can record 14 bits of data in its RAW images. With a 12-bit image you can lose two-thirds of your tonality through level adjustments, and your image will still have smooth transitions from one tone to the next. The same image would look terrible if it had originally been recorded as a JPEG.

For example, the left picture shown in Figure 10-7 was a bad exposure and is shown as it came straight from the camera. The image on the right was repaired with the help of the Histogram tool.

Histograms tell no lies (see Figure 10-9). The bunching up of the data at the left side of the histogram on the original image (topmost histogram) shows how much the image was underexposed. The middle histogram shows what happens when you perform severe level corrections to this file when it is opened as an 8-bit image. See all those gaps in the histogram? That's called the *toothcomb effect,* and each gap represents missing data and reduced tonality. The middle histogram is from a RAW image opened up in a 16-bit working space, and you can see that it is still healthy with an intact tonal range despite my performing identical level corrections to it as I made to the 8-bit version. It's a good thing I shoot most of my images using RAW mode!

It's not always practical to shoot images in RAW. You will run out of space on your memory cards quite quickly (see Chapter 2 for a review of card storage) and your camera may perform too slowly. But when you're faced with tricky lighting, just remember that you will be able to push a RAW image harder than a JPEG in your image-editing program because RAW files have more data to work with. Many photographers shoot in both modes, depending upon the circumstances, and take anything they feel they may be "iffy" in RAW mode.

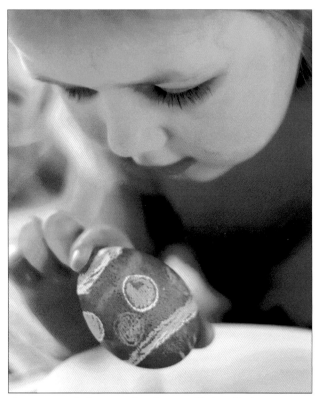

Figure 10-8: A close-up of an image with tonality issues. Note the banding of color on the cheek and in the bowl at the bottom right.

A RAW Deal

Many cameras do not offer their users RAW as a choice for saving files. This is particularly true of cameras in the point-and-shoot category. If your camera doesn't offer RAW functionality, it may offer the option to save files in the TIFF format instead. Saving in TIFF format is practically as good as saving images in RAW for all intents and purposes. TIFF images can have a bit depth up to 12 bits, depending on which camera you own. The downside here is that TIFF files are usually slower to write than RAW files on most cameras and take up more space on a memory card. RAW is always the best choice, but TIFF is a good second choice.

If your camera only saves images as JPEGs, try to disable as much of the in-camera processing as possible. These changes are almost always better done in a program like Elements.

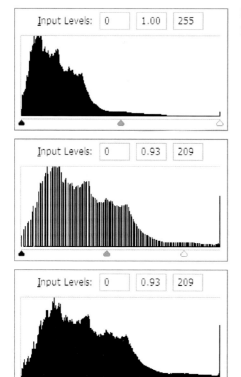

Figure 10-9: The original histogram for Figure 10-7 plus JPEG and RAW histograms, post adjustments.

Using Camera RAW

There are generally three ways to open a file that was captured in RAW format, and I'm listing them in my order of preference:

✦ Adobe Camera RAW plug-in

✦ A third-party utility such as RawShooter Essentials

✦ The native conversion software included with your camera

Note You can skip this section if your camera isn't capable of recording RAW files. Just remember to ask if your next camera has this feature when the time comes to upgrade.

Camera RAW was originally a rather expensive plug-in that could be purchased for use with Adobe Photoshop. It turned out that so many advanced amateur and professional photographers were using this software that it was just simpler for Adobe to license Camera RAW and include it with their products. If you own Photoshop Elements 3, Photoshop CS, or a newer version of either, the Camera RAW plug-in is built into your software.

If you encounter any difficulties using Camera RAW, you may have to verify that you have the correct version for your camera's files. Updates for cameras are located on the Adobe Web site; you can download the files for your camera by pointing your browser to www.adobe.com/products/photoshop/cameraraw.html.

Opening a RAW image using either the File menu or File Browser in Elements (see Figure 10-10) opens the Camera RAW dialog box. As you can see from Figure 10-11, the dialog box features a large preview area, a histogram for viewing exposure information, and several banks of controls for manipulating the image before it is opened in the main Elements Editor.

Tip
Camera manufacturers use something called a Software Development Kit (SDK) to aid software developers such as Adobe create software that is compatible with the image files that the camera produces. Camera RAW does not use any of the manufacturer's SDKs from either Canon or Nikon (or anyone else, for that matter). While this means Camera RAW works quickly and changes that you make to preview images are shown in real time, it also means that you may have to disable some of your camera settings to use your images most effectively in Camera RAW. You may have to test results with camera settings for items such as exposure compensation, sharpening, and white balance.

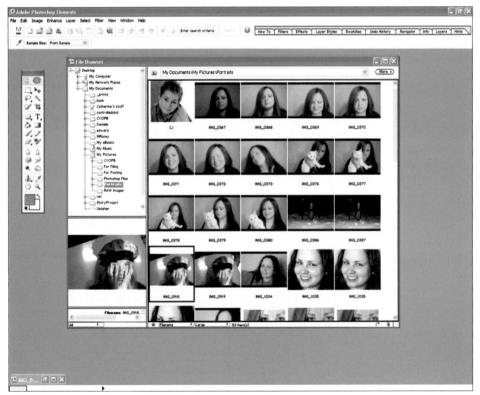

Figure 10-10: RAW files are visible in the Elements File Browser.

I have highlighted the controls that I consider to be the most important:

✦ **Main panel:** This tool palette is where you can correct lighting, color saturation, and color balance. The default setting is for Camera RAW to automatically choose the settings that will yield the most balanced histogram, and the software usually does a good job of this. Make a point of experimenting with these controls to see how moving each affects the overall exposure and coloration of the image. The most critical of these sliders are

- **Temperature:** Pictures taken in shade will have a bluish cast, which makes skin look pallid. Pictures by an incandescent light will have a strong reddish cast that can also be unattractive. Use this slider to correct the light temperature.

- **Exposure:** You can add or remove up to three f-stops of exposure here. If you accidentally under- or overexposed your image, this is where you fix it first.

- **Shadows:** Use this slider to make shadows darker if they are not well-defined enough for your liking.

- **Saturation:** Moving this slider to the right increases the amount of color in your picture.

- **Luminance Smoothing:** This lowers the contrast between neighboring pixels, giving your image something of a soft-focus effect.

- **Color Noise Reduction:** Some digital cameras have "noisy" sensors that introduce random color noise (tiny unwanted splotches of color) into the images they produce. Noise can also exist in an image taken with a high ISO (higher than 400) setting. If your image contains too much noise, use this slider to repair the problem. This comes at the cost of losing a small amount of detail from your picture.

✦ **White balance tool:** Place this tool over a neutral area in the picture—that is, a white or gray area—and click your mouse button. Camera RAW uses this reference point to instantly correct the color temperature of your picture. I probably use this tool, which I cover in more detail shortly, with over 90% of my portraits.

✦ **Bit-depth selector:** This drop-down box toggles between 8 bits and 16 bits. Because the whole point of using RAW is to have access to the extra data, set it initially to 16 bits . However, some processes such as adding layers and using certain filters will not work with 16 bit images in Elements and you may have to work with it in 8 bit mode.

Blowout Recovery

Every so often you're going to overexpose an important image that you want to keep. Do RAW conversion software packages let you recover the overexposed areas of an image? It depends on what type of camera you own. For example, you can salvage approximately one exposure value of data from images made on a Canon EOS 20D using both Camera RAW and RawShooter Essentials. You can salvage slightly less from images made using a Canon EOS Digital Rebel (300D). You'll have to experiment with your particular camera to see what kind of adjustment its RAW image files allow.

Simply open your RAW conversion software of choice and load the problem image. Reduce the exposure compensation slider until you see details begin to appear in the areas that were previously pure white. Once the details have appeared, you have recovered the missing highlight detail in your image.

White Balance tool

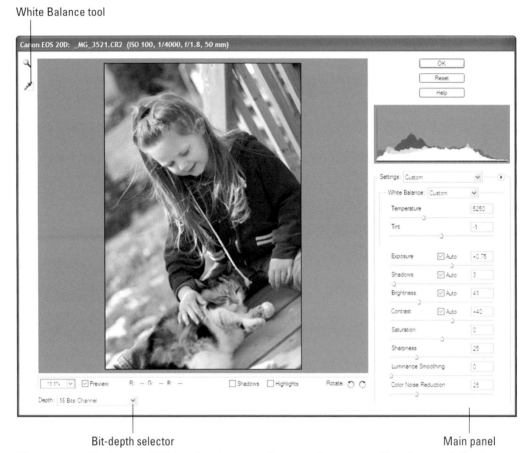

Bit-depth selector Main panel

Figure 10-11: The Camera RAW interface features a large preview area and handy controls for the most common tasks.

Here are the basic steps for opening an image in Elements using Camera RAW:

1. **From the Elements Editor window, Choose File.**

2. **Choose Open.** A file selection dialog box opens.

3. **Navigate to the folder where your RAW images are stored, highlight one with your mouse pointer, and then double-click to open.** The Camera RAW dialog box (see Figure 10-10) appears.

4. **Inspect the preview image and histogram to see if automatic settings recommended by the software are acceptable.** You are looking for a healthy histogram, which is one where there is an even distribution of dark and light values. Make adjustments to the Exposure, Brightness, Contrast, and Shadow sliders as necessary.

5. **Correct the white balance by selecting the White Balance tool (item 2 in Figure 10-11) and clicking a neutral area (usually the background — the tone or color which is most prevalent in the image).** You may also want to fine-tune the color balance by using the Temperature slider.

6. **Drag the Saturation slider to your preferences.**

7. **Click OK to open the image in the Elements Editor.** Don't worry, your image is not altered permanently; Elements is simply moving your "pre-edited" image onto the workspace. You will have to save it specifically to alter the original.

Don't worry if you can't get the image to look exactly the way you want it in Camera RAW; this is like playing horseshoes, where you get points for being close. The remaining fine-tuning can be done in Elements itself where you have a plethora of tools at your disposal.

Using RawShooter essentials

RawShooter essentials (see Figure 10-12) is a free program distributed by Pixmantec (`www.pixmantec.com`). It duplicates most of the functionality of Camera RAW, but you won't have to go out of pocket to get your hands on a copy of this program. Although Camera RAW is definitely the better of the two programs, you may want to consider using RawShooter Essentials if you already own an older version of Photoshop or Elements and would prefer not to upgrade.

Note

Unfortunately, at the time of printing RawShooter Essentials was available for Windows only. For Mac users, Adobe offers a new RAW processing program called Lightroom (currently in beta) that you can download as a trial version from `http://labs.adobe.com/technologies/lightroom`.

RawShooter offers mostly the same exposure and color adjustment options that Camera RAW does, so I won't explain them again here. The most notable areas of difference between the products are that RawShooter has an integrated file browser and offers a batch-processing mode. This feature lets you apply your adjustments to a large number of files at once instead of just being limited to working with a single file at a time as you are with Camera RAW and Elements.

As mentioned previously, RawShooter essentials is compatible with older versions of Photoshop and other image-editing programs like Corel's Painter and Paint Shop Pro X. You also won't be able to beat its price (free!).

Using native software

Generally, the free RAW conversion software that comes with cameras suffers from extremely poor user interface design. The Canon dSLR software, as an example, is not that bad, but it is nowhere near as elegant and easy to use as Camera RAW. There is also the fact that if you own a fair number of digital cameras, you won't want to learn the intricacies of five different software packages. It's better to just learn one and spend the extra time making images.

You may feel differently, and that's all right. If your camera is capable of shooting in RAW format, its manufacturer probably included some kind of RAW conversion software in the package, which you've neatly packed away somewhere. (You *did* keep it, right?)

Once you load your software, you'll discover that it has the same basic workflow as Camera RAW and RawShooter Essentials:

1. **Open a RAW image file.**

2. **Adjust the exposure values.**

3. **Adjust the lighting by setting a white point or choosing a custom color temperature.**

4. **Select a bit depth to open the image at (16 bit!).**

5. **Make further refinements in your image-editing software.**

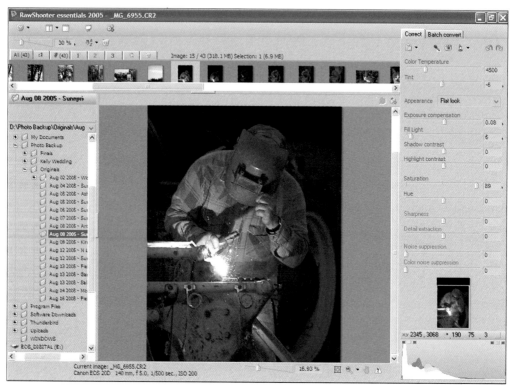

Figure 10-12: RawShooter Essentials

Read, Listen, and Learn

Honestly, the best way to make sense of all the information available on this subject is to read a lot of user reviews, talk to other photographers, and get involved in community sites on the Internet where people like us gather to talk about . . . well, all this stuff that bores most other people at cocktail parties. Not only is your individual equipment and the style of work you do a factor in deciding which software and processing practices you use — but your own personality is as well.

The next phase of the process is basic image editing, where you put all of this information, software, and hardware to good use.

✦ ✦ ✦

11

Basic Image Editing

© Istoica.com

There is a strangely persistent rumor that I have heard from time to time. It goes like this: professional photographers take perfect images right in the camera. Well, I'll let you in on a not-so-little secret. It's not the professionals who say that. What professional photographers do is *try* to compose, light, and pose the perfect portrait right in the camera. This is what you do, I assume. This is what we all do.

Of course, no one has gotten it down just yet. No one. Sure, I get some perfect pictures, you get some perfect pictures, and my 15-year-old niece could get a perfect picture too, if she had the right equipment and the right information. But until you get the perfect picture every time, each and every time, you're just like the rest of us. Trying. It's like golf. If you went out and got a hole in one, would you just assume every hole you played thereafter would be an ace and stop bothering to check where the ball landed? Of course not, that'd be silly.

Although no amount of work can rescue a badly conceived and composed photograph, the difference between a good image and a great image is often that the latter was post-processed properly before being printed. Your camera may already be set up to do some image processing internally when it saves images to its memory card (as discussed in Chapter 2), but the fact remains that your images will most likely still need some work and, at least, a professional going-over before you send them to the printer.

In this chapter you'll learn how to correct lighting, dodge and burn, remove odd color casts, soften wrinkles and reduce blemishes, and bring your images into perfect focus. It's easier than you think, and you'll be amazed at the difference a bit of post-processing makes in the final print.

Professional Diligence

Forget the rumors. Take it from a pro: every photograph you take with your camera should be done its due diligence. As a professional you are obligated to check for hairs, dust, fine airborne particles, minor peripheral distortions, color accuracy, focal sharpness, quality at large sizes, and tonal regularity. Most portraits shot in the standard digital image ratios 4:3 and 3:2 are cropped into other ratios for their final printed format. In other words, it's part of your job to take the photograph from the camera, nurture it through the darkroom phase, and send it into the world a full-grown portrait.

Ansel Adams made a comment once to the effect that dodge and burn were tools created to help God out with his tonal irregularities. In fact, Adams was the master of the darkroom and often wrote words that clearly indicated that he believed the perfect print was a two-phase process. Not to spend too much ink on the obvious, but I am fully prepared to accept the wisdom of Mr. Adams.

Tip Every photograph needs to be looked at in image-editing software before it goes to the client or the print lab. This is your work and it does your professional reputation no good to fail to notice a hair or a scratch. When a model takes his or her shots to the agency, you can be confident that the director will look at them with, at least, a pair of reading glasses . . . and sometimes a loupe!

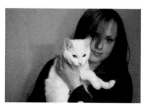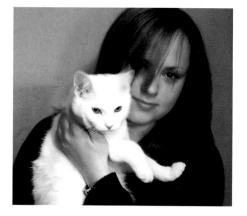

Figure 11-1: This figure shows a typical portrait from its original state to its finished state. It was cropped, adjusted in terms of tone and color, and fine tuned and sharpened.

How much you alter or change the photograph depends entirely upon what the client wants, what purpose the photograph is to be used for, what your professional and artistic preferences are, and, finally, how far from your vision the photograph turned out. You may be more a purist and not want to change very much in the photograph, or you may have the sort of style where you work with every eyelash and strand of hair. It's assumed your clients know your style and are comfortable with it. What you do or don't do is really a matter of your own personal style and the needs of your clients.

That said, there are standard things that are more or less universally done in the portrait business that are important to know how to do: whitening teeth, blending facial blemishes, dealing with background anomalies, and altering color saturation, for example.

The trend today in the portrait business is toward natural-looking portraits with features evident. There is a celebratory aspect to this style that is wonderful for creative photographers and allows for interesting compositions and poses. It also means that there is a lower tolerance for a great deal of "effects" in finished portraits. People want to look more crisp and in focus than soft and smooth. See Figure 11-2.

© Utata.com

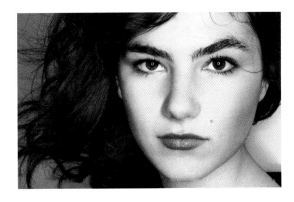
©Istoica.com

Figure 11-2: Although smoother, moodier styles — as shown on the left — will always be done and have their place in the portrait world, most people want a more natural appearance to their finished portrait — as shown on the right.

As you are working on photographs in the darkroom keep in mind that the more natural the model looks, the better. There are exceptions, of course, and you need to understand what your model(s) want in the finished look. For passports and archival headshots, of course, there must be an absolute minimum of visible correction as these photographs will be looked at very closely and critically and must be very accurate representations of the models.

There is no right way or wrong way to edit photographs. There is no right or wrong portrait — only those that a lot of people like and those that a lot of people don't like. I assume you want to make those that appeal to the broader spectrum rather than the narrower one.

Basically, I would sum up my advice on popular appeal as it relates to portrait photography processing in two succinct statements:

✦ The model(s) should be identifiable. If you want to process very dramatically, do not do it to such a degree that the model is not recognizable as him- or herself *unless this is the specific intention of the portrait*.

✦ Everyone wants to look good — but no one really wants to look "plastic," so keep the processes which uniformly smooth the canvas to a minimum because the loss of skin texture alters the personality of the portrait drastically.

Best-Practice Editing Process

Every photograph you take will, as I said, need to be opened and checked for a variety of conditions that are just part and parcel of photography. Dust gets onto lenses and into sensors, tiny scratches are etched onto filters, and models have bad skin days. Additionally, some condition that existed during shooting may have created a photograph not quite to your standard, and you may need to lighten, darken, or increase the contrast or sharpness of specific areas.

The order in which you perform these tasks is quite important because the effects of editing are cumulative, and each step affects how the next is performed. Following is my recommendation for a best-practice editing process. If you do things in this order — even if the particular processes that you use vary with each type of step — your own processing best practices will develop based upon a solid model.

Step 1: Crop, resize, and fix resolution

Naturally, the first thing to do is save a copy of your original in TIFF or some other lossless format and close the original file without making any changes or saves. Keeping in mind that a JPEG file degrades each time it is saved (which includes automatic saves in Photoshop), it's not a good idea to use your original files for anything except making working copies. If you are working with RAW images this is not an issue as they must be converted to working copies by the software you are using.

The second thing to do is crop your image, if it needs any. I don't like to shoot with my camera on its side, for example, so I always need to crop any photograph I intend to use in portrait orientation. When cropping, keep these things in mind:

✦ Do not damage your composition or alter the balance with a heavy-handed crop. Before committing yourself to the crop make sure that what is left still adheres to the compositional guidelines outlined in Chapter 4.

✦ Do not crop too closely, even if it preserves your composition. Keeping in mind the compositional vignetting information from Chapter 9, ensure that you leave some breathing room around the model.

✦ Keep in mind the purpose of the photograph. Some images need to adhere to a standard size or aspect ratio (such as passport or identification photographs), and many clients will not want to have to pay for expensive custom framing for portraits that are not in any standard size or aspect ratio.

The third thing is to fix the resolution and adjust the image to the correct size for how you want the finished image to appear, based on the purpose for which it is intended. If you plan to print the image, the

resolution should be set at or near 300 dpi, but if you are using it on the Web, the highest the resolution needs to be is 72 dpi. If you want an 8-x-10-inch print at 300 dpi, as an example, your original image needs to be 2400 pixels wide by 3000 pixels high.

Tip

To learn how to change image size and/or resolution in Photoshop or Elements, you can type "resolution" into the Help system search box as shown in Figure 11-3, and then select the topic entitled "Changing the print dimensions and resolution of an image." It shows you the specific steps for the version of Adobe software you are using.

Figure 11-3: Adobe's Help system for both Photoshop and Elements is very comprehensive and easy to understand. It uses an HTML (hyperlinked references) interface for quickly finding related items.

Step 2: Correct or enhance tonal quality

The tonal quality is how accurately the colors are recorded and how balanced the range of tones represented in the portrait appear. Simply: lighting. It is one of those critical but often-overlooked aspects of photo processing. See Figure 11-4. Correcting the lighting as a first step tells you exactly what else may need repairing. If the photograph is too dark, for example, you will not be able to see any other imperfections. If the photograph is too light, you will not notice skin tone irregularities; additionally, it may seem unfocused and you may be tempted to over-sharpen it.

I recommend that you test several lighting adjustments — it is often not apparent that a photograph is too dark until you see it lighter. Most Photoshop and Elements functions allow you to preview the effect before committing to it. As long as the preview check box is ticked you can see what the final image will look like and you can either click OK or Cancel, depending upon whether you like the effect or not.

In this phase you will use adjustment layers and dodge and burn tools, as well as the shadow and highlight tools, which are all discussed in detail in the next section.

Figure 11-4: It's surprising how often you don't realize what is wrong until you make it right, and equally surprising how much difference a few levels lighter or darker can affect a portrait.

Step 3: Fine-tune and correct problems

Dust, scratches, artifacts, and errant pixels are what you're after first. Although these issues were more of a problem with film than they are with digital, it is still an issue because hairs and dust pieces can get into your camera while you change lenses, and filters can become scratched. Don't discount airborne dust and particulate either because, depending on the lighting, these show up also.

This is also the phase at which you perform any corrective edits. From removing blemishes and evening out skin tones to lifting dust, you can correct and improve a portrait in the darkroom in many ways. To work in this phase you will be using, among other things, the Healing tool, the Clone tool, and the Patch tool, which are all described below.

Tip In post-processing you are doing the detail work, and you should work on the image in its actual-pixel size and use smaller-sized tools. As you proceed, check the image in its printed size regularly to see that the result is the same as in the "bigger picture" view. Actual pixel size view is greatly magnified from the print version, and alterations will look quite different in each view mode — checking back and forth is a good idea.

Step 4: Sharpen and clarify

Photographs look more in focus in the LCD of your camera than they do on the screen — this is simply a function of the level of detail you can see at a small size. See Figure 11-5. The overall focal quality of your image is very important because the image will likely be printed and viewed in a large size. Once all of the lighting work is complete and any necessary corrections and improvements have been made, it's time to ensure that the image is as sharp as it needs to be. To work in this phase you will be using the sharpening tools, which are described in the next section.

Figure 11-5: Sharpness is another one of those areas where it's hard to know your photograph needed it until you try it. If you intend to print the image, sharpening should be done in print-size view.

Perfect the Tonal Quality

Assume that you have resized and cropped your image. You're working with a non-lossy copy and the original is safely put away.

Tonal quality is a silent killer. It's one of those things that you often do not know is wrong or "off" until you see it done correctly. Tonality and color balance are creative choices, of course, and each photographer has his or her own style.

Generally, the first step in achieving tonal perfection is to work with the photograph's levels.

Adjusting levels

Levels, as the name implies, is simply the degree, or level, of each tone or color in a photograph. The combined measurement of each tone or color is called the "level." The two tools you'll use to correct the lighting in your images are the Levels Adjustment and the Shadow/Highlight tools. They are available from the Enhance option on your menu bar under Adjust Lighting.

Note There *is* a third option called the Brightness/Contrast tool. Like its name implies, it allows you to adjust an image's tonality. It works quite crudely and is not a very good choice for working with portraits except to test for effect when making adjustment decisions.

Using a Levels adjustment layer

When you adjust the levels of an image, you are in reality adjusting its tonal range. The Levels tool allows you to change three variables in your image: the *highlights*, the *midtones* (also referred to as *gamma*), and the *shadow* areas. Highlights and shadows are sometimes referred to, respectively, as the white and black points because the role they play in the image is to identify the tonal range by finding the tone closest to white and the tone closest to black.

The highlights are the light tones — typically teeth, the whites of the eyes, often background, some skin tones, white clothing, and so on. The shadows are the dark tones — typically hair, the iris of an eye, and sometimes background or dark clothing. Midtones are those in between. When you set the highlights and shadows properly in either Photoshop or Elements, the midtones are usually adjusted appropriately. See Figure 11-6.

Tip When tone values are concentrated at either end of the tonal range, such as a photograph that is mostly dark or mostly light, you may need to adjust the midtones manually. If the image is fairly well balanced with a large midtone area, adjusting midtones specifically is not usually necessary and in fact should be avoided when possible because the results can be unpredictable.

Although you can alter the levels of a layer directly by a variety of means, it is best to make adjustments in a nondestructive manner such as using adjustment layers. Adding an adjustment layer modifies the appearance of all of the layers that sit below it without actually making any changes to the pixels of the image. Follow these steps to create a Levels adjustment layer, as shown in Figure 11-7:

1. **Click the New Adjustment Layer button on your layers palette, and then click Levels from the pop-up menu.** Alternately, you can choose Layer ➪ New Adjustment Layer ➪ Levels from the menu bar at the top of the Editor. The levels dialog box appears (see Figure 11-7).

2. **Adjust the Input Levels sliders until your image looks properly exposed.** These sliders lie just below the histogram. The black slider on the left controls the black point (shadow). The gray middle slider controls the gamma level (midtones). The white slider at the right sets the white point (highlight) for the image.

3. **Adjust the output levels.** Below the Input Level sliders are two additional sliders that can be used to vary the output levels of the image. Moving the black slider to the right lightens the dark areas of the image. Moving the white slider on the right darkens the highlights.

4. **Click OK to save your changes.**

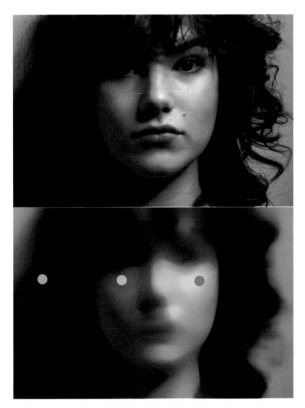

Figure 11-6: A photograph has three basic tone areas, which are referred to as highlight (red), midtone (cyan), and shadow (yellow).

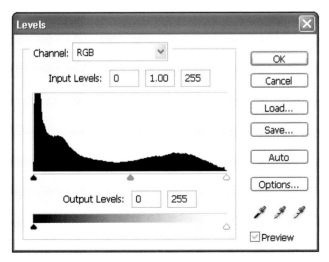

Figure 11-7: Levels dialog box

The Adjustment Layer Button Doesn't Work!

If you're working with a RAW file in a 16-bit working space, the adjustment layer button on your layers palette will be grayed out in Photoshop Elements 3. One of the things that software companies do to encourage the purchase of the full-featured and more expensive versions is to limit functionality in the lesser versions. However, you may find when working in a 16-bit workspace that some functions are unavailable in even the full version, so before you upgrade, make sure you're getting ahead of the problem.

Meanwhile, there's a workaround for the problem of a grayed-out adjustment layer button.

1. **Press Ctrl/Command+J to copy your image to a new layer.**

2. **Press Ctr/Command+L to open the Levels dialog box.**

3. **Make your level adjustments as necessary.**

4. **Do you need to allow parts of the bottom layer to show through?** Use the Eraser tool to erase the parts of the top layer that you don't want.

You can now safely convert your image back to 8-bit mode, which turns on the entire editing functionality available in Elements. You'll find that most companies producing image-editing software restrict 16-bit editing to their professional versions.

Using the Shadow/Highlight tool

The Shadow/Highlight tool presents you with three options. You can lighten shadow areas and darken highlights to bring out hidden detail, and adjust the contrast of the midtones (gamma).

Because these changes cannot be applied in the form of an adjustment layer, it is best to copy your image to a new layer and make these changes directly to it.

Follow these steps to open this tool:

1. **Press Ctrl/Command+J to copy your image to a new layer.**

2. **Choose Enhance ⇨ Adjust Lighting ⇨ Shadows.** The Shadow/Highlight dialog box appears (see Figure 11-8).

3. **Adjust the Shadow, Highlight, and Midtone contrast sliders until you are satisfied with the appearance of the image.**

4. **Click OK to accept the changes.**

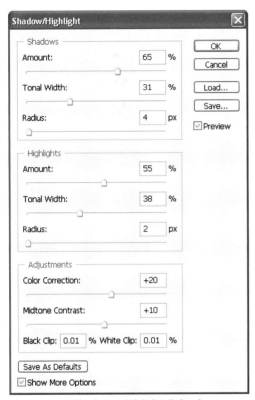

Figure 11-8: Shadow/Highlight dialog box

Dodging and burning

When you *dodge,* you are selectively lightening an area of an image. *Burning,* on the other hand, is selectively darkening part of an image. This name is a holdover from the pre-digital days of photography when photographers like Ansel Adams (who helped popularize these techniques) would burn in areas of a print by overexposing them with a flashlight, or dodge them by blocking areas where light from the enlarger lens exposed a print. The burned areas of the print came out darker, and the dodged areas of the print came out lighter.

This was an extremely hit-and-miss proposition in the darkroom, and it was not uncommon for artists to go through a whole box of enlargement paper trying to get the appearance of their print just right. Restricting your dodging and burning to Photoshop's digital darkroom is much less expensive, while delivering precise results each and every time.

Photoshop runs circles around the old darkroom in that it allows you to be selective about the tonal ranges you dodge and burn: shadows, midtones, and highlights. As an example, you can dodge the midtones and highlights in a woman's hair (see Figure 11-9) while giving her rich, dark shadows, and vice versa.

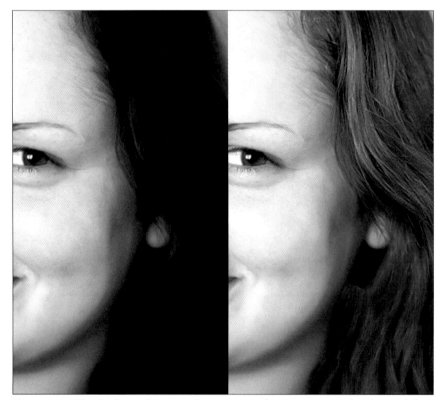

Figure 11-9: The Dodge and Burn tools are among the most powerful and useful that Adobe offers. With them you can selectively alter small or large portions of your image.

You'll find the buttons for the Dodge and Burn tools located in the Toolbox at the left of the Editor. They are grouped together with the Sponge tool. If you place your mouse pointer over any of these tools and right-click, the other tools immediately become available in a small drop-down menu.

Tip A little triangle appears in the bottom right of the Toolbox to indicate any tool that has nested tools. Adobe combines alike tools to preserve desktop space, so if you're looking for something and it isn't immediately visible, check to make sure it's not just underneath another tool.

You are directly manipulating the image when you dodge and burn, so start out by copying the data to a new layer to edit in a nondestructive mode:

1. **Press Ctrl/Command+J to copy the image data to a new layer.**

2. **Select either the Dodge or Burn tool.**

3. **Select the tonal range you want to modify on the options bar.**

4. **Select a brush and size.**

5. **Set the opacity for your brush.**

6. **Start dodging and burning!**

Using an overlay layer

Both Photoshop and Elements allow you to set the options for how one layer blends into the layer below it. One of the options is called *overlay*. A layer set to overlay has interesting properties. Painting a light color on the layer lightens the midtones and highlights while leaving the shadow areas mostly alone. Painting a dark color on the overlay layer deepens shadows without affecting highlights too noticeably. Painting on an overlay layer with the colors white and black is my preferred method of selectively lightening and darkening many of the black-and-white portraits I produce. The effect it produces is quite similar to dodging and burning.

Here are the basic steps:

1. **Click the New Layer button on the Layers palette to create a new layer.**

2. **Set the layer blending mode to Overlay.**

3. **Set the opacity of the new layer to 20%.**

4. **Select a paintbrush from the Toolbox.**

5. **Select the brush size and opacity — I suggest 25% opacity.**

6. **Select either white or black as your foreground color from the color palette, depending on whether you want to selectively lighten (dodge) or darken (burn) areas of your image.**

7. **Start painting your image.**

Correcting color casts

Different types of light have different color temperatures. Photographs taken in these different lighting situations all come back with odd-looking color casts if no corrective filters were applied when the picture was made.

Cross-Reference For a refresher course on light temperatures, see Chapter 3.

Most digital cameras are built with the ability to analyze the color temperature when a picture is made and apply electronic filters internally. Problems arise when the light's temperature is either not close to what the camera is preset for, or the camera just plain guesses wrong. Either way, you're stuck with a funny-looking image. Happily, this is an extremely quick fix.

Sampling a neutral area

If you're an Elements user, you've just been blessed with what is probably the only gotta-have-it feature that hasn't made it into Photoshop: the Remove Color Cast tool. Here's how you use it:

1. **Press Ctrl/Command+J to copy your image data to a new layer.**

2. **Choose Enhance ⇨ Adjust Color ⇨ Remove Color Cast.** The Remove Color Cast dialog box appears.

3. **Place the eyedropper over a neutral white or gray area in your image (it *must* be white or gray), and click your left mouse button.** Elements removes the color cast from the image (see Figure 11-10).

4. **Press OK to accept the changes if you are happy with them.** If not, try sampling a different neutral area in the image for better results. If you have to try several variations, be sure to click the reset button between samplings.

That's it! The grumbling sound you're hearing is thousands of wedding photographers who had to purchase an expensive third-party plug-in to do the same thing to their JPEG images in the pro version of Photoshop.

Where's the Neutral Zone?

The crew of television's fictional starship *Enterprise* always had to worry about straying into the Neutral Zone and mixing it up with the Klingons. Your problem is the opposite of James T. Kirk's—there's no neutral zone to poke your nose—okay, your eyedropper—into. Where to find a neutral reference point? I've successfully used the following as white balance references to remove color casts in my photos:

✦ Whites of the subject's eyes (just don't click on a blood vessel!)

✦ Neutral white and gray buttons on clothing

✦ Gray, silver, and white hairs on the heads of older subjects

✦ The frames of eyeglasses

✦ Pearl earrings and brooches

✦ Teeth if they're quite white

There's usually something in the image you can use, so be sure to zoom in and look around. On that odd occasion when you can't find something, you can still apply a digital filter to fix the colors in your photo.

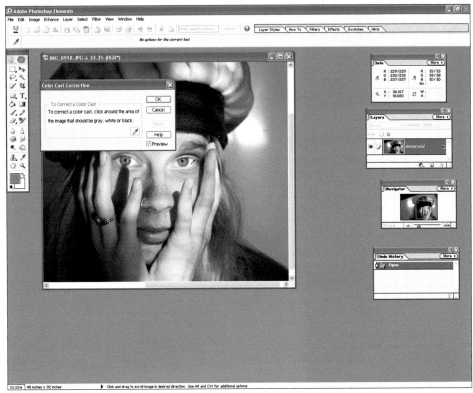

Figure 11-10: Removing color cast in Elements is easy and efficient if you have a neutral white or grey area in your original.

Applying digital filters

Exposing a digital image is a lot like shooting with slide film back in the old days. Those who actually did shoot a fair amount of slide film can be forgiven for shuddering at this point. The number one headache with slide film was that there was *no post-processing of any sort*; any modifications to an image were made *in camera*. This often meant carrying around a very large and expensive pouch of filters to compensate for practically every imaginable lighting condition.

With digital, the nastiest of color corrections can be performed after the fact. Recent versions of both Elements and Photoshop allow photographers to add any of the popular color filters they want digitally, without having to worry about headaches such as reduced light levels and degraded image quality that plagued film shooters. Adobe offers 18 basic filters to choose from in the Filter drop-down list. To remove a color cast, simply choose the complimentary color from the list. For example, a photo taken in the shade usually has a bluish cast, so adding a yellow/orange warming filter fixes the problem.

Filters are applied via adjustment layers, allowing you to modify the appearance of your image, not the pixels of the image itself. Follow these steps to apply a filter:

1. **Click the Adjustment Layer button on your Layers palette, and then select Photo Filter from the pop-up menu.** The Photo Filter dialog box appears.

2. **Choose a filter from the drop-down list.**

3. **Use the slider to set the filter's opacity (strength).**

4. **Preview the change to make sure it is acceptable.**

5. **Click OK to accept the change.**

The ability to digitally add photo filters after the fact is a powerful tool to have in your artist's toolbox, so be sure to experiment with it.

Fine-Tuning and Correcting

Software like Photoshop has made the removal of dust, scratches, blemishes, and even scars and wrinkles extremely easy. With some practice, you can learn to perform the same processes and create professional portraits that can stand any sort of scrutiny.

The principal tools used for image cleanup are the Healing, Clone, and Patch tools. The latter is available only in Photoshop, but it deserves mention because of how useful it is.

What these tools all have in common is that they let you replace the bad pixels in an image with better pixels that you have selected (*sampled*) from elsewhere in the same image (and sometimes even a different image!). Although each tool takes you to the same destination, each one takes a slightly different path to get there.

Using the Healing tool

Like its name says, the Healing tool is used to repair an area of an image that is not looking as good as it should. As a general rule, the Healing tool should be used in areas with texture where preserving both texture and tonality is vital. Elements offers two variations on this tool: the Spot Healing tool (selected by default), and the Healing Brush tool. I suggest you avoid the Spot Healing tool and use the Healing Brush tool instead, which is much more precise in the results it delivers. The Spot Healing tool and the Healing Brush tool are nested together and whichever one was used last will be on top. You can toggle nested tools by right clicking the tool with your mouse and selecting the tool you wish to make active.

The Healing Brush allows you to sample the color, tone, and texture from one area of an image and paint it over another area. Photoshop does a lot of heavy lifting in the background to merge the new information that you paint into your image with this tool into the surrounding areas. The results (see Figure 11-11) look amazingly natural!

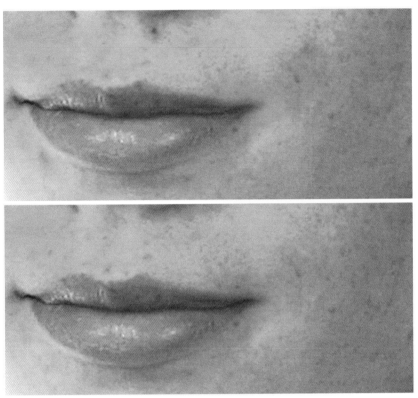

Figure 11-11: The Healing tool is a very "smart" tool and the results are usually completely unnoticeable.

Here are the steps:

1. **Press Ctrl/Command+J to copy your image data to a new layer.**

2. **Choose the Healing Brush tool from the Toolbox.**

3. **Set your brush options on the options bar. I suggest the following settings as a starting point:**

 - **Diameter:** 40 px
 - **Hardness:** 50%
 - **Spacing:** 25%
 - **Angle:** 60 degrees
 - **Roundness:** 15%

4. **Position your mouse pointer over an area that you want to sample.**

5. **Press and hold the Alt/Option key (your cursor changes to small cross hairs while the Alt/Option key is depressed) and click your left mouse button to sample the image.**

6. **Paint over the blemished area of your portrait, using small, short strokes.**

7. **Resize the Brush tool and sample new areas as needed.**

8. **Use the Undo History to backtrack when needed.**

This is pretty much *the* touch-up tool to use when dealing with skin or fabric. You'll want to spend some time mastering it.

Using the Clone tool

Like the Healing Brush tool, the Clone tool allows you to paint data sampled from one area of the image over another. The Clone tool differs from its cousin in that it does not preserve texture particularly well, it lacks the brush options, and it does not blend the new information you have painted into the image with its surroundings as masterfully as the Healing Brush tool. I prefer to use the Clone tool for removing objects from the background of my images, particularly in the out-of-focus areas.

If I had to name my number one use for the Clone tool, it's dust busting. One of the drawbacks of a digital SLR camera with removable lenses is that dust inevitably winds up on the sensor despite weekly cleanings. The Clone tool allows me to remove dust spots from most of my images in a matter of seconds.

One novelty offered with the Clone tool is the Alignment option. When turned on, the sampled area moves along with your mouse pointer as you paint. I find this useful for removing distracting wires and poles that have crept into the background behind my subjects. With the Align option unchecked, the Clone tool simply repeats the area you originally sampled as you paint.

Here are the steps for using the Clone tool:

1. **Press Ctrl/Command+J to copy your image data to a new layer.**

2. **Choose the Clone tool from the Toolbox.**

3. **Set your brush options on the options bar.** Choosing a brush with soft edges makes the new data you paint into the photo merge with the background better. Choosing a brush with hard edges makes the cloning obvious (see Figure 11-12).

4. **Choose whether or not to use the Align function.**

5. **Position your mouse pointer over an area that you want to sample.**

6. **Press and hold the Alt/Option key (your cursor changes to small cross hairs while the Alt/Option key is depressed) and click your left mouse button to sample the image.**

7. **Proceed to clone over the areas of your image that you want to replace.**

8. **Resize the Brush tool and sample new areas as needed.**

9. **Use the Undo History to backtrack when needed.**

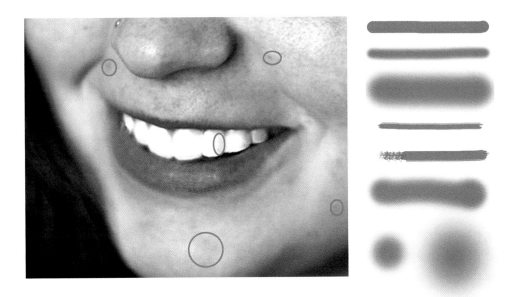

Figure 11-12: Choosing the right brush tool is important when performing any corrective work because you want to make sure that your handiwork is not apparent. The more hard the brush edge, the more obvious the correction. Generally, choose a brush that allows you to work on the area without touching any other area.

Using the Patch tool

The Patch tool essentially combines the texture- and tonality-preserving ability of the Healing Brush with the ease of use of the Clone tool. How useful is the Patch tool? If it were the *only* feature that distinguished Photoshop from Elements, I would still pay the extra cash for the upgrade in a heartbeat.

You can use the Patch tool to draw an outline around a target area, and then choose a source area to use to replace the target pixels. Photoshop carefully matches the texture, lighting, and hue of the source pixels and the target pixels. This is my favorite tool for eliminating those unsightly bags under people's eyes, double chins, and any other piece of work that would be time consuming using the Healing Brush.

Here's how easy it is:

1. **Press Ctrl/Command+J to copy your image data to a new layer.**

2. **Choose the Patch tool from the Toolbox.**

3. **Draw a selection around the pixels in the target area that you want to replace.**

4. **Position your pointer over the target pixels and press your left mouse button.** Drag the outline from the target pixels over the source pixels that will blend best.

5. **Release the mouse button.** Photoshop automatically blends the new pixels in with the old.

6. **Use the Healing Brush to touch up as necessary (you'll hardly ever need to).**

Sharpen and Clarify

Although you likely may achieve focal perfection in the viewfinder, you may find that when you look at the image in an editing program that your digital camera has rendered the image a little smoother or softer than you remember seeing it. Digital photographs often appear a little soft in focus, even from the very high-end cameras. A digital camera sends the picture data from the sensor to the recording media in a mosaic, which is a collection of small squares joined together to create an image, much like a design made in ceramic tiles. The camera electronically interpolates this mosaic into a smooth picture — or tries to. This is where the trouble begins. In film the image is being pressed onto the recording media without any interpretation from the camera. In digital photography the camera makes decisions — a lot of them and very rapidly.

When the camera creates the whole image from the mosaic, the sharp edges of those little squares can get blurred, which causes areas of your photograph to seem, if not unfocused, definitely soft.

Some models of digital cameras sharpen the image as part of their software, and some cameras let you specify how much sharpening (if any) you want the camera to do, but usually as part of your processing you'll want to fine-tune this process yourself. Some photographers, in fact, claim that every digital image needs some sharpening, and this seems to be a fairly safe bet. It won't hurt to check, in any case (see Figure 11-13).

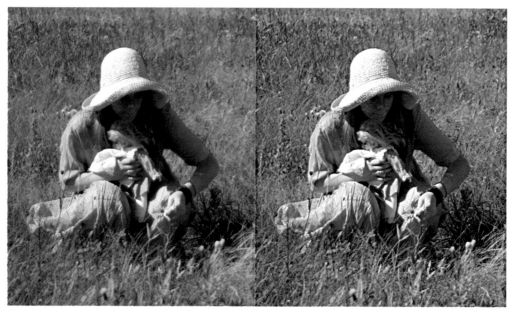

Figure 11-13: I strongly recommend that you test sharpening on all images. Out of the camera, I would not have thought by looking at it in Photoshop that this photograph needed sharpening. I was wrong.

The primary tool for sharpening digital photographs is the Unsharp Mask (USM). It's located in the Filters menu (Filters ⇨ Sharpen ⇨ Unsharp Mask). The Unsharp Mask filter finds contrast boundaries between like collections of pixels and increases the contrast between them so that their edges appear sharper. A little sharpening goes a long way, and it's usually a trial-and-error process to get the correct results.

When working with the USM tool, I advise that you view the photograph at either actual size if it's for a Web application or print size if it's for a print application. Viewing the entire image when you are sharpening is a good idea so that you can ensure you are not creating over-sharpened areas.

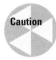

Caution Oversharpening makes an image look jaggy and lines the edges of elements with a thin white band, which is very unattractive. Make sure you use the preview option with any sharpening tool. Watch for jagged edges, white lines, and "dimpling" in smooth areas when sharpening.

When the USM dialog box is open (see Figure 11-14) you see three controls called:

✦ **Amount:** The amount of sharpening desired.

✦ **Radius:** How far away from the edge of each distinct element or group of similar pixels the filter will work.

✦ **Threshold:** How much difference there has to be between the light value and the dark value of the pixels of each element or group of like pixels before the sharpening filter goes into action.

The sharpening effect is greater as the Amount or the Radius increases, but is actually reduced as the Threshold increases. Although there's no right or wrong rule that works universally, a good starting point for digital photographs would be

✦ **Amount:** 60%

✦ **Radius:** 2.5 to 3.0

✦ **Threshold:** 4 to 6

Sharpening is like any other editing in that you can perform it very selectively by using layers. For example, if you want to sharpen a specific area of a portrait (such as the eyes or hair) but do not want to sharpen the face at all, simply make a layer, perform the edit, and use the Eraser tool to wipe away any parts you do not want. The original layer will be visible below the partially erased layer. Alternately, you can use the Selection tool to outline the area you want sharpened and apply the filter to that area only.

Sharpening is the last phase in a standard editing process, after which it is usually time to save your photograph and send it to the printer or to the Web. There may still be a few things of a more specialized nature, such as vignetting and black-and-white conversions, that, although important to know, do not need to be done to every photograph. The more processes you understand and the more tools you learn how to use, the more you can customize the way you use your software.

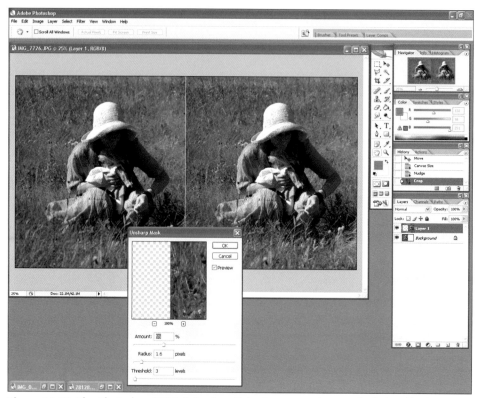

Figure 11-14: The Photoshop USM dialog box. Selective processing, particularly with sharpening functions, is a very useful skill to have. Many photographs need specific processing in specific areas.

I use a pen tablet, for example, and I almost never use any paintbrush-style tool except the Smudge tool (nested with the Sharpen and Blur tools); I have all but forgotten how to use many tools because I use them so rarely. Other people I know use the tools I never do and laugh at me when I tell them about my little Smudge tool secret. The basic best practices described here are the starting point, but all of the software discussed is rich with possibility and potential. Experiment. Find out what makes it purr.

And really, try out the Smudge tool. It's quite the adventure at first.

In the next chapter I'll go through red eyes, color conversions, center spot filter effects, and creating vignetting effects. *Then* I'll talk a little about saving and printing your files.

✦ ✦ ✦

12 Finishing Touches

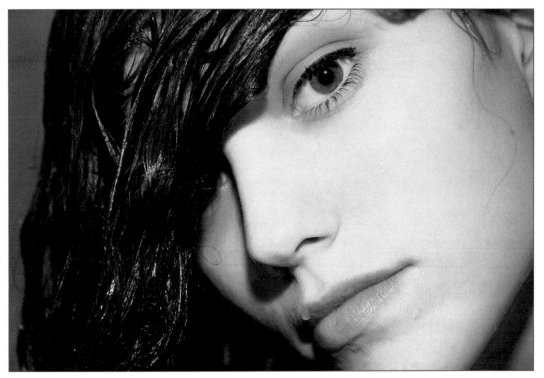

© Istoica.com

Photography is both a craft and an art. At various stages in the process, your technical or your artistic skill may be the most important thing in your arsenal. As with many types of visual art (painting and sculpting, as examples) much of the technical skill exists simply to support the artistic ambitions. Perhaps learning how lighting is set up doesn't excite you by itself, but surely the notion that knowing how to do so will vastly improve your finished portrait is exciting.

When you adhere to best practices and practice a lot, and when you take the time to learn the theory behind those practices, you will find that you begin to make intuitive decisions when you're behind the camera. You'll know what will be a problem and what won't, what you can fix and what you can't. You'll know, for example, that it's better to overlight than underlight because you can add shadows easier than you can create highlights from darkness.

Most of the processes in this chapter build upon the tools and concepts explored in Chapter 11. The idea is to train yourself to notice the smaller details that separate an amateur effort and a professional result. The added benefit of learning post-production skills is that awareness of these details make you a better photographer by helping you find and correct out-of-place elements before the picture is taken. It's much easier to spend ten seconds fixing unwanted strands of flyaway hair before making an image than ten minutes removing stray hairs from the shot afterwards.

If you want to end up with something that looks as gorgeous as the portrait shown in Figure 12-1, all you have to do is make sure you don't stop learning, practice the lessons you do learn, and think of your craft as an ever-evolving art form.

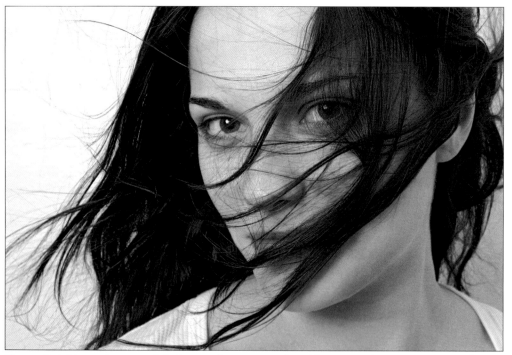

Figure 12-1: The perfect portrait is the one that turns out how it's supposed to turn out. Your job is to keep learning and practicing so you can produce the "perfect" portrait every time.
© *Istoica.com*

Make Eyes Sparkle

As you know, photographers often use multiple light sources to illuminate their subjects. Even in out-of-studio situations, there are many opportunities for multiple light sources, which usually result in multiple catchlights.

Whether you choose to keep or remove the extra catchlights is a matter of your style and taste, but my professional recommendation is that you remove them on what I call "fireplace portraits" and formal headshots, and make your own decisions regarding the balance. A "fireplace portrait" is one where I expect the person or persons will want a large print, usually larger than 16 inches wide, to hang in a prominent place in their home. Usually this is on the wall above the fireplace, hence the nickname.

If you decide to remove the extra catchlights in your images, leave the ones closest to the 11 o'clock or the 1 o'clock position and remove the others. Figure 12-2 shows a set of eyes that have inherited a dominant catchlight from the key light and a smaller secondary catchlight from the fill flash.

Figure 12-2: Note the secondary catchlights from the fill flash.

Getting rid of a catchlight is usually much simpler than adding one. Here are the steps I normally use:

1. **Press Ctrl/Command+J to copy your image to a new layer.**

2. **Select the Patch tool.**

3. **Use the Patch tool to draw a selection around the catchlight you want to remove.**

4. **Click in your selection with the mouse and, holding down the mouse button, drag the selection over the pupil you want to replace the selected area with. Release the mouse button.**

5. **Repeat as necessary to remove all traces of the catchlight (as shown in Figure 12-3).**

Figure 12-3: Secondary catchlights have been removed.

Removing Red Eye

Contrary to popular belief, red eye is not caused by demonic possession or spending your spare time reading photography how-to books. It's caused by placing your flash too close to your lens, and is a common by-product of using the on-camera flash of even the best digital camera.

The light from the flash reflects off the blood-vessel-rich retinas at the back of your model's eyes and bounces back into your lens, as shown in Figure 12-4. Even though red eye can be minimized the fact is that you'll probably wind up with this problem in some of your photographs.

Figure 12-4: Red eye is generally caused by the flash being too close to the lens and can happen to the best of us.

Using the Red Eye Removal tool

The button for the Red Eye Removal tool lives in the Toolbox at the left side of your editor.

1. **Select the Red Eye tool from the Toolbox.**
2. **Place the cross hairs for the tool over the afflicted pupil, and click the left mouse button.**
3. **Repeat with the other pupil.**

4. **You will most likely still have a bright spot left where the red was.** If this is the case, select the Burn tool from the Toolbox with your mouse pointer.

5. **Set the tonal options (midtones, possibly highlights) and brush size for the Burn tool, and use it to paint out the right patches on each pupil.**

Removing red eye manually

Sometimes the Red Eye Removal tool is a little too clumsy for the task, and on your printed work you want the model's eyes to look their best, so you should probably do it manually. Follow these steps:

1. **Press Ctrl/Command+J to copy your image data to a new layer.**

2. **Zoom the image in (Ctrl/Command++) so that the eyes take up the majority of the work area.**

3. **Click the eyedropper in the Toolbox and use it to select a color from the iris of the eye.** It should be as close to neutral gray as possible.

4. **Use the Paintbrush to paint over the red area with the neutral color you selected.** Be very careful not to paint over the eyelid. Repeat with the other eye.

5. **Set the blend mode of the top layer to Saturation.** The red gleam disappears, although you may be left with gray and hollow-looking eyes.

6. **Choose Filter ➪ Blur ➪ Gaussian Blur.**

7. **When the Blur dialog box appears, set it to 1 pixel and apply.** This softens the edges of your touch-up job.

8. **Press Ctrl/Command+J to duplicate the Saturation layer. Set the blend mode of this new layer to Hue.** This restores some of the missing color. If the iris has too much color now, lower the opacity of the layer.

9. **If the pupils are still too bright, burn them using black paint on an Overlay layer.**

10. **You can merge down or flatten the extra layers at this point if you're happy with the appearance of the eyes.** See Figure 12-5.

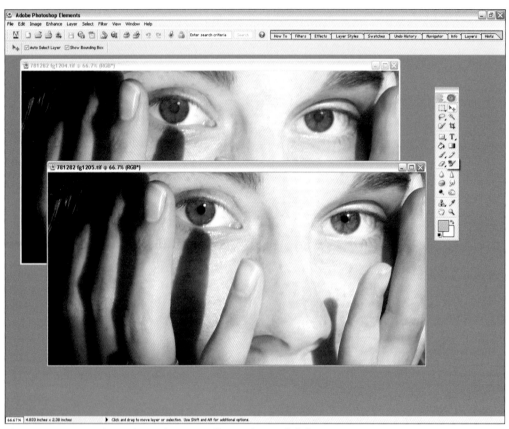

Figure 12-5: Removing red eye changes a disaster into a delight.

Whitening Eyes and Teeth

I make sure that I always give the eyes and the teeth some attention whenever I'm retouching a portrait. Healthy teeth should not be a pure white, but certainly a pearly white. I prefer the eyes to have a subtle but healthy glow, with any angry-looking blood vessels toned down.

Keep in mind that a light touch is required for this finishing work; a heavy hand creates a fake-looking image. Check often as you process a portrait, looking at it in both print- and actual-size views (see Figure 12-6) to be sure your edits are forming up the way you want them to, as a whole.

Figure 12-6: The size at which you view your image as you work on it can make a big difference. When you work in actual pixels on details such as eyes, use print-size or actual-size (which is highly magnified) view to frequently verify your work.

Whiten and brighten eyes

The goal here is to desaturate, or remove the majority of the color from the whites of the eyes, and increase the color saturation of the irises to make them more noticeable and appealing.

Whiten

Here are the steps to whiten and brighten eyes in Photoshop:

1. **Use the New Adjustment Layer button to create a hue/saturation layer.**

2. **Adjust the Color Saturation slider down to around –80 to remove most, but not all, of the color.**

3. **Select the color black as your foreground color from the Color palette.**

4. **Use the Fill tool to cover the entire layer mask with black.** This allows the layer below to show through.

5. **Select the color white as your foreground color from the Color palette.**

6. **Select the Paintbrush tool from the Toolbox.** Choose a soft-edged brush of the appropriate size. See Figure 12-7.

7. **Paint the layer mask white over the whites of the eyes.** This applies the mask where you are painting, and you'll see the color being removed where you paint. Do this for the whites of both eyes.

8. **Click the New Layer button on your Layers palette to create a new layer.**

9. **Set the layer opacity to 15%.**

10. **Set the layer blend mode to Overlay.**

11. **With white still set as your foreground color, use your Paintbrush to paint over the entire surface of the eye, *except* for the pupil.** This subtly brightens the eye.

Figure 12-7: Selecting the right-size brushes for each task is important, as is being clearly able to see the area you are working with. The Brushes palette in Photoshop has a very large selection of brush shapes and textures. Experimenting is a good idea.

Brighten

Here's how you can boost and clarify the color of the iris a bit:

1. **Click the New Adjustment Layer button to create a hue/saturation layer.**

2. **Adjust the Color Saturation slider down to around +15 to slightly increase the color of the image.**

3. **Select the color black as your foreground color from the Color palette.**

4. **Use the Fill tool to cover the entire layer mask with black.** This allows the layer below to show through.

5. **Select the color white as your foreground color from the Color palette.**

6. **Select the Paintbrush tool from the Toolbox.** Choose a soft-edged brush of the appropriate size.

7. **Paint the layer mask white over the irises of the eyes only.** This applies the mask where you are painting, and you'll see the color becoming more emphasized where you paint. Do this for the irises of both eyes (see Figure 12-8).

Whitening teeth

Many, many people do not want to smile for their photograph out of sensitivity about their teeth. I'd estimate that at least a third of portrait clients are sensitive about how their teeth look, and it can result in awkward, tight-lipped smiles. If you want your models to smile and they're concerned about how their teeth will look, you can assure them that you know how to make their teeth white again. See Figure 12-9 for an example of a portrait before any whitening of the teeth was performed.

To whiten and brighten teeth into "pearly whites," follow these steps:

1. **Click the New Adjustment Layer button to create a hue/saturation layer.**

2. **Adjust the Color Saturation slider down to around –90 to remove most, but not all, of the color.**

3. **Select the color black as your foreground color from the Color palette.**

4. **Use the Fill tool to cover the entire layer mask with black.** This allows the layer below to show through.

5. **Select the color white as your foreground color from the Color palette.**

6. **Select the Paintbrush tool from the Toolbox.** Choose a soft-edged brush of the appropriate size.

7. **Paint the layer mask white over the teeth.** This applies the mask where you are painting, and you'll see the color being removed where you paint. Do this for all of the visible teeth, but not the gums.

8. **Click the New Layer button on your Layers palette to create a new layer.**

9. **Set the layer opacity to 25%.**

10. **Set the layer blend mode to Overlay.**

11. **With white still set as your foreground color, use your Paintbrush to paint over the teeth again, avoiding the gums.** This gives the teeth a healthy glow, as shown in Figure 12-10.

12. **Inspect the teeth for the presence of any blemishes or particles of food.** Use the Patch or Clone Stamp tools to remove them using the same procedure described for dealing with dust or blemishes in Chapter 11.

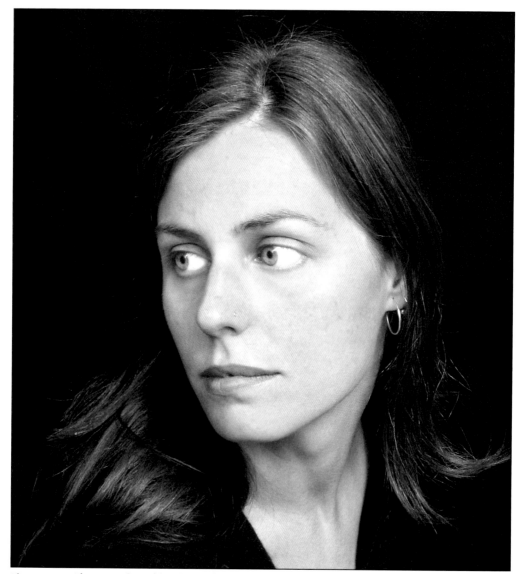

Figure 12-8: The eyes after whitening and brightening. Take special care with the eye area and use a very delicate touch when making adjustments so that the finished portrait retains a natural appearance.
© *Rachael Ashe*

Figure 12-9: Whitening and brightening the eyes and teeth can have a major impact on a portrait's final appearance.

Figure 12-10: Whitening the teeth can create a very subtle but important improvement to a portrait's final appearance.

Soft-Focus Effects

The soft-focus filter is one of those pieces of equipment that has been made mostly obsolete by the arrival of affordable image-editing software. Many people still use them, of course, because they're one of the pieces of equipment that made the transition from analogue to digital. For those who do not have a soft-focus filter to screw onto the end of their lenses, Photoshop is here to help.

Although there are many Photoshop plug-ins for sale that allow you to duplicate the effect of these filters, I recommend that you do it manually. Here's how to produce your own quick-and-dirty soft-focus effect:

1. **Press Ctrl/Command+J to copy your image to a new layer.**

2. **Select Filter ⇨ Blur ⇨ Gaussian Blur.**

3. **Set the blur amount to 30 pixels (or higher if you like).**

4. **Click OK to apply the blur.**

5. **Set the opacity of the new layer to 30% (or adjust it to your preference).**

You now have a soft, dreamy-looking image with the majority of the edge definition preserved (see Figure 12-11).

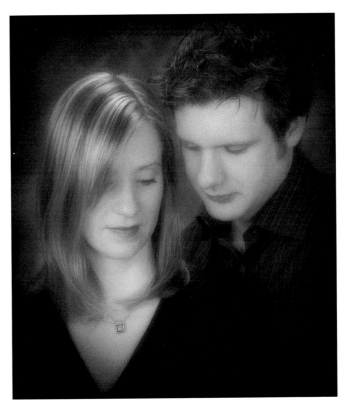

Figure 12-11: A soft-focus effect can create a lovely dreamy or romantic portrait. It's a very popular effect for couples, brides, and mother-child portraits.

Center Spot with Outer Blur

When you're looking at an image, your eye is naturally drawn to the in-focus parts of the image first. This is a powerful way to place the viewer's attention squarely on the subject of the photograph, as discussed in Chapter 4. However, depending on the type of camera and/or lens you used, and the circumstances of the photograph itself, throwing the background out of focus may not have been an option at the time. No worries, though — it can be done through software instead, as shown in Figure 12-12.

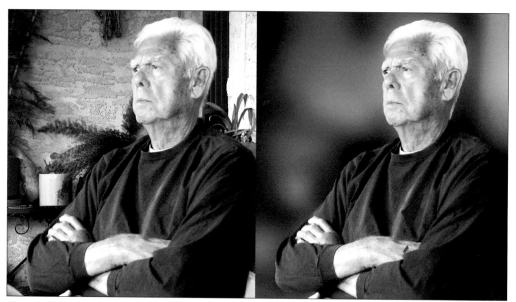

Figure 12-12: A before-and-after shot showing an image that has had a distracting background blurred.
© Marya Figueroa

Here are the steps to do this in the full version of Photoshop:

1. **Press Ctrl/Command+J to copy your image to a new layer.**

2. **Select Filter ⇨ Blur ⇨ Gaussian Blur.**

3. **Set the blur amount to 15 pixels (or higher if you like, depending on how much blur you want).**

4. **Click OK to apply the blur to your new layer.**

5. **Use the Elliptical Marquee tool from your Toolbox to drag a selection around the area of the photo where you want the sharpness preserved.**

6. **Click the Layer Mask button to create a new layer mask on the top layer.** This applies a black mask in your selection and causes the area outside of it to show through as sharp from the layer below.

7. **Press Ctrl/Command+I to invert the layer mask.** Now the center spot shows through sharp from the bottom layer. The transition between the blurred and sharp areas is too harsh; you'll fix that next.

8. **Making sure that your layer mask is still selected in the Layers palette, choose Filter ⇨ Blur ⇨ Gaussian Blur from the menu bar.**

9. **Set the blur amount to 150 pixels (or higher, depending on your preferences).**

10. **Click OK to apply the blur to your layer mask.** There is now a gradual transition between the blurred area and the in-focus area.

Vignettes

As with the center spot with outer blur, the idea behind a vignette is to help focus a viewer's attention on the subject of a photograph. For a medium-to-low-key photograph this is accomplished by creating a dark vignette effect around the subject so that your eye immediately goes to the lightest area in the image. For a high-key image, a vignette is used to lighten the area around the image so that the viewer's eye is drawn to the darker skin tones of the model, as shown in Figure 12-13.

Figure 12-13: A light vignetting effect using a high-key portrait.
© Cheryl Mazak

Here is how to create a center spot vignette in Photoshop:

1. **Click the New Layer button on your Layers palette to create a new layer.**

2. **Set the layer blend mode to Overlay.**

3. **Set the layer opacity to 40%.**

4. **Select either white (for a high-key image) or black (for a medium or low-key image) from the Color palette as your foreground color.**

5. **Use the Elliptical Marquee tool from your Toolbox to drag a selection around the area of the photo that you want to highlight with a vignette.**

6. **Press Ctrl/Command+I to invert the selection.**

7. **Use the Fill tool to fill your selection with the foreground color (either white or black).**

8. **Press CTRL/Command+D to deselect the selected area.**

9. **Select Filter ➪ Blur ➪ Gaussian Blur from the menu bar.**

10. **Set the blur amount to 150 pixels (or as high as 250 pixels, depending on your preferences).** This softens the transition between the vignetted area and the subject area of the image.

11. **Use the Eraser tool to remove the vignette from any areas of the subject that you do not want darkened or lightened.**

Color and Tone Conversions

Black-and-white or monochromatic imagery is enjoying a resurgence in popular appeal. In fact, a majority of clients will at least inquire about a black-and-white option. Although some digital cameras have a "black and white" or "sepia" mode, the images are captured in color and then converted to black and white after the fact. Doing it in Photoshop amounts to the same thing and can often be done better because you have more control over tonal range.

There are two really excellent ways to convert to black and white in Photoshop. The first is very easy and simply involves using the Image ➪ Mode ➪ Grayscale command. In my experience this is not only the easiest method, but the best one if your image is evenly toned, such as a close-up. See Figure 12-14.

If you are using Adobe Photoshop (and not Elements which does not offer this feature) and have uneven tones or a lot of negative space, a better method might be to desaturate the image using the channel mixer, which you do by following these steps:

1. **Use the New Adjustment Layer button to create a channel mixer layer.**

2. **Check the Monochrome box.**

3. **Your skin tones will probably be blown out (too white) at the start.** Move the Constant slider to the left until normal detail appears in the skin again.

4. **Adjust the Red, Green, and Blue sliders until you achieve a look that you like.**

5. **Click OK to apply the change.**

Using the channel mixer *is* more work, but I find that it produces much better results, giving the image much more depth and character than just straight conversion, particularly when the image is full or partial body and has a lot of visible background. See Figure 12-15.

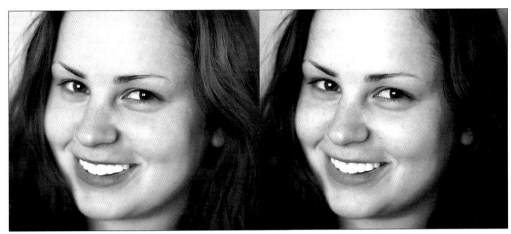

Figure 12-14: A portrait converted to grayscale using the automated Photoshop function.

Figure 12-15: A portrait converted to grayscale first using an automated function and then using the channel mixer which is found in the full version of Photoshop.

Shooting in Monochrome

Black and white is a great option for models with uneven or red skin tones. It generally provides a much smoother appearance to the skin, and the subtle shades of red are easier to work with in monochrome than in color.

Creating Sepia-Toned Images

I love sepia-toned black-and-white images. The sepia toning gives a black-and-white portrait a warm, brownish-yellow look that is very retro, as seen in Figure 12-16. And unlike real-world sepia toning as done in the darkroom (the toner has a rotten-egg stench that sticks to your skin for *days*), sepia toning an image in a program like Photoshop is quick and painless.

You start with a black-and-white image that is still in the RGB (Red/Blue/Green) color mode. Follow these steps to sepia tone it in Photoshop:

1. **Use the New Adjustment Layer button to create a photo filter layer.**

2. **Choose the Sepia filter.**

3. **Adjust the strength of the Sepia filter to achieve the desired look.** Some prefer a subtle toning (less than 50%) whereas I prefer a stronger look (upwards of 75%).

4. **Click OK to apply the photo filter.**

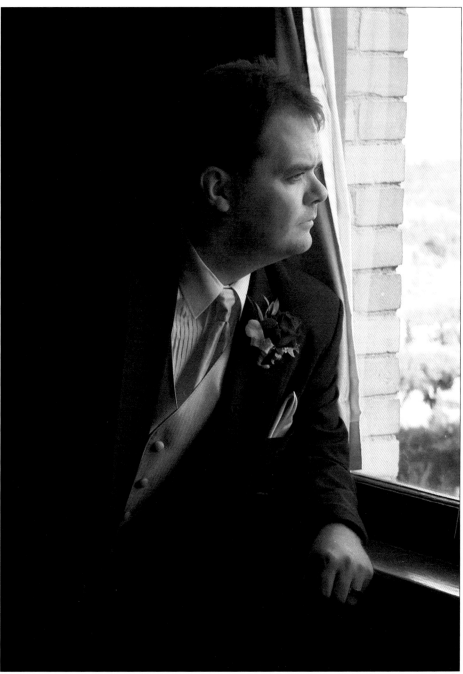

Figure 12-16: Sepia portraits have an "old world" feel to them and are becoming very popular wedding, sibling, and other keepsake portraits.

Saving Files

Saving your work is the final stage of the darkroom phase. After it is saved you can send it to the printer beside your desk or the one at the professional lab. I recommend that you save your originals and finished files with similar filenames so you can easily find the "negative" if you need it for some reason.

The concepts of workspace and embedded color profiles, as well as reflective versus absorptive color systems (we put color on the screen in RGB, which is an additive process, and we put color on the printed page in CMYK, which is a subtractive process) is a long and complex one and well worth exploring. The References and Resources appendix has a link to a great site that explains this aspect of color theory. Point is, it's much too complex a topic to cover in one section of a chapter.

What I can give you is a brief overview of the general parameters that you may need to learn to get your portraits printed as best they can.

A word about printing

Most professional photographers keep a higher-end inkjet printer in their office simply because you have to be able to make quick prints sometimes. However, most professional portrait photographers do not, in fact, do their own printing for finished work. There are a variety of reasons for this, notably that the industry has not yet come up with an actual continuous-tone printer. Because the client bears 100% of the cost of prints, it makes little sense to burden yourself with the cost of keeping up with printing technology or spending a lot of your valuable time creating a product which is better done at a professional lab.

That said, you will probably need a printer of some type. They're very useful for producing contact sheets, testing out your processing ideas, and creating quick or small items such as passport or identification photographs.

Continuous tone versus ppi or dpi

The analog world was once much easier to understand; prints were *continuous tone*, and one simply made an enlargement from the negative or transparency to the size needed. It was sort of like stretching silly putty—everything got bigger but kept its smooth edges and overall tonal quality.

The digital environment is different, and it has to do with the way that the camera makes files. In Chapter 11, I talked a little about how a digital photograph is made from a lot of very tiny squares, like a mosaic. And for the same reason that these squares make an image a little soft, they can also cause problems for enlargements and printing. The effect is that each square becomes larger, and any softness, jagged edges, or rough color transitions are more pronounced.

Tip *Pixels per inch* (PPI) and *dots per inch* (DPI) are often used interchangeably. Although technically this is incorrect, it isn't a practical problem because everyone usually knows what's being talking about. Technically however, scanners, digital cameras, and screens are all measured in PPI and printers are measured in DPI. We're talking about the same thing (number of units of color per square inch), so when you see DPI instead of PPI, or the reverse, don't worry—they usually refer to the same concept.

The human eye is incapable of noticing detail below a certain size or resolution. This varies from person to person, and ambient conditions make a difference, but the average is between 200 and 240 dots per inch. When an image is made up of dots smaller than this, they appear to the human eye to be continuous in nature. Images that you see in books, magazines, postcards, catalogues, and even fine-art reproductions are made from somewhere between 70 and 300 dots of ink per inch of space — depending upon the type of publication.

Resolution

A digital image has no inherent size or resolution. A digital image is a file that contains a certain number of pixels in each of the height and width dimensions. The resolution of the image that these pixels create changes as the image size changes because the number of pixels that make up the image are being spread over a greater or lesser area.

If the resolution used to make a print is too low, you will be able to, literally, see the dots. This is not acceptable for any professional work, of course. What you are seeing are the pixels (those little tiles that make the mosaic I keep talking about), which are the units used to record the image created by the camera on its imaging chip.

The "right" resolution is the one that produces a print that looks good to the human eye. Most professionals stick to a resolution between 240 and 360 dpi, with the majority sticking to the industry standard 300 dpi, which is considered the minimum number that qualifies as "high resolution." Some photographs need every bit of the 300 dpi, and some can be printed at a lower resolution. It depends a great deal on the tonal range and level of detail in the portrait.

What size, resolution, and type?

It depends on what you're doing with them, of course:

✦ **For the Web:** Images for Web or on-screen use typically need a maximum of 72 ppi. A computer monitor is a 72 dpi device and it is not capable of showing more. Generally speaking, Web images are saved so that they can be seen comfortably (without scrolling) on a browser open on a standard 1024-x-768-pixel screen, which means that they should not be much wider than 700 or 800 pixels and not much taller than 500 or 600 pixels. For the Web your images can be JPEG, which is universally acceptable for all Web applications; PNG, which is slightly less universal in acceptance; or GIF, which is not recommended for anything except illustrations or line art.

✦ **Professional printing lab:** High-end lab printers need different resolutions. Check with your lab for the resolution that they need for their particular printer. The size, of course, is dependant upon how large you want to print your image. You should check with your lab to see what file type they prefer, but most accept JPG and TIFF, and many accept other formats such as Adobe's proprietary PSD.

✦ **Inkjet printing:** Many photographers do their printing these days with a desktop inkjet printer, and conventional wisdom says that the *minimum* printing resolution for inkjets is around 240 dpi/ppi. Many of my friends in the business tell me that it is, in fact, a 360-ppi resolution that produces the best possible inkjet print. Check your printer manual for instructions on any limitations it might have regarding file types it accepts.

Go Forth and Make Portraits

I won't pretend that's everything, all the knowledge. In the big scheme of things it's a small drop, we can likely agree. But what it should do, or what I hope it's done, is to give you enough knowledge and information so that you can go ahead and take portraits with confidence and enthusiasm.

You'll learn, and sometimes the hard way, what works best, what you like the most, and, most importantly, what makes clients smile and come back time after time. As long as you're committed to always learning and experimenting and pushing the limits a little here and there, you'll do fine. Just fine.

Good luck.

References and Resources

The Internet is an amazing place. On it you can find practically anything you want or need to know. However, the largest advantage of the Internet (free publication to all) is also one of its drawbacks. Not to say, of course, that all Web material is unreliable. It isn't. Much of it, in fact, is quite valuable. My advice to you is to consider the source when dealing with Internet information and to verify all information against another source, just to be sure. I am not kidding you when I say that I do most of my basic research on the Internet, but I usually crack paper-and-ink books to check my facts.

I have endeavored to provide only links that I believe contain accurate information or resources that I think are useful. However, I do want to caution you that I have no control over the contents of the sites mentioned, nor am I able to ensure they will look the same way when this book is published (another benefit/drawback of the Internet). That said, good luck and good surfing.

4-H Style Portraiture

From the University of Minnesota, the 4-H photography manual. It's concise, has some great tips, and is an easy read. To read the whole article, point your browser to www.extension.umn.edu/distribution/communications/DL2960.html.

500 Poses!

Now here's a thing: you have to purchase this one, but it looks like fascinating creative-idea material.

Clip Art Image Gallery: 500 Model Poses w/CD-ROM (Paperback)

Point your browser to www.amazon.com/gp/product/0764178288/102-1373667-1937726?v=glance&n=283155.

A Little History

A wonderful, three-part article on the history of fashion photography. To read the whole article, point your browser to www.aidan.co.uk/article_fashion1.htm.

About

About.com is a wonderful resource that I use often. Although you may find many areas of About useful, one of the best is the Graphics Software section. To visit the Graphics Software division of About.com, point your browser to http://graphicssoft.about.com/od/photoshoptutorialscolorcor/.

Business

The US Bureau of Labor Statistics has a lot of information about the business, from average wages to working conditions and contracts available. Individuals interested in a career in photography should visit this site to find out about current market conditions. Point your browser to www.bls.gov/oco/ocos264.htm.

Career Advice from iseek

iseek gives you some advice on what it takes to be a professional photographer and outlines some of the ways you can take steps toward a career in the field. To visit this site, point your browser to www.iseek.org/sv/13000.jsp?id=100409.

Color Theory — RGB and CMYK

A quick tutorial on color theory that might help explain some of the differences between print color and computer screen color. To read the entire article, point your browser to www.rgbworld.com/color.html.

Complete Digital Photography

I'll say, "This is for the gearheads," and hope you understand I mean that affectionately — I often call myself a gearhead. Like to read reviews? Often take a long time to decide on which new lens to buy or what focal length is best based on the empirical evidence? Try the many interesting things over at Complete Digital Photography. Point your browser to www.completedigitalphotography.com/index.php.

Digital Imaging Links

This is the personal site of Lars Ekdahl, appropriately titled *Lars Ekdahl's favourites in digital imaging*, and it is one of the best resources for all things digital imaging that I have ever encountered. I find myself there frequently, looking for this or that information. To visit Lars' page, point your browser to www.ekdahl.org/digital.htm.

Doing the Math

Like to calculate your lens choices, camera settings, or lighting distances by the numbers? Lots of people do. And there's a Web page for people just like you! To visit this page and find out how it's done "by the math," point your browser to www.outsight.com/hyperfocal.html.

Glossary of Photographic Terms

It's a dictionary for photographers. Forget what DOF or POV means? Want to know what a 3D Color Matrix Meter is? What a magnification ratio means on your new lens? There's a place with everything from A to Z, literally. I've been using it for a long while and I have not stumped it yet. To visit the Glossary of Photographic Terms, point your browser to www.mir.com.my/rb/photography/glossary/terms_a.htm.

The History of Portraiture

An interesting article on the early portrait process. Included in the text is advice about how to arrange a model so that breathing does not blur the extremely long exposures. To read this article, point your browser to www.picturehistory.com/find/c/354/mcms.html.

The Learning Page — More History

The Library of Congress has the most interesting things! In this case a Web page that outlines the history of Daguerreotype photography, which was among the first portrait work done in photography. To visit this site and read the entire article, point your browser to http://memory.loc.gov/ammem/ndlpedu/collections/dag/history.html.

Joe Zeltsman Knows a Lot of Things

This is an absolute treasure. A full 16 chapters containing a lot of the expertise and experience of this gifted photographer. Presented online, it's easy to follow, and even though some of the methods are no longer popular and the digital age has changed a lot, some things never change. To visit this site, point your browser to http://groups.msn.com/Asktheoleproaboutphotography/joezeltsman.msnw.

Ken Rockwell

Noted photographer and Nikon enthusiast Ken Rockwell is virtually a legend. It's hard to imagine hanging out in too many photography circles and not hearing the name Ken Rockwell. He knows a lot of useful things, has a lot of opinions, and keeps very good lists of other excellent places to go, books to read, and a very wonderful page of great how-to articles. To visit Ken Rockwell's site, point your browser to www.kenrockwell.com.

Lights, Camera, Alien Bees?

Alien Bees is just a cool site. Not only do they have great deals on individual lights, but they also have a variety of package deals for every level of operation. From flash units to reflectors and monitors, you can pretty well get it all here. Great service, great products, and a very fun site. To visit Alien Bees, point your browser to www.alienbees.com/index.html.

Online Training Library

QuickTime movies! If you have a hankering to learn about Photoshop with QuickTime movies, this will be fun! To visit this site, point your browser to `http://movielibrary.lynda.com/html/modPage.asp?ID=116`.

Note that you need to have QuickTime installed to view these movies, and unless you are on a broadband or other high-speed access, they may take a while to download.

Photoshop Support

One of my favorite sites when I have a quick question about how to achieve something in Photoshop, this is a gem of a resource that should go straight to your bookmarks folder. To visit Photoshop Support, point your browser to `www.photoshopsupport.com`.

Retouching Techniques

From the Photoshop Tips and Tricks section, a wonderful article on retouching. Point your browser to `www.graphic-design.com/Photoshop/beauty_retouching.html`.

Setting Up Group Portraits

An article by Kenneth Hoffman entitled "Setting Up Group Portraits" is well worth a read. To read this whole article, point your browser to `www.picturecorrect.com/articles/group_portraits_arrangement_tips.htm`.

Stock Work

Many stock companies have Web sites where amateurs and professionals can submit images for inclusion in the company's stock gallery. If your image is accepted and someone uses it, you will be paid a royalty for each use. Many amateurs and a great many professionals augment their incomes with this sort of work.

These companies generally have pages where they keep a list of the items that are in demand and that they are seeking. To your great advantage, people pictures are the most often requested and used images from stock companies.

A partial list from the Alamy site contains these items, at time of print:

The Relationships category

✦ Using color to convey a mood, i.e. using deep red to convey passion and love.

✦ Woman/man wearing red clothing.

✦ Looking through rose-colored glasses at someone, to convey the message that you may not be see- ing them as they truly are.

✦ Black—the color of power, control, i.e. male stopping female from leaving through a door, could have the man dressed all in black or a completely black background.

✦ Couple sitting at a table, opposite each other with a symbol of their troubles in the middle, i.e. baby's rattle to symbolize loss or failure to conceive a child, bills, credit cards to symbolize debt, or a broken heart symbol, etc.

✦ Couples running through enclosed woodland, looking back in fear.

✦ Couples running hand in hand happily through a field of corn, or lavender.

✦ Showing anguish through images, i.e. someone watching the clock, as if someone was late home.

The Self-Expression category

✦ Woman submersed under water, could be a bath or pool to convey a message of sadness.

✦ Someone in an empty room, holding onto a picture of lover, family member, to symbolize grief.

✦ Walking down an empty road, symbolizing anguish.

✦ Someone in a confined space, fighting to get out.

✦ The feeling of someone being followed or chased, i.e. could have a female looking over her shoul- der, with a ghostly figure in the background.

✦ Expressions of happiness, i.e. someone sitting in a comfy chair, looking cozy and contented, or someone lying on a deserted beach.

✦ Walking down the street on their own overwhelmed with happiness, smiling to themselves.

✦ Someone who is grieving—throwing soil or a flower into the grave of a friend or family member.

✦ Female enjoying eating a big box of chocolates on the sofa.

✦ Expressions of anger, i.e. red-faced man looking like he is going to explode with anger.

✦ Someone walking through an open space, free from everyday life.

✦ Someone expressing anger, i.e. punching the wall or table or screwing up a letter.

✦ Expression of grief, i.e. showing someone who looks lost in a field or street with people passing them by, as if they were invisible.

✦ Woman hugging her legs to her body in an isolated space.

✦ Pictures to illustrate anger, i.e. a person opening a drink can with the word *anger* on the can, open- ing the can to release the pressure.

To see a current list of Alamy's needs, point your browser to www.alamy.com/contributors/ source/0506/needs.asp.

Other stock companies

Index Stock Imagery

www.indexstock.com/default.asp

Istockphoto

www.istockphoto.com/index.php

✦ ✦ ✦

Going Into Business

The most important aspect of a new business is a solid, viable business plan. Simply, a business plan defines how much money you expect to spend (costs), how you expect to conduct your business affairs (marketing), and how much you expect to earn (pricing). It's the combination of your budget, your marketing plan, and your company philosophy.

Basic Business Setup

You will need to do a variety of things before you actually hang the shingle above the door. In order to make sure your business has a solid step, you need to get it off on the right foot.

Business license

Many people don't factor this into their planning, which is a mistake. You must establish your legal business identity so that you can operate legally, charge taxes, file taxes as a business, and set up trade accounts with suppliers. Every country, state, province, and sometimes even municipality has different rules for what steps businesses must take to become registered. Check with your local Better Business Bureau or small-business agency for the rules that apply to a photography business, particularly a home-based business, if this is your plan. Do not discount the importance of working "on the level" and being properly registered with the right people.

Caution If you are using your home for your business, you need to check the zoning regulations and restrictions in your area before you get started. Some residential areas have zoning restrictions that do not allow you to operate a service business from your home.

Business banking account

Usually when you register a business you will have some form of official receipt indicating you have done so. Bring this form to your bank so that you can open an account for your business. You should get an account that allows you to write checks, use a debit card, or make cash withdrawals without penalty. Ideally, you will also apply for and receive a credit card in the name of the business.

Tip It is important to separate your business from your personal finances. Often when you start a business you are working with some capital – either money you have saved or borrowed or gotten from a small-business start-up grant. Deposit all your capital into the account as your opening deposit, and as soon as the account is established, use it to pay all your business expenses. If you are going to use a credit card to finance your daily business, you should have a separate card for your business and financial expenses.

Insurance

Getting the right insurance for yourself and your business is an important step and shouldn't be ignored. Basic business liability insurance is a must-have, particularly if you have clients coming to your studio. Liability insurance exists to protect you if your customer, for example, trips on the steps and suffers an injury, and it usually protects others when you are working at their location.

Additionally, your equipment should be insured against loss or damage if your homeowner's or renter's insurance does not already cover it (usually it does not without special riders). You should also consider setting up health and disability insurance in case you cannot continue working due to a health issue or injury.

Join professional or trade organizations

Participation or, at least, membership in the local chamber of commerce is a virtual must-do (and a wise idea from a number of perspectives, discussed in the "Marketing" section later). Also, you should investigate any photography associations or other professional organizations or groups with which your business is aligned. For an excellent list of photography related organizations around the world, point your browser to www.profotos.com/education/referencedesk/organizations/index.shtml.

Tip

Almost every city has some form of published material that allows you to see what new businesses have been registered that week or month. Sales and marketing people use these extensively to make contact with new businesses, and the contacts you can make this way can be useful to you. When you register your business name, I urge you to use carefully worded descriptions. Many photographers end up doing work for other small businesses, and I know one interior designer who contracts for a lot of photography work who likes to check those listings for "fresh talent," as she calls it.

Supplier and photo lab arrangements

To make a small business successful, you should develop a relationship with your photo lab (printing service), framer, and photography equipment suppliers. The quality of their work and their ability to meet scheduled deadlines has to be excellent. Remember, your choice of photo lab can make or break your business.

Caution

You will notice that I am offering advice on printing services. The reason for this is that I recommend quite strongly, especially to people just starting in the business, that they not attempt to create their own prints. Though it may be slightly cheaper, it takes a very, very good printer (that most of us, myself included, cannot afford to own) to come close to what a professional lab can do with their continuous-tone process. I strongly urge you to "do it like the pros" and have a lab do all your final printing. Inkjets are perfectly fine for proof printing, of course.

As this section's cautionary mascot, I give you Wolfgang Amadeus Mozart.

Oh, Mozart is *always* the example, I know — but he *is* a good one. He was brilliant, we can generally all agree on this basic premise. And you know that he died poor, right? Indeed, the brilliance of his work notwithstanding, he died flat broke. The caution is, of course, that talent and skill and brilliance do not always make a successful business. In fact, Mozart's two big mistakes are the same two that most people make: excess and administrative failure.

Simply, Mozart spent too much of his money on things he did not need, and he was rarely paid for the work that he did. Something tells me Mozart would have two of everything possible and of the best quality — and be one thin step ahead of the bailiff. What Mozart needed was a business plan. And so do you.

Costs

The costs for starting and running a business are wildly variable, of course, and depend upon your own unique circumstances. There are, however, some very standard formulas for getting a business off the ground. The first place to start is, naturally, with the costs.

Generally, you will have costs of three types: startup, overhead, and operating.

Startup costs

Startup costs are those that are related to starting your business and include your capital expenses (equipment and premises) and your administration expenses (business licenses and signage, accountant and lawyer fees, incorporation fee, and other like costs).

To calculate, your startup cost is the total cost of all the items you will buy or have already bought that are a direct cost to your business. You need to know, bottom line, how much money you need to have to start a viable business. Depending upon what you already own, it can be as little as a few lights or as much as a new camera and a few lenses. In addition, identify any office equipment you will need within the first year, such as a computer, software, telephone, fax, scanner, office furniture, and other related things.

Tip

Ironically, the startup costs of a business can also become part of the overhead cost. If, for example, you have borrowed money (even from yourself) for which you have a regular payment, this should be included in your overhead cost, which is the cost of running your business from month to month whether you are earning income or not.

Simply sit down with a pad of paper, a pencil, and a calculator and start making a list of all the things you need to have (whether you own them already or not). Then, investigate the costs of these items carefully by checking online or with a variety of suppliers so that you are able to make the best deals possible on anything you need to buy. When writing down the cost of an item, ensure it is a real-dollar cost and includes any taxes, fees, duties, and shipping costs.

Don't forget the odd costs such as first and last month's rent (for studio space if you're renting), any deposits you might have to give for services such as telephone or Internet access, the roof carrier you had to buy for the car to carry around your equipment, and other such items that are easy to let slip under the radar. You might well try to dress it up for the bank manager — many people ill-advisedly try this — but whatever you do, *don't try and fool yourself.*

When you're done you should have a pretty good idea what it will cost you to start the business and whether you can afford to do so. By juggling what you think you need (maybe you do have to use your basement for the first year instead of that great studio space you've always dreamed of renting) and what you really *do* need, you can pretty well always come up with a plan that works.

Tip

When making your list of things you need in order to start a business, include anything that you already own, but separately from what you need to buy. The first group contains assets (and can be used for financing in some cases) and the second group contains expenses. This will help you determine your budget and plan how you will purchase any additional equipment you may need.

Overhead costs

Overhead costs are those related to your business and that exist whether you earn any income or not. These include rent, loan payments, equipment depreciation, salaries (including your own!), utilities, and other like costs. Overhead costs are typically worked out so that you know the base cost to run your business each month. Because your business plan works on a yearly basis, you can multiply this by 12 and know what the first year will cost you — whether you ever take a photograph or not.

 Caution Overheads are the reason that "watching your pennies" is still a saying today, I think. Many business star-tups make the same mistake, which is to undo themselves with a lot of small expenses that seem innocu-ous by themselves (like bad pixels) but that can add up to be a fearsome monthly beast. Be careful that the Yellow Pages ad and the association dues, the every other day of boxed donuts for your assistant, and the extra reflector you really don't need won't add up to trouble for you.

Whenever I've worked out business plans, I've always done the first step (startup costs) and then worked on the overheads, going back and forth between the two until the sum of the two was within a reachable level.

When you are done calculating your startup and monthly overhead costs, you will have a very good idea of what you need to bill out per month and per hour to keep your business profitable.

Operating costs

Operating costs are directly related and usually proportional to your income (photography light bulbs, printing costs, traveling expenses, and other business supplies like background paper and props). In other words, they do not exist unless you have done a job. Generally speaking, operating costs are labor, supplies, and materials used to provide the service or product the business is selling.

Many photographers charge operating costs as a straight add-on hourly charge (usually called a studio or supplies charge) and then bill for any direct expenses such as travel, costumes, or props as a separate item.

Doing the Math

Say you need $10,000 worth of equipment to start your business. If you were starting out from scratch, this would not be an unreasonable number.

Now say you have $6,000 worth of that already. If you have the camera, a few lenses, a couple of extra bat-teries, some CF cards, a reflector or two, a computer and software, and a few pieces of lighting equipment, chances are quite high that this is also a reasonable number.

You have, therefore, an asset base of $6,000 and a capital requirement of $4,000 to start your business. That's not bad! If your business overhead costs are, as an example, $2,000 a month to run, you need $24,000 to do that for a year. So, you need $28,000 ($4,000 + $24,000) to start and run your business for a year.

If you calculate the number of working hours in a year (typically 2,000 is used, which is 40 hours for 50 weeks), you will know how much your business needs to earn an hour. In this example case, it needs to either operate for 40 hours per week, 50 weeks of the year, and bill at least $14 per hour to break even, or it needs to operate 20 hours per week, 50 weeks of the year, and bill at least $28 per hour. Or something in between — you get the idea.

One of the main reasons you need a business plan is to establish what you need to charge for your time and services so that you can be profitable. After you know what it costs you in capital dollars (cost of startup), what it costs you to operate on a monthly basis even if you have no business (cost of overhead), and the amount of cost you incur per shooting hour (or photograph), you can easily establish how much money you will need to be profitable.

Pricing Your Services

Pricing. Ah yes, the most difficult and often-asked question is this one. "What should I charge?"

Oh yes, I know that you know it's coming, but it can't be helped. The answer is "it depends."

If you set too high a price, you might price yourself out of the market. If you price too low, you will damage the market — to yours and everyone else's discomfort. Although it might be nice for us to find out that we can get our oil changed for $4 an hour at the cheap place, it will make a lot of mechanics very, very unhappy. And it will make whoever is doing it very, very poor. And, in the end, the whole market will really be in a pickle.

There are a thousand methods of coming up with a price, naturally, but there are a few basic business principles that come into play here. Notably, you must cover your costs and generate a profit. This is your first priority and your primary obligation to your business: you must make a profit or it ceases to be a business.

Check the competition

Check with other portrait photographers as to what they charge and how they put together packages. Portrait photography pricing is complicated because it usually is not a simple matter of taking a picture and selling it. Often portrait photographers put together packages that include so many poses and so many prints for a set fee. Others have an hourly fee only and some charge strictly by the print. I recommend a two-level pricing system: one for the photography and another for the prints.

Studio Charge

Often small-photography-business operators work out an encompassing cost per shooting hour based upon averages and call it a studio charge, similar to a "shop charge" at automobile garages. It is a charge for those things that you have used to create the product and includes things such as:

✦ Consumables such as batteries, CF cards, rolls of background paper, cleaning supplies, light bulbs, and lens cloths

✦ Value depreciation of your equipment — you will need to repair or replace your worn-out equipment

✦ The cost of you spending uncalculated amounts of time thinking about what you will do, processing images, or looking through proofs — the cost of your creativity and skill, if you will — which also covers the time when you are not actually shooting but are still engaged in some work for the client

To cover these items, I charge a $20 per hour studio charge for all time spent actually shooting, either in the studio or in the field, *in addition to* any other hourly or per item charge that exists.

The best way to know whether your pricing ideas are within a reasonable range of what the existing market offers is to ask around and get price lists. I recommend that you start at Wal-Mart or another similar place that has a large retail portrait studio. This is generally the lowest pricing available and a very good benchmark for you. You will be more expensive, of course. The issue here it so make sure you are not less expensive.

Calculate your base rate

All of the calculations that you did earlier can be put to use now so you can determine, first, what you *have* to charge — that is to say, the base amount you must charge to keep your business viable.

1. **You know what your business needs to earn per hour to cover its overheads (which includes paying you, the photographer).** This is your base rate.

2. **You've figured out what your studio or supplies standard charge per hour should be.** Add this to your base rate and you have your *minimum* hourly rate. In other words, you can't afford to be in the business if you have to charge less than that per hour.

What you eventually charge depends upon what other professionals in your area charge, what sort of work you do, and how in-demand you become. What you start out charging, generally, is something close to what the mainstream market is charging.

Caution

There is no nice way to say this. People aren't paying for how good you are, they're paying for how in-demand you are. Generally speaking, these two states are linked, and a photographer becomes popular because he or she is good. But when you are starting in the business your relative talent or creativity cannot usually be used to charge a premium — no matter how much better you are than that guy who takes terrible headshots but has all the town business. You earn a price premium; you don't go into the market feeling entitled to one.

Pricing commercial work

Commercial work is that done for a business or a person acting as a business and not a private individual. If you have a contract to take all the headshots for a large real-estate agency corporation or the stock shots for a food supply business, for example, this would be commercial work. You generally charge a flat per session or photograph fee, with a contracted fee that is stable for some agreed-upon period of time.

The rail freight business has a minimum weight at which it is worth it to move a rail car from one location to another, and you tend to take contract work for heavy, dense things like sheet metal and boxed nails to quickly fill cars to minimum weight. This is called *base freight*. Contract work, for the photographer, is the base freight and is an excellent way to pay for some of your overheads. Sure, the work can be boring (imagine taking 100 used-car-salesman clone-like headshots in an afternoon!) but it's one of those things that keeps the bills paid and is reasonably easy to perform. I used to sell space on a freight train, and I can tell you that you sell the base freight cheaply, generally. There are two reasons for this. One is that you need to get the train moving, and the second is that everyone else sells it cheaply, too.

The question is, as always, what is "cheap," and how "cheap" are you willing to go? No one charges a lot of money for this kind of work, and it's fairly simple to check around and find out what the going rates are.

A very good friend of mine, also in the freight business, said a smart thing to me once. He said that there was enough base freight for everyone, and there was no use fighting for it or trying to take more than your share—in the end all it meant was that there would be no room left in the car for the good stuff. In other words, don't try to take on too much low-paying or barely profitable work. Simply, you will not have enough time to find the really fun, cool, well-paying work.

If you plan to, don't undercut your competition to any great degree, and not at all, if possible. Remember, this is a business for professionals.

Pricing retail work

Retail photography customers generally expect and prefer to be presented with an all-inclusive price for a specific package of services. Below are recommendations and a brief discussion for a few of the more standard scenarios.

Weddings and events

✦ Set a flat fee per hour.

✦ Charge a standard, agreed-upon price for each print (in each size) and agree on how the print will be delivered (bare, matted, framed, and so on).

✦ Require a minimum dollar order per hour of coverage.

✦ Ask for a nonrefundable payment for three, four, or five hours of the minimum per hour order at the time the order is placed.

✦ Ask for an advance payment, usually an additional 25% of the expected order, two weeks prior to the event.

Private sector—Individuals, couples, families, pets

✦ Set a flat fee per hour of shooting time.

✦ Charge a standard, agreed-upon price for each print (in each size) and agree on how the print will be delivered (bare, matted, framed, and so on). If you want to make packages, which many people like, simply select a standard mix of sizes and calculate their prices, allow for a small volume discount, and call it a package.

✦ Ask for a nonrefundable advance payment of one or two hours studio time. Charge cancellations a minimum of two hours studio time.

Arts and entertainment—Dancers, models, actors, athletes

✦ Create three levels of portfolio packages. A single shot, a 10–15 shot, and a 16+ shot package. Price them according to how many hours you think they will take to shoot and how much the printing will cost. It is generally true that photographers "give a break" to fellow artists, but just like they expect to be paid to sing in the chorus, you must expect to be fairly compensated for your work.

✦ Many models will work for you in exchange for free portfolio shots and as long as it works out for everyone (you have a paying client who can use the work, or you need a shot for your own portfolio).

Pricing Advertising, Agency and other Commercial Work

If you were pricing for commercial work, such as shots to spec for an advertising agency, you would generally charge as follows:

- ✦ A basic per diem, per hour or per shot fee. It will depend a lot on the type of work. If it is a series of headshots for a company roster, a charge per image (plus studio charge for your time) is acceptable. If the work involves you setting up scenes or shots, trying several variations or working with more than one model or prop, a charge per hour is appropriate. If you feel the job will take more than 6 hours or so, charge a per diem rate.
- ✦ Your studio charge (for each hour charged).
- ✦ Your direct expenses plus a margin of 20%–50%.

Pricing prints

Your print pricing, as it relates mainly to your retail portrait business and not any sales you may make through a gallery, is a very simple calculation. You should charge the cost that you incur to create the print plus a reasonable markup. Again, this will depend upon what the market will bear and how much you want the business.

Most photographers that I know see the prints as a very minor aspect of their expected income, which is expected to come primarily from the hourly photography fee. This is not to say that they see the provision of a high-quality print as secondary; they just do not count on the income from prints to do much more than pay the lighting bill.

The exception to this is that sometimes photographers offer unique specialty packages (with custom framing, binding, or laminating) that require a lot of effort from the photographer to produce. In these cases, price the items profitably, however expensive that seems. Unless you're Proctor and Gamble, who make the laundry detergent Tide and regularly authorize it to be sold as a loss leader (it makes no profit) to get people into the store, I don't recommend selling any of your products or services at a loss.

Model releases

I recommend that you get a release signed by every model that you pay, with either real money or with your services. Additionally, I recommend that you get a release from anyone who just agrees to model for you because you asked, whether they are a friend, a family member, or a member of the congregation. It's not about trust or protecting your rights so much as it's about being in good administrative control of your business. It's about knowing what you can legally and morally do with each photograph that you take. It's good to be in control when the object of that control is your business.

Caution I am sure it doesn't apply to you, but I have seen some photographers hustle through the release process because it can make people uncomfortable. In most standard model releases, the wording basically says, in most cases, that the photographer can do whatever they want with the photograph. So it's understandable when people get uncomfortable, and a large part of your job as a pro is to explain what it means, to assure them of your intentions, and to spell out any potential uses you can imagine for which you might employ their photographs. The caution here is to make sure you understand the document you are producing and that you are able to explain it professionally. Saying, "Oh, don't worry about it, it's nothing," about a release query is, in a word, unprofessional.

Standard Model Release

FOR GOOD and VALUABLE CONSIDERATION, receipt of which is acknowledged, I hereby grant **[YOUR NAME]**, in connection with the photographs s/he has taken of me, or in which I may be included with others, the following worldwide irrevocable rights and permissions:

(a) the right to use and reuse, in any manner deemed appropriate, said photographs, in whole or in part, modified or altered, either by themselves or in conjunction with other photographs, in any medium or form of distribution, and for any purposes whatsoever, including, without limitation, all promotional and advertising uses, trade purposes; and

(b) the right to use name in connection therewith, if s/he deems it appropriate; and

(c) the right to copyright said photographs in his/her own name or in any other name that s/he may choose. I waive the right to inspect or approve of any use thereof.

On behalf of myself and my heirs and assigns, I hereby release, and discharge Photographer from any and all claims, actions and demands arising out of or in connection with the use of said photographs, including, without limitation, any and all claims for invasion of privacy or unfair use. This release shall inure to the benefit of the assigns, licensees and legal representatives of the Photographer, as well as the parties, if any, for whom the work was originally undertaken.

Please check one:

___ I am over the age of eighteen years and I have read the foregoing and fully and completely understand the contents hereof.

___ I am the parent or duly authorized representative of the model, who is a minor, and I have read the foregoing and fully and completely understand the contents hereof.

Photographer: **[Your Name]**

Date:_____

(Model or Parent/Guardian Signature)

(Print Model and Parent/Guardian Name)

Phone:_____

(Address)

I do not recommend that you get a model release for your retail work because there is no reason why you would need to do anything with the photographs people paid you to take for their own private use. As a professional, in fact, I recommend that you do not consider those photographs to be your creative property so much as they are the physical property of whoever paid you to take them.

Not to say, of course, that you won't have that one amazing client walk through the door that your camera loves, or that one or two of those cool shots you took for the contemporary dancer won't want to be in your portfolio. That will happen. When it does, deal with it on an individual basis and ask the client whether you may have the rights to one or more of the photographs that you took.

In all cases, when dealing with legal matters, whether the release is the standard one shown in "Standard Model Release" (which is the one I use), or any other binding document, you should be absolutely certain that it does the job you intend it to do. I cannot advise you specifically on legal matters as I am not a lawyer and the laws vary from location to location. The advice that I will give you is to establish your collection of legal releases and other binding documents that are a part of your business and to have them checked by an attorney. Alternately, there are books available with collections of lawyer-produced standard legal forms and many of the links provided in the web reference in "Join Professional or Trade Organization" offer basic forms used by professional photographers that you can download and modify for your own use.

Marketing Your Business

Marketing is not just making an ad for the Yellow Pages (although that is part of it) or printing business cards. Marketing involves you selling yourself, particularly in a small service business where *you* are the name and face of the business, generally.

You want to build a solid reputation for doing good work, on time and at reasonable rates, and marketing is the way that reputation becomes known. Basically, marketing is researching and locating potential clients, getting your name spoken in the right places, and ensuring that your existing clients are happy enough to recommend you to their friends and associates. You should plan a certain amount of time every day to spend in marketing your business. Usually, a new business is half fieldwork and half marketing.

Define the target market

The first step in developing a marketing plan is to develop solid information about your target market. This includes, but is not limited to:

✦ Market size

✦ Sales potential

✦ Assessment of your competition

✦ Information on pricing and marketing practices

For example, your main market's focus is in entertainment, fashion, business, and the private sector (individuals and families, clubs and teams). Your major buyers include performers and models, business people, art directors of publications, interior designers and decorators, companies that build model homes and, of course, the private individual.

Make a list of possible customers in your area and determine their levels of demand. Minor league sports teams need portrait photographers, as do schools, clubs, local magazines, decorators, event planners, wedding planners, and so on.

Create a portfolio

Creating a portfolio of your best work is critical. It must represent your style and skill as well as provide a sampling of your versatility, creativity, and ability to work within traditional styles, if required. Your portfolio is what you show to prospective customers and its quality and *presence* helps determine whether they will find you worth hiring or not.

There is no way to cover the creation of a portfolio here (that could fill another book), but here are a few hints for putting one together:

✦ It must be a representative sampling. If all your best shots are of children, you will have to go with some of your second-best shots.

✦ If possible it should include at least one example of the following types of portrait: child, couple, man, woman, pet, and group in each of the casual and formal styles.

✦ The individual pictures should be shown inside a matte or printed with a wide matte area and be presented in such a way that prospective clients can handle the photographs if they want. This can mean keeping several copies of portfolio shots on hand, but it's a small price to pay for the incredible advantage of making your portfolio accessible.

✦ Even if you print at home with your inkjet printer and obtain very pleasing results, I urge you to use a lab to print portfolio images. You may find this extreme, but you must take my word that it is neither extreme nor unusual for an art director to whip out a loupe and examine your portfolio images. You can fool a naked eye, but one with a loupe attached to it is not so easily fooled. It will depend, of course, on what you are doing with the portfolio. If you are making one to leave in your waiting area for prospective clients to look through, the inkjet is fine. If you are making a portfolio to take to the biggest ad agency in town, have a lab make your prints.

Do not ever include photographs of yourself or your children — even if they're your best. The exception to this would be if you have a professional model for a child or you are one yourself — but even then, I'd avoid it.

Portfolios can be generated in a variety of formats as well. While the most popular and most often used format remains the physical one, usually in a black leather case with loose, matted prints there are a number of more modern options:

✦ **Create a web site or a web page to show off your best photographic work.** Ensure that a way to contact you exists and that you frequently update the contents. You can add this URL to your Yellow Page ads, business cards, flyers and other advertising material.

✦ **Create a slide show or other on-screen presentation that is stored on CD or DVD.** Make sure the images are low resolution so they cannot be printed or used for commercial purposes.

Tip

Although not directly related to portraiture, I have written another book called *Create Your Own Photo Blog* (also published by Wiley) that shows you how to set up your own photo blog and use it to generate a portfolio site. My photo blog was, in fact, how I got started in the professional photography business, so I can attest to their effectiveness. Public sites such as www.flickr.com offer you a place to store your photographs and although you can send potential customers to these sites, it makes a much better impression if you have a personal portfolio site.

Go get 'em, Tiger

Every situation is its own, of course, and there must be a million ways to get business, from the timid mouse to the bull-in-a-china-shop approach. I recommend you aim somewhere in the middle, near the tiger cage.

Public relations helps any business — this is just a fact. As the name implies, this means that you interact with the community (or public) on behalf of your business to generate or improve its reputation. There is nothing, as they say, that can beat word of mouth to make a small business into a successful small business.

Not surprisingly, there are many things you can do in this area:

✦ Write letters of introduction, as succinct as you can manage, along with a list of the services you are prepared to provide to all the interior designers, event planners, wedding planners, minor league sports leagues, and private schools in your area.

✦ Pick your best work and make the rounds of the local galleries, coffee bars, and museums — or see if you can get some hanging space at the artists' co-op.

✦ Visit the local daycare centers and offer your services — many companies perform school photography but most neglect daycare centers.

✦ Offer to teach an adult education or children's photography workshop to get your name known in the community in a way that is directly associated with your business.

✦ Make flyers, have them printed cheaply at the local quick-print shop, and go to the ballet and dance schools, the children's theatres, and any place where children gather to do activities and put one on the bulletin board.

✦ Send letters of introduction and a list of the services you are prepared to provide to the editors of the community newspapers and local magazines.

✦ Real-estate agents and car salesmen often have a portrait on their business card — it might be a good idea to send a letter to the local real-estate governing agency and the car dealerships.

✦ Volunteer a picture to a local charity or non-profit organization if they're having an event or charity auction.

✦ Make a contact in the commercial interior design business and see if you can get your work displayed in the lobby or a waiting room of a public building, hotel, or eating establishment. Often small-restaurant owners are happy to have fresh art to hang on their walls.

✦ If it's appropriate to do so, find some local people who will sit as a model for you so you can build your portfolio — in exchange you can give them free prints (don't forget to get a model release).

✦ Make really cool business cards and leave them on the grocery store, mall, and community club bulletin boards.

✦ Local police and fire departments may need someone to help train officers in photographic evidence gathering as well as requiring portraits and community relations photos.

✦ Ask the local high school or community college if they need a professional photography business on their career day tours, work and learn programs or as part of any trade programs which require on-the-job apprenticeship.

✦ Hotels, retreats, convention centers, and restaurants always need menus and an assortment of portrait-type photography performed; you can send a letter to the general managers of those types of places in your trading area.

✦ ✦ ✦

Index

Continued

Continued